Museums

in the 21st Century
Concepts Projects Buildings

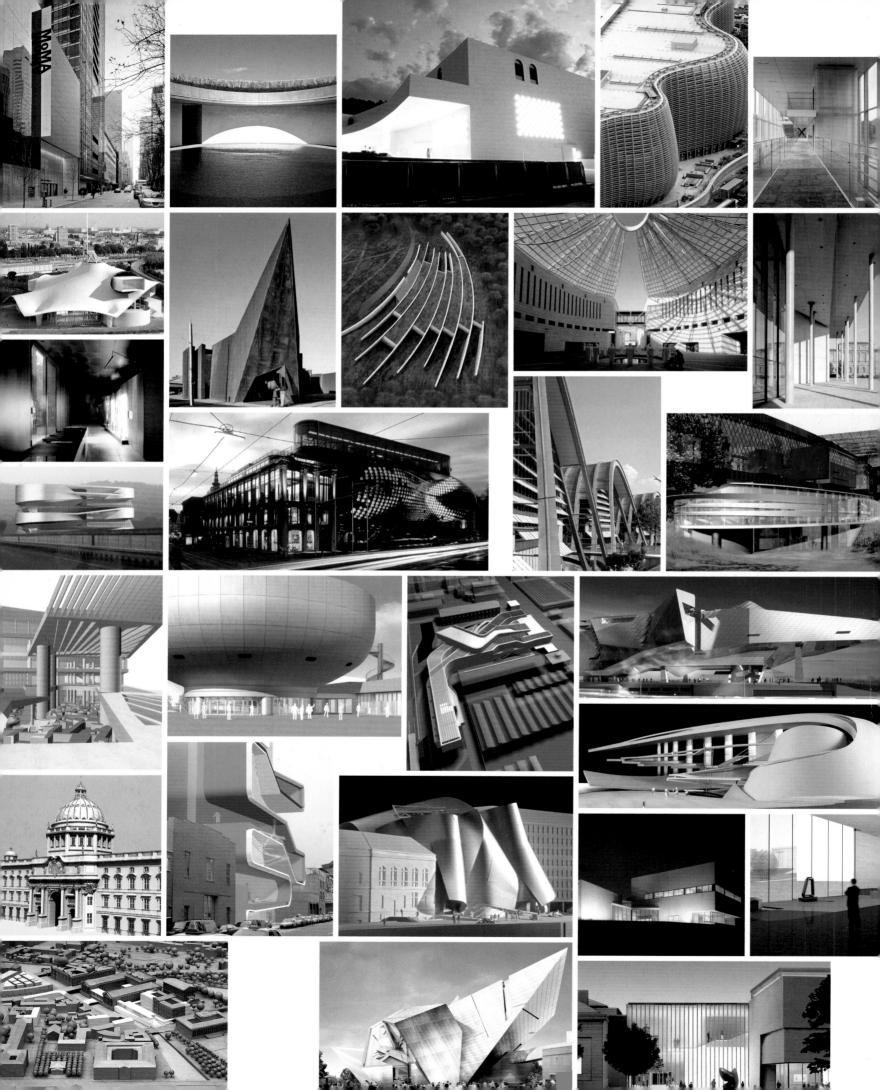

Museums
in the 21st Century
Concepts Projects Buildings

Edited by
Suzanne Greub and Thierry Greub,
Art Centre Basel, Basel, Switzerland

with essays by Thierry Greub, Gottfried Knapp, Werner Oechslin,
Leon Paroissien, James Russell and Hiroyuki Suzuki

and contributions by
Shozo Baba, Haig Beck and Jackie Cooper, Werner Blaser,
Dana Buntrock, Pippo Ciorra, Christine Gisi, Thierry Greub,
Kenjiro Hosaka, Philip Jodidio, Jann Kern, Gottfried Knapp,
Annette LeCuyer, Andres Lepik, Matilda McQuaid,
Joan Ockman, Lilian Pfaff, Lionello Puppi, Terence Riley,
Angeli Sachs, Leon van Schaik, Verena M. Schindler,
Peter-Klaus Schuster and Moritz Wullen, Werner Sewing,
Lewis Sharp and Andrea Fulton, Frank R. Werner

Prestel
Munich · Berlin · London · New York

2nd, revised and expanded edition 2008

© Prestel Verlag, Munich · Berlin · London · New York, and Art Centre Basel, 2006

© of works illustrated by architects, their heirs or assigns, with the exception of: Joseph Beuys, Paul Klee, Barnett Newman, Jean Nouvel, UN Studio I van Berkel and Frank Lloyd Wright by VG Bild-Kunst, Bonn, 2007; Francis Bacon by The Estate of Francis Bacon/VG Bild-Kunst, Bonn, 2007.

© of the essay by T. Riley on Taniguchi: The Metropolitan Museum of Art, 2004.

Photographic credits: page 225

Library of Congress Control Number: 2007941971

British Library Cataloguing-in-Publication Data: a catalogue record for this book is available from the British Library;

Deutsche Bibliothek lists this publication in the Deutsche Nationalbibliografie; detailed bibliographic data is available on the Internet at http://dnb.ddb.de

Opposite page: Stephan Braunfels Architects, Pinakothek der Moderne, Munich, Germany

Prestel Verlag
Königinstrasse 9
80539 Munich
Tel. +49 (0)89 24 29 08-300
Fax +49 (0)89 24 29 08-335
www.prestel.de

Prestel Publishing Ltd.
4 Bloomsbury Place
London, WC1A 2QA
Tel. +44 (0)20 7323 5004
Fax +44 (0)20 7636 8004

Prestel Publishing
900 Broadway, Suite 603
New York, NY 10003
Tel. +1 (212) 995 2720
Fax +1 (212)995 2733
www.prestel.com

Editors: Suzanne Greub and Thierry Greub, Art Centre Basel
Overall idea: Suzanne Greub
Concept and selection of projects by: Suzanne Greub and Thierry Greub
Project management: Christine Gisi, Art Centre Basel

Catalogue
Project coordination: Victoria Salley and Anja Besserer, with the assistance of Julia Höffner and Veronika Wilhelm
Project management and editorial direction: Delius Producing München, Barbara Delius
Translated from the German by: Paul Aston (Oechslin, Greub, Knapp, Ando, Braunfels, Gigon/Guyer, Coop Himmelb(l)au, Anamorphosis, Chipperfield, Gehry, atelier brückner I ART+COM, foreword Schuster) and Michael Robinson (Piano, Nouvel, Tschumi, Holl, Spacelab);
Translated from the Italian by: Paul Aston (Botta)
Copyedited by: Danko Szabó
Design and layout: zwischenschritt, Rainald Schwarz, Munich, with Andrea Mogwitz, Munich
Design of the cover for the museum edition Berlin: Polyform, Berlin www.polyform-net.de;
New entrance building, the Museum Island Berlin / David Chipperfield Architects / Rendering ART+COM Jan. 2008
Origination: reproline mediateam, Munich
Printing: Aumüller, Regensburg
Binding: Conzella, Aschheim b. München
Printed in Germany on acid-free paper

978-3-7913-3840-8
English trade edition

987-3-7913-3839-2
German trade edition

Exhibition
Selection of host museums: Art Centre Basel
In charge of host museums: Christine Gisi, Rebekka Rudin
Framing: Mohler Philipp GmbH, Liestal
Plates: reproline mediateam, Munich
Transportation: Maertens Art Packers & Shippers BVBA, Brussels

This catalogue is published on the occasion of the exhibition
Museums in the 21st Century: Concepts, Projects, Buildings

Concept and production of the exhibition:
Art Centre Basel, Suzanne Greub

Exhibition venues
1 April 2006 – 25 June 2006
K20 Kunstsammlung Nordrhein-Westfalen, Düsseldorf, Germany

21 September 2006 – 29 October 2006
MAXXI, Museo nazionale delle arti del XXI secolo, Rome, Italy

23 November 2006 – 18 February 2007
Lentos Kunstmuseum Linz, Linz, Austria

20 March 2007 – 1 July 2007
Musée des Confluences, Lyons, France

7 December 2007 – 3 February 2008
Caixa Geral de Depósitos Culturgest Lisboa, Lisbon, Portugal

7 March 2008 – 25 May 2008
Pergamon Museum, Staatliche Museen zu Berlin, Berlin, Germany

20 June 2008 – 14 September 2008
Louisiana Museum of Modern Art, Humlebaek, Denmark

10 October 2008 – 11 January 2009
National Museum of Art, Architecture and Design, Oslo, Norway

6 February 2009 – 3 May 2009
University of Michigan Museum of Art, Ann Arbor, Michigan, USA

29 May 2009 – 23 August 2009
Frist Center for the Visual Arts, Nashville, Tennessee, USA

18 September 2009 – 3 January 2010
Art Gallery of Alberta, Edmonton, Canada

28 January 2010 – 18 April 2010
New Mexico Museum of Art, Santa Fe, New Mexico, USA

14 May 2010 – 22 August 2010
BMW Museum, Munich, Germany

16 September 2010 – 2 January 2011
MART, Museo di Arte Moderna e Contemporanea di Trento e Rovereto, Rovereto, Italy

27 January 2011 – 1 May 2011
Museum aan de Stroom, Antwerp, Belgium

26 May 2011 – 21 August 2011
Centro de Arte y Naturaleza, Fundación Beulas, Huesca, Spain

Contents

Foreword

Museums are still booming. New museums are being built, while existing museums are being given facelifts in the form of either renovation or extensions. To take a few examples from Switzerland and the nearby principality of Liechtenstein: Morger, Degelo and Kerez's new building for the Kunstmuseum, Liechtenstein was opened in November 2000; the Franz Gertsch Museum in Burgdorf was opened in October 2002; and the Aargau Kunsthaus acquired an extension in October 2003 designed by Herzog & de Meuron and Rémy Zaugg. In June 2002, the Zentrum Paul Klee – designed by star architect Renzo Piano – opened its doors on the eastern edge of Berne, the Kunsthaus in Zurich had a ceremonial 'reopening' after four years of total renovation, and in Basel, Gigon/Guyer's conversion and extension of the Kunstmuseum is currently under way.

Undoubtedly, the key event that launched this tide of museum-building was the completion of the Pompidou Centre in Paris in 1977, designed by Renzo Piano and Richard Rogers. That structure openly stated its claim to be an art machine, and with its sunken position really was open to the street, and yet it can be seen as a museum or just as a viewing platform. Museums therewith lost their standard formula for pathos. The subsequent culmination of the process at the end of the 20th century was Frank O. Gehry's Guggenheim Museum in Bilbao (1991–97). The

immediate knock-on 'Bilbao effect' made two things absolutely clear. First, that a city, and possibly even a whole region, can profit from a new museum, and secondly, that architecture had finally become emancipated from the art exhibited inside it.

The Art Centre Basel, which has designed and organised international touring exhibitions since 1984, had such a positive response with its first architectural exhibition – *Museums for a New Millennium: Concepts, Projects, Buildings* – covering museums from 1990 to 2000, that a follow-on exhibition seemed the obvious thing. In 1999, twenty-five pioneering projects were presented in the catalogue and accompanying exhibition. Between 2000 and 2005, the exhibition was on show in eighteen museums, ten countries and three continents – latterly at the National Museum of Contemporary Art in Seoul in the summer of 2005.

Museums in the 21st Century: Concepts, Projects, Buildings has this same international flavour as its basis, featuring outstanding and future-oriented museum buildings from 2000 to 2010 in four continents. After an introductory essay by Dr. Werner Oechslin (Professor at the ETH in Zurich) and speculations on the subject of 'museums today' by Dr. Thierry Greub (Art Centre Basel) come four essays that to some extent break new ground, with a look at the history of museum-building in Asia/Japan (Dr. Hiroyuki Suzuki, Professor of the History of Architecture at Tokyo University), Australia (Dr. Leon Paroissien, Adjunct Professor to the School of Design and Architecture at Canberra University), Europe (Dr. Gottfried Knapp, of the *Süddeutsche Zeitung* in Munich) and the USA (James S. Russell, AIA). A closer look at twenty-seven completed, planned or current construction projects then gives a wide-ranging survey of current museum architecture. In their individual ways, each can be taken as a gauge of present-day trends in architecture.

Projects were principally selected on the grounds of innovation and the kinds of commission they represented, with the aim being to keep a balance between work in Asia (Japan), Australia, Europe and the USA. In this context, it is particularly regrettable that two firms could not take part: Herzog & de Meuron (Basel) for deadline reasons and SANAA (Kazuyo Sejima, Ryue Nishizawa & Associates, Tokyo) because they do not participate in overview exhibitions.

We should like to thank everyone who contributed to the realisation of this book and the exhibition. We should mention in particular our staff member Christine Gisi (project manager), who shouldered the whole organisational work for both book and exhibition with tireless energy and enthusiasm, the architects and staff of the architectural firms, who managed to fit us in beside their existing workloads, and finally the authors of all the articles in the catalogue. They have succeeded in formulating the key points of the given buildings with admirable, trenchant succinctness.

As organisers, we are particularly grateful to the directors of the host museums. Their commitment and interest in our exhibition has been a source of great pleasure, and inspires us to carry on with other ambitious exhibition projects in the future.

Basel, December 2005

Suzanne Greub
Thierry Greub
Art Centre Basel, Switzerland

Museum Architecture:
A Key Aspect of Contemporary Architecture

Werner Oechslin

1. Cathedrals

In the 19th century, civic pride turned major towns into cities, endowing them with all the institutions that reinforced their role as the focal point of life and society. In the main, these involved public buildings. This development peaked around 1900, when architecture came up against its biggest crisis to date – the encounter with modernism. "Industrial architecture," asserted Gropius in 1913, should be derived from the new "demand for beauty of external form." The Deutscher Werkbund espoused stations, factories and stores as new large building types, celebrating the "engineer's buildings" that evolved "from within, that is, without false masking work by the architect", as Hermann Muthesius put it in the same year. The new metropolitan dimension and a suitable style for it seemed all set to go – what Karl Scheffer in his *Die Architektur der Grossstadt* (1913) called "modern utilitarian monumentality". He subsequently provided the winged words to go with it – factories were the "new cathedrals". In his view, "more mature art can be found in factory buildings than in almost any new monumental public buildings."[1]

Thus the monumental history of architecture continued to be written despite all the changes of form and style. The catch phrase "new cathedrals" generally surfaces even today whenever a new public building causes a stir. "A luxurious cathedral of learning" was the headline in a Zurich newspaper when Calatrava's new law library was opened in 2004. But opinions differ. For some, "spectacular architecture" – unlike town-planning projects – is paid too much attention. Others, like the Hamburg Architectural

Centre, are decisively in favour of it, advocating "big buildings making big waves" and "cultural projects as a driving force for urban development". Common to all is the old *panem et circenses*. The buildings are supposed to be attractions, crowd-pullers, breaking new ground and expressing modern urbanism. When Höger's Chile Haus was opened in Hamburg in 1924, the list of great buildings (the Pyramids, the Lighthouse in Alexandria, the Mausoleum in Halicarnassus etc.) had had the Eiffel Tower and Le Corbusier's North American grain silos added to it. Seen in this light, the history of architectural wonders continues seamlessly and uninterrupted.

There is no doubt that museums feature prominently on this list. People may dispute whether more people visit football stadiums or museums – but is there really such a tide of humanity and such an unquenched thirst for art? The suspicion nags that the phenomenon of museums as art buildings is being reduced to the – spectacular – shell of the architecture, which in accordance with the latest fashion is treated as art, a piece of sculpture. Are we back with psychophysics, which Ozenfant and Jeanneret took as their starting point under the title *Sur la Plastique*, so as to get architectural structures to work on the soul of mankind with mechanical reliability? Where's the art in that?

Nothing can get round the realisation that museum buildings as "cathedrals of today" and museums as institutes of art relate to two very different worlds. The mechanism of supply and demand operates here as well. What has brought about the museum boom? Whether museums can really – or indeed exclusively – claim to account for the throng of visitors and the thirst for

art is at least questionable. If you regularly read the debate in the quality dailies, collecting seems to be at least as dominant a force. In recent decades, collections have become two a penny, and when they get to a certain size they need a home to guarantee their continued existence. Cut-throat competition has long been under way among all the accumulated, stockpiled hoards of art. What collections deserve to be housed in museums? What other ways are there of dealing with over-production of art? Certainly, the prospects are good for museums to continue to flourish into the future indefinitely.

2. "These days, everyone collects."

But is that enough? Or does the sculptural exterior of architecture conceal an art and collecting problem? The problem is not new. When Josef Strzygowski published his book *Die Krisis der Geisteswissenschaften* in 1923, he had long diagnosed a "tide of collecting activity", which posed a threat to art scholarship. "These days, everyone collects," he said. No other field of scholarship was, he claimed, so strongly supported – and so undermined at the same time. He believed that a "spirit of disregard for the whole and a view of art as a servant of power and possession" prevailed. It was welcome that museums had, in principle, found room for *l'art pour l'art*, but for an understanding of the "actual workings of art development" he found museums "thoroughly disturbing" institutions. He went so far as to rate the assumption that "buildings and space" in museums were wholly subordinated to the task of showing off works of art "scientifically unsustainable".[2] Indirectly, this describes and criticises

the autonomy of museums that has come about thanks to the building of museums. The development of museums has, of course, hived itself off into an independent activity – and since then has urged more and more ideas as to how art and collecting can be got across and packed into suitable containers. That is the fundamental reason why museum architecture must continue to develop and keep coming up with new solutions.

When Darmstadt professor Heinrich Wagner wrote an outline of museum architecture within his comprehensive handbook of architecture (1893), it formed part of the section called "Buildings for education, scholarship and art". He described museums as the "cultural gauges" of a nation.[3] This, likewise, merely serves to underline that museums – in content as well as accommodation – must change and develop for this very reason. If we now discover that museums indicate the state of architecture development more clearly than other buildings, we will need to take that aspect of "cultural gauging" into account. That museum fabrics often serve this function better than the contents cannot be overlooked, and flatters the architecture. However you rate the results, it is clear that museums as architectural commissions will continue to have an important role as cultural leitmotifs.

3. 'Wellness' and museums

Museums as institutions have trimmed the old traditional view of their educational role in order to adapt themselves to present-day habits in dealing with culture as consumption. The 'shop and coffee' departments have expanded exponentially and acquired a status of their own. On the other hand, the series of Medici Rubens in the Louvre, for example, which like other artists among the traditional educational greats used to have a big room all to themselves, now just rate the status of a cabinet for specialists. Museums have changed, even though it is still the unchallenged classics of the permanent collections that continue to provide the actual justification, the *fundamentum in re*, for museums and museum culture. At the same time, it has become evident that fashions are now on the turn again, and the clarity of our neglected 'provincial museums' both surprises and impresses once again.

There is no shortage of art, and things are being done to exhibit or store it in new museum buildings. But what is a *Schaulager* (art warehouse)? When Herzog & de Meuron presented this latest variant of 'culture-gauging' architecture in Basel in May 2003, the two Zurich dailies headlined their reviews 'The Luxury Way to Store Art' (*Tagesanzeiger*)[4] and 'Power Training Gym Replaces Café' (*Neue Zürcher Zeitung*).[5] All this does is document the dynamism of museum architecture, which is maintained and provoked by art and artists themselves when they demand "room for spaces" and whisk up configurations of "open space" and "off space", or, like Nedo Solakov recently in the Kunsthaus in Zurich, simply fill the museum with "leftovers" of gallery exhibitions as a "museum depository for remainders".[6] The over-production of art and the notorious passion for collecting are ultimately the reason why existing museums are full to bursting and dumping stuff elsewhere, which means setting up new museums. But we have long ceased to be satisfied with the traditional arrangement of works of art. A critic in the *Frankfurter Allgemeine Zeitung* refused to go along with the (dynamic) concept of a "circulation system of pictorial curiosity", demanding in its place a new "resonance body of aesthetic experience".[7]

So we get excited about museums as totalities. We want to incorporate the art experience into the 'cathedral' or conversely clap the impressive cathedral on to the emotion. Why shouldn't ways of perceiving art change with the shapes of the museum, and vice versa? When the J Paul Getty Museum started offering museum visitors not just the long familiar audio guides but also appliances that show little images of the picture concerned, to make sure users look at the right picture, a hail of protests pelted down. And rightly so! And yet not so rightly. The recognition effect has long been admitted to be important for apperception. *Déja vu* is the motivating force and active ingredient of education! Ultimately we hope that the original and only the original has something to do with it and will captivate the viewer. If that were not the case, the museums would be empty. But the crush proves that works of art have no competition, because people do not like to be wrong about what they see and perceive. They look for truth in art. And in the end, what do we know about what kind of art experience individual visitors take home with a picture + text device? At least one can say in view

of the enduring museum boom that the chances are good that there will continue to be art. Or one even presumes to claim that, finally, art has reached the masses.

At any rate, art is still at the heart of it. And when you look closer, you notice that a lot of what is said to be fundamental to the building of museums concerns one of the oldest functions of museums – preserving, and security measures. That applies not just to the Acropolis or Stonehenge, where problems have to be solved at an acute stage. And as art moves, no-one can ignore the ambitious tasks of comprehensive reorganisation, deployment and presentation. Often enough it is new buildings that have this as a declared aim, or conversely, that trigger off necessary processes of this kind, rearranging things or providing an 'aesthetic lift', depending on your point of view. But we should not forget that, when architects set about the topic of museums seriously, it is an ambitious challenge they face. Museums are one of the subtlest architectural commissions in this double orientation of highly complex organisms serving the changing face of art and icons that are supposed to have city-branding signalling and identification effects.

4. Icons

Looked at this way, one may assert that, unlike 'mere' office-block skyscrapers, where despite a significant shape an immediate relationship with a quickly associated content is wanting, museums have a remarkably firm, solid image after 300 years of history. The idea of a modern city without museums is inconceivable. They are as much crowd-pullers as they ever were, regardless of whether it's the shops or the works of art visitors head for. Because so many people are oriented not any old where but palpably towards a particular thing, a content, they are the best indication of what otherwise would have been a public long in a state of crisis in an urban context. That architects should feel particularly challenged by the task and aim for quite deliberate effects with all the resources of form available to them is basically their duty. "Il faut concevoir pour effectuer!" – this dictum from the pen of Etienne-Louis Boullée was considered to be turning Vitruvius's teaching on its head. Achieving an 'effect' is a classic objective of architects, and not just since Boullée's time. And where should this especially apply, if not in the case of public buildings? Museum architects today are continuing that tradition. Their works will subsequently be rated for the extent to which they have achieved this particular aim.

But whether the objective is successful and whether only museums should wave the flag for a kind of architecture that is emblematic of a space and a city is unresolved, and open to question. When Daniel Libeskind was asked in 2005 what interested him about his Westside shopping centre project in Berne, then in the process of development, he replied quite pragmatically that something new and of its time had come about in the combination of shopping and wellness. The architect faced a task that had to be approached just as carefully as a museum. In short, one should not underestimate architecture during such processes. New forms of consumption and business are wanted! If architects fail to endow them with comprehensible form with recognition effect, they might be commercially successful but certainly not culturally. This aspect cannot be pinned down in statistics. But it should not be underestimated, for example, the way Samaritaine in Paris or Messel's Wertheim store in Berlin were. And above all, people should not be underestimated either, by taking them into account only as consumers.

Libeskind's demand that non-museum buildings also be carefully planned is completely on target. The added cultural value could and should have a much larger role in architecture. The question is whether the current formulae – Libeskind talks about "expressive" and "sentimental forms"[8] – are sufficient or whether a much more fundamental approach is required. And one needs to immediately add, critically, that merely "spectacular" is not enough for a long-term effect. A critic calling Frank O. Gehry's MARTa Museum in Herford "a little Guggenheim"[9] is the sort of thing that happens. An internal reference system may be part of the recipe for a successful icon, but public buildings must refer to things beyond themselves. That is both difficult and risky. Renzo Piano, who designed a widely praised "classic" museum for "classic" art at the Fondation Beyeler in Riehen, was accorded headlines such as 'the Klee Hangar' and 'Cultural

Wellness Zone' for his Klee Museum near Berne. Forms shift and merge, and that is part of the risk of metaphors such as the "cathedrals of today", regardless of whether they are applied to factories, department stores or museums. To this extent the situation remains open – and the expectations of museum architecture great.

1 Karl Scheffler, *Die Architektur der Grossstadt* (Berlin 1913), p. 160 (here in connection with Behrens's buildings for AEG)
2 Josef Strzygowski, *Die Krisis der Geisteswissenschaften* (Vienna 1923), p. 310
3 Heinrich Wagner, 'Museen', in: Eduard Schmitt/Heinrich Wagner et al., *Handbuch der Architektur*, part 4, 6th half vol., 4th section: *Gebäude für Sammlungen und Ausstellungen* (Darmstadt 1893), p.173
4 Barbara Basting, 'Die Luxusvariante der Kunstvorratshaltung', in: *Tages-Anzeiger* (23.05.2003), p. 57
5 Samuel Herzog, 'Kraftraum statt Konditorei', in: *Neue Zürcher Zeitung* (23.05.2003), p. 57
6 Nedko Solakov, *Leftovers* (Kunsthaus, Zurich 2.9.–13.11.2005)
7 Thomas Wagner, 'Vorstand des Verschiebebahnhofs', in: *Frankfurter Allgemeine Zeitung* (7 December 2000), p. 53
8 Conversation with Daniel Libeskind, 'Den Bauten eine Stimme geben', in: *Neue Zürcher Zeitung am Sonntag* (23.01.2005), p. 55
9 Klaus Englert, 'Ein kleines Guggenheim', in: *Neue Zürcher Zeitung* (13.05.2005), p. 43

Museums at the Beginning of the 21st Century: Speculations

Thierry Greub

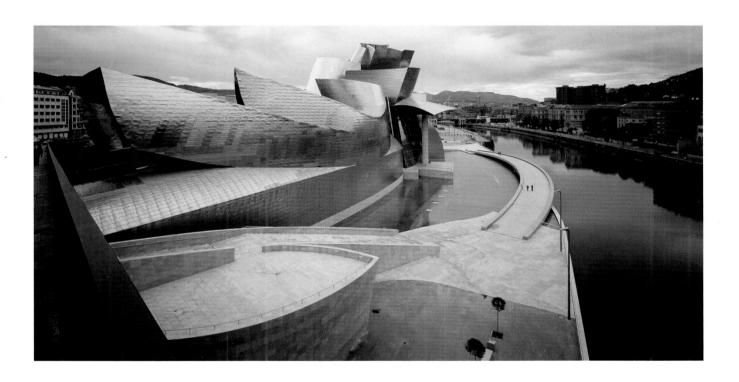

Fig. 1: Frank O. Gehry, Guggenheim Museum Bilbao, Bilbao, Spain, 1991–97

Museums have become one of the most desirable commissions for architects to win, now that cities have discovered museums as a marketing factor. A spectacular museum building possesses supraregional attraction, and in the best cases assures the city both a distinctive emblem and a city-centre function. Rundown or peripheral parts of cities can be revived by a museum and linked to the rest of the city – examples that spring to mind are Frank O. Gehry's Guggenheim Museum in Bilbao (1991–97, fig. 1) or Herzog & de Meuron's Tate Modern in London (1994–99). As Coop Himmelb(l)au note in the brief description to their Musée des Confluences (see pp. 138–43): "The incentives to make direct, active use of it make it not just a museum building but an urban meeting point. The architecture combines the typology of a museum with the typology of an urban leisure centre."[1]

A museum building can also act as a catalyst for economic revival in an urban area or indeed a whole city and region. Along with the urban context and the image factor, there is the function of the buildings themselves that make them top-notch cultural rendezvous. In previous times it was 'only' the paintings or the sculptures that prompted a trip to this or that museum. Now the museum buildings themselves can make the effort twice as rewarding.

Yet hand in hand with the constant announcements of new museums being built or founded there are always reservations about

these new buildings. The main thrust of criticism (along with the long-term financial consequences) is always that the architecture dominates the art exhibited inside. As Markus Lüpertz had already shrewdly expressed back in 1984: "Architecture should have the greatness to present itself so that art is possible inside it, so that art is not driven out by the claim of the architecture itself to be art and without art being exploited by the architecture as 'decoration', which is even worse."[2]

In other words, since the 1990s we can distinguish between two diametrically opposed forms of architectural articulation. On the one side is the expressive, deconstructivist architectural approach of Zaha Hadid, Daniel Libeskind or Frank O. Gehry (to mention just a few of the best-known names). Their buildings very quickly attract accusations of overpowering the art inside. Indeed, it is undeniable that they assert an enormously powerful presence and first and foremost draw attention to themselves – and the works exhibited inside have to fight against this pre-eminence.[3]

On the other side is the 'minimalist' architecture. Herzog & de Meuron set the benchmark with their 24 × 8-metre cube for the Goetz Collection in Munich (1989–92), and architects such as Peter Zumthor (Kunsthaus, Bregenz, 1991–97, fig. 2) and Morger & Degelo (Kunstmuseum Liechtenstein, Vaduz, 1997–2000) took a similar approach in their individual ways. The box-shaped museums like those in Bregenz and Vaduz claim, above all, to constitute a completely neutral and 'democratic' starting point for the art exhibited. But by the time Brian O'Doherty came up with his publication Inside the White Cube [4]

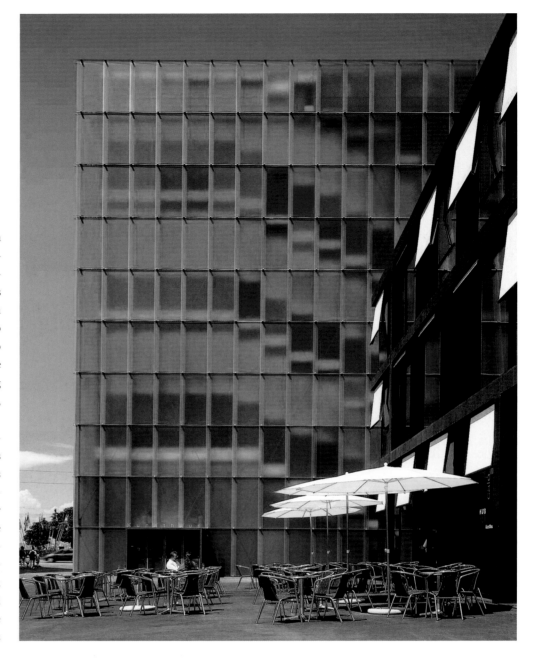

Fig. 2: Peter Zumthor, Kunsthaus Bregenz, Bregenz, Austria, 1990-97

the myth of the neutral minimal cube was deprived of its mystique, for the building definitely makes claims of some sort – and no more so than when it claims to be making no claims whatsover.

With these two extremes – and the whole range of expressive possibilities in between – in mind, only one sensible conclusion can be drawn in order to escape polarisation. The architecture of the museum itself, the building anchored in its urban context together with its functional rooms

for the administration, must *function* in the dialogue between building and art, architecture and users (museum staff and visitors). In the end, it is therefore the experience of every individual visitor to the museum that decides whether the definition of the space in which he finds himself and sees cultural artefacts is a success or a failure. The future of a museum lies in proving itself as a complex space for new, permanent experiences and not just for lavish but short-term spectacles.[5]

Five tendencies can be observed with regard to museums built since 2000.[6]

1. Classic modesty

When post-1968 museums, qua educational institutions, moved to the top of the agenda as social pillars in need of change, the consequence of the challenge to the educational value, exhibition practices and the 'content' of art museums and their selection criteria etc. was a liberating discarding of reach-me-down, time-worn ideas.

Yet it was all too readily overlooked that with their Janus-like duties museums are not in a position to plump for one side rather than another. Museums must conserve the works entrusted to them and at the same time put them on display, inventorise them and make them comprehensibly available to every member of the public. It was with this in mind that Brad Cloepfil of Allied Works Architecture defined the duty of a museum to be a "future-orientated, flexible public institution."[7] This backward as well as forward-looking gaze is the nub of the matter, but is at the same time every museum's pre-eminent opportunity. At any time, the question it has to

answer is, how can it fulfil both functions? How can museums set standards that are above the run of the mill and at the same time open to ordinary life?[8]

Two answers by architects have already been mentioned – the minimalist reduction (Bregenz) or the revolution with the grand expressive gesture (Bilbao). A strikingly large number of new museum buildings surprise us with a third response, however, which is a kind of golden mean between these two extremes. They might be called 'classic' museums, both in their aesthetic appearance and in their deliberate, explicit resort to classic approaches to building museums.

One example is the Pinakothek der Moderne by architect Stephan Braunfels, opened in autumn 2002 (see pp. 84–89). Braunfels consciously harks back not just to the tradition of museums as a building type but goes directly to the origins of museums as an architectural form. Basically, the classic museum building consists of a square or elongated building formed of a central dome structure in the middle – mostly a rotunda to provide light – and a series of elongated galleries on four sides with courtyards and often roofed with vaults. In his *Précis des Leçons* of 1802–05, French writer Jean-Nicholas-Louis Durand codified the building type in written form. Its purest implementation he considered to be Karl Friedrich Schinkel's Altes Museum in Berlin (1822–28, fig. 3), and in the shape of an elongated building Leo von Klenze's Alte Pinakothek in Munich (1826–36, fig. 4).

In Italian palaces and especially French châteaux such as Versailles, sculptures and pictures were originally kept in long galleries that acted as linking sections between two wings or

the main building and the park. These transitional areas – along with the curios cabinet (*wunderkammer*) – are the ancestors of modern museums.

A similar recent modesty is evident in the noticeable increase (compared with the 1990s) in the number of conversions and extensions of existing buildings as against new buildings (cf. the extension buildings by Taniguchi and Associates for MoMA in New York, see pp. 20–25, or by Gehry at the Corcoran Gallery of Art in Washington, see pp. 176–81). It is no longer just the self-sufficient monolithic crowd-puller that seems to count today – there is also increased respect for existing structures.

But even this dialogue can in turn become shrill and turn into tense conflict, as in the case of the extension building for the Denver Art Museum by Libeskind (see pp. 194–99), or remain more restrained and less extravagant, like Steven Holl's Nelson-Atkins Museum of Art in Kansas City (see pp. 200–05).

2. New transparency

Whereas this modesty and respect for what is already there is directed against the mania for originality in museum building in the 1990s, transparency in museum buildings is a direct response to criticism of the classic temple museum – a complaint voiced loudly from 1968 and even earlier – and an open attitude towards new technical possibilities. In effect, transparency means reducing the differences between inner and outer areas. This has various purposes: used socially, the museum as an institution opens up to its environment, but chiefly, as far as visitors are con-

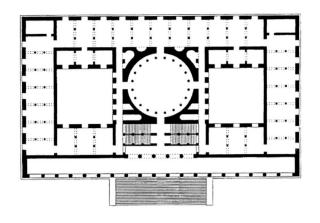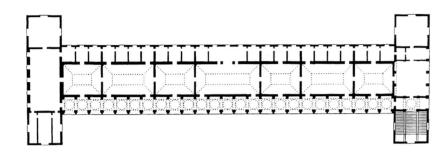

cerned, the view out of the museum is linked with the view into the museum.

Ever since it opened in 1968, Mies van der Rohe's *Nationalgalerie* in Berlin has been the benchmark for building museums with regard to openness, light and external reference. But how much more radically this intended transparency is set out in the new media centre by Diller, Scofidio + Renfro at the Eyebeam in New York (see pp. 182–87). The outer skin is wrapped round the building like gauze so that the interior shows through. The building itself appears only as a frame – in the way the firm of New York architects had already brilliantly put into effect in the walk-in *Blur* for the Swiss EXPO 2002 (see fig. 1, p. 180). Architecture thus becomes a virtual icon and is completely dissolved.

Brad Cloepfil makes this explicit comment on the subject in connection with the conversion of the Contemporary Art Museum in St Louis (2000–03) thus: "The project is intended to create an urban building with a façade that blurs the frontier between inside and outside. Art steps out into the street, the street comes into the building. This allows room for transparency that has hitherto been denied it in the institutionalised realm of art museums."[9] He describes the Museum of Arts and Design in New York in similar terms as "an open and active matrix of light, life and art.... The museum should become a fluid extension of the public area."[10] – which also applies to the University of Michigan Museum of Art (see pp. 206–11).

3. New missions

The planned Museum of the Hellenic World in Asia Minor in Athens by the Greek architectural team Anamorphosis (see pp. 144–49) makes use of a symbolically charged idiom. It will be a museum wholly without object exhibits, a museum therefore in which the architecture has to stand in for the missing artefacts and must articulate them itself. That a scheme of this kind can succeed brilliantly has been demonstrated by Daniel Libeskind in the lower floor and entrance of his Jewish Museum in Berlin (1989–99),[11] where the architecture manages to convey no less than sheer isolation, total insecurity and unfathomable terror in its idiom by purely architectural means.

Anamorphosis plan to evoke three main exhibition themes in their structure solely through spatial presence. Antiquity, Byzantium and the modern era will be illustrated by appropriate qualities of light, material, function and documentation arranged like a ribbon. Antiquity, for example, will be a theatre-like, semicircular shape built of marble and stone, with daylight and a symbolically evoked link with nature. The subject of the entire architecture, inasmuch as three-dimensional capabilities are being addressed,[11] is described by Anamorphosis as (a literal) distortion of habitual ways of seeing: "The design proposes a psychoanalytical approach to Greek history and the theme of a constant exchange between Greece and Asia Minor – the motherland and the 'over there', an area that is at once autonomous and completely alien. The

Fig. 3: Karl Friedrich Schinkel, Altes Museum, Berlin, Germany, 1822–28: ground view (scale 1:1,500)

Fig. 4: Leo von Klenze, Alte Pinakothek, Munich, Germany, 1826–36: ground view (scale 1:1,500)

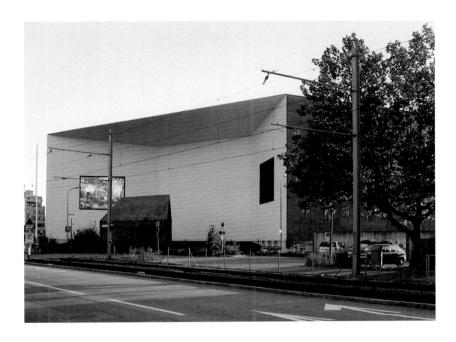

presentation of this process will be designed as a recurrent, homeomorphous and coherent spatial experience and not as eclectic thinking about the past."[12]

A less extreme example is the Kalkriese Museum and Park designed by Gigon/Guyer for Osnabrück land, which spotlights the momentous battle in AD 9, when Roman general Quinctilius Varus and his legions were overwhelmed by the German army of Armin (Hermann) (see pp. 90–95). The sole exhibits are the landscape of the battlefield and the archaeological finds.

The danger of museums of this kind becoming ossified in pathetic or empty gestures cannot be excluded – yet it seems clear that only such new types of museum can keep the institution in a flourishing state of health.

Another example is the new Schaulager in Münchenstein near Basel, by Herzog & de Meuron (2000–03, fig. 5), where contemporary art is made available and exhibited on a quite novel basis. The purpose of the showcase in respect of exhibition practicalities is that the works of contemporary art acquired by a Basel foundation over the years should not vanish into a storeroom but can continue to be on show if booked. In addition, the art warehouse will be open to everyone during the exhibition held each year.

4. New symbolism

In the Eyebeam by Diller Scofidio + Renfro in New York, there is along with such expansion of content in the old concept of museum a new kind of architectural idiom – a "new textile paradigm", as Gerhard Mack has called it. According to Mack, "consumerism, zeitgeist and shop design" can be "combined to make a stimulating experience" so that "both architecture and clothing can be seen as covering for the body."[13] This "affinity", says Mack, is a leitmotif running through contemporary architecture and is also found in new museum buildings. Thus, for example, it is particularly obvious in the Eyebeam, where a "ribbon" winding through the whole building functions as both floor and ceiling. It separates the two different areas of the media centre (production with the studio and presentation with the museum and theatre), while at the same time linking them quasi-permeably.

The structure of the ribbon as used by the Amsterdam firm UN Studio (Ben van Berkel and Caroline Bos) constitutes a variation of this idea. Both their Möbius House private house in Het Gooi (1993–98), which, designed in the shape of a Möbius strip, caused an international furore, and the Mercedes-Benz Museum in Stuttgart are developed from the notion of a ribbon (see pp. 114–19). The latter directly evokes the star in the Mercedes emblem, but as in the Eyebeam it involves an endless strip that moreover cites Frank Lloyd Wright's spiral in the Guggenheim Museum in New York (1943, 1956–59, see fig. 1, p. 115) and the spiral structure of Le Corbusier's ideal museum. All these shapes represent per-

manence, even eternity, as they are infinitely continuable. The time-honoured symbolism of Eternity thus re-enters architecture via the back door of the formal basic structure. The preliminary sketch of the Mercedes museum thus quite rightly carries the caption 'neverending story'.

5. New body reference

The new museum buildings are, moreover, united in paradigmatic form by a new attentiveness to visitors. It consists of getting them to participate in the form of involvement and activation in the architecture. It is virtually the entire person who is experienced in motion outside and in contemporary architecture. The visitor enters into a dialogue with the architecture externally through its exteriors, thereafter through the fluidity of scale and dynamic building axes and then through the often novel spatial experiences.

Among all the pros and contras, plaudits and laments in the debate about new museums, it is generally forgotten that the empty museums exhibiting 'nothing', the symbolic baggage and the new body reference are closely related to post-1970 contemporary art. Object Art, Minimal Art and present-day installation art and, above all, the world of the New Media are reflected in the expressive, Minimalist and body-emphasising museums of the 1990s and the present decade. In this light, the empty museums are reacting to the virtual reality of the present time.[14]

This new, greater intensity not only of the exterior but also the external reference and visitor activation appears to be the survival strategy of new museums in the 21st century. It therefore seems of secondary importance whether a min-imalist cube or a transparent ribbon is involved – it is first and foremost intensity that is transferred to the visitor and allows him to experience a lasting shift of perception. As Robert Kudielka recently expressed it in connection with Herzog & de Meuron, museums would therefore be a space for 'speculation'. Speculation is understood here in its 18th-century meaning of the "highest form of movement of human thought, a seeing that in emerging from within rather than introspecting attains a view of its self."[15] The museum would then really be a place "combining looking, reflecting and understanding".[16]

1 Unpublished project description by the architects' office
2 Stanislaus v. Moos, in: Vittorio Magnano Lamugnani / Angeli Sachs (eds.), *Museums for a New Millennium: Concepts, Projects, Buildings* (Munich, London, New York 1999), p. 15. Cf. the diametrically opposed statements by artist Georg Baselitz (for the subservient neutral museum) and architect Peter Eisenman; Eisenman says "Architecture should challenge art. We must suppress this view of architecture as a subservient profession." In: Georg Baselitz, *Museumsarchitektur. Texte und Projekte von Künstlern*, (Kunsthaus Bregenz: Archiv, Kunst, Architektur, vol. 2, Cologne 2000); Baselitz's manifesto is on pp. 11–14
3 For the issues relating to works of art and new museums, see Ekkehard Mai (ed.), *Die Zukunft der Alten Meister. Perspektiven und Konzepte für das Kunstmuseum von heute* (Cologne 2001)
4 Brian O'Doherty, *In der weissen Zelle / Inside the White Cube* (ed. Wolfgang Kemp), (Berlin 1996)
5 See Willibald Sauerländer's telling remarks on this point, 'Musentempel und Lernorte. Museen im 21. Jahrhundert', in: idem, *Die Luft auf der Spitze des Pinsels* (Munich/Vienna 2002), p. 155
6 It is, I think, important to note that these points are not completely new aspects. Each of them can look back on a long tradition of a sort.
7 Project description by Allied Works, Seattle Art Museum Expansion, unpublished
8 Gerhard Mack, *Kunstmuseen auf dem Weg ins 21. Jahrhundert* (Basel 1999), p. 18. With regard to the traditional duties of museums as institutions (collecting, researching and conserving), cf. Helmut Börsch-Supran, *Kunstmuseen in der Krise. Chancen, Gefährdungen, Aufgaben in mageren Jahren* (Munich 1993), p. 20 ff
9 Project description by the architectural office, unpublished
10 Ibid., without page reference
11 Cf. on the (paragone) theme of genre demarcations and convergences between architecture and sculpture recently: Markus Brüderlin et al. (eds.), *ArchiSkulptur: Dialoge zwischen Architektur und Plastik vom 18. Jahrhundert bis heute*, exhib. cat. (Fondation Beyeler, Riehen, Ostfildern-Ruit 2004)
12 Project description by the architects' office, unpublished
13 Gerhard Mack, 'Der Stoff, aus dem die Häuser sind. Die Architekturbiennale Venedig überrascht mit einer Konjunktur des Textilen', in: *Neue Zürcher Zeitung am Sonntag*, 6 October 2002, no. 30, p. 76
14 Cf. (along with the elaboration of the subject in Frank Maier-Solgk, *Die neuen Museen* [Cologne 2002]) esp. the essay by Horst Bredekamp: 'Museen als Avantgarde', in: Annette Tietenberg (ed.), *Das Kunstwerk als Geschichtsdokument* (Munich 1999), pp. 192–200
15 Robert Kudielka, 'Spekulative Architektur: Zur Ästhetik von Herzog & de Meuron', in: Philip Ursprung (ed.), *Herzog & de Meuron. Naturgeschichte*, exhib. cat. (Centre Canadien d'Architecture, Montreal, Baden 2002), p. 189
16 Ibid., p. 189

Japanese Architects and Museums: The Attempts in 2004

Hiroyuki Suzuki

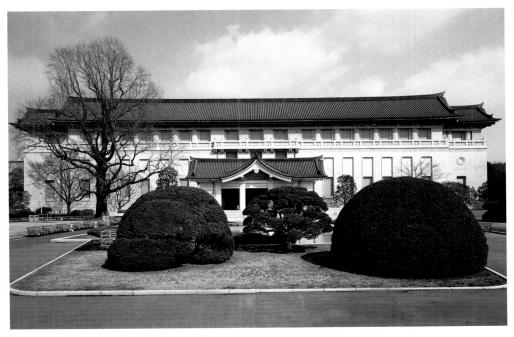

Fig. 1: Josiah Conder, Tokyo National Museum, Tokyo, Japan, 1877–81

Museum architecture is not the same around the world. The notion of how the fine arts are considered varies by culture. Consequently, architectural styles for museums which are receptacles of art works show a remarkable variety according to the cultural zone in which they are located or the culture to which they belong. Moreover, as the ideas for the arts continue to transform, museums, too, keep evolving their concepts by exploring new design possibilities. Here, I would like to introduce an overview on the possibilities of today's museums in terms of their building typologies and design concepts by recounting three of the new museums created in 2004 by Japanese architects. As these three museums de-

lineate the predicaments inherent in designing today's museums, each demonstrates the adoption of a clearly distinct approach in solving the identified problems.

In Japan, the first museum was launched in 1877 as the pavilion for the First National Industrial Exhibition in Ueno Park, Tokyo. Even the very word *bijutsu* in Japanese was invented to describe the *fine arts* just four years before, in 1873, when Japan first participated as an independent nation in the World Exposition in Vienna, Austria. Until then, there had been no generic term to define the fine arts in their entirety, only specific words to represent the various individual categories of fine arts, such as

kake-mono (wall-hung picture scrolls), *cha-wan* (teacups and bowls), *hori-mono* (carvings and sculptures), *saiku-mono* (crafted works) and so forth.

In the pavilion of the First National Industrial Exhibition, various items, including framed paintings and crafted works, were exhibited enmeshed alongside the industrial items. The purpose of the exhibition reflected the spirit of the country as it was forging a modern industrialised nation. The pavilion was constructed with bricks in the Western architectural style. It featured an enigmatic façade comprised of three gabled dormer windows in a row. Judging by the form of the entrance, its designers presumably adopted the (neo-)Gothic architectural style so that the building would epitomise civilisation and enlightenment while also serving as a showcase for the very products produced by civilisation and enlightenment.

The Tokyo National Museum was erected four years later, in 1881, directly across from this pavilion. It was designed by Josiah Conder, who had been commissioned from England as an official national architect by the Meiji government. The museum building included a series of arches in the Islamic style. Why Conder, who was well versed in things Japanese, employed Islamic design features for Tokyo's first permanent museum building is puzzling.

Given that the Islamic style was the most understood and adopted non-European architectural style in Europe, Conder presumably felt that it represented a suitable style with which to connect East and West, and that a hybrid or eclectic design would be appropriate for the museum in Japan, a nation just embarking on a

process of modernisation. It was felt that a museum built to house an assortment of collections that were born in the oriental cultural zone or sphere ought, likewise, to manifest an oriental architectural style. The idea that the architectural style of a museum should reflect the cultural origin of the works and collections housed within the building was introduced by the Musée du Louvre in Paris. If we are to understand what the Louvre set out to accomplish, we should re-examine the objectives the museum set itself.

Plans to convert the Palais du Louvre into a large-scale national museum were reported in the French newspaper *Le Moniteur* on 5 September 1833. It said the new museum would: "collect the fine art works which transcribe and honour the history of France into the edifice that ennobles the glorious French heritage of the past and forebodes the throne of King Louis-Philippe of France and his government to be the continuation of that sublime tradition".

What is important here is not France's greatness but the general idea, established for the first time, that the museum was *the institution* and *the place* to which fine art works were *collected*. In other words, first would come the building, then the works of art to be collected there. It is important to note that the word 'collect' referred to the act of assembling a comprehensive and systematic collection of art works. As to where the collected works should be housed, they would require an appropriately conceived edifice with a suitable design style. Accordingly, the relationship of the collected works and the building as their container was validated here. By shouldering the weight of 'national eminence', the museum building held precedence over the art

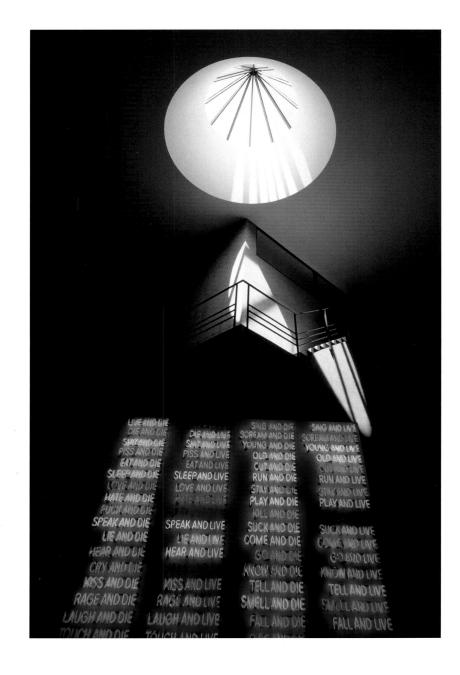

works themselves. Like the Louvre, other major museums, such as the Hermitage in St Petersburg, Russia, also resulted from the conversion of former royal palaces because the development of these museums often coincided with, or derived from, the need to establish visible entities to demonstrate national prestige.

By comparison, museums completed in the 20th century for the collection of modern art works typically introduced 'white cube' exhibition spaces designed not to interfere in any way

with the art works on display. The modernisation process of museums may be characterised as the transition in terms of the way art works were exhibited: from the method of display in historic spaces to display in neutral, non-interventional spaces. Yet even today, museums are shaped and designed by the principle of correlating their architectural style with their collections.

Despite the prevalent formula of modern museums providing neutral spaces for the exhibition of modern art works, there seems to be a

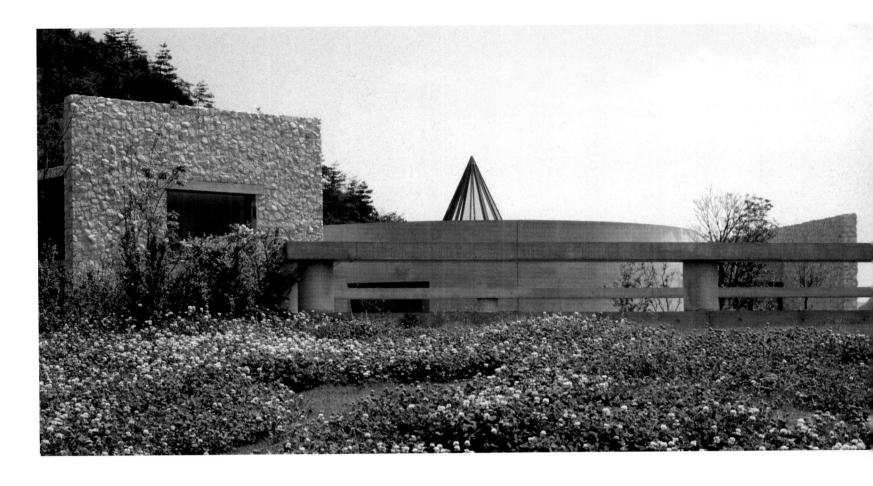

Fig. 2 (left): Tadao Ando Architect & Associates, Benesse House, Naoshima, Japan, 1990–92: interior view

Fig. 3 (above): Tadao Ando Architect & Associates, Benesse House, Naoshima, Japan, 1990–92: exterior view

Fig. 4: Tadao Ando Architect & Associates, Art House Project, Naoshima, Japan, 1998–99: 'Minamidera'

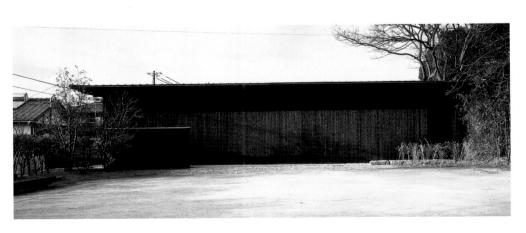

wave of inventive ventures to explore new possibilities for museums. One such possibility is to commission art works to suit the exhibition spaces available – a policy known as site-specific production and exhibition and which aspires to present museums with uniquely designed original space in creative configurations. The Guggenheim Museum in Bilbao by Frank O. Gehry, with works by Richard Serra, Mario Merz and Richard Long, is a representative attempt.[1]

In Japan, Benesse House qualifies as a museum that pursued such objectives. Designed by Tadao Ando, Benesse House was completed in 1992 (see figs. 2 and 3, see also pp. 26–27). The advent of this museum was a historic event for Naoshima, a small island in the inland sea of Seto-uchi, and opened new possibilities for the development of the island. Benesse House commissioned many art works from various artists with the understanding that the works would be for the specific display spaces in the museum. This formula eventually led to another experimental plan, the 'Art House Project', which expanded the spaces within the museum to include houses, temples and shrines scattered around the island for the creation of various site-specific art works. As part of this project, Tadao Ando collaborated with James Turrell on the Buddhist temple ruins of Minami-dera to create a modern structure with darkness or shadow and light as its theme (fig. 4). The 'Art House Project' encourages the participating modern artists to re-encounter the genius loci of Naoshima buried

deep in its community and surroundings and to rediscover the potentials of its architecture as sites for the recreation of their works.

Tadao Ando added another museum building on Naoshima in 2004: the Chichu (or Underground) Art Museum (see pp. 26–31). The museum is comprised of three exhibition spaces deep undergroud for three art works. Each art work was created for the corresponding exhibition space and, conversely, each of the three exhibition spaces was specifically designed to accommodate the corresponding art works. In other words, the three exhibition spaces or sites in the museum become whole with the three art works in them; in turn, the three art works become complete with the museum. Ando's underground design was intended primarily to not disturb the surrounding natural habitat as well as to create pure exhibition spaces. Therefore, this museum manifests its concept as the antithesis to that of the 'white cube'-style museums with their autonomous art works.

In New York the same year, Yoshio Taniguchi completed the expansion and renovation of the Museum of Modern Art (MoMA) (see pp. 20–25). It was no accident that a Japanese architect was commissioned to undertake a major architectural project for a very high-calibre museum in the West, for Taniguchi has, throughout his career, pursued and designed neutral, white cube exhibition spaces in his works. In 1997, MoMA's Architect Selection Committee had invited ten groups of architects with worldwide reputations to submit design proposals for the MoMA project: Weil Arets, The Netherlands; Jacques Herzog and Pierre de Meuron, Switzerland; Steven Holl, USA; Toyo Ito, Japan; Rem Koolhaas, The

Netherlands; Dominique Perrault, France; Yoshio Taniguchi, Japan; Bernard Tschumi, USA; Rafael Viñoly, USA; Tod Williams and Billie Tsien, USA. It was from this list that Taniguchi was eventually chosen.

I presume that the Selection Committee appreciated the restrained and neutral exhibition spaces in Taniguchi's design proposal. After all, it was MoMA that had played an important part in conceptualising and founding the very idea of the neutral, white cube exhibition spaces.

MoMA opened in November 1929 with six rooms for its gallery and office spaces on the first and second floors of Heckscher House at the corner of Fifth Avenue and 57th Street in Manhattan. It was initially intended to exhibit the modern art collections of Mrs. John D. Rockefeller, Jr. and other wealthy ladies. For its inaugural exhibition, works by Cézanne, Gauguin, Seurat and van Gogh were displayed in an unprecedented manner, with each painting hanging separately on the white gallery wall. The idea was to provide a viewing ambience free of any obtruding elements. Compared with the typical exhibition method until then of hanging many paintings in multiple rows and columns on the decorated walls of palaces and salons, MoMA's new method was, indeed, revolutionary and modern, and it paved the way for the display of modern art works in white cube exhibition spaces.

In 1932, MoMA moved to the townhouse at 11 West 53rd Street (part of the present site) to expand its exhibition spaces and held a series of epochal exhibitions, including the Architectural Exhibition (1932), which created the term 'International Style', the Machine Art Exhibition

(1934), the Cubism and Abstract Art Exhibition (1936), the Fantastic Art, Dada and Surrealism Exhibition (1936) and the Bauhaus Exhibition (1938). Then, in 1939, MoMA built and opened on the same site, with some expansion to the adjacent lot, its new, larger main building designed in the International style. The intimate relationship between *modern* art works and *modern* architecture was thus established. The history of MoMA, therefore, is the history of establishing the endorsement of modern art as well as devising the concept of the neutral, white cube exhibition spaces.

In his design proposal for the MoMA, Taniguchi made no abrupt or radical changes to this concept, which is precisely why he was rewarded with approving nods from the Selection Committee. However, Taniguchi never intended the museum to be raised above the street solely to exercise the conventions of *universal* spaces, and only to exist in detachment from the surrounding context. The Shiseido Art Museum, the first museum Taniguchi designed, illustrated how he was aware of the existence of the adjacent *Shinkansen* (or Bullet Train) tracks. In fact, he considers the relationship of architectural space(s) and the surrounding conditions very seriously. It is no surprise, therefore, to see that his MoMA design included a careful assessment of the museum's site, between 53rd and 54th streets, and its surroundings. Taniguchi cultivated a certain relationship between the two streets and various buildings, and created a courtyard space that simultaneously connected and separated the different parts of the museum. Through this courtyard space the urban milieus of midtown Manhattan were filtered into the museum.

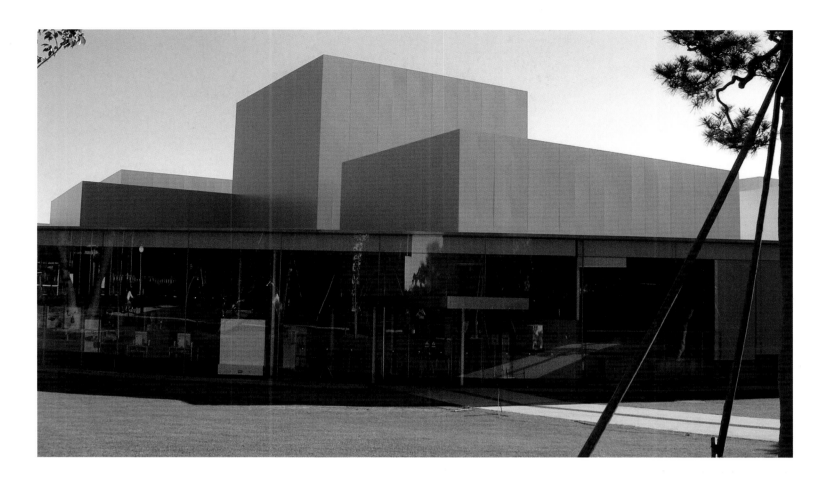

Fig. 5: Kazuyo Sejima + Ryue Nishizawa/SANAA, The 21st Century Museum of Contemporary Art, Kanazawa, Japan, 2000–04

Although the way in which the axes of the courtyard were intentionally shifted is an abstract reference to the stepping-stone design of Japanese gardens, there is no specific Japanese elaboration. It acts only to arrange the linking or binding of all the different parts of the museum that contain the neutral, white cube exhibition spaces and to validate its existence in the New York urban fabric.

Another newsworthy event in 2004 was the completion of the 21st Century Museum of Contemporary Art, in Kanazawa, designed by Kazuyo Sejima and Ryue Nishizawa of the SANAA architectural design office (fig. 5). The architects collaborated fully with museum curator Yuko Hasegawa in designing a structure that would allow maximum freedom in the operation of the museum and its exhibition spaces. The bold design called for an enormous circular glass wall to enclose all the exhibition spaces, thus providing ample natural light and allowing for different display methods for a variety of modern art works. Although the individual exhibition spaces

were still designed as a multiplicity of white cubes, provision was also made for visitors to circulate freely between the cubes – or even just shelter from the rain. Here, too, an alternative philosophy in exhibiting modern art was introduced – one that questioned the display methods of the white cube museums.

What is the future of museum design? What concept will it be based upon? What form will future museums take? These issues are open to debate for there are multiple possibilities. As time goes by and art works change, so will the nature of our understanding of what constitutes art. Museums will also change and evolve, and the development of diverse ideas about the arts will prescribe the architectural transformation of museums. As long as our interactions with the ever-changing ideas about the arts remain animated and lively, the future of museum design and architecture will be accordingly rich.

Taniguchi and Associates

Expansion of the MoMA, The Museum of Modern Art
New York, NY, USA

Client:	The Museum of Modern Art
Design:	1997–2003
Construction:	2001–2004
Budget:	no data

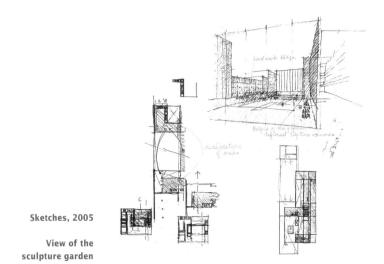

Sketches, 2005

**View of the
sculpture garden**

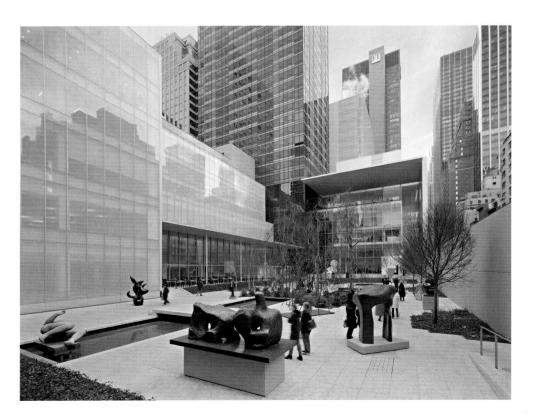

In the initial planning for The Museum of Modern Art's expansion, before any architects were considered, a critical decision was made to find an architect who would be able to transform the museum's campus of buildings and additions into a unified whole rather than simply add on. The museum, having always been bounded by other structures with different owners, had previously grown only as adjacent space became available, without the possibility of a unifying vision. Several architects had expanded the 1939 Goodwin and Stone building over the preceding six decades before Yoshio Taniguchi was selected in an international competition. The North Wing and East Wing had been designed by Philip Johnson and were built in 1954 and 1964, respectively. Both structures flanked The Abby Aldrich Rockefeller Sculpture Garden, also designed by Johnson and finished in 1953. In 1980, the museum began its most ambitious expansion until that time with the construction of Cesar Pelli's design for the Garden Wing, at the eastern boundary of the Sculpture Garden, and the fifty-six-storey residential tower that abuts the museum, with the museum's six floors extended beneath it and further to the west.

Taniguchi's approach focused on the specific urban conditions of the museum's midtown building. The through-block entrance hall links the north and south façades of the museum, which not only extends the public space of Man-

Exterior view from the south, 53rd Street

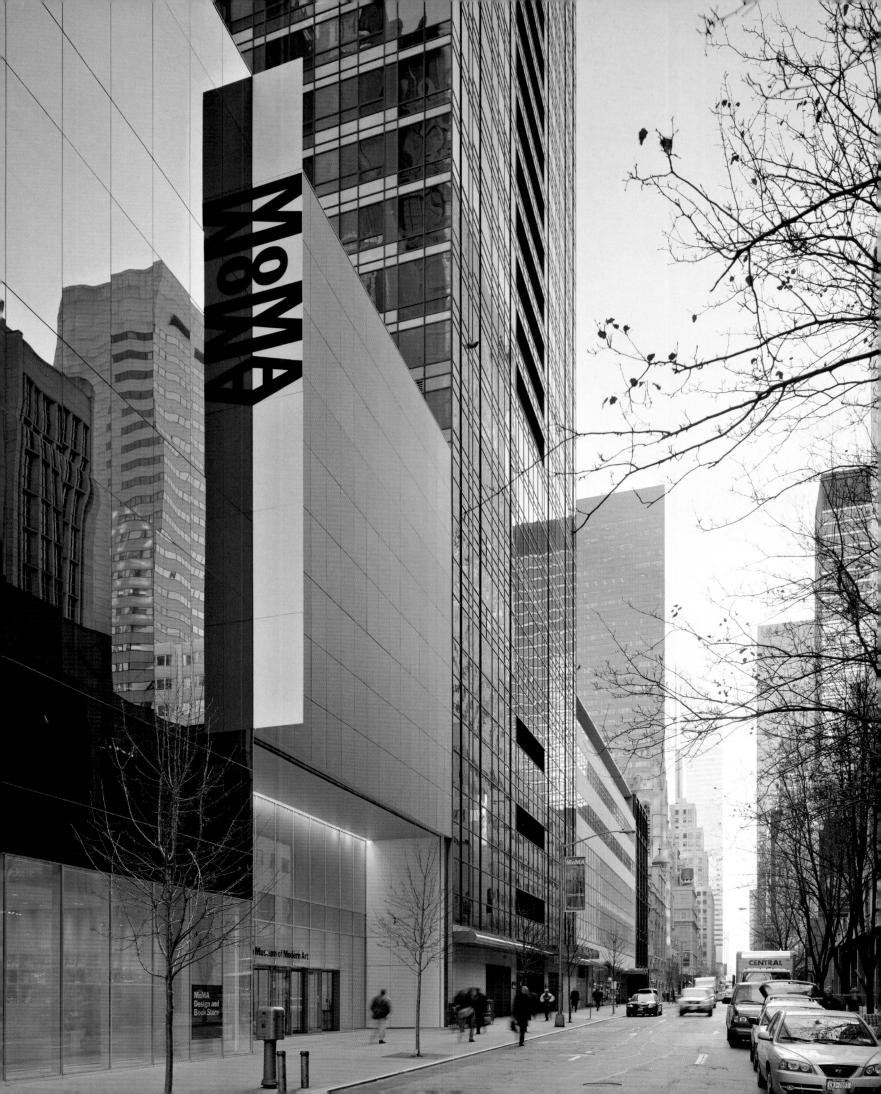

Sketches, 2005

General view from the north,
54th Street (computer simulation)

hattan's streets into the museum but also redefines the structure as having a volumetric definition rather than a front and a rear. His plan also called for both the history of the museum and its programmatic elements to be physically evident. To this end, he retained all of the façades along 53rd Street as a kind of urban archaeology, from Goodwin and Stone's 1939 building, to Johnson's 1964 East Wing, to Pelli's 1984 tower, to his own westernmost extension. Conversely, from the north, on 54th Street, on either side of the garden, two volumes of equal height frame the museum's traditional open-air centre, replacing the much smaller Garden Wing and North Wing. To the east of the garden is the volume that houses the educational facilities and to the west are the principal exhibition spaces, which together reflect the institution's dual mission. Between them, the renovated 1939 building and East Wing have a continuous façade, behind which are the departmental galleries. Each element has a distinct volumetric and material expression of the functions within.

A key factor in creating this sense of legibility was the relationship between Pelli's tower and the new museum. Now at the centre of the museum, the integration of the tower into Taniguchi's plan depended on its clear articulation. Whereas previously it had no presence from within the building, Taniguchi's initial design carved spaces around it, including a central, top-lit atrium, making the full height of the tower visible not only from the garden but from the interior as well. The principal circulation around the atrium begins at each floor with bridges that span the volume of space that connects the Sculpture Garden to the east and the atrium to the west, tying the old and new public spaces together in a single composition.

In the original Goodwin and Stone building, the oldest works of art in the chronologically installed collection were on the lowest floor and the most recent on the highest, a pattern that continued for decades after the former staircases ceased to be the principal route through the building. Taniguchi inverted the sequence, placing the largest contemporary galleries on the lowest floor, adjacent to the largest public space, and the successively smaller, historical galleries

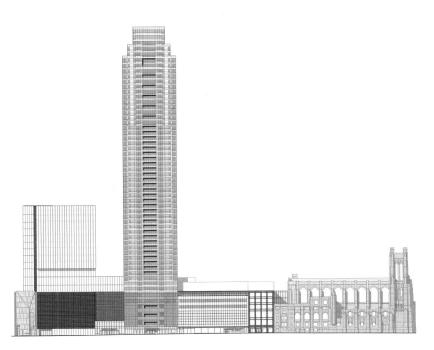

View from the south

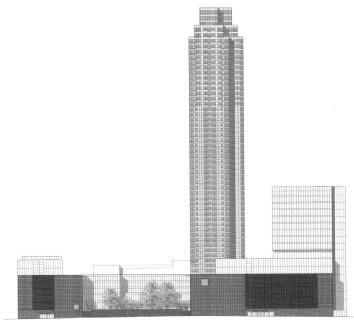

View from the north

above. The unsolicited inversion of the traditional order restored contemporary art to a central place in the museum.

Taniguchi worked closely with the curatorial staff to refine his concept to reflect their need for wall space and regularly proportioned rooms. The centripetal force that had characterised the interior was retained in a more localised fashion, in the atrium itself, surrounded by the more regularly shaped galleries extending to the exterior façade. The resulting intertwining of composed exterior volumes and dynamic central atrium exemplifies Taniguchi's ability to address specific and seemingly contradictory needs simultaneously.

Ceiling heights were also studied to reflect the generalised scales of the museum's collection, which ranges from the easel paintings of the Post-Impressionists to the monumental sculpture and installations of recent years. The result was three distinctly proportioned gallery floors with a sliding scale of proportions from the 22-foot-high and 200-foot-long gallery for contemporary art to the 13-and-a-half-foot-high and 25-foot-wide galleries for work dating back to the late 19th century.

The curators were keen to address some of the failings of the museum that had been exacer-

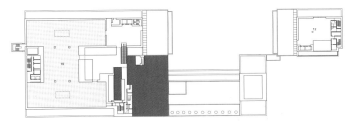

6th floor

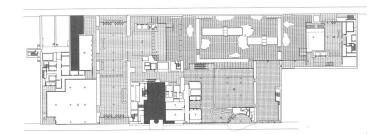

1st floor

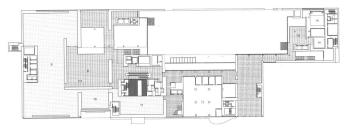

Ground floor

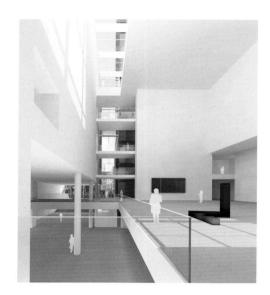

**Interior perspective
(computer simulation)**

**Atrium space on the 6th floor,
with *Triptych* (1991) by
Francis Bacon**

bated by the previous incremental and opportunistic growth. Reflecting the pattern of the row houses that had formerly occupied the block, circulation through the galleries had become increasingly linear, with long stretches in which visitors had neither a reorienting vista nor any option other than to forge ahead in a long sequence of spaces. Taniguchi addressed this issue by providing frequent and unexpected views out to the garden and the city beyond and by providing visitors with an autonomy of movement that had been so lacking before.

By the 1970s, The Museum of Modern Art's long-standing curatorial policy of favouring an environment that emphasises the works of art and, conversely, de-emphasises the architecture surrounding it was perhaps the central focus of debates about museum design. The key element of this debate was the supposed neutrality of the 'white cube' – the white-walled, minimally detailed, and evenly lit gallery for which the museum had become famous. The discussion large-

ly hinged on the notion that there were only two choices: the atectonic spaces that had typified MoMA's galleries or the more architecturally assertive museums that were being built at the time. Taniguchi's design staked a new position in this debate that has long roiled the art world. While MoMA's own history has been coloured by a presumption that architectural expression and the proper environment for looking at art are mutually exclusive, Taniguchi has demonstrated that the two can be intertwined, specifically when the former is designed as a subtle but rich series of sensory experiences that heighten awareness.

Terence Riley

Excerpt from Terence Riley, 'Nine Museums by Yoshio Taniguchi', reprinted by permission from *Yoshio Taniguchi: Nine Museums* © 2004, The Museum of Modern Art, New York

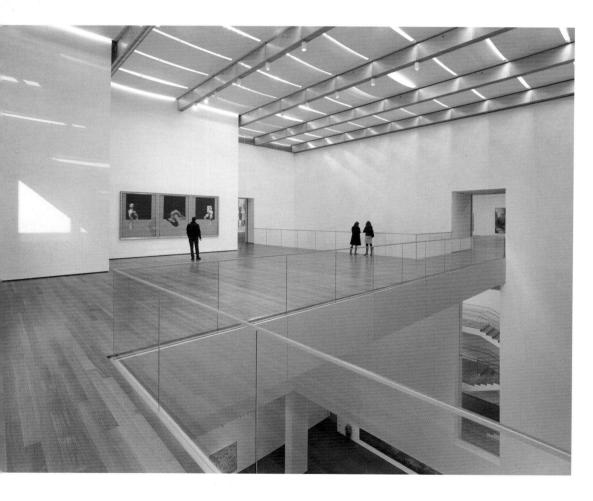

**First floor atrium with
Barnett Newman's *Broken Obelisk*
(1963–69)**

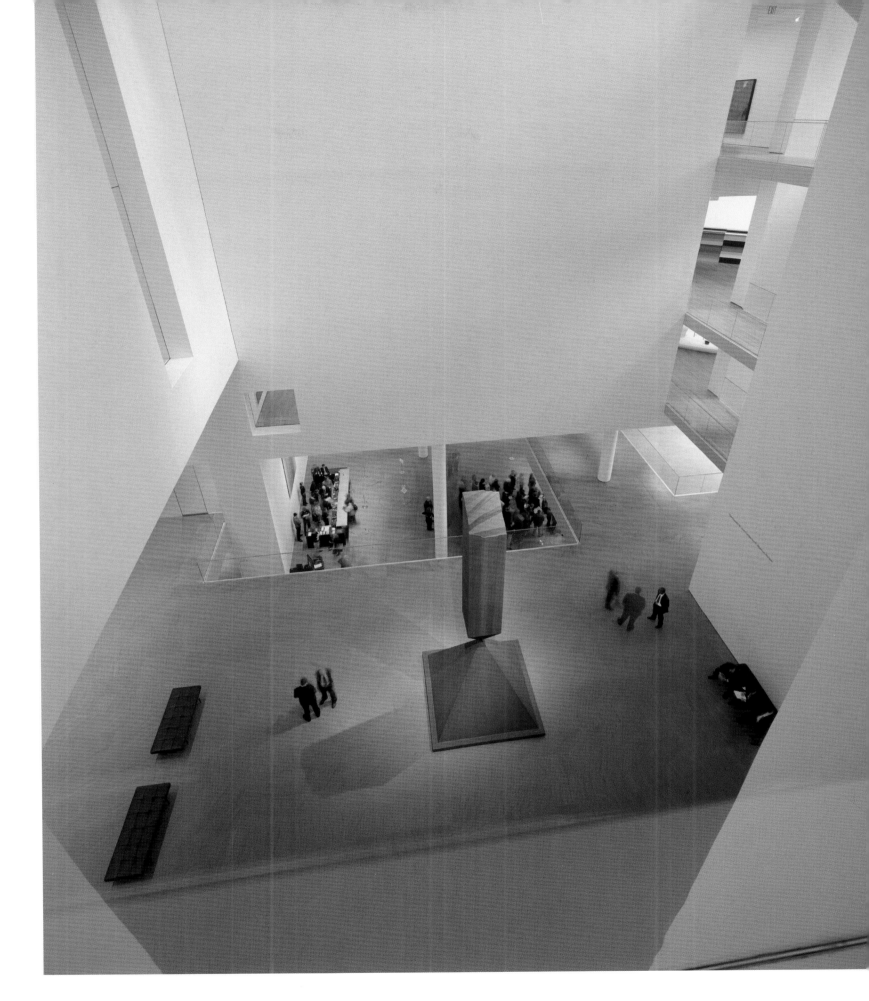

Tadao Ando Architect & Associates

Chichu Art Museum
Naoshima, Kagawa, Japan

Client:	Naoshima Fukutake Art Museum Foundation
Design:	2000–2002
Construction:	2002–2004
Budget:	no data

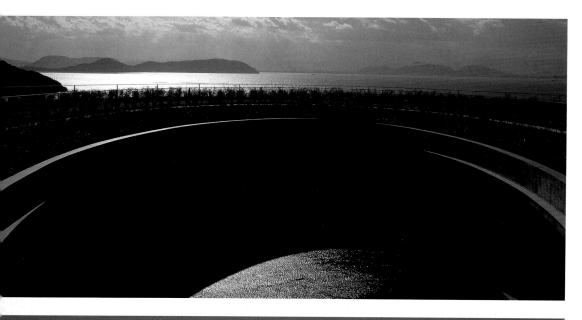

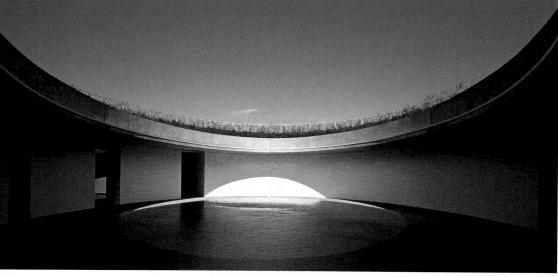

Annexe, Benesse House, oval-shaped inner courtyard with water basin

Tadao Ando – cultural shrines of contemporary art

At the start of the 21st century, at the peak of his fame as a representative of the 'architecture of stillness',[1] Tadao Ando builds cultural shrines of contemporary art. The new forms of presentation he devises in the spatial design of these buildings do justice to a museum concept designed to fulfil the expectations of visitors. If, once they are inside the museum, visitors allow the reciprocal effects of light, nature and clear design to weave their magic, the creative spirit is combined with nature at rest. An incomparable architectural enchantment of contemplative peace surrounds them, and they feel they have been transposed into a temple built by a Zen Buddhist architect. Ando's predilection for simple, solid design with ingenious proportions is the basis of his notion of good architecture that accords with both practicability and contemporary style.

The conscious illumination of exhibits by daylight evokes an atmosphere of poetical experience and is quite different from what happens in other museums. Yet despite their effectiveness, Ando's buildings are anything but spectacular. Laid out in a strictly geometrical way, they are designed in the tradition of new architecture. Constructed with simple spatial arrangements and a use of concrete that brings out all its subtleties, all his buildings have in them a distinctive touch of the originality and quality of a minimal architecture.

The phenomenological experience of space in the poetry of light and the delicate 'mesh' of concrete walls is the essential feature of Ando's

architecture. Space oscillates between non-material, fluid light and severely geometric elements, and thus seems to hover in an intermediate zone that is only indirectly tangible to the viewer, through seeing and experiencing. In this respect, Ando's buildings are an evolution of the concept of a gesamtkunstwerk. Of Tadao Ando, one might justly say, 'I am what I do.' His austere, fascinating buildings create sublime beauty and lucid spatial arrangements. His search for transparency, light and airiness down to the last detail – for open spaces and the blending of interior and exterior – are the result of optimised sequences.

Tadao Ando's Benesse House for contemporary art (1988–92)

The small island of Naoshima lies in the Pacific, between the islands of Honshu and Shikoku. Here, the heirs of the publisher Fukutake have posthumously set about realising his lifelong dream of a museum with sculpture, installations, Land Art and artist houses (see p. 17). Benesse House stands on a hill and can be reached directly from the seashore via a tunnel road. The main building contains the Museum for Contemporary Art, a small hotel with a restaurant and cafeteria, plus seminar rooms. The annexe (1992–95), a guesthouse, is reached by cable car. The well-appointed suites in it are arranged round an oval pool. The connection between building and nature takes the form of an extensive view towards the sea on one side and a view of vegetation with flowering shrubs on the other. The rooms are arranged in an ellipsis, and look out towards the paradisiacal oasis of the oval pool in the middle of the annexe building. The theme of nature and art is underlined by the water effects in the artificial pool to evoke peace and meditative introspection – a mark of Tadao Ando's architecture. The variations in the wave patterns of the sea suggest infinity. The surface of the water in the pool conveys a sophisticated pattern of reflections depending on the wind. The effect of withdrawal and peace this surface generates is artistic essence in empty space. There is confidence in the sensory stillness.

Site plan

Aerial view of Benesse House and the oval-shaped annexe (at the front)

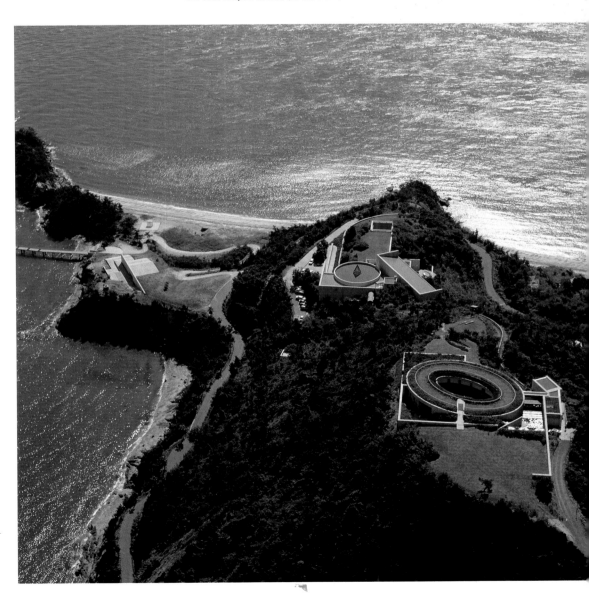

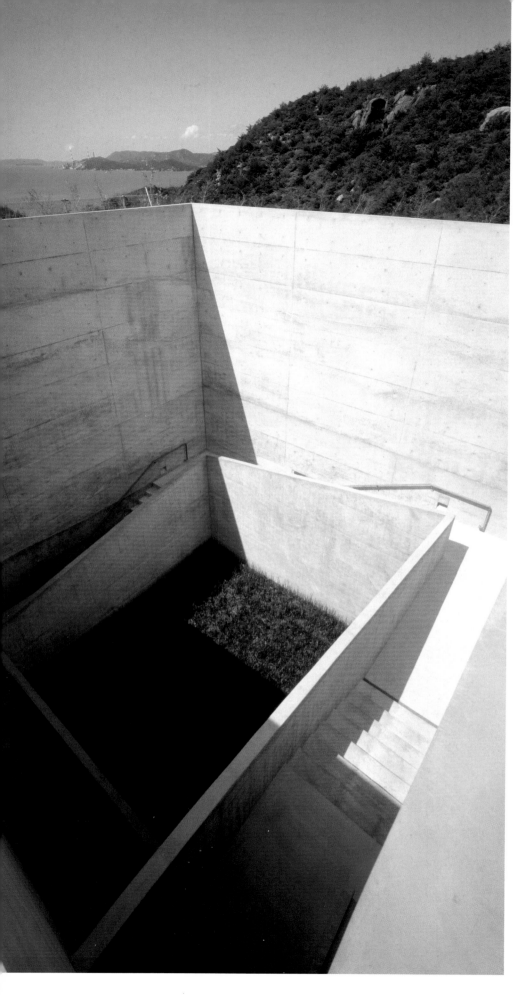

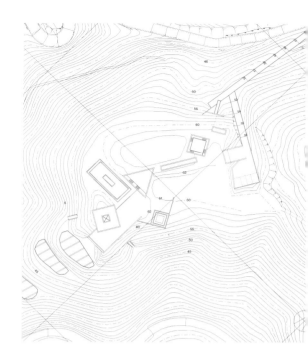

Site plan of the Chichu Art Museum

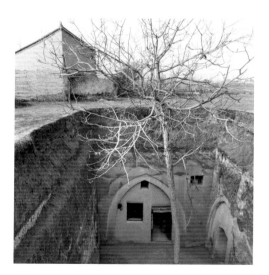

Fig. 1: Earth house in Qian Ling (Shan-Xi), China

Inner courtyard of the Chichu Art Museum

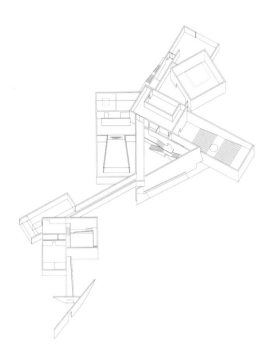

Axonometry from the north-west

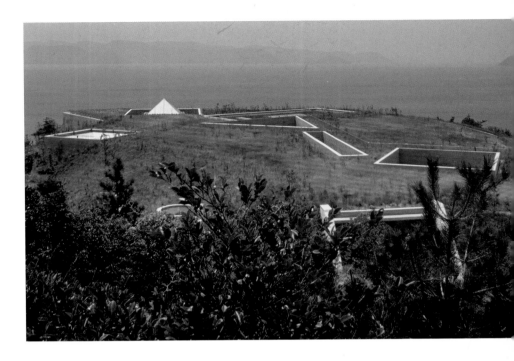

View from the north-east

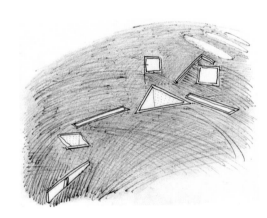

Sketch, 2004

Chichu Art Museum on Naoshima Island (2000–04)

Tadao Ando constructed the Chichu Art Museum, which is sunk into the ground, as the Japanese word *chichu* (buried) indicates, around 600 metres from the Museum for Contemporary Art. The idea of sinking the building into the ground was first and foremost for the sake of the splendid panorama. The sunken rooms contain permanent exhibitions of three important artists: Impressionist Claude Monet (in a room measuring 12 × 12 × 6 metres) and well-established artists Walter de Maria (10 × 24 × 8 metres) and James Turrell (8 × 8 × 8 metres and 10 × 24 × 5 metres).

Tadao Ando had already manifested his respect for nature earlier, for example, in the seminar project at Vitra (1993), the Benetton Fabrica communications centre in Villobra/Treviso (2000) and the Langen Foundation Museum in Hombroich (2004). With his 'sunken courts', Ando sinks architecture into the ground, thus encumbering nature with structural volumes only as far as necessary. Digging down in this way produces a sunken atrium. In China's Henan Province, earth houses have been a way of life for centuries, and still are (fig. 1). Normally, the arrangement is a rectangular courtyard dug out of the ground. It is sunk some six metres into the ground and accessed via a ramp finishing in a doorway. From outside you can see only the hollow of the open courtyard. In the middle is a tree that absorbs the rainwater. The living spaces are recessed into the ground around the central courtyard in every direction. The earth houses constitute an interplay of nature and structure.

Tadao Ando's Chichu Art Museum, built in 2004, constitutes a revival of the tradition of sunken inner courtyards, and in this way he manages to preserve the splendid panorama of the Pacific Ocean and picturesque coastal landscape. The sunken rooms are each devoted to masterpieces by three artists: four waterlily pictures by Claude Monet, a sculpture by Walter de Maria, and three meditative light installations by

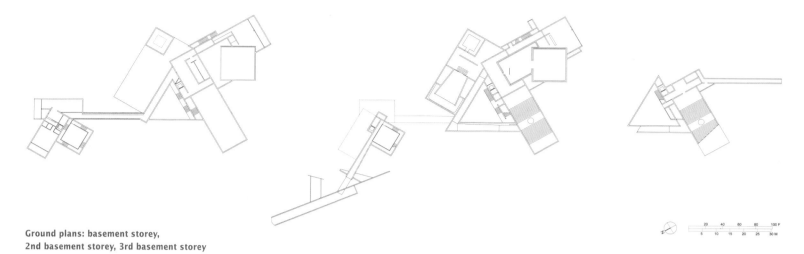

Ground plans: basement storey,
2nd basement storey, 3rd basement storey

Interior views

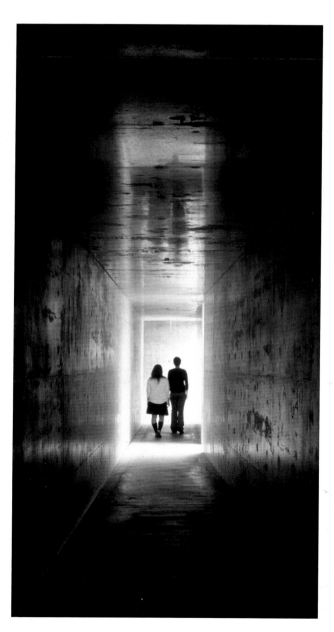
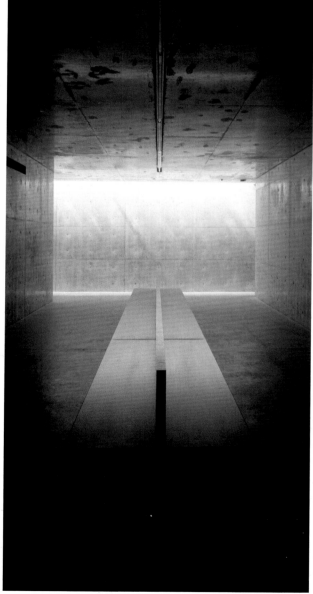

James Turrell. The structure with its basic geometric shapes, set into the ground on a rock overhang facing the Seto inland sea, is incontestably a masterpiece of museum building. Tadao Ando himself says of it: "Darkness rather than the light, below ground rather than above – the Chichu Art Museum is the most direct expression of this feeling rooted deep inside me."[2]

Werner Blaser

1 Werner Blaser, *Tadao Ando: Architektur der Stille / Architecture of Silence* (Basel 2001)
2 Naoshima Fukutake Art Museum Foundation (ed.), *The Chichu Art Museum* (Ostfildern 2004), p. 88

Interior views with works by Claude Monet, Walter de Maria and James Turrell

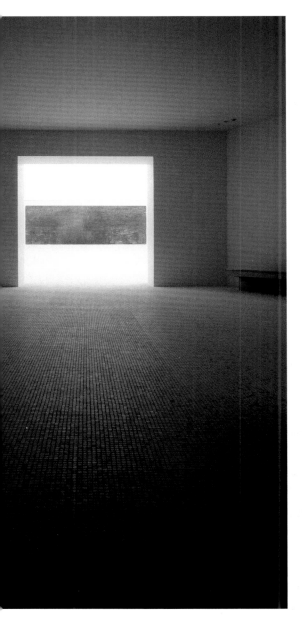

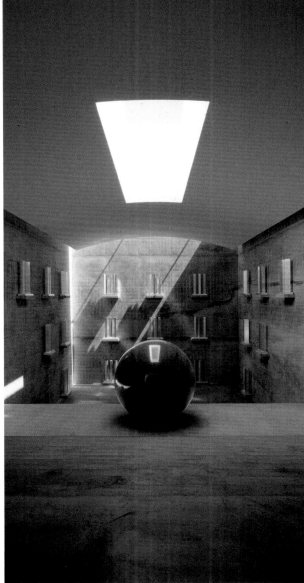

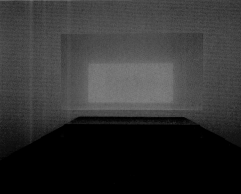

Jun Aoki & Associates

Aomori Museum of Art
Aomori, Aomori Prefecture, Japan

Client: Aomori Prefecture
Design: 1999 – 2002
Construction: 2002 – 2006
Budget: 12 billion yen

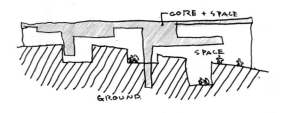

Conceptual design, 1999 – 2000

3D simulation, interlocking of roof
structure and trenches

Sectional drawings, 2004

The aporia of creating an art museum

Jun Aoki believes that an architect who undertakes to design an art museum faces an aporia. He defines an art museum as "a space dedicated to the creation of a thing by a human being by his or her own power.... That being the case, the relationship between the person doing the creating and that space should not be specified."[1]

The space he cites as a model is the open field – a space that takes on meaning only when something occurs there, a space that is clearly ideal for an art museum. However, it does raise the question: can an architect responsibly create a space from which objectives and conditions have been extracted?

Topos

The Aomori Museum of Art can be seen as Aoki's answer to the aporia. In 1992, remains of a community were discovered at the Sannai Maruyama site at the northern end of the main island of Honshu. This site, said to be 4,000 to 5,500 years old, is virtually contemporary with Stonehenge and Mohenjo-Daro and belongs to the so-called Jomon period of Japanese prehistory.

Aomori Prefecture established a cultural district centred on the site and decided to construct an art museum as a core facility. The 393 entrants in the international design competition were apparently troubled by the Jomon Loop, a pedestrian road that was to be built under the

Exterior view

32

basic plan. Jury chairman Toyo Ito described Aoki's winning scheme as "a powerful proposal, not in the sense of being striking in appearance, but in the sense of having carefully-thought-out spaces."

Generative rule overdrive

How did Aoki go about designing his scheme? He says we can escape the aporia by adopting as an overdrive – as Frank Gehry did in Bilbao – a generative rule free of compositional or expressive constraints. The generative rule should have no basis or justification if, in creating a new building as opposed to using a ruin, we are to arrive at an open field. The rule should not be implemented for some desired psychological effect but should be a geometrical generative rule as much as possible.[2]

The rule for the Aomori – Aoki's biggest project so far, with a total floor area of 16,000 square metres – was simple: an irregular engagement of two sets of projections and recessions. One set consists of trenches dug in a geometric pattern, suggestive of the nearby archaeological

Sketch of the site plan

Site plan

site, the other, a structure with a flat roof and an underside with projections and recessions. White cube spaces are accommodated inside, but the interstice between the two sets is also used as a gallery in which earthen trenches form the floor and the walls, making the spaces site-specific. Trenches not engaged by the structure are used as open-air galleries or work yards.

The structure has been carefully designed to suggest a single object. The brick curtain wall chosen for the exterior may not be monolithic,

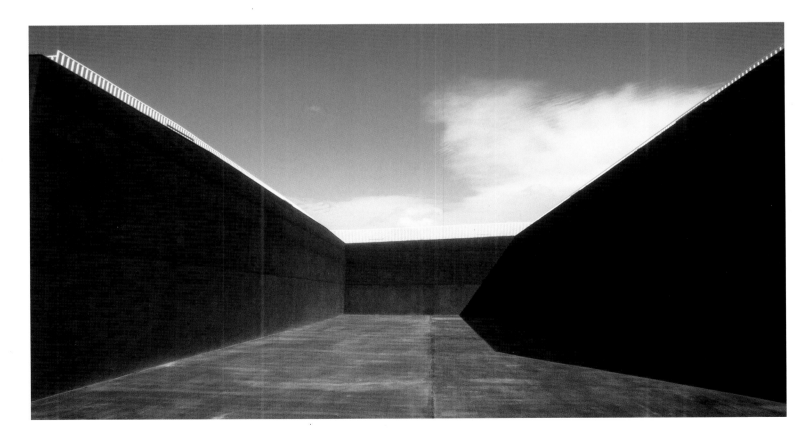

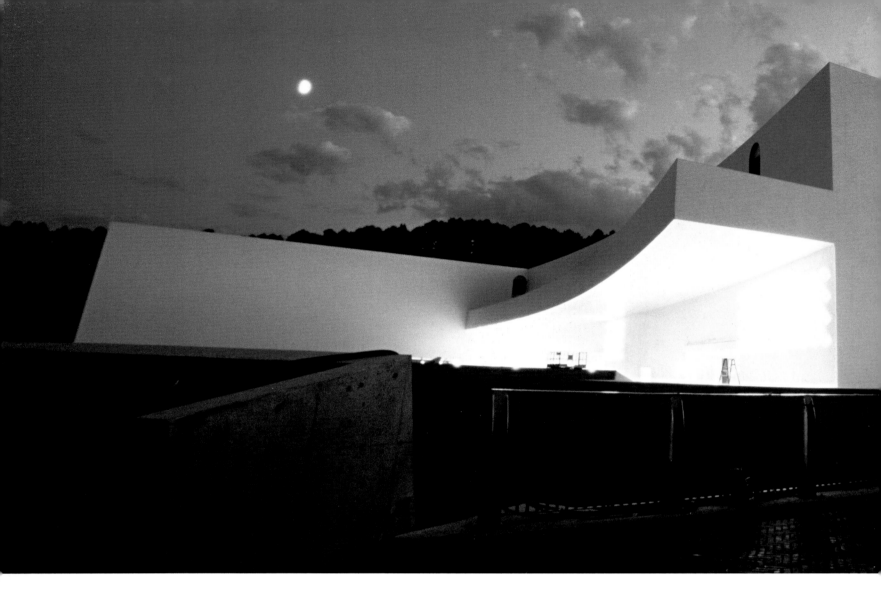

Sketches of ground plan, 2004

Fig. 1: Jun Aoki & Associates, 'U bis', 2002

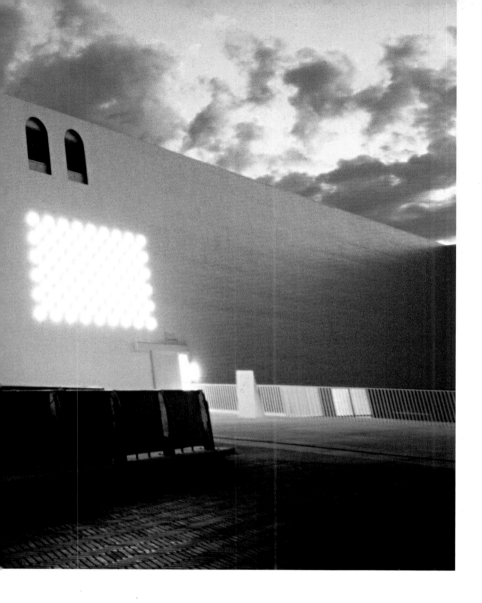

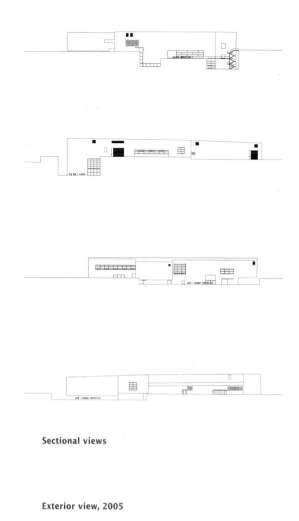

Sectional views

Exterior view, 2005

but the repetition of elements makes the structure look like a single entity. It also appears to float in the air, its detachment from the ground made all the more striking by the wall's resemblance to masonry.

Programme and circulatory body

The museum's collection will include Japanese-style paintings, oil paintings, sculptures, prints, craftworks and, in all likelihood, Jomon-period earthenware. A relatively small yet highly diverse collection can make a museum seem unfocused. Aoki avoids this by giving a strong character to the gallery spaces, which range in size from 50 to 500 square metres, with ceiling heights varying from three to 19 metres.

A chequerboard pattern of white cube and earthen galleries will provide visitors with several circulation routes, but all the routes will begin at the Aleko Room, where three backdrops created by Chagall in 1942 for the play 'Aleko' are hung. The earthen galleries are gaps left between the white structure and the trenches so that visitors perceive the earthen galleries as the keynote of the composition, and the white cubes as unique spaces.

Ornament and space

In 2002, Aoki created 'U bis', an ornamental space behind a temporary partition (fig. 1). Considered a wall, the interface between two spaces is an inviolable material object, but Aoki reconsidered it as ornament, something that interrelates with human consciousness.

According to Aoki, the Aomori is "a condition in which two worlds such as outside and inside exist, each empty of meaning in itself but endowing the other of meaning", and such a condition should be called "ornament or dress as space".[3] Indeed, in Aomori, spaces are not defined by walls; spaces shape and complement each other. Conceiving the interface (condition) that defines two interrelating but disparate spaces as ornament enabled Aoki to escape the abstract character of volume manipulation. This project represents a paradigm shift in his approach to architectural space.

An art museum that relativises architecture

What is the origin of architectural space? The Parthenon – a paternalistic space where columns and the roof create a heroic drama? In such a work, the architect manipulates these elements to create a perfect space. However, the column rising from the ground, the axis mundi, is not the only primary form of architecture. Aoki took

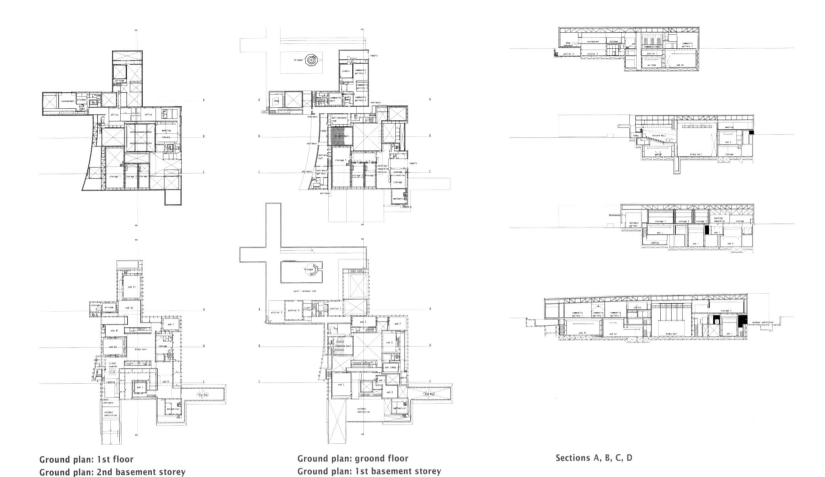

Ground plan: 1st floor
Ground plan: 2nd basement storey

Ground plan: groond floor
Ground plan: 1st basement storey

Sections A, B, C, D

note not of the large columns at the remains but of the trenches. He dug into the maternal earth and, by covering it with the structure, created space.

Instead of a narrative (the rising of the building from the ground) there is only the fact (the engagement of the trenches and the structure). In the space born fortuitously between earthwork and architecture, maternity and paternity, time has been erased, enhanced, preserved. The Aomori thus becomes "a space dedicated to the creation of a thing" because the space itself gives concrete expression to the condition of a work of art: it has the immediacy of something newly created but which also seems to have been in existence for a long time.

Interestingly, the Loop (fig. 2) will not be built, which means that the Aomori Museum of Art will already have the appearance of a ruin when it is eventually completed.

Kenjiro Hosaka

1 Jun Aoki, 'Harappa to Yuenchi' (Open Field and Amusement Park), in: *Harappa to Yuenchi*, (Okokusha, 2004), p. 13
2 Ibid., p. 22. For key concepts (such as 'generative rule overdrive') to interpret Aoki's architecture, see Kenjiro Hosaka, 'Ethics for Architecture, Architecture for Ethics' (trans. Alfred Birnbaum), in: *Jun Aoki Complete Works 1*, 1991–2004 (INAX Shuppan, 2004), pp. 20–63
3 Jun Aoki, 'Concerning Ornament or Dress' (trans. Hiroshi Watanabe), in: *Jun Aoki Complete Works 1*, 1991–2004 (INAX Shuppan, 2004), p. 17

Aomori Prefecture, Japan, 1999–2000.
Design model

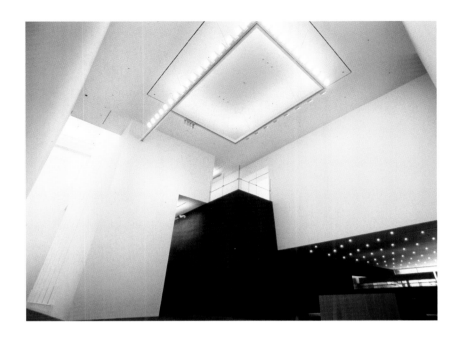

Schemes, 1999–2000

Interior views, 2005

Kisho Kurokawa Architect & Associates

The National Art Center
Tokyo, Japan

Client: The Agency for Cultural
 Affairs
Design: 2000–2001
Construction: 2002–2006
Budget: US $350 million

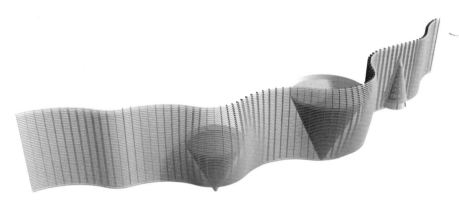

Concept of fractal curtain wall

Aerial view of the museum in an urban context
during construction, 2005

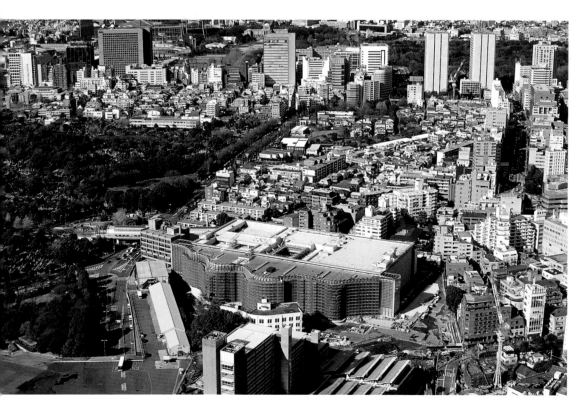

The modern role of the art museum

Recently, art has gone through great change. New formative works of art and installations, such as 'sculptures of light', no longer fit into the categories of painting and sculpture and become less suited for exhibition at traditional art museums. Also, there has been a steady rise in the number of special exhibitions and those featuring works solicited from the public. While the role of the art museum as an urban institution will continue to grow in importance, architecture that provides new functionality will be needed. That means a shift away from the traditional model of the art museum that serves to exhibit and store works of art towards exhibition spaces that can handle works of art that are difficult to exhibit.

The National Art Center, Tokyo, designed by Kisho Kurokawa, is a new facility that will allow this new trend to flourish. Kurokawa has designed ten art museums to date, including The Museum of Modern Art, Saitama (1982, fig. 1) and the Van Gogh Museum, Amsterdam (1999, fig. 2). The National Art Center is located in the Roppongi district of downtown Tokyo in an area surrounded by greenery on the former site of the Institute of Industrial Science, University of Tokyo.

Kisho Kurokawa's proposal was selected through international competition by The Agency for Cultural Affairs. SATO SOGO Architects & Associates, SAKAKURA , and Shojo Uchii were other finalists, but the second and third place was not officially announced.

The building lot is approximately 30,000 square meters, with a building area of 12,428 square meters and a total floor area of 47,960

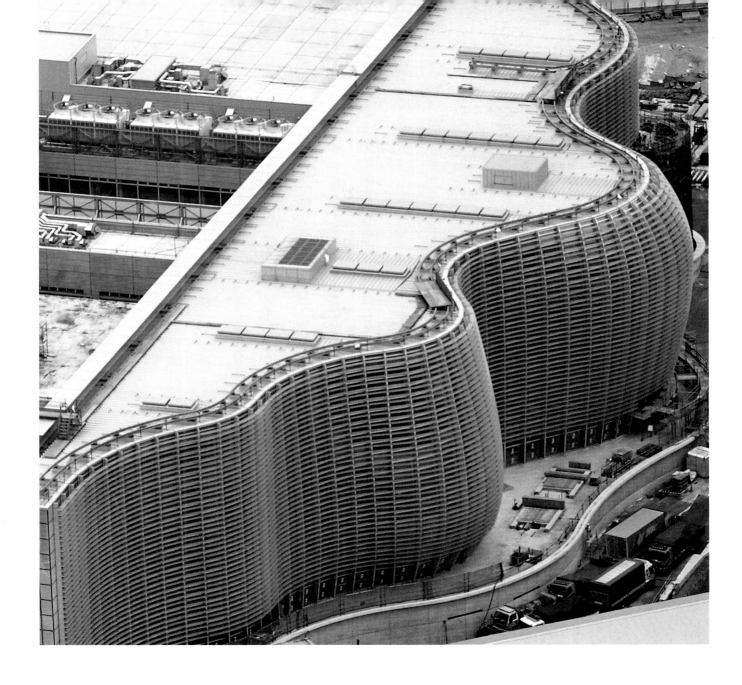

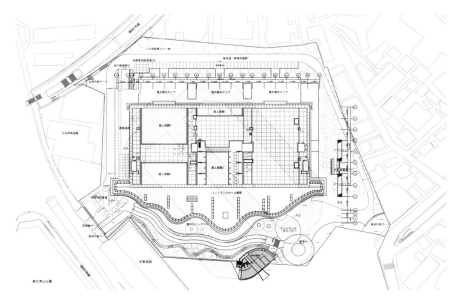

View of the curtain wall
during construction, 2005

Site plan

Fig. 1: Kisho Kurokawa Architect & Associates, The Museum of Modern Art, Saitama, Japan, 1978–82

Fig. 2: Kisho Kurokawa Architect & Associates, Van Gogh Museum, Amsterdam, Netherlands, new wing, 1990–98

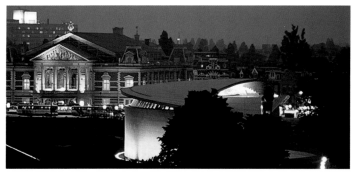

square meters. There are two basement levels and six storeys above ground, all resting upon a structure designed to absorb seismic energy to cope with tremors. For legal reasons the number of floors is two and six, but in reality there is one basement floor and four above-ground floors. This difference is generated by the insertion of structural/equipment floors (Mechanical Wafer) that are counted as separate storeys. The Mechanical Wafer serves as a structural floor that supports the broad, column-less span of the display spaces. It also houses equipment, supplying power and air-conditioning to upper and lower floors from the shortest possible distance. Air-conditioning and heating will be supplied through a floor- and ceiling-vent system. This superstructural design was developed for the Osaka International Convention Center (2000) and its effectiveness has been well proven.

There are seven enormous column-less display rooms on the first to third floors, each with a floor area of 55.95 × 34.2 metres (a total of

Façade detail

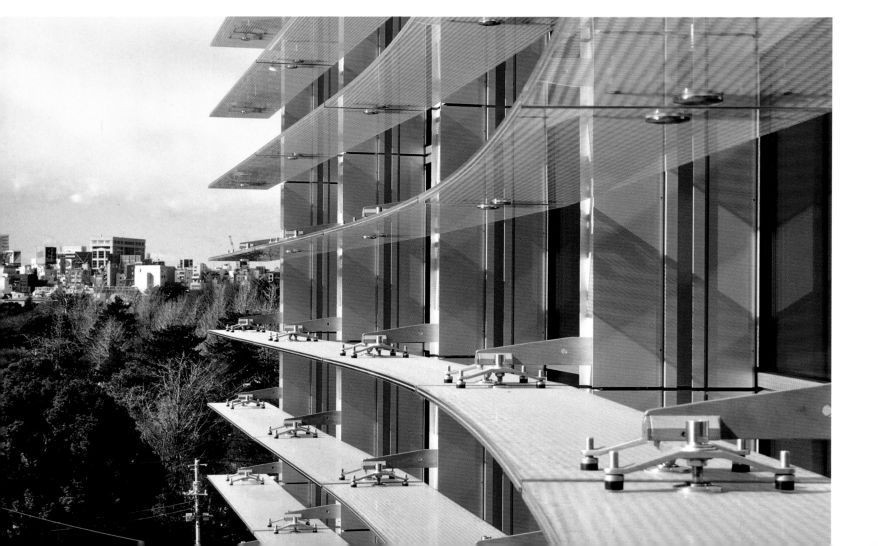

almost 2,000 square metres) and a ceiling height of five metres (one room is eight metres high). These spaces will be able to accommodate exhibitions of a wide variety of artworks. The total exhibition space of 14,000 square metres is the largest of any art museum in Japan. The basement level is one long receiving bay, and one-way vehicular traffic allows a high volume of works to be brought in and out efficiently. On the north side of the exhibition spaces on each floor there is a corridor-like lounge area with a glass curtain wall. Here, visitors can rest their eyes by looking out across the city and far into the distance, or down onto the outdoor sculpture garden.

In addition to this set of exhibition rooms, there is the main approach on the south side, 160 metres long, plus a four-storey atrium 21.6 metres high. In contrast to the rectangular, functional exhibition spaces, the atrium's gently curving glass curtain wall creates an attractive atrium space. Visitors see two inverted cones – one large and one small – that create an extraordinary feel. The upper section of the cones contains restaurants and cafés from which they can look down into the atrium space. The atrium is also an amenity space, providing many services to complement the exhibition spaces.

The glass curtain wall of the atrium is supported by structural mullions made of steel, arranged vertically at a two-metre pitch. The façade is fitted with horizontal rows of glass louvres at a 40-cm pitch that block direct sunlight and create a subtle balance between the contrast of openness versus enclosure within the atrium. From the outside, the glass louvres blur the contour of the wall's curvature.

The use of glass louvres on the outside of the atrium's glass curtain wall is connected to Kurokawa's theory of intermediate space. In traditional Japanese architecture, an important element is the 'engawa veranda', which is considered to be neither indoors nor outdoors. It is exposed to the wind and rain, but when the paper sliding doors are opened, it functions as an extension of the interior space. It is thus an indistinct area. Building an intermediate space like this in a country with relatively hot summers is part of traditional Japanese wisdom. This vagueness also provides an ambiguity that makes different inter-

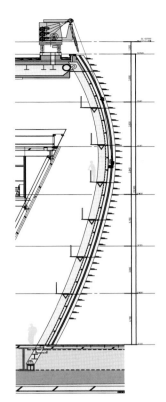

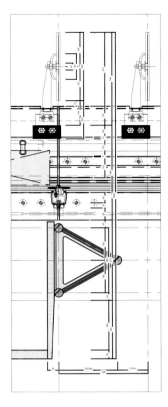

Sectional view of lobby curtain wall: horizontal and vertical sections

Façade detail

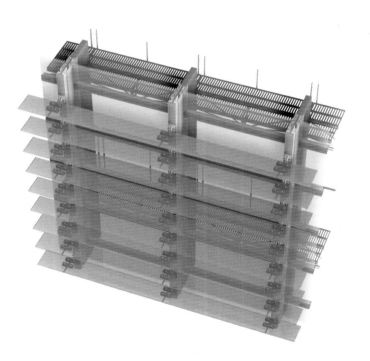

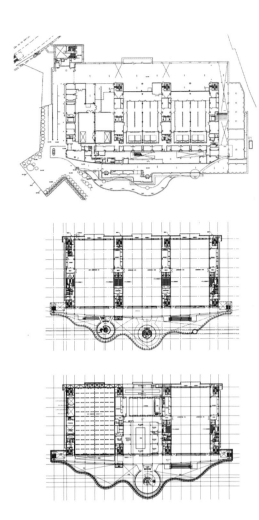

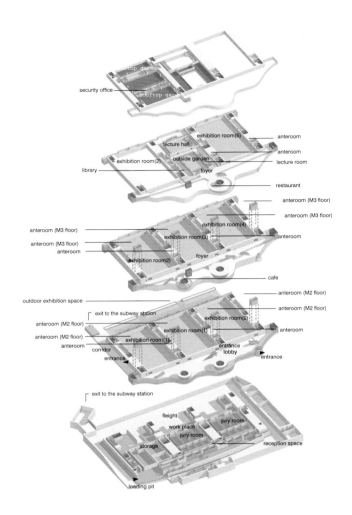

pretations possible. Here, louvres do not simply block sunlight but play an active role in blurring the border between outside and inside, which is why they are made of transparent glass. The louvres create an intermediate space that makes visitors aware of being inside and seeing the outside through the louvres. From the outside, the glass louvres blur the wall's contour, adding ambiguity to the form.

The buildings designed by Kisho Kurokawa always exemplify the synergy of theory and design. The National Art Center is no exception. It incorporates aspects of his theory – symbiosis, metabolism, abstract symbolism, fractals, intermediate space, and green corridors – with his innovative design methods.[1]

Trees planted all around the Center create a green corridor to the nearby forest and blend the art museum into the natural environment. The green corridor is important both in terms of urban design, through its visual appeal, and eco-

logically. Isolated trees have limited value to the natural environment, whereas connected stretches of trees become a living environment for birds, small animals, insects and an entire ecosystem.

The various theories, techniques and the design discussed above are synthesised in the National Art Center, Tokyo, resulting in the crystallisation of an architectural creation. Moreover, having a new type of art museum that focuses on exhibitions and does not maintain a permanent collection will have a significant impact on the development of urban culture in the future.

Shozo Baba

1 Kisho Kurokawa, *Metabolism in Architecture* (studio vista, London 1977); Kisho Kurokawa, *Le Metabolisme* 1960–1975 (Centre Georges Pompidou, Paris 1997); Kisho Kurokawa, *Metabolism and Symbiosis* (Deutsches Architektur Museum, Frankfurt 2005)

Exhibition room
(under construction), 2005

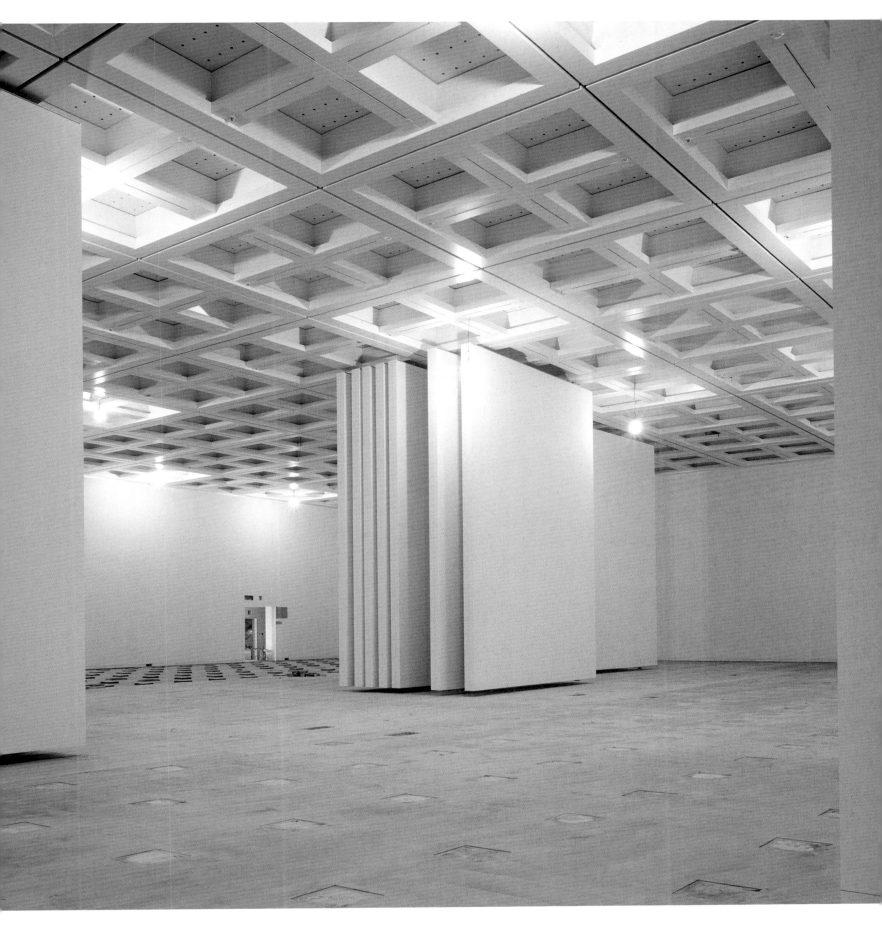

Fumihiko Maki + Maki and Associates
Shimane Museum of Ancient Izumo
Shimane, Japan

Client: Shimane Prefectural
 Government
Design: 2002–2003
Construction: 2004–2006
Budget: 7 billion yen

Aerial view of the Izumo Shrine

Preliminary drawing: the shrine in relation to the museum

Izumo and *oku*

In April, 2000, preparations for a festival at the oldest shrine in Japan led to the accidental unearthing of an 800-year-old pillar three metres in diameter, composed of three fat, cedar logs banded together with metal. The find corroborated the existence of an earlier, 48-metre-tall timber shrine, Kitsuki Taisha, thought to have been reached by a long ceremonial stair. The area has yielded some of Japan's earliest metal tools and ornaments. The current shrine, the Great Shrine of Izumo, is 24 metres tall and the largest shrine in Japan; at twice that height, the ancient Kitsuki Taisha would certainly have been a powerful presence.[1]

A public exhibition of the pillars demonstrated the acute need for a new museum: even before the doors were opened, more than 2,500 people had lined up for the brief display of these lumps of wood. The open competition in 2001 called for a 10,500-square-metre museum, at a projected cost of 7 billion yen (about US $7 million). It was won by Pritzker Prize-winning Fumihiko Maki. Among the seven finalists were Kiyonori Kikutake (along with Maki one of the original Metabolists of the 1960s), Shinichi Okada, Tadahiro Toh, and Akira Kuryu (Maki's former employee).

One of the competition jurors was Masato Otaka (another member of the Metabolists group of the 1960s). Otaka and Maki together wrote an essay suggesting the Metabolist approach should be one of space, not form. Yet Otaka's architecture was appreciated mostly for its unusually public scale and weight. While an architecture of monumentality is not what an

outsider tends to associate with Japan, Maki's proposal, too, was uncommonly solemn and massive, in contrast to his customary delicacy.

A full 40 years have passed since Maki established his office in 1965. He is best known internationally for his design of Hillside Terrace, built between 1969 and 1992; the complex elucidates his handling of nature and cultural history, a precedent with direct links to the Shimane Museum. When Hillside Terrace was first planned, Maki understood that temple precincts to the south would preserve a lushly overgrown territory destined to become distinctive, and his design mediates between a retail zone pressed hard against the street and expansive views of the temple's treetops. In phase C of the design, completed in 1973, Maki awkwardly retained an ancient burial mound, squeezing new retail activity against the remains of earlier eras. He offered his explanation in a 1975 essay: "For Japanese, the land is a living entity. At the foundation of this idea there is a feeling of deep respect for the land based upon its reverence – a feeling deeply rooted in folk beliefs…. The Japanese do have a strong aversion towards removing existing wells or tumuli."[2]

In his discussion of *oku*, Maki did more than simply justify the presence of a burial mound within a chic shopping complex. He outlined Japanese and Western concepts of spatial hierarchy, arguing that pantheistic Shinto traditions offer a multiplicity of weighted moments diffused throughout the landscape – the Japanese *oku* – while Western monotheism values a celebrated centre. Maki contextualised mountains and unseen shrines outside villages as spiritual referents. When discussing the Shimane Museum of Ancient Izumo, he echoes these sentiments, pointing to two culturally important poles: Izumo Shrine and virginal forests shrouding the surrounding mountains.

What is particularly interesting about Maki's text on *oku* is that Maki can remember a time when Shinto was used to promote nationalism. Maki simply chose to ignore this period; he rejects the use of Shinto for political intent, while validating it as a fundamental influence on Japanese culture. These dual traditions of Shinto, however, remain a vexing problem. The political

Site plan

Plan of the museum with ground plans of the glass pavilion (3rd and 2nd floors) and the offices (2nd floor)

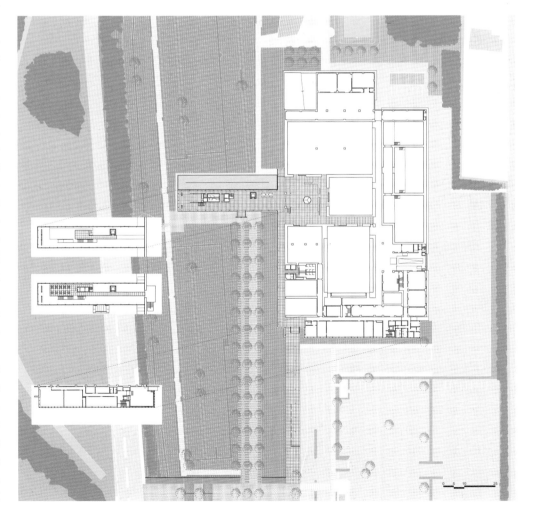

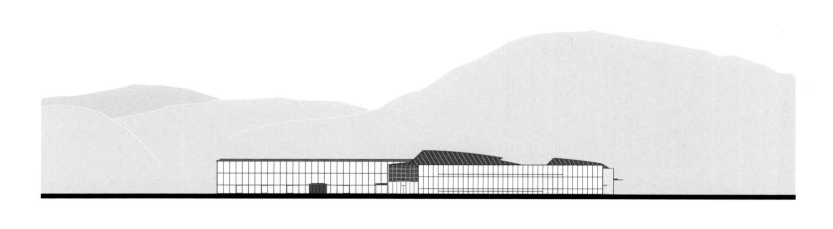

View from the south and section

exploitation of Shinto makes the conflating of shrine and state taboo, but this publicly funded structure, on the grounds of one of Japan's most important shrines, inevitably contradicts the separation of sacred and secular. As a result, Maki's conception of the museum oscillates between gestures that embrace the sacred landscape, shadowed by the symbolic presence of Shinto, and those that are studiously secular. This resulting tension runs through the Shimane Museum of Ancient Izumo and enriches it. This oscillation is played out along a carefully choreographed processional path through the landscape and the museum, and through materials and spaces that rely on a rich symbolic language.

For the informed visitor, Maki offers many references to the history of this place – but for the uninitiated, the Shimane Museum of Ancient Izumo will seem decidedly modern. One of the strongest examples of this dual reading of the building is seen in the unarticulated walls of corroded weathering steel that run along the approach, both on the 120-metre-long west façade and half-buried in berms flanking the path. The dark steel is more formidable because of its minimal detailing and mammoth size; the

effect establishes a modernist monumentality appropriate to the building programme and context. Corten also recalls the bronze tools in the museum's collection and iron found on the site in the early stages of construction. Maki's office first used Corten in the 1997 Kaze-no-Oka Crematorium, writing, "The architecture's earthy tactility connotes the primordial relationship between life, death, earth and sky."[3] But the rusted steel also establishes a contemporary dichotomy of rough and smooth, forming a contrast with a vitrine-like pavilion projecting from the museum, reaching towards Izumo. A delicate, glass curtain wall meets slabs of rusting steel, a treatment entirely new in Maki's work. Where visitors are distanced from the museum, the rusting steel and black slate dominate; closer, where hand and eye engage, Maki's jeweller-like detailing will sparkle in its settings.

Within the airy, glass structure, a ceremonial stair ascends to an observation deck overlooking the roof of Izumo Shrine, this stair deliberately calling to mind the elongated stair of the 13th-century Kitsuki Taisha. Maki once wrote, "A place ... is a dramatic stage on which contemporary mythic ceremonies are held. To create architec-

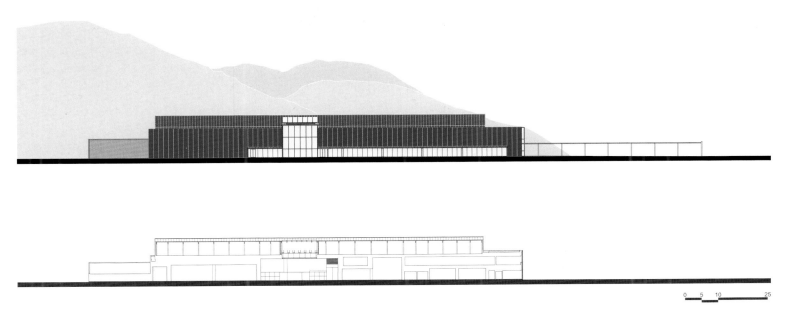

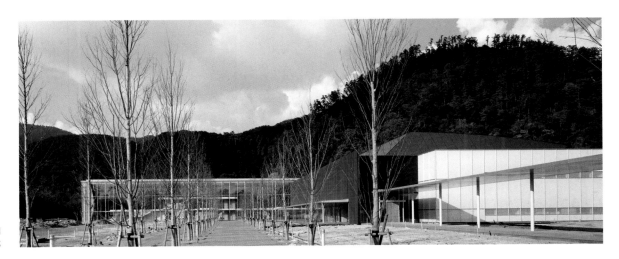

View from the west and section

Views from the south and
north-west, 2005

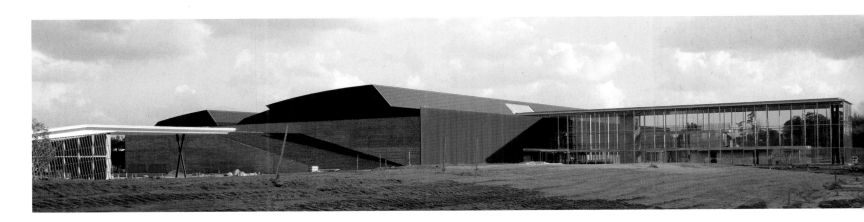

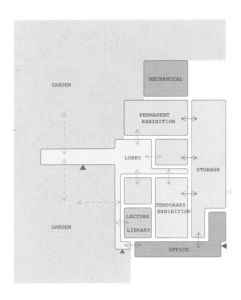

Planning concept diagram

Exhibits:
ritual bells in bronze,
bronze mirror, bronze swords

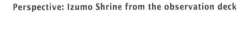

Perspective: Izumo Shrine from the observation deck

ture is to build places and to give life to 'time' (that is, past, present and future)."[4] The observation deck embraces the ancient past, but this crystalline pavilion, open and modern, also looks to the future; it is a privileged pivot overlooking ancient *oku*. The platform also offers a highly effective draw for the museum, without the need to pander to entertainment paradigms; the decidedly secular gesture of overlooking the shrine is a rare opportunity in Japan. As a result, Maki's museum will remain a required stop for visitors to Izumo long after Kitsuki Taisha's archaeological remains have lost their novelty.

Dana Buntrock

1 For more on these findings, see: www2.pref.shimane.jp/kodai/about-kodai/matsuo.htm
2 Fumihiko Maki, 'Japanese City Spaces and the Concept of Oku', in: *Japan Architect* no. 265 (May, 1975), p. 62
3 'Kaze-no-Oka Crematorium', in: *Space Design* no. 424 (January, 2001), p. 44
4 Fumihiko Maki, 'The Present that is Tokyo', in: *Space Design* no. 256 (January, 1986), p. 140

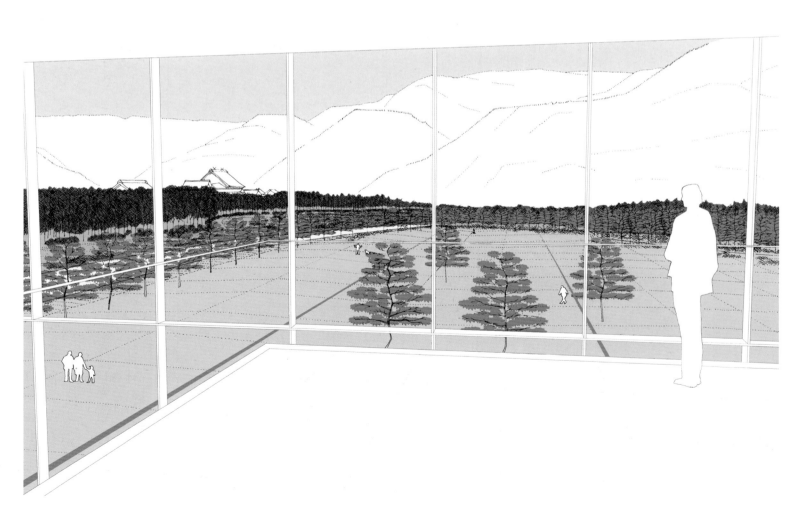

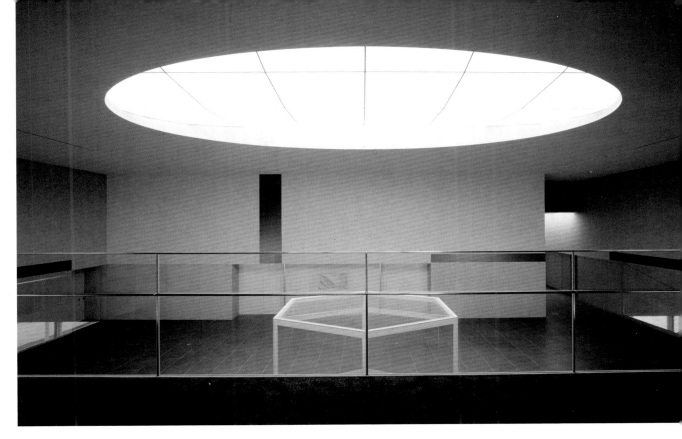

Exhibition lobby, 2005

Viewing gallery in the
glass pavilion, 2005

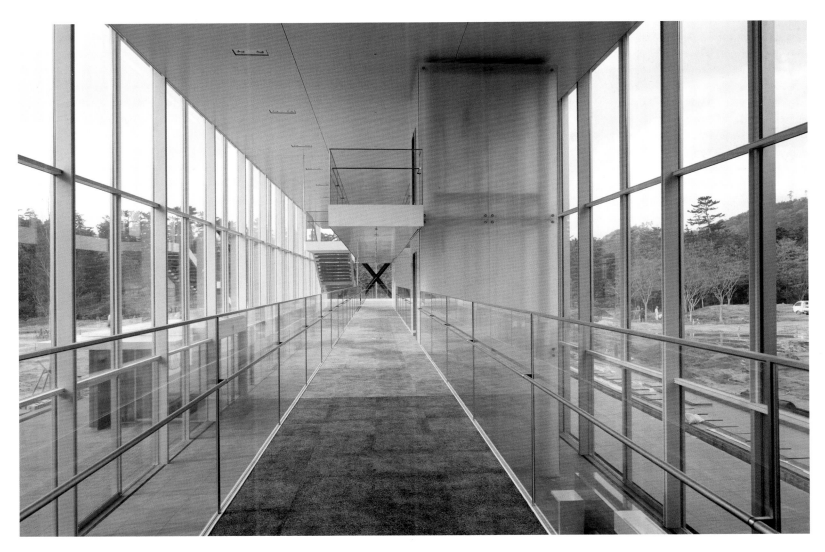

49 **Fumihiko Maki**

Shigeru Ban Architects with Jean de Gastines
Centre Pompidou Metz
Metz, France

Client:	CA2M: Communauté d'Agglomération de Metz Métropole
Design:	2003–2005
Construction:	2006–2008
Budget:	60 million euros

Draft: Chinese hat and lattice structure

Night view, main entrance (computer simulation)

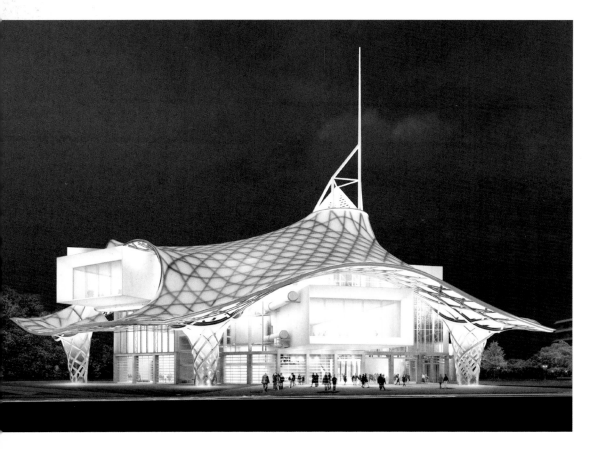

The Centre Pompidou-Metz, designed by Shigeru Ban with Jean de Gastines, will be the first satellite museum of the Pompidou Centre when it is completed at the end of 2008. Located in eastern France close to Germany, Belgium and Luxembourg, Metz will offer the region a vital new cultural centre focusing on areas of modern and contemporary visual art. The centre will provide access to an outstanding collection with international scope from the Musée National d'Art Moderne, Paris, and will house a theatre for viewing performances and films, conference area multipurpose studio, a documentation centre for modern and contemporary art, bookshop, restaurant and a café.

Ban's team won an international competition launched in March 2003. From a pool of 157 applications the jury selected Ban with de Gastines and Gumuchdjian along with five other finalists: Foreign Office Architects (FOA); Herzog & de Meuron; Stéphane Maupin and Pascal Cribier; NOX Architekten; and Dominique Perrault.

Ban studied at the Southern California Institute of Architecture and later at Cooper Union's School of Architecture before starting his own practice in Tokyo in 1985. He is particularly known for his innovative paper tube structures, which have been used in temporary housing in Kobe, Japan (1995), Turkey (1999) and India (2001), following devastating earthquakes in each of these areas. His use of paper and other materials like wood and bamboo is always in concert with structure to create an integrated building system specific to each context and programme. It is not an application of just the newest materials but a system in which the

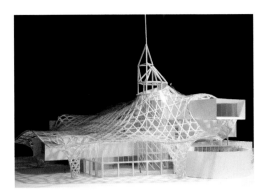
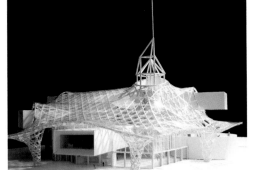
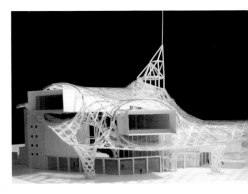

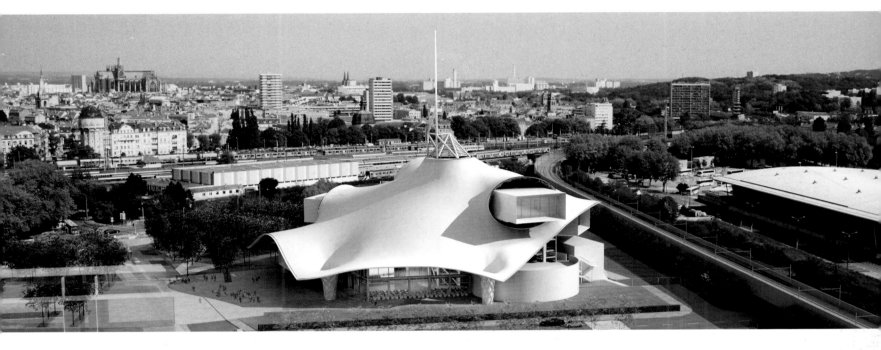

expression of a concept is the most vital. This can be the need to find the least expensive and most expedient form of temporary shelter, as in the Paper Log Houses, or to translate regional craft forms such as bentwood techniques into a roof for a day-care centre.

This way of thinking pervaded the winning team's scheme, which is distinctive for the enormous lattice roof that forms a public plaza and city centre. This hexagonal umbrella of woven, laminated timber – inspired by a Chinese woven-bamboo hat – incorporates a translucent membrane made out of PTFE that will cover the entire complex, offering both shade and protection from inclement weather while making a direct visual connection with the outdoors.

The roof has been a recurring theme in Ban's architecture over the past decade, and he has

The museum in an urban context
(computer simulation)

Site plan, view axes

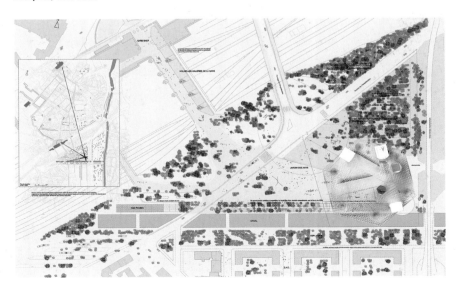

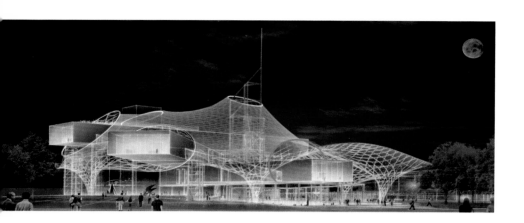

Energy budget study,
summer and winter

Sectional view: forum –
exhibition rooms, south façade

used a variety of materials such as wood, paper tubes, and bamboo to create dramatic roof structures that cover such diverse functions as a lumberyard, childcare centre and sculpture garden, sports hall (fig. 4). In traditional Japanese architecture the roof is considered the most expressive and important element of a building. Proportion, curve and texture define its beauty and reveal the architect's sensitivity, especially in buildings of monumental size like the Centre Pompidou Metz.

The 10,000-square-metre cultural complex includes 5,000 square metres of exhibition space, all contained under the roof. Three rectangular, cantilevered boxes house parts of the Pompidou Centre's permanent collection in a climate-controlled environment. Each of the 87-metre-long

and 15-metre-wide boxes will be directed, like a box camera, towards a view of one of the city's historic monuments, such as the railway station and the cathedral. These large picture windows will be the only view outside from the galleries, creating more usable and flexible gallery space.

Ban and his team reinforced the important relationship that the centre has with the outdoors by encasing the entire complex with movable glass shutters (cf. figs. 5–7), which can be opened to the new surrounding gardens and park. Circulation between these indoor and outdoor spaces is very fluid, creating a harmonious relationship with the centre's parkland environment.

Metz will be Shigeru Ban's fourth project in France in collaboration with Jean de Gastines.

He has completed a museum and boathouse for the Institut du Canal de Bourgogne, in Pouilly-en-Auxois, and social housing in Mulhouse. His third project is his own office in Paris (figs. 1–3). In order to maintain a minimum overhead and close proximity to the Centre Pompidou he received permission to locate his office on the rooftop of the parent museum. With a structural framework of paper tubes, Ban created a long, continuous tubular space that houses workspace, conference room, model workshop, reception and rest areas. In many ways it relates to all of the other functional elements on the exterior of the building, including the distinctively coloured technical ducting and the escalators.

The design for Centre Pompidou Metz exactly fulfils and disseminates the same mission

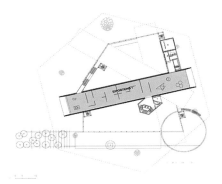
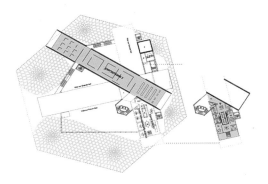
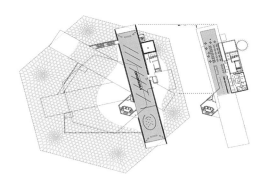

Competition plans: exhibition gallery 1, exhibition gallery 2 and administration, exhibition gallery 3 and restaurant

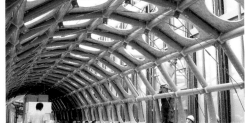
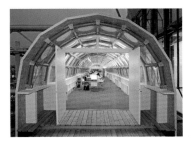

Figs. 1–3: Ban's provisional 'Paper Temporary Studio' on the Centre Georges Pompidou, Paris

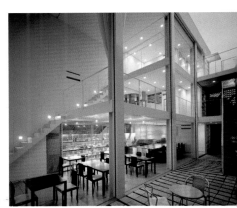

Fig. 1: Shigeru Ban Architects, Atsushi Imai Memorial Gymnasium, Odate, Akita, Japan, 2001–02: interior view

Figs. 5–7: Shigeru Ban Architects, 'Glass Shutter House', closed, open, and restaurant, Tokyo, Japan, 2001–03

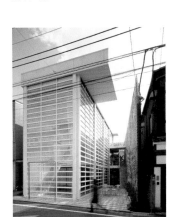
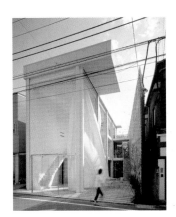

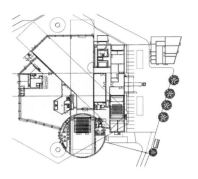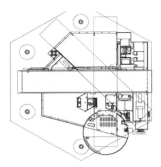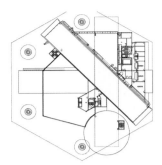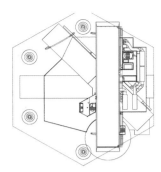

Ground plan: ground floor, exhibition galleries 1, 2, 3

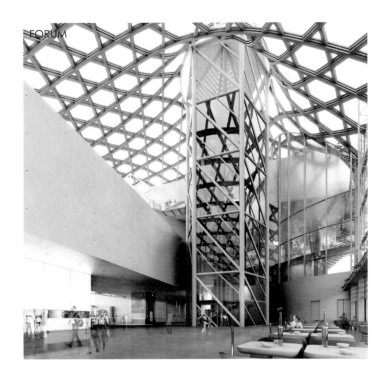

FORUM

Interior view of the forum (computer simulation)

and ideas that made the Centre Pompidou in Paris the most important cultural institution of its time when it was built in the 1970s. The winning team of Renzo Piano and Richard Rogers envisioned a centre that would not only service art-museum visitors, but also tourists and locals, giving them a dynamic meeting place where activities would overlap in flexible spaces. As Piano and Rogers described it, the Centre Pompidou was to be "a people's centre, a university of the street, reflecting the constantly changing needs of the users".

More and more, cultural institutions have become the means of revitalising cities. New architectural landmarks housing art and other cultural activities are a city's monument and proof of its prosperity. When the Centre Pompidou Metz opens in 2009, it will not only make an important art collection accessible to a much larger audience but will repeat the pioneering achievement of its parent institution in Paris when it opened almost thirty years ago – creating an international destination that embodies civic and cultural pride.

Matilda McQuaid

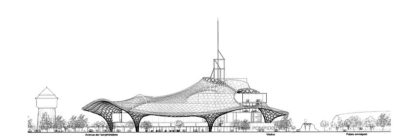

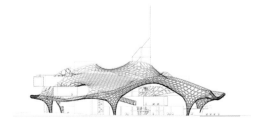

South and west façade

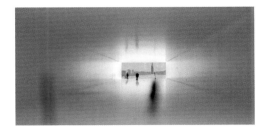
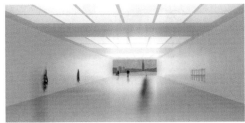
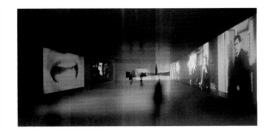

Ambience in the exhibition galleries

Energy budget and light protection study

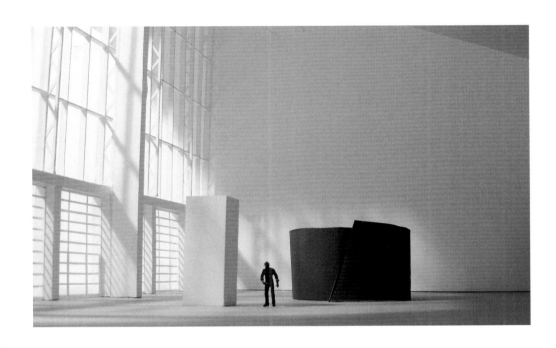

Working model, great exhibition nave

Entrance area (computer simulation)

Art Museum Buildings in Australia:
A Narrative of Incremental Achievement

Leon Paroissien

Melbourne, capital of the south-eastern state of Victoria, has a series of public art collections and exhibition galleries along its north-south axis. The most significant of these is the state art museum – the National Gallery of Victoria (NGV) – with its outstandingly rich collections.

The NGV has long been a symbol of Melbourne's cultural aspirations and an institutional inspiration to other states. With major funding from the 1904 bequest of businessman Alfred Felton, and the assistance of advising representatives in London, the NGV assembled a significant collection of European art in the 20th century. The state's pride in its art museum is reflected in its being the only state gallery to refuse to surrender its claim to being 'national' after the Australian colonies federated.

The NGV has now divided its collections and exhibitions between two sites astride the 'cultural spine' of the inner city. The NGV's 1968 building reopened in December 2003 as NGV International (fig. 1) after a major refurbishment designed by Italian Mario Bellini in association with the Melbourne firm Métier3. Meanwhile, NGV Australia – a major new cultural centre designed by Lab Architecture Studio in association with Melbourne architects Bates Smart – had already opened on Federation Square in 2001 to mark the centenary of the Federation of Australian States (fig. 2).

In recent years, three smaller art museums or exhibition galleries have been built along the same north-south axis of Melbourne: the Australian Centre for Contemporary Art (2002) (see pp. 62–67); the RMIT University Gallery, in Storey Hall, (1995), designed by Ashton Raggatt McDougall; and the University of Melbourne's

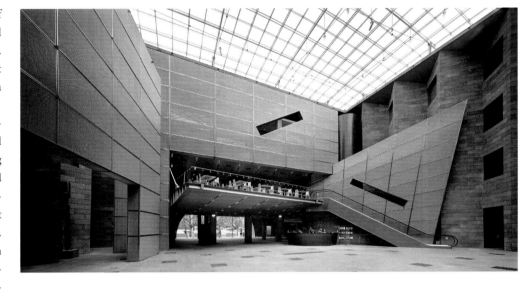

Ian Potter Museum of Art (1998), designed by Nonda Katsalidis.

During the last three decades, Australia has witnessed an unprecedented development in the visual arts: all major art museums collect contemporary art (including Indigenous art); there has been an incremental growth in the number of commercial galleries; and Australian artists, including many Indigenous artists, are represented in exhibitions and collections throughout the world.

This development has emerged from a long history of visual artists – Australian-born and immigrant – having contributed to the country's cultural life. Artists were historically prominent among advocates of the development of museums – and supplied all the early art museum directors from among their ranks.

After British colonisation of Australia began in 1788, societies for the arts and sciences were

Fig. 1: Mario Bellini in cooperation with Métier3, National Gallery of Victoria (NGV International), Melbourne, Australia, renovation, 1996–2003: foyer

established remarkably early. Successive gold rushes in the second half of the 19th century brought upsurges in wealth and stimulated spurts of immigration. Substantial libraries and museums appeared, reflecting new-found prosperity and growing civic pride.

The federation of the Australian colonies in 1901 might have sparked a cultural quickening in the early 20th century but for the disproportionate commitment of a small population to two World Wars and the ravaging effects of the intervening world depression. It was therefore nearly two centuries after European settlement before an Australian cultural building – Sydney Opera House – would attract widespread international attention for its concentrated ambition and groundbreaking design.[1]

In 1968, when the relocated NGV opened its doors, it was Australia's first purpose-built art museum to house an established collection. Canberra, the nation's capital, did not see the opening of the long-planned National Gallery of Australia until 1982. Meanwhile, the similarly long-envisaged National Museum of Australia opened as recently as 2001.

Roy Grounds (1905–81), designer of the NGV's 1968 building, was a Melbourne architect highly respected for his earlier modernist domestic buildings. The resulting, highly defined, 'medieval modernist' rectangular building, with

Fig. 2: Lab Architecture Studio in cooperation with Bates Smart, Federation Square (NGV Australia), Melbourne, Australia, 1997–2001: exterior view (left: National Gallery of Victoria, right: Australian Centre for the Moving Image)

forbidding high walls concealing three internal courtyards, was reminiscent of Grounds's various inward-looking houses of the 1950s. The dark basalt façade, the Boullée-like central arch springing directly from the pavement, a rippling 'water-wall' beyond the arch dissembling views of the foyer, together with the extensive use of timber in exhibition areas all reflected Grounds's highly eclectic interpretation of modernism.

A generation later, the refurbished building has maintained an interconnection with distinctive features of Grounds's 1960s design, while radically expanding institutional facilities. Bellini's rectilinear glass-and-steel forms are juxtaposed against original Grounds features – such as the zigzag of bluestone walls in the former courtyards. The multiple internal axes created by Bellini's redesign have established very different dynamics within the severe rectangularity of Grounds's original volumes. Bellini's interventions opted for a drama of contrasts (in forms and materials) within the now much more intensively utilised site.

At the parallel NGV site across the Yarra River, a single ambitious enclosure – the roofing of a wide cluster of railway tracks – created a 3.6-hectare area for the construction of Federation Square that is not only a new contemporary focal point of the city but also a vibrant site for popular outdoor performances, restaurants, book and music stores, a national broadcaster for television and radio, as well as housing the Australian Centre for the Moving Image (ACMI).

The new NGV Australia building has provided the state gallery with a further 14,000 square metres in area, including 7,250 square metres of exhibition space. Selections from the historical and contemporary collections of Australian art include a significantly accentuated range of work by Indigenous (Aboriginal and Torres Strait Islander) artists. A temporary exhibition gallery at this site also complements permanent collection galleries. The NGV uniquely now has two major dedicated spaces for special art exhibitions – one at each of its museum sites.

Turning from Melbourne to the regions: in 1950, there were only seven regional or city art museums in all Australia – mostly in Victoria. Stimulated by later population surges and competition between states and cities, civic pride and the rise of tourism, the development of further art museums spread north along east-coast states: to New South Wales in the 1970s and to Queensland in the 1980s and 1990s.[2] In Australia there are now some 200 public art museums and exhibition galleries – in addition to the six state galleries, the Museum and Art Gallery of the Northern Territory and the National Gallery of Australia.

Substantial private collections have been rare in Australia's history. However, in recent years this situation has begun to change markedly. In December 2003, Australia's first small art museum initiated and endowed wholly by private funding opened in the vineyards of the Yarra Valley, 60 km from Melbourne (fig. 3, see also fig. 1, p. 63). Collectors Eva and Marc Besen established a not-for-profit company, donated a site of exceptional beauty and funded the construction and ongoing costs of the TarraWarra Museum of Art, which was designed by Melbourne architect Allan Powell. They also donated a selection of works from their personal collection of Australian art that spans the last 50 years.[3]

Sydney – Australia's oldest and largest city – has traced an entirely different path in the development of its state art museum: the Art Gallery of New South Wales. Unlike Melbourne and other state capitals such as Adelaide, Perth or Hobart, the possibility of a combined library, museum and art gallery was early rejected in Sydney in favour of an independent art museum.

State Government Architect Walter Vernon designed the earliest surviving building of the Art Gallery of New South Wales. It was erected in stages between 1897 and 1909, but the distractions of wars and the Depression ensured that the gallery remained incomplete until 1969.[4]

The bicentenary of the exploration of the east coast of Australia by Captain James Cook in 1770 prompted the first of a series of significant extensions to the Art Gallery of New South Wales over several decades.

Andrew Andersons was a young architect in the Government Architect's Branch in Sydney when he designed the first modern extension to Sydney's state art museum – the Captain Cook wing – in the late 1960s. In doing so, Andersons recalled Louis Kahn's Yale University Art Gallery, with its committed use of exposed concrete construction, strong formal geometry and considered connection to the original Beaux-Arts building. During his time at Yale, Andersons had visited the studios of Josef Albers and Alexander Calder, taken an art history course by Vincent Scully, and had explored museums and art galleries in New York.[5]

The resulting renovations and extensions to the Sydney state gallery were decisively contemporary in form and materials. However, the new building also utilised sandstone on the exterior

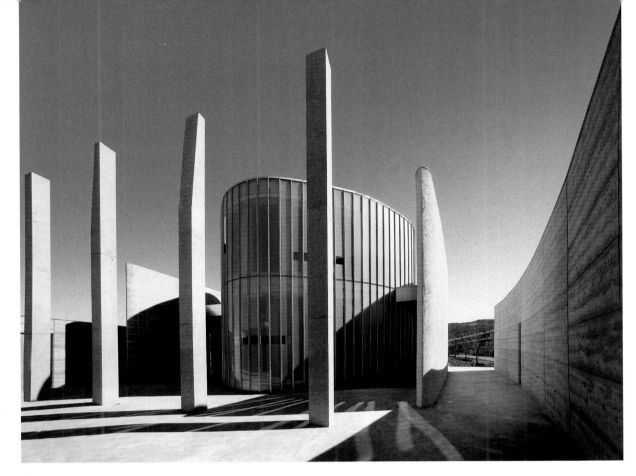

Fig. 3: Allan Powell, TarraWarra Museum of Art, Healesville, Victoria, Australia, 2000–03: inner courtyard and museum entrance

and travertine marble on the floors, creating an active dialogue with the classical formality and historic materials of the original building completed at the beginning of the 20th century.

The subsequent bicentennial commemoration of the 1788 settlement of Australia occasioned further extensions to the Art Gallery of New South Wales. Andrew Andersons was again the architect. Among subsequent additions and changes to the Art Gallery of New South Wales in the 1990s, Andersons designed the Yiribana Gallery for Indigenous Australian art, together with an auditorium (completed 1994). The most recent additions to the state gallery (opened 2004) were new galleries for Asian art – in a glazed pavilion format (like an illuminated lantern at night) – designed by Richard Johnson of Johnson Pilton Walker.

Such an incremental growth of a single art museum complex contrasts with the stand-alone buildings achieved in recent decades in Perth (1979), Brisbane (1982) and the National Gallery in Canberra (1982). Improving a museum in stages – as funding becomes available – has become the most typical model of development for Australian museums, enabling them also to

adapt to changing needs. Such a 'staggered progression' has had the great advantage not only of conserving heritage buildings that might rashly have been torn down as fashionable standards changed but also of displaying art of earlier periods in the conserved architectural contexts to which they originally related.

Andersons, who (ironically) has never been commissioned to design a new, free-standing museum building, is currently working on a specific commission for design improvements and extensions to the National Gallery of Australia in Canberra. Andersons's other commissions have included a major extension to the Art Gallery of South Australia in Adelaide; extensions to the Ballarat Fine Art Gallery, and to the Museum of Modern Art at Heide (both in Victoria); the Queen Victoria Museum and Gallery in Launceston, Tasmania; the Penrith Regional Gallery, New South Wales; and the Queensland University of Technology Art Museum, Brisbane.

One of Andrew Andersons's greatest challenges – and perhaps one of which he may be most proud – is the conversion of an imposing but stratified seven-storey state government office building diagonally opposite Sydney Opera

House into the Museum of Contemporary Art (MCA).[6] The opening of the MCA in 1991 finally gave Australia its first major museum for modern or contemporary art – envisioned in an audacious bequest of expatriate artist John Wardell Power written in 1939, but not received by the University of Sydney until 1961 (fig. 4).

The state Queensland Art Gallery (QAG, Brisbane) has a distinctly different history from those already covered: an institution with a collection assembled much later and with fewer resources historically, and which has opted more recently for development of a two-site solution to its current need for more space. The QAG was established in 1895. From its inception it was – like Sydney's state gallery – a stand-alone art institution rather than following the combined library and museum model. However, it was never satisfactorily housed, and occupied a sequence of temporary premises until it opened dramatically in its first permanent – grandly scaled – building in 1982.

Like the National Gallery of Victoria, the QAG was built as part of a late 20th-century Cultural Centre complex, on the south bank of the Brisbane River. The architect of the 1982

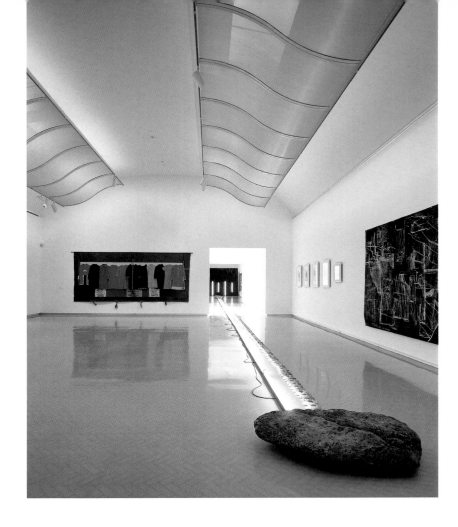

building was Brisbane-based Robin Gibson. The geometry of this first building, and its location within a complex of other cultural buildings, led eventually to the need for an entirely new building to assist in housing the expanding collection of about 11,000 works and an enlarged programme of temporary exhibitions.

Like other Australian state galleries, the QAG had already begun to collect Asian art when, in 1993, it decided to make a bold move in focusing positively on the Asia-Pacific region. The gallery initiated the Asia-Pacific Triennial of Contemporary Art, the success of which during subsequent years gave the institution a new national position of distinctiveness, and has undoubtedly influenced the gallery's decision to specialise in modern and contemporary Australian and international art – with special emphasis on Indigenous arts of Australia and contemporary Asian and Pacific art.

In the 1990s, an additional riverside site 200 metres upstream from the original building was selected for a new Queensland Gallery of Modern Art (GOMA).[7] The 14,000-square-metre building (with 5,000 square metres of exhibition space) has been designed by the Sydney-based firm Architectus, in association with Brisbane architects Davenport Campbell (fig. 5). Still under construction, the building will be a third larger than the original building. The new gallery is due to open in late 2006 and will include two cinemas, educational, research and multimedia facilities, and lecture theatres.

The public spaces of the earlier building in Brisbane were inward-facing – an understandable 1980s response to museum conservation needs, especially in the subtropical climate of Brisbane – and its language was late international modernism. In many respects the new building looks afresh at traditional Queensland buildings of earlier periods, with their pitched rooves, wide verandahs, overhanging eaves and fluid interchange between inside and outside activities. For decades in the late 20th century, Queensland buildings were driven by fashionable pressures to emulate buildings designed for more temperate climates elsewhere. This has changed dramatically, and some of the most innovative design in

Fig. 5: Architectus, Queensland Gallery of Modern Art, Brisbane, Australia, 2004–06

Australia is to be found in the tropical north of the country.

It is clear that Australian museums, when they have the opportunity to create new facilities for their collections and programmes, now have a greatly enriched pool of expertise to draw upon. They have relevant, highly-tuned technical knowledge of design and museological possibilities at their disposal, and the courage to identify and collaborate – as proactive clients – with the most resourceful and innovative designers of our time.

1 Although not open until 1973, the Sydney Opera House designs by Jörn Utzon date from a 1959 competition.
2 For an outline of the development of art museums in Australia's regions (other than state galleries), see Pamela Bell, 'Regional Galleries in Australia', in: *Art and Australia*, vol. 39, no. 3, 2002, pp. 390–403.
3 Maudie Palmer and Bryony Marks (eds.), *TarraWarra Museum of Art*, Healesville, Australia, TarraWarra Museum of Art, 2005
4 Steven Miller 'History of the Art Gallery of New South Wales', www.artgallery.nsw.gov.au
5 Author's interviews with Andrew Andersons, August 2005.
6 The writer was Founding Director of the Museum of Contemporary Art and effectively the client for the building's refurbishment.
7 Queensland Gallery of Modern Art Architect Competition, Brisbane, Queensland Art Gallery, 2002

Wood / Marsh Pty Ltd Architecture

ACCA, Australian Centre for Contemporary Art
Melbourne, Victoria, Australia

Client: Arts Victoria
Design: 1996
Construction: 2001–2002
Budget: AUS $11 million

**Aerial view of the museum in
an urban context**

Site plan

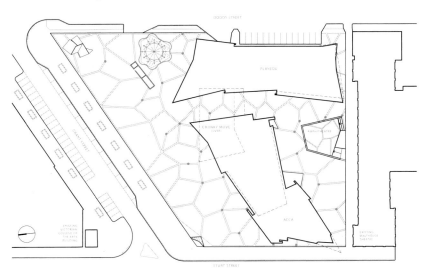

Australian Centre for Contemporary Art (ACCA) does not have a collection. It exists to provide public access to contemporary art, much of which fights to free itself from 'the system' of the market/gallery process that feeds collections. Such contemporary art in Melbourne has found its way into the public imaginary through a nesting of site-specific installations and events, artist-run spaces, government-supported artist-run spaces, and then ACCA. In the 1980s and early 1990s, the institution was housed in a cottage in the Domain, a park near the Botanical Gardens. Often, this Arcadian setting added a surreal quality to the experience of looking at works that had often emerged from the grittier parts of cities. In its industrial shed, the Temporary Contemporary in Los Angeles seemed to be so much closer to what emerging work needed. When (after ACCA was completed) a director, a site, finance and a collector came into alignment, Allan Powell's TarraWarra Museum of Art (2004) opened in the vineyards to the east of Melbourne, showing how the collection imperative could be satisfied (fig. 1, see also fig. 3, p. 59).

For ACCA, resolution was more complex, the knot of immediacy and current artistic ambition being impossible to untie into a reflective space. In the early 1990s, Director Jenepher Duncan worked to find a more appropriate location for ACCA: a property boom was underway and the committee assessed many proposals for locating the gallery in the foyers of giant commercial projects. Art added value by attracting tenants and by allowing developers to increase the bulk of their projects through a cultural contribution to the public realm. The tensions between these potential partners were even more problematic

than those of the earlier period, and none of the projects we examined made any sense for a venue committed to supporting experimental art.

Much delicate negotiation by the director and supporters in the Ministry for the Arts eventually focused on a site next to a theatrical complex badly in need of additional facilities; a site that was of no interest to developers because it sat over the entrance to a new freeway tunnel and could not support a commercially viable density of development. Capital budgets were pulled together for a theatre workshop, for ACCA and for a base for the contemporary dance company 'Chunky Move', and eventually a shortlist was formed: Ashton Raggat McDougal (ARM), Norman Day, Denton Corker Marshall (DCM), Edmond and Corrigan, Allan Powell, and Wood Marsh. All the submitted schemes were inventive, but only the Wood Marsh scheme adhered

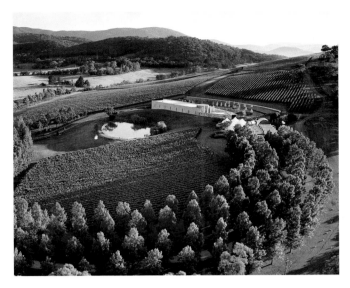

Fig. 1: Allan Powell, TarraWarra Museum of Art, Healesville, Victoria, Australia, 2000–03

Main entrance with courtyard

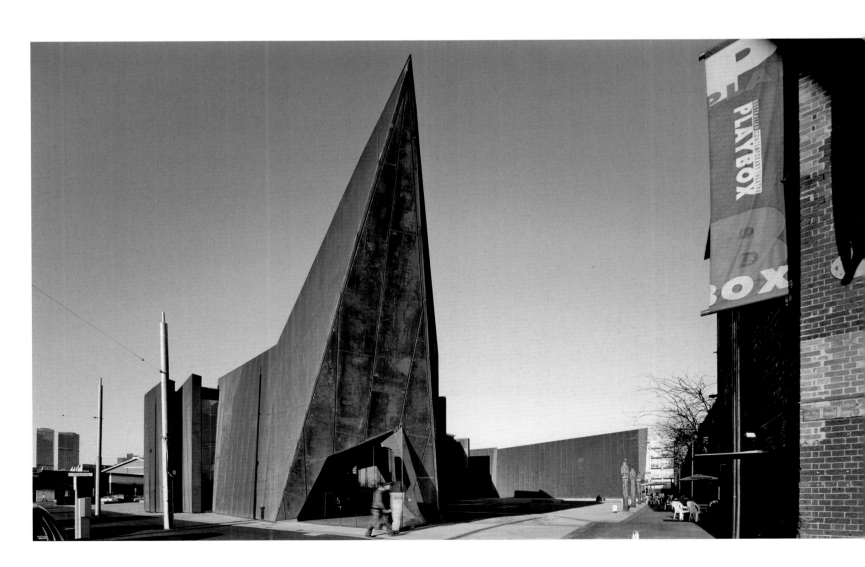

63 **Wood/Marsh**

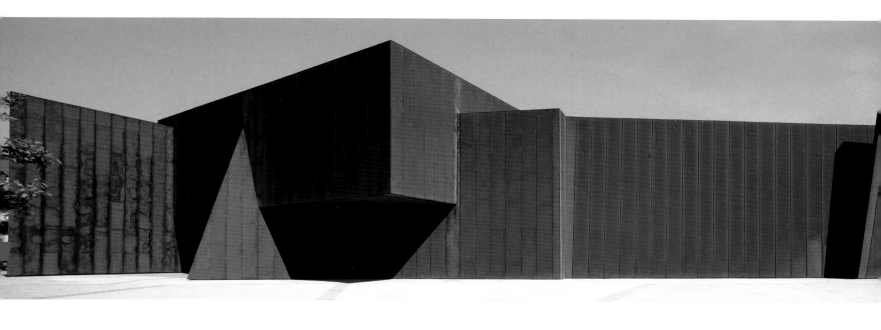

View from the north

Typical façade section details

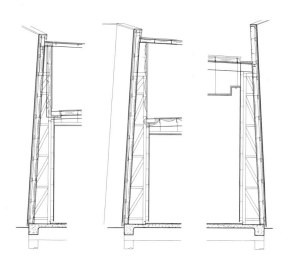

comprehensively to the principles laid out in the brief: that the building be a machine for exhibiting in, capable of supporting any manner of installation or event in one large hall and three smaller halls that could be used enfilade or as chambers off each other; that the entrance and the foyer not divide the gallery into two lobes of space; that the theatre workshop be separate from ACCA and adjacent to the service zone of the theatre complex; that Chunky Move have its own separate entry and that the new complex create a tight urban space for the use of theatre-goers and those attending exhibition openings.

The various parts of the complex have fulfilled their functions well, though certain aspects of the original concept have not been taken advantage of by the current directors. The theatre workshop is a daily drama in its own right, but there is a tendency to screen it from public view. The administrative needs of Chunky Move have been extended by its success, and the lounge area designed for informal interaction between artists has been colonised for offices. The overflow opening from the foyer of ACCA into the hard court has not been exploited, and exhibition openings are intensely crushed events confined to the interior of the building. But this may be what the mainly young and single attendees enjoy about these events. Nevertheless, the courtyard has hosted memorable open-air performances and is one of the city's most compelling spaces.

Despite misgivings by artists about the design of the galleries, many fearing that the design (in particular the metal expansion joints in the floors and the negative skirting) would overwhelm their works, the spatial configuration has been an outstanding success. ACCA'S current Artistic Director Juliana Engberg has been able to find a distinctive expression in every exhibition, such that no two appear to have been in the same space.

But a gallery has other functions in a city, replacing for many the functions of buildings of congregation from former ages; churches, palaces and cinemas. How do the urban protagonists of today relate to the gallery? For the young and the old who live in the inner city, this is a room in which to meet others at a regular social event – the opening. It is also a place for contemplation, intimate communication and the chance encounters that bars and public transport do not afford. The traditional protagonists are here: collectors cruising the shows looking for the next trend; artists looking for the next edge; and against the great red walls of the exterior that remind some of the great red rock at the heart of Australia (Uluru), those intimidated by what is inside or excluded from it by circumstance, scrawling their names in a rising tide of marks on

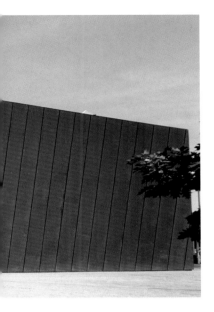

Façade cladding panel layouts

Courtyard

Façade detail

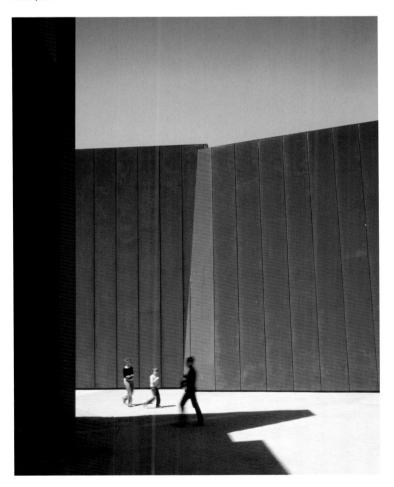

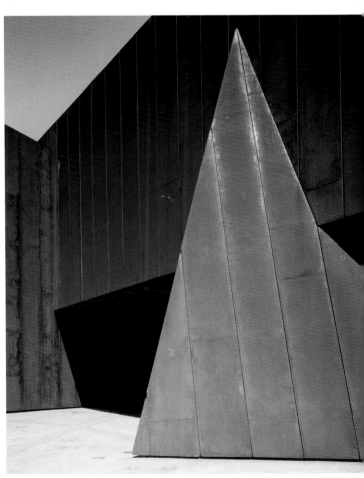

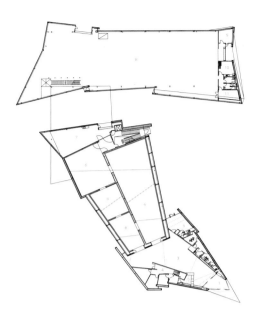
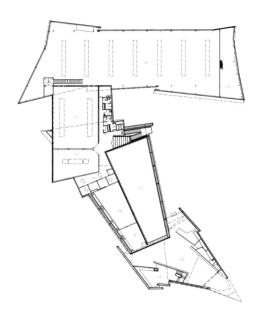

Ground plans:
ground floor and 1st floor

Interior view of the lobby

the rust. This causes an unnecessary anxiety among officials for graffiti on Corten slowly cancels itself out. The building thus both serves and registers the city's radical intentions for art and performance.

Buildings exist in the city and in the oeuvre of their creators simultaneously. And for these architects, this design, now 12 years old, marks a stage in their careers. In 1999, I wrote: "At their best, Wood Marsh assert that the knowledge base of architecture lies in our primal relationships with the physical world: colour, sound, touch, dance and play. They have, in that sense of fun, in the way in which they put us back in touch with the joy of the physical, the power to be both popular and profound." ACCA has this power. The interior is completely malleable to directorial intent, perhaps even extending directorial imagination. The intense material oneness of the exterior evokes much that is Australian in experience, and yet at the same time that oneness opens the building to scalar shifts, so that in some views and some lights it is an urban object – massy and extensive – while at other times you feel that you could put it in your pocket – fondling it like a talisman.

Leon van Schaik

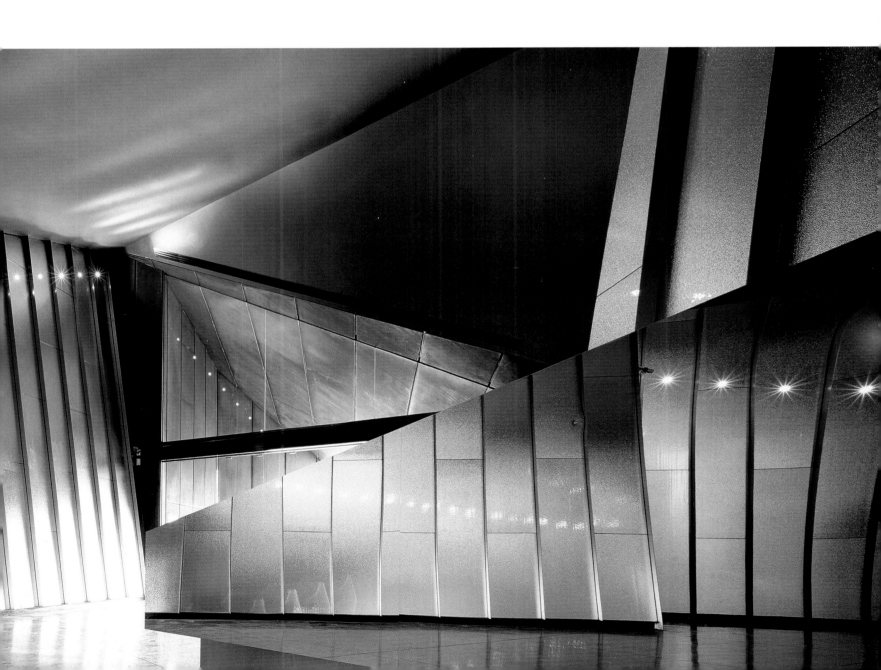

Denton Corker Marshall Pty Ltd

Stonehenge Visitor Centre and Interpretive Museum
Wiltshire, UK

Client:	English Heritage
Design:	2001
Construction:	2005 – 2007
Budget:	£20 million

Fig. 1: Stonehenge, Wiltshire, UK

Comparative scales

View from river (computer simulation)

Architecture, qua landscape

Stonehenge rises dramatically out of the windswept Salisbury Plain. Mystery veils its origins and religious purpose. The region is reputedly threaded with ley lines of powerful electromagnetic energy, making the chalk flatland of Wiltshire a charged setting for a sacred monument. Built in stages over more than a millennium (2750–1500 BC), the ancient circle of stones is understood to chart the heavens and track the movements of the sun. People from near and far would gather here for religious rituals and especially to observe the spectacular rising of the sun on the solstice. The means by which Neolithic communities transported the monoliths to the site from distant places, dressed and planted them precisely in the earth, and then raised and positioned the lintels can only be surmised.

Stonehenge is indivisible from its landscape. The stones stand out from the undulating plain against the sky, the circle gathering up the open terrain for miles around. Any structure in its vicinity would compromise the elemental power of this World Heritage Site.

With this in mind, the selectors for an architect to design a new visitor centre and interpretive museum sought a landscape-led response. In 2001, English Heritage held an ideas competition, won by the Australian firm Denton Corker Marshall. The short list included Michael Hopkins (UK), MDVRD (Netherlands) and Studio Granda (Iceland). A factor that excited the judges' attention was Barrie Marshall's own house at Port Phillip Bay in Victoria, a building seemingly submerged in the landscape.

Site plan

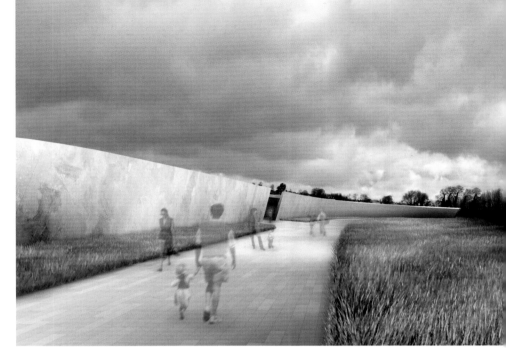

**Approach from car park
(computer simulation)**

The architects were invited to explain their approach to the site. Barrie Marshall's initial sketch is a plan view of Stonehenge in its broad landscape setting, with the visitor centre – located three kilometres from the monument – shown as a series of lines scored into the earth.

The scored lines suggest both the formal and programmatic ordering of the visitor centre. Superficially, it appears not as a building but a series of massive grey walls: pure landscape form without any visible sign of 'building'. Formally, the building is a sequence of shallow, curved linear volumes buried in the ground and covered with grass. The programme is distributed among the linear volumes, which read as layers (both physical and temporal) that visitors penetrate progressively before reaching the transit point to be transported by light rail to Kings Barrow Ridge, from where they walk the remaining 1.5 kilometres to the stones. The first layer of the building, behind walls five metres high (the only architectural representation that is offered to view), is the covered entry courtyard and foyer. Then there are the orientation gallery, café,

assembly areas, ticketing, shops and toilets. Then exhibition gallery and theatrettes and, finally, the light rail station, where visitors assemble to be taken to the major exhibit of this museum, Stonehenge itself.

Throughout the design, Denton Corker Marshall use counterpoint and poetic evocation to establish the new building as an opposite that serves to reinforce and safeguard the singularity of the ancient monument. They play an oppositional game. Stonehenge rises out of Salisbury Plain, and one is always aware of its being above the horizon, silhouetted against the sky. The visitor centre is below the horizon, and the lines of building are perceived not as structure but rather as elements in the landscape.

Stonehenge, at some 1,000 square metres, is considerably smaller than the visitor centre of 5,000 square metres. By burying the building, the architects avoid the potential problem of compromising the time-honoured heroic scale and image of the monument in the landscape. (An existing visitor car park and access road are to be removed and the landscape restored.)

Initial conceptual sketch by Barrie Marshall, 2001

THE TALLEST TRILITHONS 7.9 M 4.7 M THE VISITOR CENTRE ENTRY WALL

Comparative scales

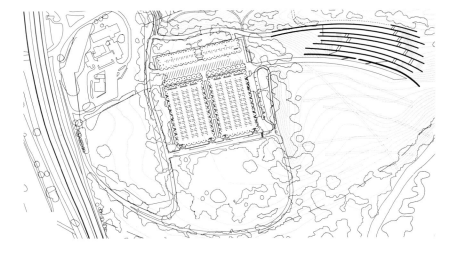

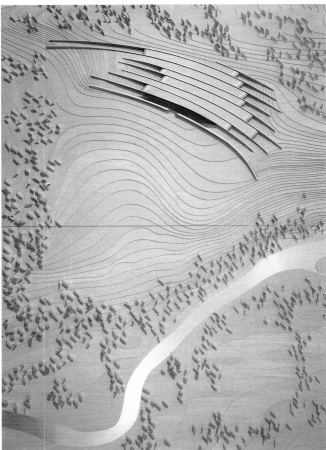

Site plan

Final design model, 2002

The history of architectural form until modern times was understood through two different tectonics: mass/wall, and trabeation/post and beam. Stonehenge is an archetypal trabeation structure. The architects make the building the opposite of trabeation: it is wall.

Stonehenge is a circle: a centralised enclosing space. For the visitor centre, the architects establish an oppositional spatial figure, a series of curving walls open at each end: striated space escaping to infinity.

Stonehenge is manifestly constructed from stone: sarsen megaliths (grey sandstone from Marlborough) and bluestones (brought from Wales). The visitor centre is made from metal: matt galvanised steel. Stones are hewn, which speaks of their monolithic and material nature. The walls of the visitor centre clearly are fabricated: all the nuts and bolts are revealed. You know the walls to be thin and pieced together. The metal (like stone) acquires the patina of time, becoming dull leaden in colour. This op-

position suggests a poetic of age, but one that is in contrast with stone: it's new, modern technology, the opposite of ancient Neolithic construction techniques.

Standing within the circle of stones, one is aware of the open sky overhead. Perhaps with a degree of surprise, visitors arrive to find themselves entering a building that is buried beneath Salisbury Plain. Once inside, they are aware that earth covers the roof. However, this is not felt as an oppressive weight. Nor is the spatial experience dark or cavernous. The long curving walls are lit from above by ribbons of daylight (concealed skylights run the length of both sides of each wall). The walls do not support the ceiling but disappear upwards into these bands of light, while the ceiling apparently floats. Visitors are simultaneously aware that they are beneath the earth as well as beneath the sky.

The difficult task confronting the architects was how to make a very large and functionally complex building legible to the great number of

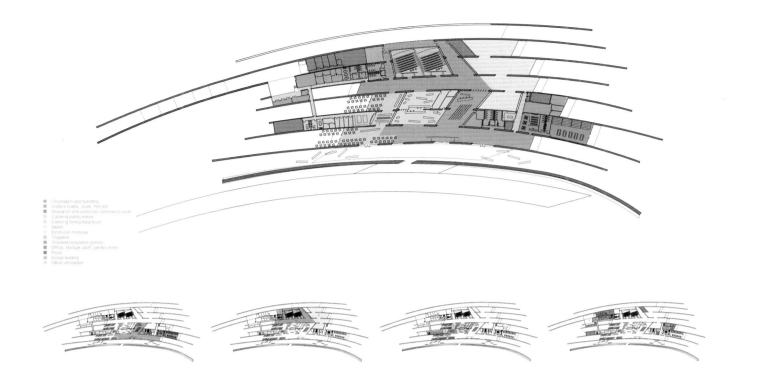

- Circulation and ticketing
- Visitors toilets, cloak, first aid
- Research and corporate community suite
- Catering public areas
- Catering food preparation
- Retail
- Exhibition modules
- Theatres
- Ticketed circulation gallery
- Office, storage, staff, garden store
- Plant
- Group waiting
- Other circulation

Ground plan, programme

Aerial view (computer simulation)

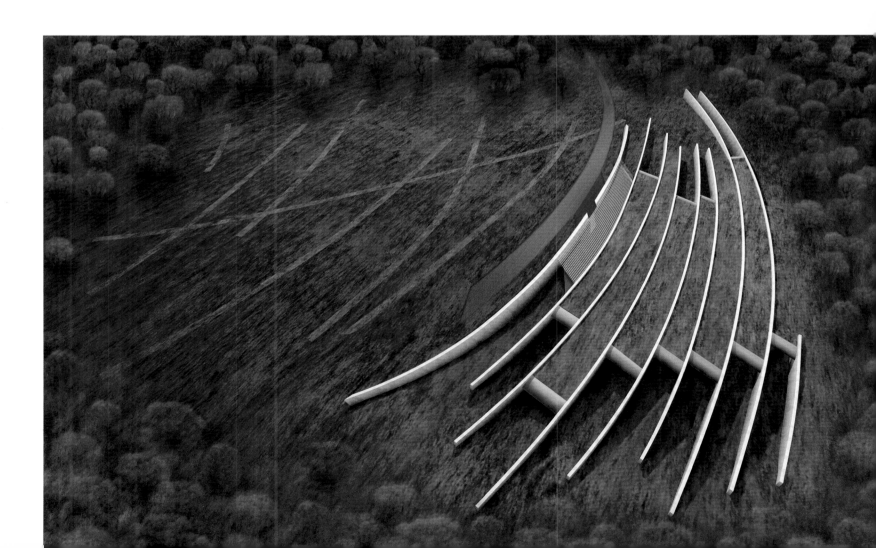

people who visit Stonehenge. Denton Corker Marshall's notable skill is in translating the most complex of programmes into a simple and highly legible parti that drives architectural form-making. Other comparable works are the Melbourne Museum and the Australian embassies in Beijing and Tokyo.

What sets the visitor centre apart from nearly every other building of its type (and is astonishing given the contemporary reliance placed on architecture to provide outstanding identity branding to cultural institutions and public places) is that it is almost not a building. The architecture is subsumed by the landscape. The architects chose to make a building that is so self-effacing, so much part of the landscape of the windswept plain it is lodged in, that all that prevails in the memory's eye is the image of the ancient stone circle standing out on the plain.

Haig Beck and Jackie Cooper

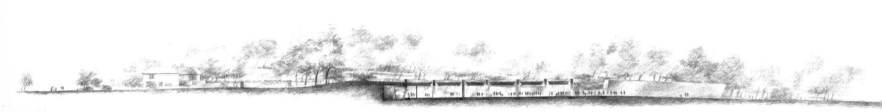

Sketch: cross-section

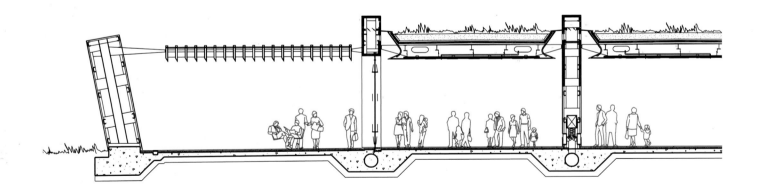

Sectional views: detailed section and cross-sections

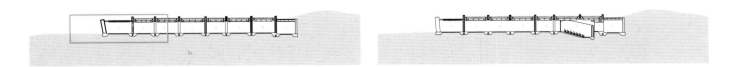

Sketch: entry courtyard

Exhibition room (computer simulation)

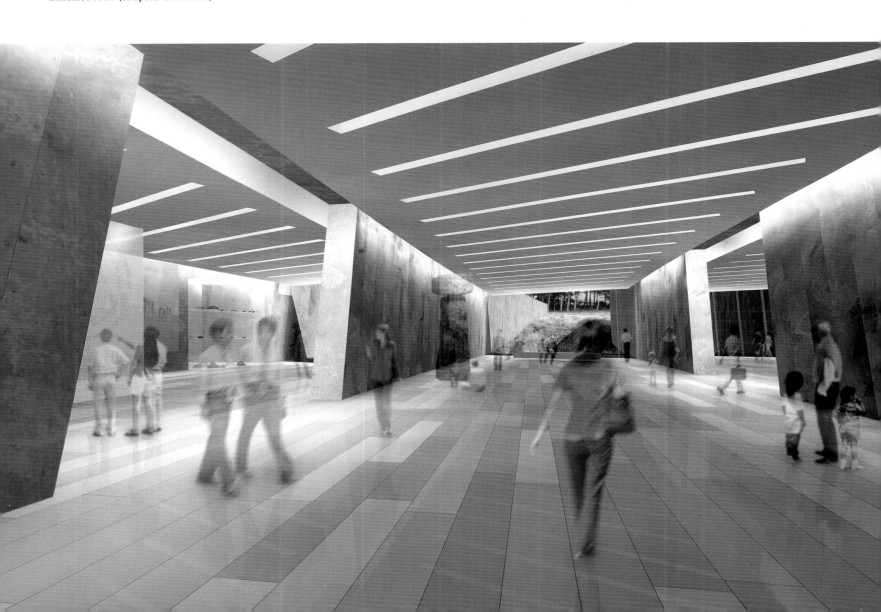

The Perils of Variety:
New European Museum Buildings

Gottfried Knapp

The Guggenheim Museum in Bilbao has played a critical role in the recent history of museum building (see fig. 1, p. 9). It is no exaggeration to say the development of contemporary museum architecture can be divided into pre- and post-Bilbao eras. Ever since the sensational success of Frank O. Gehry's showpiece with the public, all museum projects – in America even more so that in Europe – have been measured against this benchmark. In some competitions, as for example for the MAXXI in Rome, where Zaha Hadid carried the day as if it were a matter of course, the showpiece effect was one of the few conditions to be formulated in precise terms. Yet the unique variety of recent museum buildings in Europe is due less to a sudden readiness to experiment with style than to the wealth of new tasks museums are nowadays called on to cater for.

Among 14 new-build projects in Europe that are looked at here, only five have the job of housing existing art collections. And even these differ from each other so markedly that any typological similarity is improbable even externally. Most closely continuing the traditional programme of museum buildings of the 1970s and '80s are the Pinakothek in Munich and the Centre Pompidou's outreach facility in Metz. In Munich, Stephan Braunfels, starting from Schinkel's Altes Museum and its central rotunda (see fig. 3, p. 12), has created a cool modern building with great spatial values appropriate to the requirements of the four collections inside. Rarely have the opportunities offered by indirect toplighting been better exploited than in the rooms for the pictures of classic modernism on the upper floor of the Pinakothek der Moderne. But as contemporary art prefers architecturally undefined, manipulable spaces and very often requires dark rooms, the luminous, spatial quality of Braunfels's architecture is in many places just a stab in the dark. On the ground floor, the architect created a series of side-lit daylight rooms for temporary exhibitions of the four institutes, but even here exhibition designers tend more and more frequently to bring their own hermetic installations with them. Germany's favourite art museum thus has to deal with a conflict that goes back not to its architecture but to its difficult gestation: large, neutral rooms for major temporary exhibitions such as contemporary art needs are due to be built only in the second phase of construction, which has now been shelved indefinitely. A building that is perfect for permanent collections therefore has to act as an events hall for art, which is sometimes possible only with great effort.

In the case of the Centre Pompidou in Metz, Shigeru Ban and co's winning team took their client's need to accommodate experimental activities into account by devising a structure based on a frame that stands on novel, braided structural supports, with a huge, translucent synthetic membrane drawn over it. Thrust across the immense space beneath the glass-fibre sail-vault are elongated rectangular boxes at various heights, each 87 metres long and 15 metres wide. These serve as exhibition galleries of various kinds, and at the ends offer a view of the sights of the city across the new surrounding park. The architects have packed the other functions into the airspace beneath and between so as to leave lots of room for public experiences. The new branch of the Paris museum will no doubt make its mark less as a receptacle for an important art collection than as an events centre. But that is what makes the new Pompidou the ideal successor to the popular Parisian steel shelving by Piano & Rogers, which has likewise proved its worth as a marketplace of the arts.

Athens: the new Acropolis Museum. Even if the Greeks fail to reunite the famous sculptural frieze preserved, for the most part, in London with the parts left in situ in Greece, the new museum at the foot of the Acropolis that is due to house the treasure is nonetheless one of the most logical buildings ever invented for a particular configuration of art works. Bernard Tschumi has the four-storey structure of the museum rising on pylons over the open excavation site. The anticipated crowds of visitors will be shepherded through the exhibition floors and back again with amazing logic: from the entrance floor up a gently rising ramp to the Archaic Art level, then up an escalator to the Parthenon Hall ensconced above. This is a rectangular room, glazed all round, in which the ground plan of the temple is inscribed at original size and with the original orientation. Here, the fragments of the figured frieze removed from the Parthenon will be bathed in exactly the same light as they had on the temple above. Large panoramic windows will enable the pictorial works to communicate most impressively with the architectural structure they are taken from and which will look down on them from above.

For the multi-purpose building of the Paul Klee Centre in Berne, museum functions are of secondary importance. The pictures that artist Paul Klee left in his estate have to be protected from daylight, and can therefore be shown only

in rooms with controlled lighting. Since a documentation centre with research facilities and (at the request of the donor) a multi-functional event centre had to be integrated into the building alongside the exhibition rooms, Renzo Piano had three externally similarly sized but internally quite differently organised hills modelled into the landscape of the Alpine foothills. The artificial undulation in the slope will undoubtedly look good in the architect's CV, but the two rectangular rooms hidden underground can hardly be described as a particularly instructive contribution to the subject of museum building.

How the treatment of old artistic treasures has changed since the days of the first public museum buildings can be demonstrated with the five different art temples on Berlin's Museum Island and the ways each of them was extended when the Prussian art collections were amalgamated. First of all, just a few remarks on the new access to the unique ensemble. Paris was the model. With his glass-roofed, subterranean entrance structure in the cours d'honneur of the Louvre, Ieoh Ming Pei set out very clearly the huge scale involved in making a modern service building practically fit to accommodate the wealth of additional functions performed by a museum of world status. In Berlin, David Chipperfield has designed a similar central entrance and service structure for the museums on the Museum Island. It will house all ancillary functions and channel the crowds of visitors into the new 'archaeological walk' in the basement, which, like Pei's distribution node beneath the Louvre, connects the museum buildings so as to enable the breathless circuit that so many tourists want. The tour of the stylistically very divergent museums,

whose extensions only reinforce the differences between them, thus becomes an architectural safari of a compactness that is rarely to be found.

Three of the visually striking museum buildings in this book – easily identified as typical exercises in style by their creators – can be looked at briefly within this framework. In Rovereto, Mario Botta clustered the various functions of the ambitious new MART exhibition building with his usual panache around a large circular courtyard, thereby cleverly creating order in what was previously a shabby rear courtyard, but the spatial and technical ideas that occurred to him for presenting works of art are a long way behind the aesthetic impression given by the external wrapping.

In the wonderful picturesque old town of Graz, the metallically gleaming bubble of the Kunsthaus hanging over the river is considered a tourist attraction, but as an exhibition building the 'friendly alien' of Peter Cook and Colin Fournier (Spacelab) is tricky to handle with its walls and ceilings rounded on every side and the great obstacle of the travelator in the middle.

Exhibition organisers will be equally at a loss to cope with Zaha Hadid's huge futuristic sculpture for the MAXXI in Rome. The sturdy superimposed and interwoven architectural strips, which are reminiscent of the architect's industrial buildings, produce fantastic cross-views and depth perspectives. Pictorial works of normal size have no chance of holding their own against a dramatic setting of this kind. Even if Hadid encloses the exhibition objects in conventional rectangular rooms, the spectacle of the architecture dominates everything that goes on, down to the remotest corner.

In respect of the architectural proposition that art museums used to be, the post-Bilbao design escapades of architects have thrown up few interesting answers. It is in other kinds of museum that promising new perspectives have been opened up. Of course, how Coop Himmelb(l)au's huge sculptural fantasy structure on the tongue of land between the Rhône and Saône in Lyons – it forms a grandiose architectural reception for the public space it has taken over – turns out in practice as an exhibition machine for the visually unpropitious subjects of science and ethics can be decided only after the building hemmed in by motorways and railways actually comes into use.

The new ethnology museum on the banks of the Seine in Paris, in the shadow of the Eiffel Tower, can count on the enthusiasm of visitors right from the start. Jean Nouvel has filled the 200-metre empty space on Quai Branly, as with the Fondation Cartier on Boulevard Raspail, with a tall glass wall. Behind it a luxuriant park conjures up the landscapes of the cultures presented in the museum. Nouvel's museum building floats over this evocative green space. But the magic of the exotic powerfully permeates the interior as well. The tour through the highly individually-lit and equipped departments becomes an expedition through a wide range of different landscapes, climate zones and existential situations of the world. As a model, Nouvel obviously took the newly-designed Musée d'Histoire Naturelle, where the exhibits of evolution are invested with a magic aura in the semi-darkness. Only on the roof terrace of his building does he allow visitors out of the cocoon of dramatic exoticism into the stunning panorama of the

urban landscape of Paris beneath the looming presence of the Eiffel Tower.

The planned Museum of Hellenic History in Asia Minor in Athens now being taken forward by the architectural group Anamorphosis could turn out to be a model for the future – or an antidote. In their avant-garde building, the Greek architects intend to deploy successive, evocative, large-scale spaces and different building materials to attune visitors to an intense experience of the different eras being presented. Historical supporting exhibits such as those taken for granted in other history museums are to be totally banned from their building. The subject matter is to be put across solely by electronic media. That sounds courageous, not to say risky, but that modern spaces can evoke something as intangible as history cannot be doubted.

The spatial warp through the past proposed by Anamorphosis has been marvellously brought to visual reality in the Mercedes-Benz Museum in Stuttgart. The historic trail through the museum becomes a highway, a racetrack on which visitors circle in great style through the history of the oldest car factory in the world. Ben van Berkel and Caroline Bos of UN Studio have so interwoven an itinerary in constant, gentle undulation through three loops starting from a joint central hall that visitors can transit the whole building from top to bottom in a single circuit swinging this way and that. Frank Lloyd Wright's spiral in the New York Guggenheim Museum thus finds itself in a sophisticated embrace with its two siblings.

That leaves the two archaeological museums. Architecturally, they are models of reticence, nestling in the historic landscapes and attempting to use judiciously planted effects to enhance the message of what can sometimes be most unspectacular terrain. In the landscape park at Kalkriese, near Osnabrück, Annette Gigon and Mike Guyer placed the museum functions in a sober, rust-red steel block standing on stilts on the presumed site of the Battle of Teutoburg Forest in AD 9, though the site itself offers very few indications of a past military event. Visitors get a view of the battlefield and the presumed positions of the Romans and the Germanic tribes from a 40-metre-high steel tower. Apart from this structure and three small didactic pavilions, the educational value of the museums lies exclusively in the open terrain. On the historically contaminated woodland and marshy soil, sparingly distributed materials indicate the movement of the opposing military forces.

Similarly, the Australian architects of the new visitor centre at the world-famous historic site of Stonehenge, in England, Denton Corker Marshall, opted for steel as the material for their additional structures. Here, too, the ground around the memorial remains largely untouched. The visitor centre keeps well away from the henge, being conspicuously sunk into the ground nearly two miles away. Visitors coming from the car park initially see a curved steel wall. Behind this, further steel walls build up as layers in time. Having passed through them, visitors enter the rooms of the new museum, which are recessed into the hillside and form, as it were, the gateway to the past, because at the rear exit to the museum a train awaits to take them to the edge of the archaeological site and confront with them prehistory.

To sum up this brief overview of museum buildings in recent years in terms of a common denominator, one might say that in the case of art museums the formal and functional opportunities they offer seem to have been largely exhausted. In the case of technical, historical and archaeological museums, however, some fine new avenues of exploration have been opened up.

Mario Botta with Giulio Andreolli

MART, Museo di Arte Moderna e Contemporanea di Trento e Rovereto
Rovereto, Italy

Client:	City of Rovereto, Autonomous Province of Trento, Italy
Design:	1988/92–1993
Construction:	1996–2002
Budget:	no data

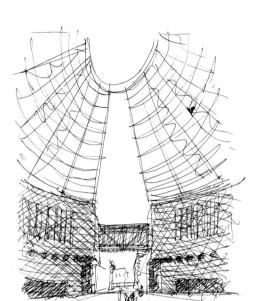

Drawing, inner courtyard, 1989/1993

Lane leading from Corso Bettini to the museum

Given the inherent ambiguity of the commission, museums are undoubtedly among the most formidable tasks architects may face. They are public institutions and as such tend to give rise to the sense of unease so well described by Quatremère de Quincy in 1815. In the *Considérations Morales sur la Destination des Ouvrages de l'Art*, he lamented the "multiple destin" that befell them: "….ôtages en France d'un récent vandalisme, trophées en Italie de la nouvelle gloire de Bonaparte et, partout, de la reclusion dans des collections, cabinet, museum…." Where in works of art deprived of "*charme*" one can perceive a foreshadowing of the notion of "aura" put forward by Benjamin to indicate the genetic relationship between the production and consumption of artistic objects. Or, as Proust once dreamed, that the works of Carpaccio and Titian now in the Louvre could be returned to Venice, their "*cadre naturel*". And kept in isolation "*sous vitrine*" – to use Barthes's phrase – and arbitrarily juxtaposed, they would confer a cacophonous intonation on the space they occupy. To Paul Valéry (backed up by J. K. Huysmans), museums were virtually "*maisons de l'incohérence*" that organised "*désordre*". Yet it was Benjamin himself who pointed out that perfecting the technical means of reproduction (photography, film) reveals the foundation in the ritual of the unique value of the authentic artistic object and its own ritual function. Producing multiple copies therefore emancipated it from a parasitic existence within the environment of the ritual, dissolving its auratic and fetishistic character within the limits of a mere consistency of display. Gianni Vattimo perceives a "sudden variation" of a similar pattern with the arrival of mass culture in late-industrial and

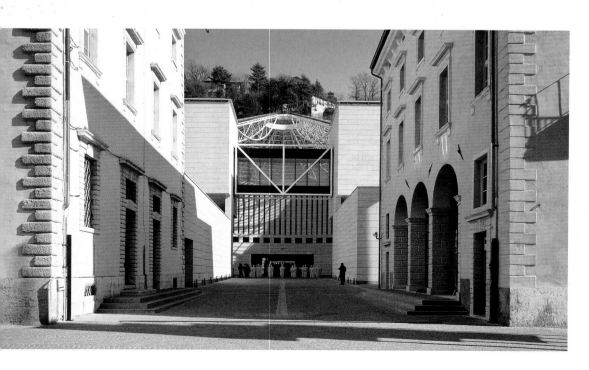

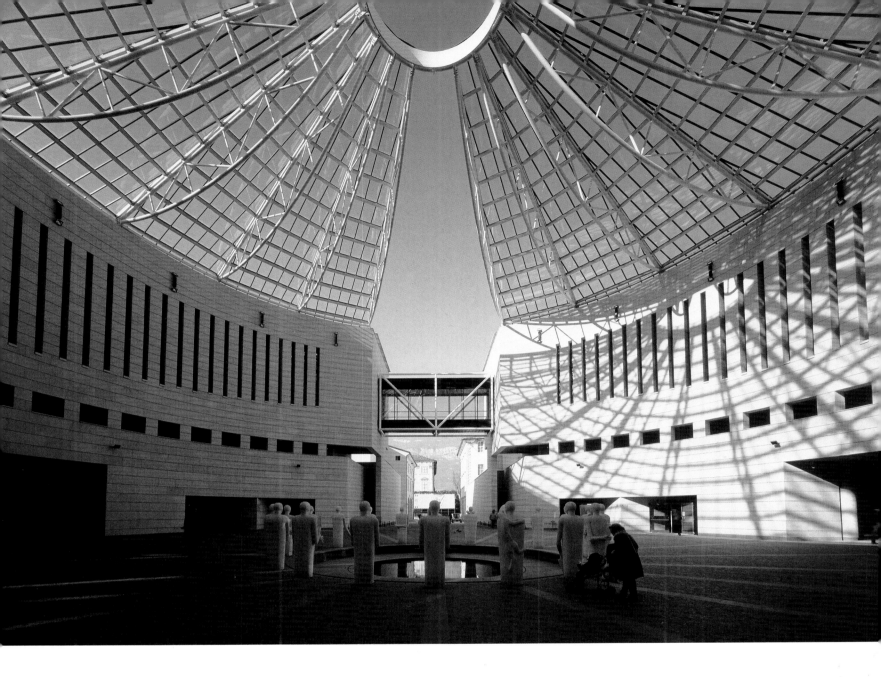

Inner courtyard with Mimmo Paladino's
Pietre group of figures (1998)

Photomontage of the museum in an
urban context

Sketches, 1989–93

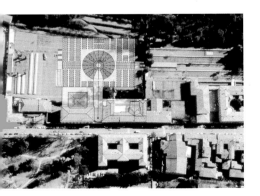

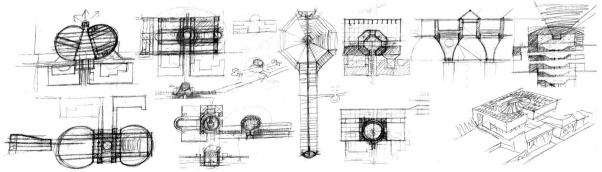

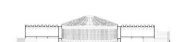

Longitudinal section

Cross-section

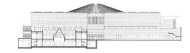

Ground plans:
ground floor, 1st floor, 2nd floor

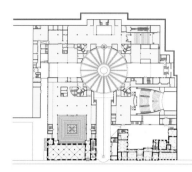

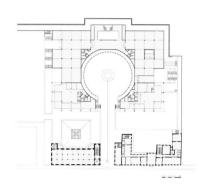

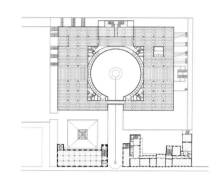

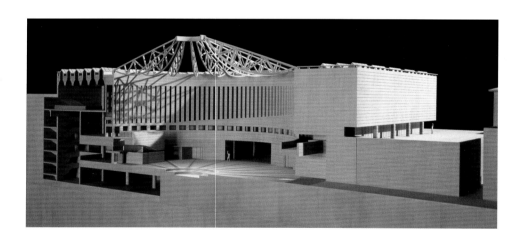

Model, 1997

post-industrial societies. Attaching the reproduction of works of art to the capillary system of their diffusion via the media rekindles a nostalgia for their authenticity and uniqueness, thus re-establishing their cultural value and, at the same time, legitimising the attractive function of museum structures or large exhibitions.

I doubt that Mario Botta is any less aware of such a process than he is of the risks that its conclusions imply, should that authenticity or uniqueness become true in an event of language, form and style that the museum structure

detaches from any reference to the contexts that have produced it, isolating it as a mere presence that just happens to be attractive. I would like to relate some observations recalling Max Frisch that Botta records in a page of his book *Quasi un diario*, an enlightening "autobiography of the spirit". Swiss writers Frisch and Dürrenmatt are to Botta irreplaceable "*maîtres à penser*". In fact, the architect dedicated to Dürrenmatt's memory a magical museum centre in the Vallon de l'Ermitage near Neuchâtel, an overt tribute "to that clear mind that monitored the follies of techno-

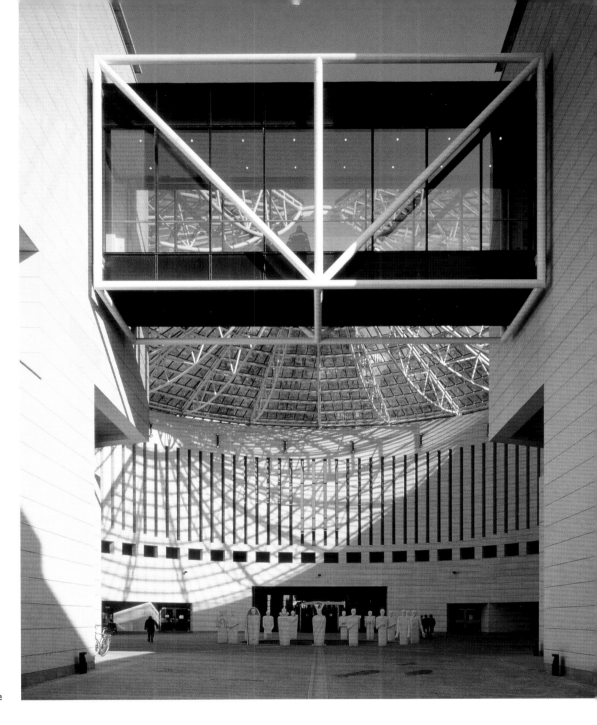

Glazed flying bridge

logical progress". And here, recalling his last meeting with Frisch, Botta dwells on one of the "somewhat naïve" questions that he was asked. "What is post-modernism?", asked Frisch, to which Botta replied: "It is a virus, a de-generation. The true problems of architecture are not tied to fashion. Post-modernists have confused the need for history with style." Earlier on, he had insisted on the "humanistic and social aspects of architecture intended as a mirror of the world, a formal expression of history in its ethical and aesthetic tension". This attitude merits much at-

tention because it represents a vital key to understanding the poetry of Botta, even in his dealings with the subject of museums, and goes beyond the dimension of a futile polemic about form. In fact, Botta has no doubt whatsoever that architecture, inspired by the theoretical programs of the modernist movement, "has been a terrible catastrophe or, to say the least, a lesson that we had better forget". But that rejection of the heritage of the past on principle, that mythical attribution to industry of a capacity for indefinite progress which architecture and town planning

would have been able to interpret and represent, was devastating. Equally illusory appears to be the conviction that the crisis can be overcome through an indiscriminate and eclectic revival of the past styles, based on the misleading supposition that it may favour a wider freedom of composition, a new richness in ornament. Loos decreed long ago that "ornament is a crime". And, even worse than illusory, the conviction is, in its etymological sense, de-generating, particularly when it postulates the "double code" hypothesised by Jenks, that is, the attribution of two

levels of communication to architectural space, one the preserve of an élite capable of understanding its own sovereign values, the other accessible to the general public. I believe that what arouses Botta's indignation above all is the arrogance deriving from such dissociation, which found depressing demonstration in the vacuous fake hedonism that the programmatic manifesto of the strada novissima turned into at the 1980 Biennale. I am, moreover, convinced that he is even more irritated by the implicit loss of any faith in the future revealed by substituting an interminable, complacent neutral flirting with styles for the awareness of history, or easy aesthetics for the rigour of ethics.

It is significant that, having agreed to design MART for the town of Rovereto, Botta worried less about (or did not raise on his appointment) the problem of the explicit functions that his architectural work would be called on to perform than the problem of the relationship that his organisation of space would have to establish with the image of history and memory embedded in the urban texture around Corso Bettini, when it came to inserting an unexpected substitute function into a place with a strong, highly-stratified historic presence. Botta's main concern is, in short, to avoid making his structure autonomous and thereby alien to the city. Its purpose is not so much to focus attention on the attractiveness of the authentic artistic object as to organise the social perception of it within the prior existence of a context. Hence, therefore, the moving of the museum away from the Palazzo Alberti and Palazzo Annona, and the entrance avenue wedged between these leading to the circular piazza, a public space for collective meetings, which highlights the variable scale of the viewing routes and the exhibition galleries lit by the neutral purity of toplighting – where the decontextualised works of art "redeem themselves and acquire significance", to use Sergio Bettini's words, in their solitariness, "in merely allowing themselves to be looked at".

Lionello Puppi

Exhibition room with *Trento Ellipse* (2000) by Richard Long

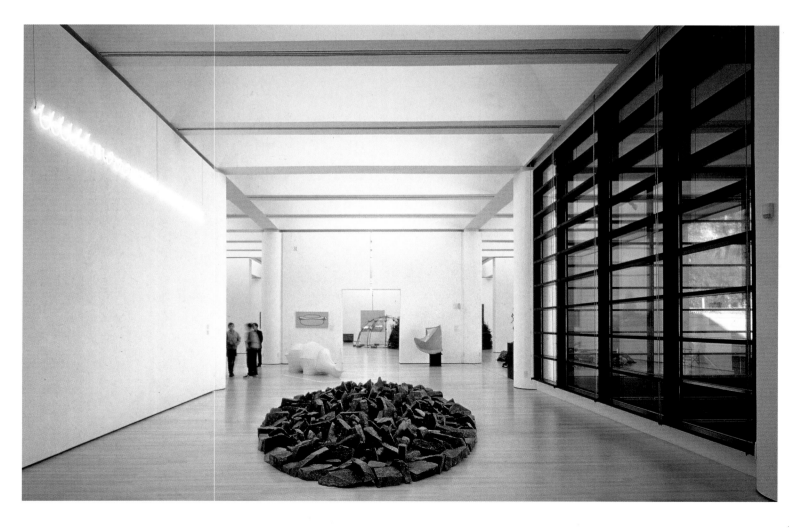

Interior views

Stephan Braunfels Architects

Pinakothek der Moderne
Munich, Germany

Client:	State of Bavaria
Design:	1992
Construction:	1996–2002
Budget:	130 million euros

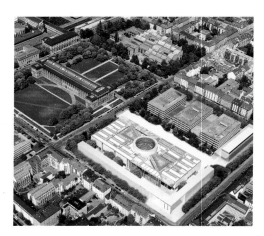 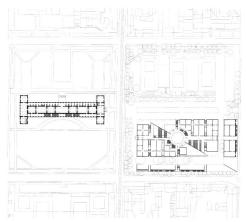

**Aerial view with photomontage of
2nd stage of construction, site plan**

North entrance area

When the state of Bavaria launched an architectural competition in 1992 for a state museum of modern art, it brought to a happy end a long period of official vacillation and indifference towards contemporary arts. The state museums in Munich should actually have found a worthy home for modernism in 1966, with the competition for the Neue Pinakothek, but when it came to planning, all attention was focused on the collection of 19th-century paintings, and so the powers-that-be removed the national gallery of modern art and the drawings collection (Staatliche Graphische Sammlung) from the construction programme and grandiosely installed the administration of the national painting collections in the new building in their place. Modernism, which was still parked provisionally in the Haus der Kunst, the building Hitler had had constructed for anti-modernism, was thus dealt another shabby, put-down blow.

It was, therefore, a major step forward when, in the direct vicinity of the Alte (see fig. 4, p. 12) and Neue Pinakotheks, the Bavarian Minister of Culture raised the prospect of a third public museum building – an institution that, like the Museum of Modern Art in New York, would be devoted to all the fine arts of the 20th century (see pp. 20–25). Along with the Staatsgalerie Moderner Kunst, which donors had generously endowed with masterpieces of 20th-century painting, the Graphische Sammlung, the celebrated Munich design collection known as the Neue Sammlung

**View from the Pinakothek der Moderne
towards the Alte Pinakothek**

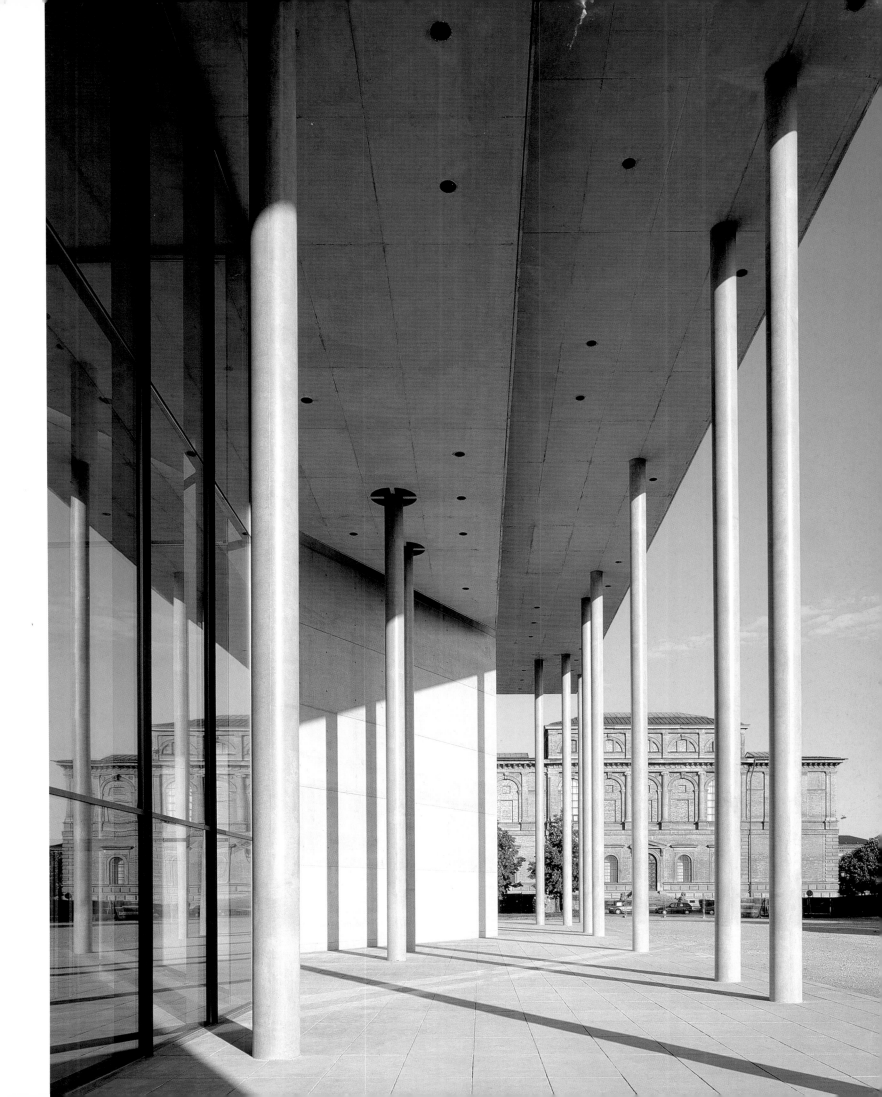

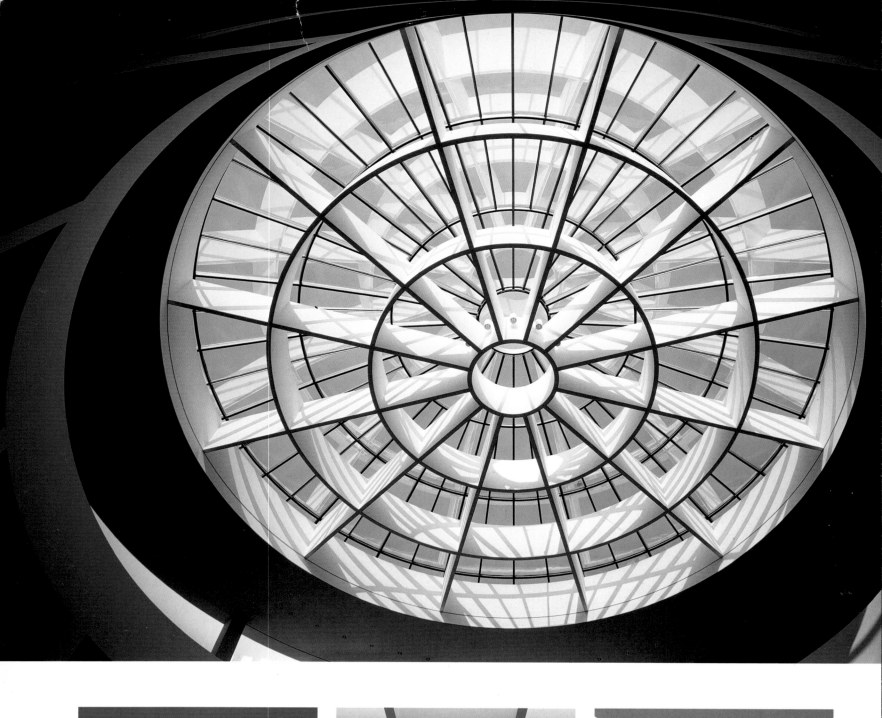

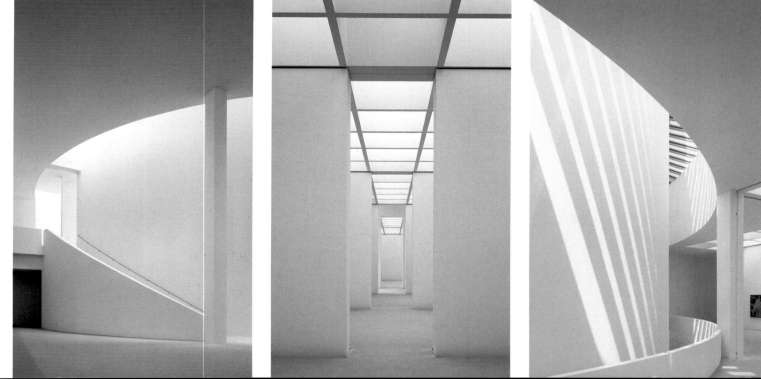

View from the south

Longitudinal section

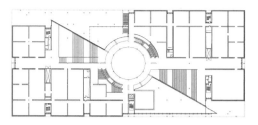

Ground plan: ground floor and upper floor

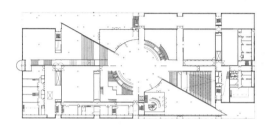

e central rotunda

asement storey,
, gallery on the

and the architectural collection of the Technical University would all find a new home in the new museum.

Unfortunately, initial enthusiasm on the official side did not last long. The construction office so mismanaged the project that in the end the politicians imposed a cost ceiling on the project that would have meant a virtual end to all the dreams. The state wanted to pay 100 million euros for its Museum of Modernism, which was still to provide 20,105 square metres of principal usable floor space and 12,000 square metres of exhibition space. It was only with very extensive private backing that the four-part building, which in the end cost 130 million euros, could be completed.

For the architect Stephan Braunfels, who at the time was based in Munich, the constant delays in the construction were pure torture. He had won the commission outright in competition against international rivals, including Herzog & de Meuron. His closest rival and hardest on his heels was the local firm Hilmer & Sattler, who won second prize. Their scheme had exhibition rooms for the four museums in a long, broad strip like shelves packed beside and over each other, with a huge shared glass lobby in the north. Braunfels won the competition because he was the only one to recognise the double diag-

onal orientation of the third Pinakothek: it is oriented one way towards the city centre, the other way towards the other pinakotheks, that is, the museum district. His design took this into account in the architecture, and indeed made the public footpath through the building the starting point of his whole plan.

A wall thus runs diagonally through the elongated rectangle of the building on all three exhibition floors. It is interrupted in the middle by the huge, inscribed central rotunda, from where broad central axes open up the side wings. The wedge-shaped space carved by the diagonal wall in the north-west remains open outside, but is covered over and can thus act effectively as an entrance hall. With its slender concrete supports, it quickly became a powerful visual emblem of the Pinakothek der Moderne. The geographical counterpart of this pillared portico, the tall triangular space at the south-east end of the diagonal, is glazed in but encloses trees, acting as a winter garden for the museum's catering side.

The wide and astonishingly light rotunda, which rises above both of the above-ground museum levels to make a third floor and is crowned by a large, glazed dome 25 metres in diameter, stirred some art historians and artists into protest because of its monumentality. But anyone who has been to the building at different

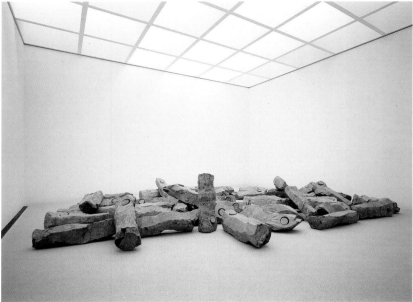

Exhibition rooms, with *The End of the 20th Century* (1983) by Joseph Beuys on the right

times of the day knows how important the rotunda is as a meeting point and generously dimensioned place of orientation for those entering it or wanting to change to another floor.

From the rotunda, the two main staircases lead into the exhibition areas, fanning out considerably as they move away from the rotunda, and the landings and huge walls are ideal for exhibition purposes. Visitors who go upstairs, where the state painting collections of works of classic modernism and contemporary art are on show, arrive at a series of top-lit rooms of differing sizes but standardised form. Braunfels was perfectly successful in concealing the lavish lighting technology and equipment required to adjust the daylight and artificial light behind the framework of the light ceiling. He also found pioneering solutions to air-condition the rooms. Incoming air streams into the rooms unnoticed from narrow conduits and grilles running along the walls below.

On the ground floor, rooms for special exhibitions are located on both sides of the rotunda. They are lit partly by large windows on the north side, partly by artificial light. This is where the graphics collections and architectural collections hold their special exhibitions and the video and photographic media sections are housed. This area is a little cramped because the state competition specified that large rooms for important special exhibitions should be constructed only in the second phase. However, as the government of Bavaria is currently busy building its museum for the Brandhorst Collection, it will be some time before these rooms are built.

On descending from the rotunda into the lower floor, visitors enter a series of unusually-shaped rooms housing one of the most important design collections in the world, the Neue Sammlung. Particularly memorable is the semi-circular space that leads down in concentric steps beneath the rotunda to a platform. One floor further down there are cleverly illuminated galleries that echo the shape of the rotunda like a circular crypt and display the jewellery of the Danner Collection.

From this unique treasure house up to the light-filled, round viewing gallery four floors up, the rotunda punched through the rectangular building demonstrates that it is the real engine that has powered the utilitarian building of the Pinakothek der Moderne far beyond the requirements of function into the realm of architectural art.

Gottfried Knapp

Stairway up to the rotunda

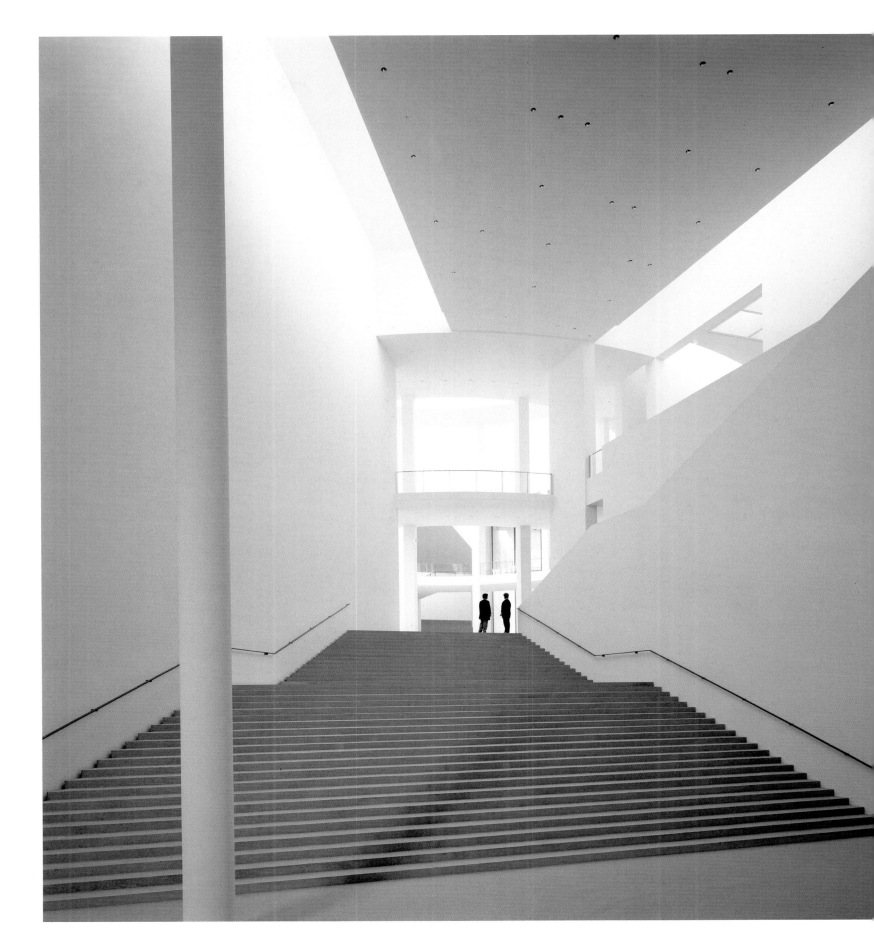

Gigon/Guyer Architects

Varus (Teutoburg) battlefield, Kalkriese Museum and Park Bramsche, near Osnabrück, Germany

Client: Archäologischer Museums-
 park Osnabrücker Land
 gGmbH
Design: July 1998
Construction: 1999–2002
Budget: 14.2 million euros

Fig. 1: Prospected surfaces in the Kalkrieser-Niewedder Depression with Roman finds (as at August 2005)

Fig. 2: Oberesch excavations with trenches and line of the vallum and graves with bones of the dead (as at August 2005)

Wooden paths, steel steps

How can a completely unspectacular site where a battle took place nearly 2,000 years ago become a memorable place? What would the museum have to look like? How would the site be designed?

The museum and landscape park at Kalkriese, around 20 kilometres north of Osnabrück, endeavours to answer these questions. It is the first museum in Europe built on a battlefield that together with its park has found a way to present the place, its history and its archaeological finds by suggestion rather than statement. The answers that architects Annette Gigon and Mike Guyer of architectural firm Gigon/Guyer in Zurich and landscape architects Zulauf Seippel Schweingruber from Baden (Switzerland) came up with consist of making what is now a wholly inconspicuous battlefield into a specific place, using visual symbols and abstract means, while presenting the historical periods as superimposed layers and getting the terrain and archaeology to tell a convincing story.

Recent excavations suggest that the site near Kalkriese is indeed the long-sought place where in AD 9 Publius Quinctilius Varus lost three legions – around 10,000 men – in a battle against the Germanic units of the Cherusci, Bructeri, Marsi and Chatti, led by the Cheruscan leader Arminius. If Varus had not lost around half the Rhine Army, world history would have been different: "The effect of this defeat was that the

Iron stelae marking the course of the Germanic vallum; at the back: time window and museum

frontiers of Roman expansion, which had not stopped at the coast, were set on the banks of the Rhine."[1]

The Oberesch Depression narrows from east to west, and is enclosed by a gentle rise to the south (Kalkriese Hill) and the Great Peat Bog in the north. At its narrowest, it is one kilometre wide. The Romans were trapped in this bottle-neck, and the main battle (or one of them) took place there (fig. 1).[2] On the edge of the slope on the left, the Germans set up a provisional but precisely planned vallum with a breastwork over 400 metres long (fig. 2). The Roman coins found in the period since excavations got under way in 1989 (all minted pre-AD 9) and the military effects, but also, for example, the high phosphate content of the area, all point unambiguously to a battlefield littered with the bones of the victims.[3]

The Kalkriese battlefield site comprises a visitor centre, the museum, three pavilions in the park and interventions in the landscape. Coming from the parking area, the visitor first enters the visitor centre (a farmstead that originally functioned as a museum) with ticket office, museum shop, conference and office rooms and a children's museum. Directly adjacent is an inn and a beer garden. The museum at the entrance to the park catches the eye from a distance. The L-shaped steel skeleton design, using double-T beams clad with massive 18-square-metre, oxidised, mild-steel plates, floats on slender stelae without damaging the historic terrain. The hall-like black box of the single-storey structure contains the 600-square-metre museum and a lecture hall, while on the narrow northern side the 40-metre-high lookout tower gives the sort of overview of the battlefield a commander would have. The museum contains everything worth knowing about the battle, with a critical look at the archaeological evidence, but also casts an eye over the history of the Hermann (Armin) cult. Archaeological finds are also on show, of course.

Armed with this knowledge, the visitor goes on to the battlefield, the 24-hectare landscape park. Iron stelae mark the course of the Germanic vallum, closer together where there is sound archaeological evidence for it, further apart where it is only assumed to have run. On the right there are vistas towards the former peat bog

(now extensive open moorland). A 'time window' sunk into the ground reconstructs 1,600 cubic metres of the vallum to show how it and the vegetation of that time looked at the lower, original level of the ground – uneven, quagmiry terrain with gentle slopes that was difficult to walk on. This section is clearly demarcated by high, rusting bulkheads. Scattered over the site are three monolithic pavilions: the 'seeing' pavilion at the entrance to the park, and the 'hearing' and 'asking' pavilions behind the landscape time window. The purpose of these light-hearted artistic interventions is to hone the eye for the landscape (in the 'seeing' pavilion it is crammed into a spherical lens and turned upside down), sharpen the perception (the 'hearing' pavilion is equipped with a horn-shaped listening trumpet that extends outside) and link the time layers together (the 'asking' pavilion has nine video monitors showing pictures of current theatres of war worldwide).[4]

The trails through the site have a similar strongly associative effect. The route the Roman troops took is picked out by steel plates placed along it like abandoned shields or tombstones. Thirty-eight of the 500 plates carry texts which in some cases visitors pick up from the ground like archaeologists coming across finds. The concealed paths used by the nimble Teutons are marked with wood carvings, later agricultural tracks by pebbles.

Museum and park are held together by steel as a material. Steel creates a sense of continuous

Site plan

The seeing, hearing and asking pavilions

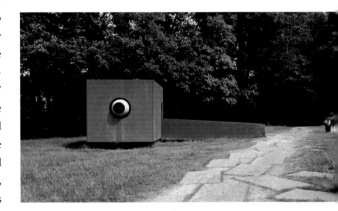

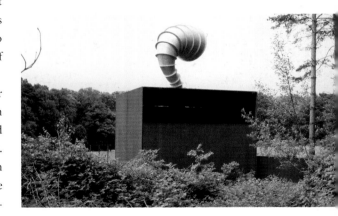

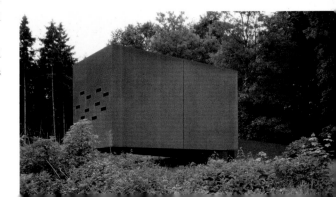

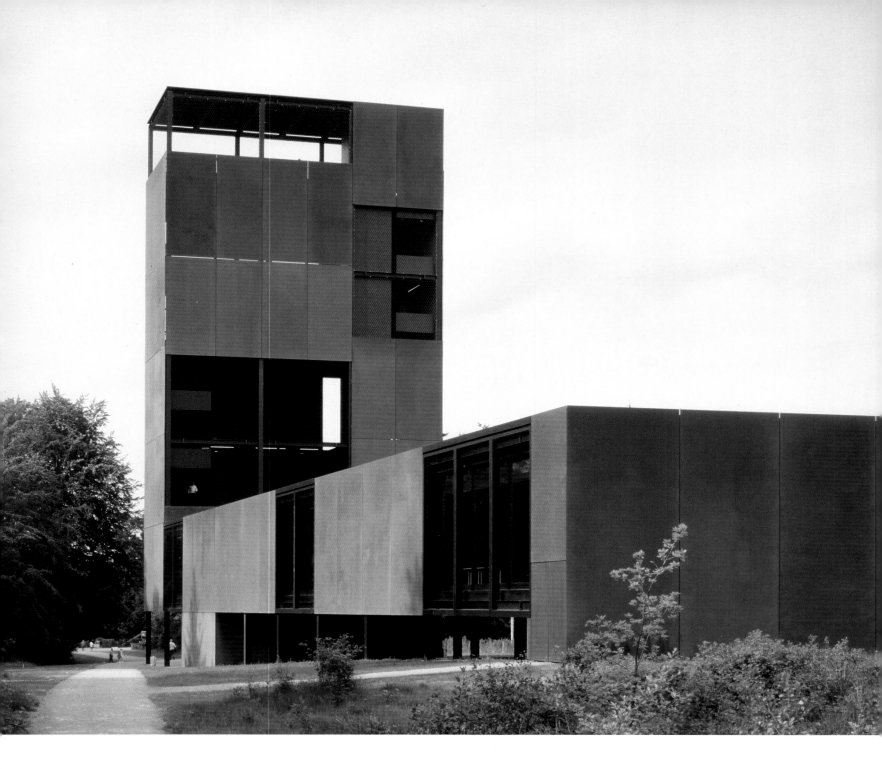

affinity over the whole site "comparable with the role of alliteration or rhyme in poetry",[5] but also acts as a polyvalent symbol. It illustrates the massive military might of the Roman army, makes the modernity of the architectural additions explicitly recognisable and alludes quite generally to the transitoriness of human endeavour.

In the competition for the job, Gigon/Guyer's victory was not that of any old architectural firm outsmarting seven other rivals (who included Schweger + Partner/Hamburg, Koch Panse

Architekten/Hanover and Groupe 6/Grenoble) but the triumph of the vanguard of the new Swiss approach to museums. Even with their very first building, the Kirchner Museum in Davos (1989–92), Gigon/Guyer became a benchmark of current museum architecture not only in Switzerland. The expansion of the Kunstmuseum in Winterthur (1993–95), the renovation and extension of the Oskar Reinhart Collection in the same city (1995–98), the Liner Museum in Appenzell (1996–98) and recently the Albers-

Honegger Donation in Mouans-Sartoux near Cannes (2000–04) reinforced this position with the shrewd choice of materials and a clear, 'minimalist' architectural idiom. At present, they are working on the reconstruction and expansion of the Kunstmuseum in Basel, along with an increasing number of town-planning projects.

The architectural items and the landscaping of the park have created an enhanced field of perception out of the unprepossessing terrain of a battlefield. It is done not by large-scale "pseudo-

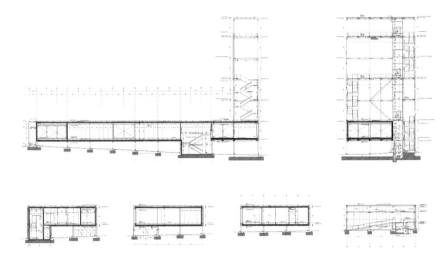

Sectional views: museum, longitudinal section,
cross-sections: viewing tower,
cloakroom, exhibition room, recreation room, ramp

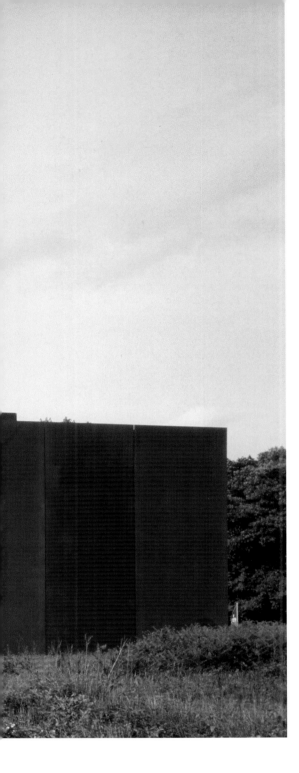

View of the museum from
the north-east

Steel plates: Romans' route of
march

Time window: reconstructed
landscape, 9 AD

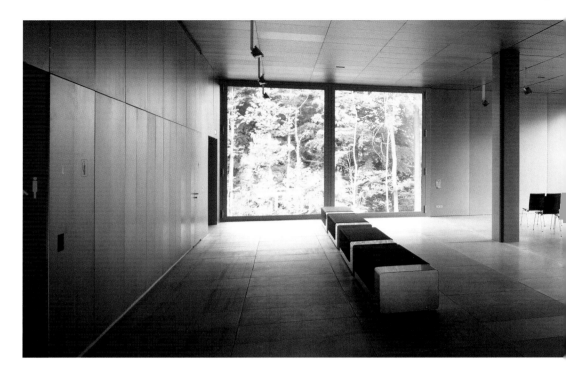

Museum lobby

historical reconstruction but … by abstract visualisation"[6] that creates detachment and imposes a critical attitude. The horizontal elements of the museum building and the verticals of the lookout tower make the fateful geographical conjunction impressively clear: the Romans' route of march and the Teutonic attack, defeat and victory, calculation and dominance, archaeological interpretation and (ongoing) excavations, a historic location in 9 AD and the situation today.

Thus the textual sources, the archaeological finds, our conceptions of the Teutoburg ambush and battles in general, architecture and landscaping come together to turn a historic battlefield into a field of associations, a "place of remembrance".[7] Over and beyond all myths and transfigurations, the museum and the authentic landscape (the only true 'exhibit') become not only an archaeological museum of a wholly new type but just as much a geographically specific paradigm and parable.

Thierry Greub

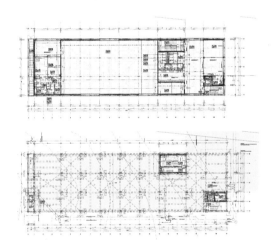

Ground plans of the museum: museum and ground level

1 Joachim Harnecker, *Arminius, Varus und das Schlachtfeld von Kalkriese*, 2nd updated edition (Bramsche 2002), p. 100 (Florus II, 30, 39)

2 Reinhard Wolters draws attention to the present-day interpretative gulf between source texts and archaeological finds in 'Hermeneutik des Hinterhalts: die antiken Berichte zur Varuskatastrophe und der Fundplatz von Kalkriese', in: *Klio* 85, issue 1, 2003, pp. 131–70

3 For the latest information on excavations, visit www.kalkriese-varusschlacht.de and the *Varus-Kurier* published by the Varus-Gesellschaft. Important publications are Wolfgang Schlüter (ed.), *Römer im Osnabrücker Land. Die Ausgrabungen in Kalkriese* (Bramsche 1991), and Wolfgang Schlüter and Rainer Wiegels, *Rom, Germanien und die Ausgrabungen von Kalkriese*, (international congress of the University of Osnabrück and Landschaftsverbandes Osnabrücker Land e.V.) (Osnabrück 1999) and the proceedings of the 'Rom, Germanien und die Ausgrabungen von Kalkriese' conference of June 2004 (publication planned)

4 The scenographic concept for the pavilions was eloborated by Lars Müller, and for the exhibition in the museum by Ruedi Bauer, Integral Concept, both of Paris and Baden (Switzerland)

5 'Architektonische Alliterationen. Ein Gespräch mit Annette Gigon und Mike Guyer', in: *Neue Zürcher Zeitung*, 1 Nov. 2002, no. 254, p. 62

6 Hubertus Adam, 'Vergangenheit als Konstruktion', in: *Archithese* 5, 1999, p. 48

7 Irma Noseda, 'Dem authentischen Ort Gestalt geben', in: *Werk, Bauen + Wohnen* 11, 2001, p. 15

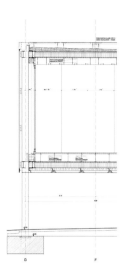

Structural detail and perspective

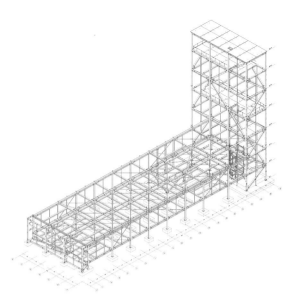

Exhibition room

Spacelab Cook–Fournier GmbH

Kunsthaus Graz am Landesmuseum Joanneum
Graz, Austria

Client:	City of Graz / Kunsthaus Graz AG
Design:	2000
Construction:	2002–2003
Budget:	40 million euros

Rough sketches

Aerial view of the museum from the north-east in an urban context

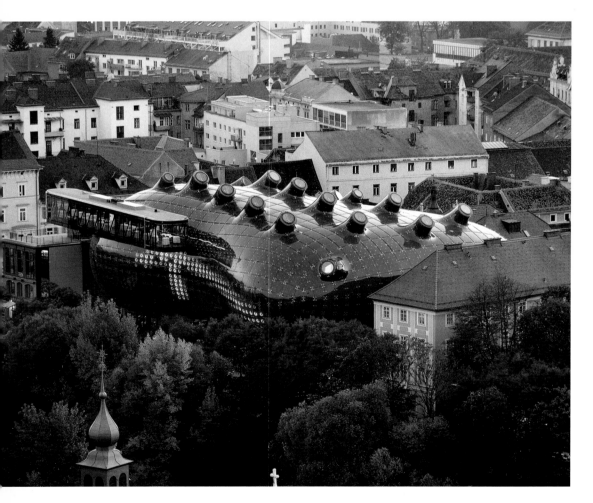

Graz, the capital of Austria's south-eastern Styria province, was able to top the reputation it has deservedly acquired as a culture laboratory – earned, for example, by the Styrian Autumn festival – by being named Europe's Capital of Culture in 2003. Kunsthaus Graz opened in the autumn of 2003 for that reason. Its architects, Peter Cook and Colin Fournier of London, intended the biomorphic, big-bellied monster to be seen as a 'Friendly Alien'. It was unanimously awarded the only prize in a Europe-wide competition in 2000 that attracted 102 entries, and has now been standing on the right bank of the Mur for the past two years. The Mur's torrential mountain waters and the stream of traffic on the embankment road keep the museum at a distance from Graz's picturesque old town.

The Kunsthaus certainly forms a counterpoint to the old town. But however firmly the building on the other side of the Mur resists its context, it has not become a provocation, and perhaps was not intended to do so either. It is true that the bubble-like monster pushes its rear side almost aggressively into the alleys behind it, and its light-trunks, the 'nozzles', are an oddly dominant feature of the town's romantic roofscape with its church towers. But on the southern street façade in Südtiroler Platz, the Eisernes Haus, a technical masterpiece of 1848 cast ironwork – now exemplarily refurbished and part of the Kunsthaus – still offers a familiar picture. And by the river bank in particular, the imposing entrance side looks like a contribution to 'Baroque Going Pop': cheeky but curvaceous and comfortable. The façade fits in entirely with the image of the idyllic, somewhat absurd, but innovative city of culture. And yet it is impossible

'Nozzles' among old roofs

**Night view from the south-east
with iron house**

to speak of empathy with the genius loci. At first glance, the exotic and slightly erratic building looks rather like a statement, a manifesto about an architectural fashion line for museum architecture. But what position is it trying to express? Art historians could be faced with dating problems: is this 1990s blob architecture or a pop structure from the 1960s 'Yellow Submarine' era? Or is it just a vague vision of 'organic building'? The answer is: the Kunsthaus is a retrospective manifesto, presented with the overwhelming gesture of 1990s event architecture, of a pop vision that is almost 40 years old, a reprise of Ron Herron's biomorphic 'Walking City', walking on techno-stilts, from the London Archigram practice. When it opened in 2003, both tendencies, particularly the event architecture, may have seemed nostalgic – an impression that became even stronger in subsequent years – but not because the museum boom might be seen as over. On the contrary: the accelerated, almost breathless, stylistic development of museum evolution will not tolerate nostalgia. Today, an ennobled Minimalism committed to Modernism seems to be in the air, but what sort of a half-life does it have?

Façade detail

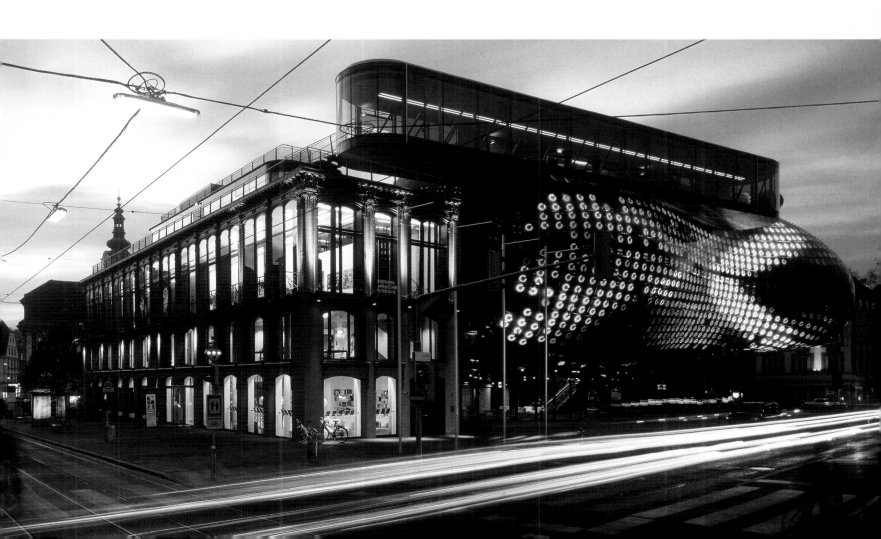

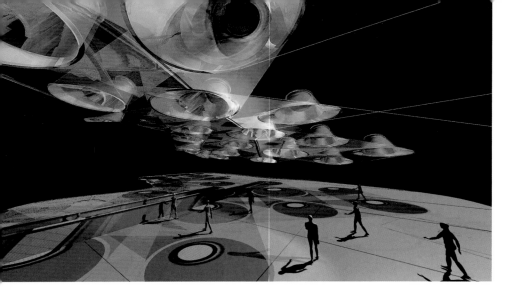

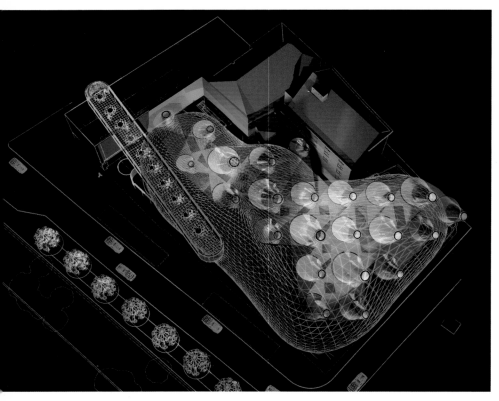

practice, but today, after chairs at the Städel in Frankfurt and the Bartlett School at London University, he sees himself more as an 'élitist populist', paying his tribute to 'show business in architecture' à la Frank O. Gehry.

What makes the Kunsthaus part of the genius loci in Graz is a detour via an affinity with Graz architecture in the 1970s: perhaps precisely because opulent and stately architecture was so omnipresent for them, young Austrian architects in the 1960s had been particularly enthusiastic in embracing Swinging London's happy pop architecture message, even though it existed merely on paper and in the media. Alongside Vienna, where Coop Himmelb(l)au took up Archigram's vision, Graz in particular was the centre for expressive architectural eruptions. Zaha Hadid recently pointed out the importance of this Graz initiative, particularly in the case of Günther Domenig, for later Deconstructivism.

But in Graz, this era had already passed in the 1900s. A hard, puristic Minimalism had become the sign of new building in Styria, and expression was followed by reduction. And so the Kunsthaus bubble seems all the more anomalous, an evolutionary stray, even though it did not appear in isolation, but was also boosted in 2003 by Vito Acconci's glazed shell in the waters of the Mur.

The Kunsthaus's biomorphic bubble floats above a glazed ground floor. Or more precisely: it was intended to float above the Mur, like a 'cloud'. But mirror glazing on the ground floor, which houses the foyer, a lounge, a media lab and a café with a view of the river, wipes out the effect of weightlessness.

From the foyer, a moving walkway rises gently into the blob's cavernous belly. And in this steel belly are two floors of exhibition space for contemporary art. Access to the second floor is also by a long moving walkway, a 'travelator'. These travelators create a sense of unease, and the central access is detrimental to the exhibition area. The 'nozzles' on the alien's back do not draw in any light, and the cold neon rings placed round their edges as a technical crutch, just like the staccato burst of neon tubes on the floor below, develop all the charm of a multi-storey car park. The rounded walls of the art uterus make less than elegant partitions essential.

Early designs: interior view and view of the roof

In Graz, the sensation signalled by the term 'out of this world' certainly does not refer to the open programme of the contemporary art museum, which does not have its own collection. For this reason, the building has to do nothing other than offer a flexible envelope for temporary exhibitions. It was precisely this lack of definition in terms of content that helped to release form from its shackles in many new museums. Form does not only not follow function, it obeys only the attention aesthetic of event architecture. In the 1960s, Peter Cook was a disrespectful pioneer of pop aesthetics with the London Archigram

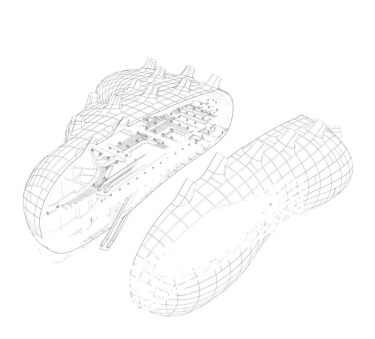

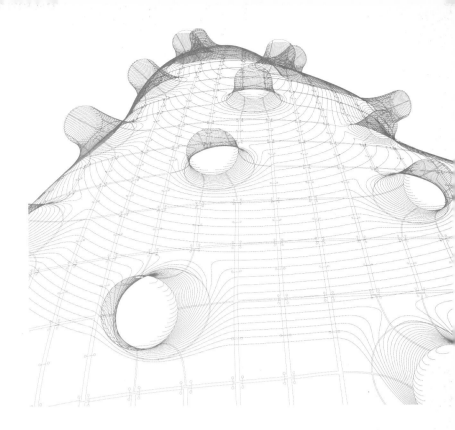

Construction: longitudinal view and
outer membrane with 'nozzles'

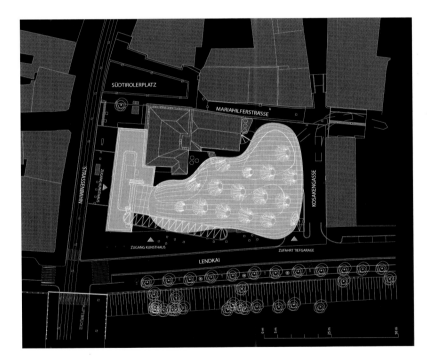

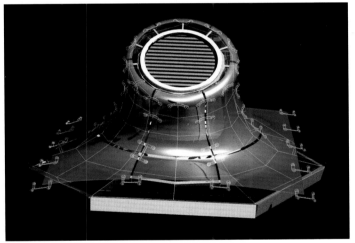

Site plan

Detail: 'nozzle' and membrane
surface

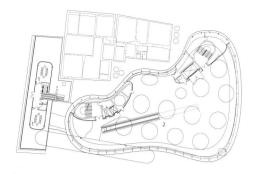

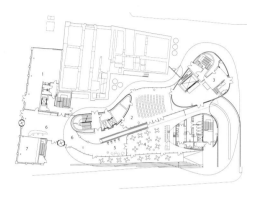

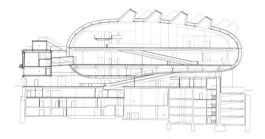

Ground plans: 2nd, 3rd floors and ground floor

Longitudinal section

On the other hand, an open view of the town is provided, magnificently and uninterruptedly, by the 'needle' – a glazed walkway protruding considerably and suspended at the side of the building. Here, romantic Graz is turned into a picture; it is the only permanent exhibition the container has to offer.

The architects intended the façade to be a membrane, the breathing, osmotic and translucent skin of a built organism. At the same time, what was happening inside was supposed to be projected outwards and communicated, and the outside world was to be brought in, as a reflection of the 'City Lights'. Instead, for reasons of expense and time, the envelope became a steel suit of armour, surfaced with insulating layers. To restore the original idea, as it were, the external skin, shimmering in green and blue, was provided by realities:united, the prizewinning Berlin architecture and design studio, with an intelligent media layer behind the perspex façade.

During the day, the envelope looks like an architectural element, a 'real' wall, while at night the wall, all 900 square metres of it, fulfils its communicative and artistic mission with countless circular fluorescent tubes, controlled by software developed especially for the purpose.

Werner Sewing

Interior views: access to the 'travelator' and main exhibition room

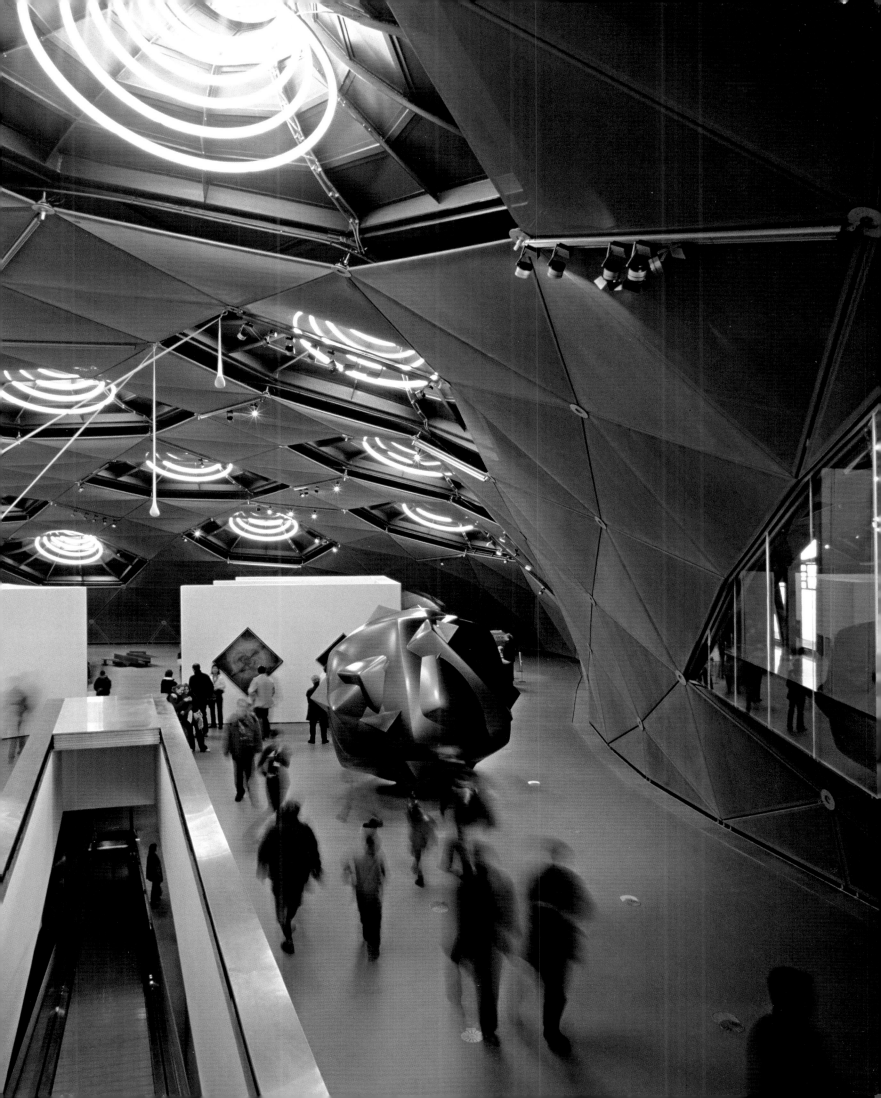

Renzo Piano Building Workshop

Paul Klee Centre
Berne, Switzerland

Client: Maurice E. and Martha Müller Foundation, Berne
Design: 1999
Construction: 2000–2005
Budget: 110 million Swiss francs (60 million donated by the Müller family, 32 million sponsorship money, and 18 milion from the Berne Canton lottery fund)

Study: site plan, 2003
Topographical sketch, 2001

View from the west

Alexander Klee had the idea of a museum devoted solely to bringing together the works from his grandfather's estate. He was thinking of a new building or an extension in the city centre. There was an existing local connection with the Kunstmuseum in Berne, as Paul Klee's heirs had put his work at the Kunstmuseum's disposal, where they were one of its principal attractions for a long time.

But realising a museum devoted exclusively to Paul Klee failed at first because neither the city nor the canton of Berne had money available for a project of this kind, or did not want to go ahead with it. To resolve this impossible problem, the widow of Paul Klee's only son, Livia Klee-Meyer, presented the canton of Berne with 650 of the artist's works in 1997, linked with the apparently utopian demand that a solution for the new museum be found by the year 2006.

Just a year later, a gift of 60 million Swiss francs and a plot of land on the outskirts of Berne gave a completely new twist to the project. Then the donors, Prof. Dr. Maurice E. Müller and his wife, Martha Müller-Lüthi, were not content to leave it at merely making donations, but immediately took over the entire concept for the project. Müller, a Berne surgeon, announced his vision of an interdisciplinary centre in the Berne suburb of Schöngrün. It was not to be a museum in the traditional sense, but an attractive tourist destination that would also promote the tourist industry. Müller had chosen the architect Renzo Piano, who would make a considerable contribution to the success of the concept.

The city of Berne and its voters were keen to see this promising and exciting centre realised, and accepted the vision. As Prof. Müller and

Martha Müller-Lüthi did not want to hold a competition, Renzo Piano was commissioned to go ahead with the museum straight away, and the Müller family took responsibility for the building process as the Maurice E. and Martha Müller Foundation. Alexander Klee's early scepticism about a multidisciplinary 'leisure oasis', and the Kunstmuseum's annoyance that its Klee pictures had to be handed over to the centre, were soon submerged in the euphoria about the new building, the star architect and the Müllers' generosity.

Renzo Piano took up the topography of Schöngrün in his architecture and designed the centre in the form of three waves, echoing Berne's gently rolling countryside. Piano also invokes Klee's symbolic language with the wavy line, thus combining art and nature (fig. 1).

The façade of the museum faces the motorway directly. The 150-metre-long Museumsstrasse[1] (Museum Street) behind the great front panes links the building's three halls. Museumsstrasse, as the centre's "living artery",[2] is intended to regulate "visitor traffic" and additionally provide a significant parallel with the motorway. Even though Piano insists that the motorway is an integral part of his project,[3] it is sunken in front of the building and thus cannot be seen from the inside. So there is no unavoidable confrontation, and the road is scarcely noticed – apart from the metaphorical connection.

The vaults, like "ship's keels"[4] rising up to 19 metres on the glass façade, slope backwards and finally disappear into the ground entirely. The centre is partially buried, and seems to grow out of the landscape, looking more like 'Land Art' than a building. The 2.5 hectares of land surrounding the centre are ecologically managed and intended to give the landscape sculpture a different 'garment' for every season. This was why the title of one of Klee's works, Monument im Fruchtland (Monument in Fertile Terrain) was adopted as the label for the three steel waves.

Visitors are led into the interior via the Museumsstrasse, which offers a café, information area, museum shop and library. The first wave, the Hügel Nord, accommodates two seminar rooms and the forum. The basement houses an auditorium and the Creaviva children's museum, where

Fig. 1: Paul Klee, *Insula dulcamara*, 1938, 481 (C1), oil and colour paste on newspaper on jute on strecher frame; original frame borders; 88 x 176 cm, Paul Klee, Centre Foundation, Berne

Exterior view near the entrance

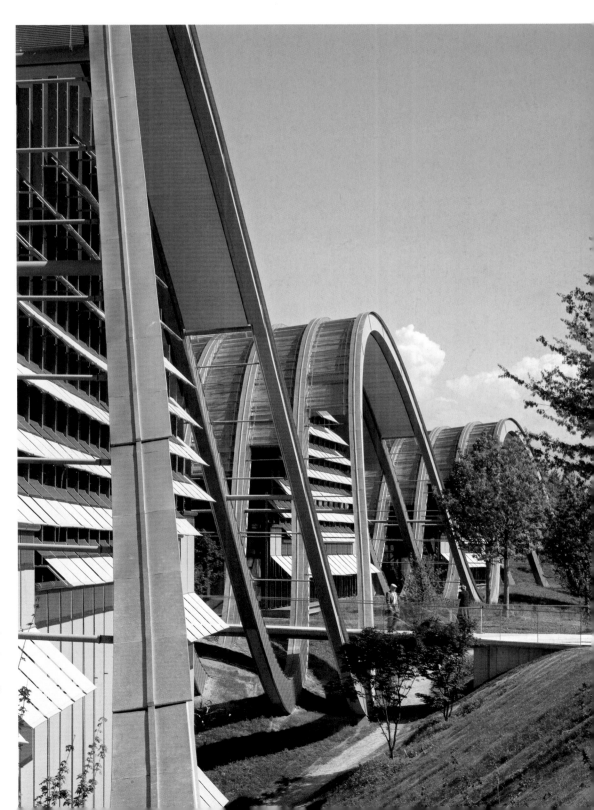

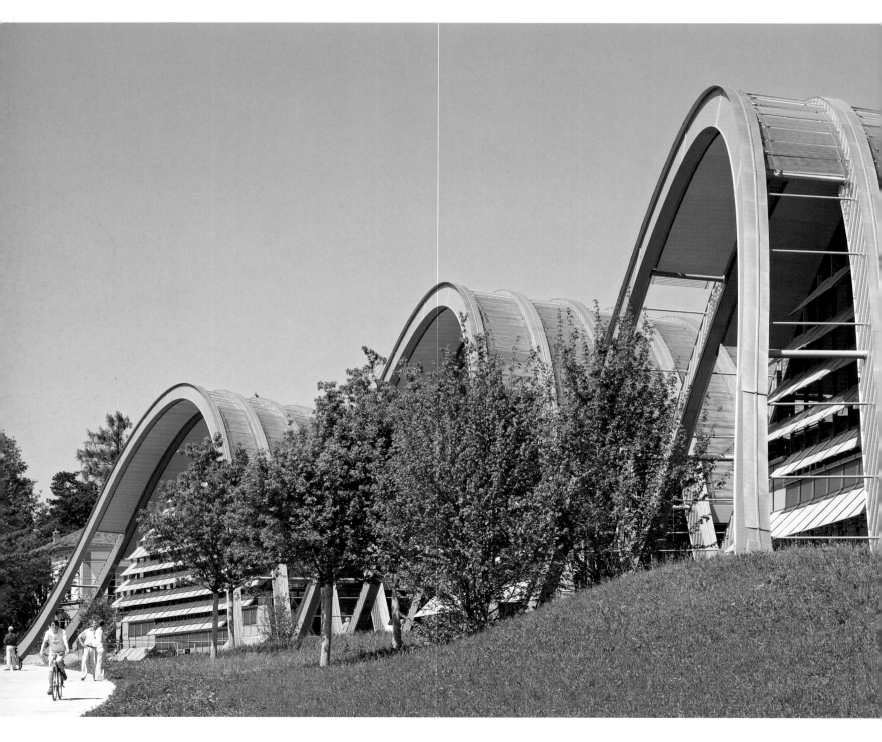

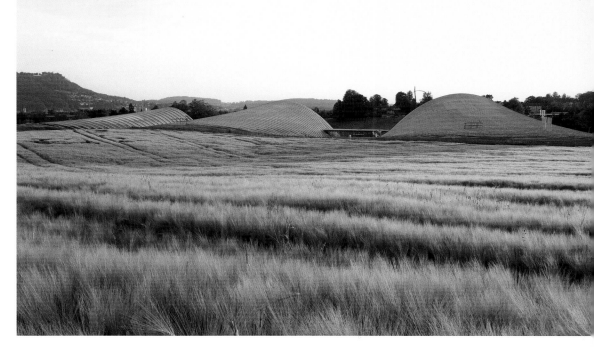

View from the north-east

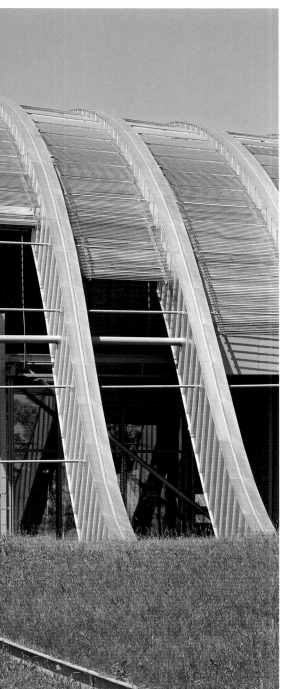

View from the south-west

families can experience Klee's work by experimentation, assisted by an *open studio*.

The collection, represented by about 200 works at any time, is exhibited in the Hügel Mitte on an alternating pattern. Piano says that on entering the large exhibition hall, conceived like a hangar, visitors leave the secular behind and turn to the sacred.[5] Indirect, muted, focused light is carefully matched with the exhibits, some of which are sensitive to light. The cavity of the undulating roof contains an elaborate steel structure from which partitions can be lowered into the exhibition space. These flexible walls and the awning that provides screening at the top articulate the 1,750 square metres of exhibition space. Structuring of this kind makes it possible to create an intimate relationship between viewer and image, despite the gigantic scale of the place and the architecture's concise precision.

In the basement of the central hill is the somewhat smaller, lower space for temporary exhibitions. The intention is that shows carrying great names like Max Beckmann or Andy Warhol attract a constant stream of visitors.

Finally, in the South Hill, the smallest and lightest of the three waves, there are more rooms for seminars, administration and research into Paul Klee's life and work. This section also contains books and films on Renzo Piano, his other projects and, of course, on the building of the Paul Klee Centre.

The idea of a museum dedicated entirely to Paul Klee in the heart of Berne has now become an interdisciplinary centre on the eastern outskirts of the city. It is intended to reflect Klee's versatility: he is presented as a musician, man of letters, philosopher and academic, and even his enthusiasm about dance and theatre and his abilities as a teacher become part of the programme. Prof. Müller states that his aim is to convey art in a visitor-friendly fashion, concentrating on research and on presenting Klee's life and work and the response to them.[6] This means that the presentation of the works themselves sometimes seems like just one of many attractions, and it is impossible to avoid feeling that the whole city and the surrounding area would like to take over Paul Klee's life and work completely. For

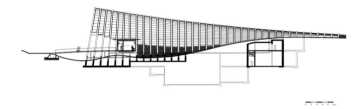

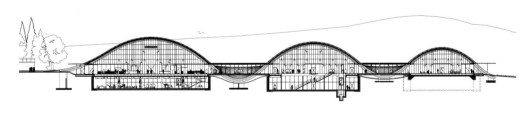

example, all the previously anonymous field paths in the surrounding area have been named after works by Klee, and the artist's grave has even been shifted into the museum park.

Even though such exaggerated use of every little detail from Paul Klee's life may annoy some visitors, the Müllers' vision has been fulfilled. The Paul Klee Centre really has become a major draw, and the visitor numbers speak both for the original concept by Prof. Müller and Martha Müller-Lüthi and also for Renzo Piano's fascinating presentation. Whether visitors will continue to pour into the Paul Klee Centre in the long term also depends on how attractive the future programme of temporary exhibitions turns out to be, despite all the founders' efforts.

Christine Gisi

1 The names originate from the Paul Klee Centre
2 Renzo Piano: letters, preliminary design, 1999, http://www.zpk.org
3 Ibid.
4 Ibid.
5 Renzo Piano, letter 1, Paris, winter 1998, see note 2

Sketch, 2005

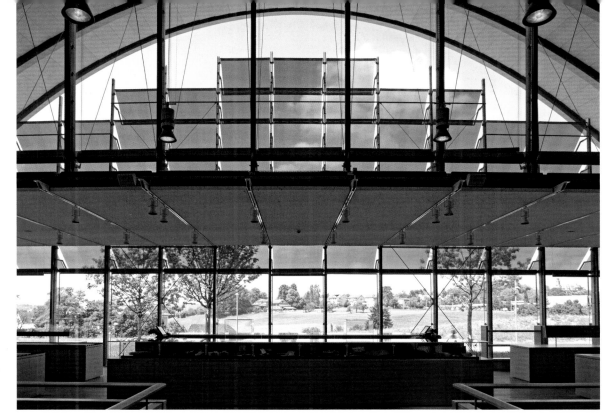

Outward view from
Museumsstrasse

Exhibition room,
permanent collection

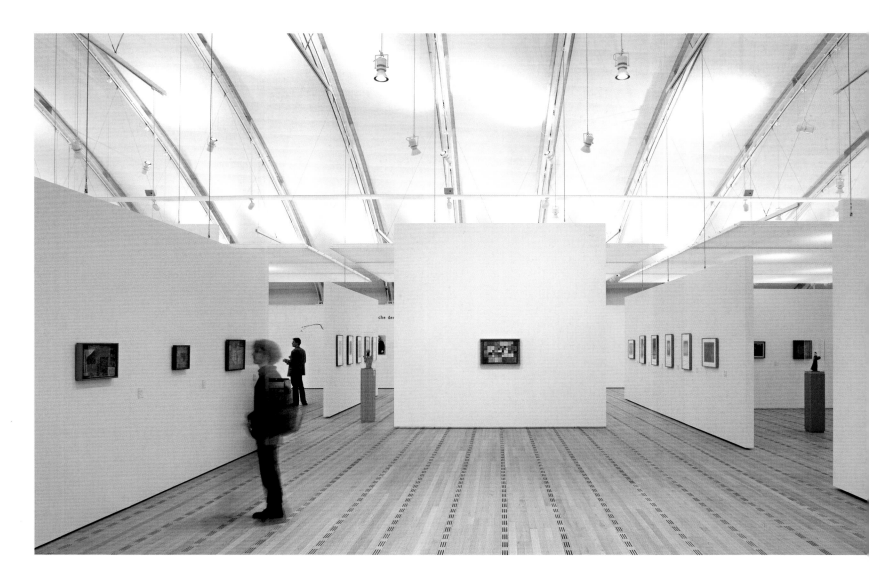

107 **Renzo Piano**

AJN: Ateliers Jean Nouvel
Musée du quai Branly
Paris, France

Client: Etablissement public du
 musée du quai Branly
Design: 1999–2000
Construction: 2001–2006
Budget: 216 million euros

Division schema

**Ground plan: ground floor at garden level
with guiding path**

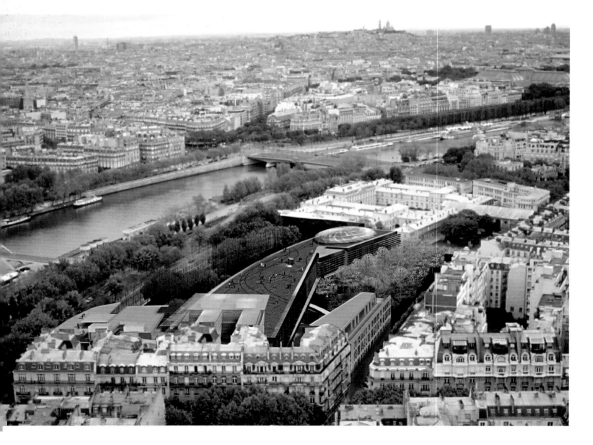

**Photomontage of the museum
in an urban context**

"There is no reason why one should not found a major museum of exotic art that would give such art space of the kind the Louvre provides for European art."

Guillaume Apollinaire, 1912 [1]

And now, after nearly a hundred years, it has happened: in Paris, what are now known as the 'Arts Premiers' from the civilisations of Africa, Oceania, America and Asia can enjoy the place they deserve on the museum scene. And what a place! The Musée du Quai Branly has come into being on one of the last building plots immediately below the Eiffel Tower, in the heart of Paris. It covers more than 30,000 square metres, including about 9,000 square metres of exhibition space.

In 1998, Jacques Chirac launched an initiative to build the 'Museum of Arts and Civilisations', as it is officially called. Jean Nouvel won the architecture competition, ahead of the Fanuele-Eisenmann duo and Renzo Piano.

As well as the actual exhibition, the museum contains a media centre, an auditorium, workshops and storage space, the aim being to establish a reputation as an international research institution in non-European art fields. A bookshop and a restaurant invite the public to linger and attract additional visitors.

With 300,000 exhibits, the museum offers one of the world's best overviews of the 'Arts Premiers'. It brings together the collections of

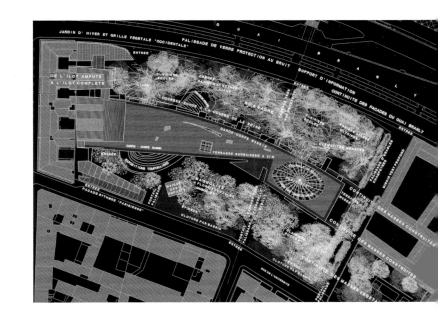

Plan view with park

Exterior views
(computer simulation)

two of the French capital's institutions with a very rich tradition: that of the Musée des Arts d'Afrique et d'Océanie and of the Musée de l'Homme.

The Musée de l'Homme is the successor to the colonial museum and holds the earliest treasures that French explorers, adventurers and administrators brought back to the Seine from the colonies. Here, we also see how the way these works are valued has changed over time. Originally, they were seen merely as absurd evidence of civilisations considered primitive and inferior. It was not until the early 20th century that the view of the Arts Premiers changed considerably. Collectors like Paul Guillaume and the poet and art connoisseur Guillaume Apollinaire detached them from their ethnological context and recognised that they were significant art in their own right. Cubist and Surrealist artists in particular, like Braque, Picasso and Miró, now began to tackle the Arts Premiers thoroughly.

Even so, the Arts Premiers were yet to receive the final accolade: a place in the Louvre. It was

not until a wing in that museum was cleared and opened in April 2000 that they at last came in from the art-historical cold.

The Musée du Quai Branly now faced the challenge of conveying to visitors that this art was doubly important: the new museum presents an opportunity to consider the exhibits as sculptures, provides information about the geographical, ethnic and historical context in which these objects came into being, and explains their functions and significance.

Jean Nouvel says: "A museum like the one on the Quai Branly should not simply be a place with didactic information, but an emotional place as well."[2]

Consequently, a decision was taken against a 'white cube': lighting, choice of materials and colours are intended to plunge visitors into a mysterious atmosphere, an alien cosmos. The geographical characteristics of the exhibits' countries of origin determine the design: we are reminded of the icily dark cold of North America, the dry and sandy expanses of Africa, the

vegetation in hot and humid Oceania. Numerous details are deployed to translate these special geographical features into architecture. This goes as far as designing the usual expansion joints on the roof terrace so that they are reminiscent of cracks in a dried-up salt lake.

The museum building is about 200 metres long. It follows the gentle curve of the Seine, and its narrow side docks with the existing buildings. In fact, the new building is almost completely hidden by the lush vegetation in the lavish park designed by Giles Clément. Oaks, maples, wisteria grow on the north side; on the south side are magnolias, cherry-trees and bamboo plantations. Nouvel speaks of a "place characterised by symbols of the forest, of the river, and by the obsessive insignia of death and oblivion".[3]

The site is contained on the north side by a glass wall 12 metres high. This – like the Fondation Cartier, also planned by Nouvel (fig. 1) – keeps out traffic noise. The long main section of the museum is supported by irregularly-arranged, 10-metre-high columns – rather like

North, south, east façades, and longitudinal section

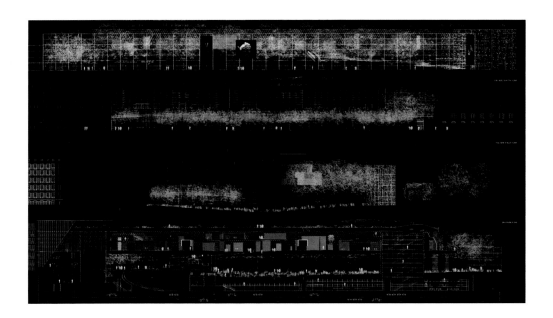

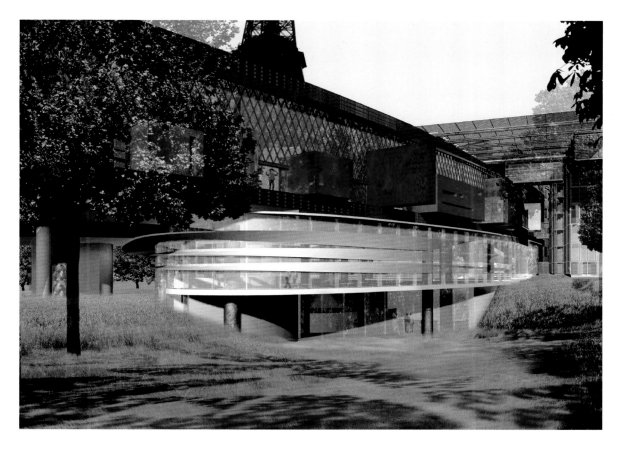

Exterior views from the south-west and south-east (computer simulation)

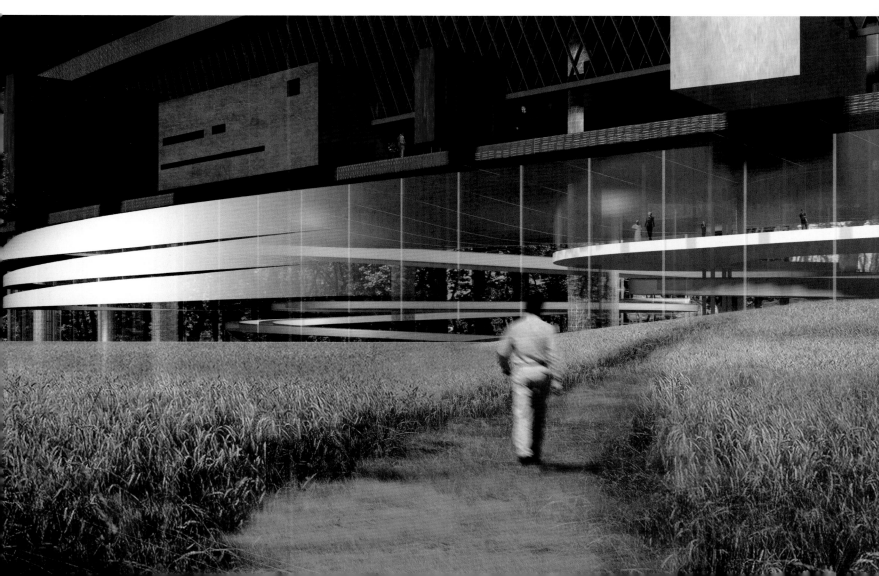

Ground plans:
2nd, 1st and 3rd floors

Exterior view from the south
(computer simulation)

totem poles – which make it possible to extend the green areas over the whole plot. The long façade of this section facing the Seine is broken up by about two dozen boxes roughly the size of garages. They are freely arranged and thrust several metres above the façade, and no one box is in the same proportions and materials as any other.

In the entrance lobby is a 2000-square-metre space for temporary exhibitions. Above that is a fantastically curved ramp winding around the 'musical instrument wing', which skilfully camouflages the building's massive, statically essential core. The ramp takes visitors to the 4,500-square-metre main exhibition level, where a breathtaking spatial experience awaits them: they are surrounded by a high, two-storey space characterised by the natural materials wood and leather and bathed in muted light to protect the exhibits. This is accentuated by colourfully glowing areas of glass alluding to the vegetation in the four parts of the earth represented. Each of these four main areas has an aesthetic and a didactic

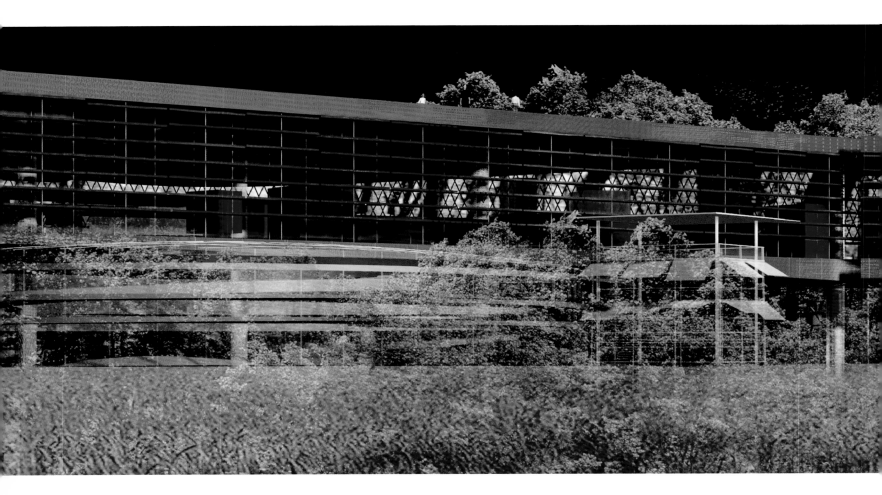

Fig. 1: Jean Nouvel, Fondation Cartier, Paris, France, 1991–94

section, the latter explaining the meaning, function and context of the exhibits. Irregularly fashioned mezzanine floors are suspended above these sections. Reminiscent of drifting continents, they pick up the idea of the geographical analogy. Here, visitors have an opportunity to research the exhibits at computer terminals.

Access to the boxes that give the north façade its shape is also from the main exhibition level. These boxes are individually designed as small yet accessible thematic galleries devoted to subjects like ancestor worship and the worship of gods.

The roof level contains the media centre and the restaurant, and can be accessed along the full length of the building. It also affords a spectacular view of the Eiffel Tower, the museum park, the Seine and the Trocadero.

It should be noted that events involving contemporary artists are accommodated in an auditorium with a separate entrance. The Musée du Quai Branly masters the difficult challenge of presenting the Arts Premiers for our day impressively and even goes beyond Apollinaire's demand that they be presented prominently by offering contemporary artists from the world's four regions a forum for their current creative output.

Jann Kern

1 Guillaume Apollinaire, *Paris Journal*, 10.09.1912
2 Jean Nouvel, project description under www.jeannouvel.com
3 Ibid.

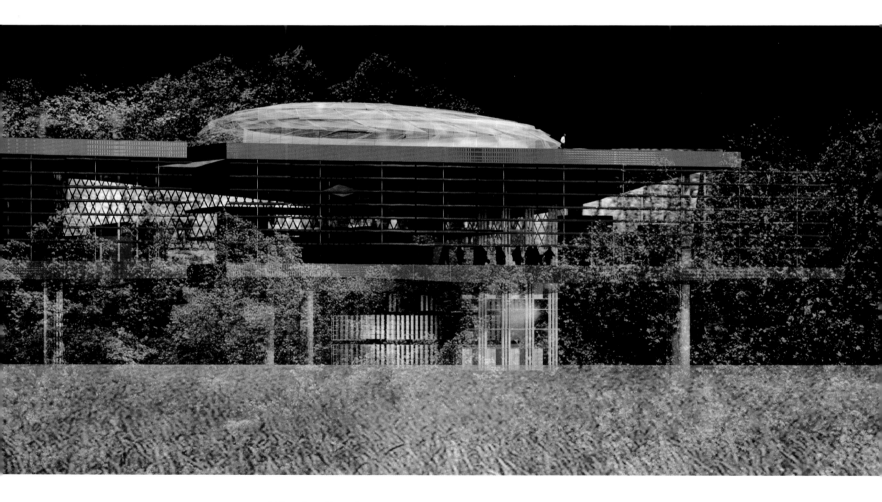

UN Studio

Mercedes-Benz Museum
Stuttgart, Germany

Client:	DaimlerChrysler AG
Design:	2002
Construction:	2003–2006
Budget:	75 million euros

Sketch, 2001

**The museum in an urban context
(photomontage)**

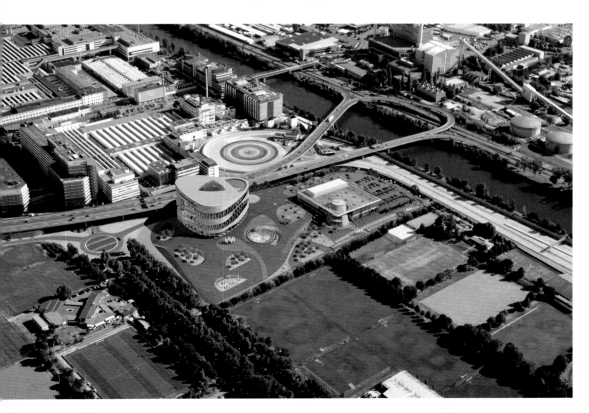

Times may be difficult for major car manufacturers, but you wouldn't know it from their construction plans. BMW AG in Munich is spending 100 million euros to build 'BMW World', a glass structure with shops, a restaurant and interactive exhibits intended to permit 850,000 visitors a year to "see, feel, hear, smell and taste BMW". At the same time, the Munich firm is erecting a factory building in Leipzig designed by Zaha Hadid, Porsche is building a new museum in Stuttgart near their Zuffenhausen production facility (architects: Delugan Meissl), and DaimlerChrysler AG, too, built an entirely new museum in Stuttgart, to replace an existing facility for its Mercedes-Benz division. Created in 1923, the Mercedes-Benz Museum has recently attracted approximately 480,000 visitors a year.

A January 2002 architectural competition brought together some of the most prestigious names in German and international architecture. The second and third prizes went respectively to the Tokyo architects Kazuyo Sejima + Ryue Nishizawa/SANAA, and to Angélil Graham Pfenninger Scholl/agps architecture, from Zurich and Los Angeles. Also participating were Asymptote (New York), Alberto Campo Baeza (Madrid), Kollhoff and Timmermann (Berlin) and Schneider + Schumacher (Frankfurt and Stuttgart). The winners were the Amsterdam firm UN Studio, whose principals are Ben van Berkel and Caroline Bos. Van Berkel and Bos are well known for such structures as the Erasmus Bridge in Rotterdam (1996), or for their more recent participation in the United Architects group (with Greg Lynn and Foreign Office Architects), which was actively considered in the course of the consultations for the Ground Zero site in New York.

The new Mercedes Museum, costing 75 million euros, opened on 19 May 2006 and has nine levels and an interior double-helix structure with spiralling ramps that allow visitors to walk through a chronological presentation of the company's production. Projections by museum officials plan for approximately 600,000 visitors a year, with a surge after the opening and when Germany played host to the 2006 World Cup. Visited from top to bottom, something like rank Lloyd Wright's Guggenheim Museum in New York (fig. 1), the Mercedes Museum is structurally much more complex than its pre-decessor. As Ben van Berkel describes it, "The structure is a continuous loop, or a spiral that generates the idea of a time machine. 170 cars can be exhibited in the 25,000-square-metre building. A section of the design shows that it is a continuous flower-like structure, a ring that holds itself up without any support in the middle." Heavily involved in computer-assisted design and parametric model-ling, UN Studio aims to do things that "have not yet been done in architecture, and to make them work". Indeed, van Berkel compares the firm's method to that of car manufacturers. "In the early work we were interested in geometry and then

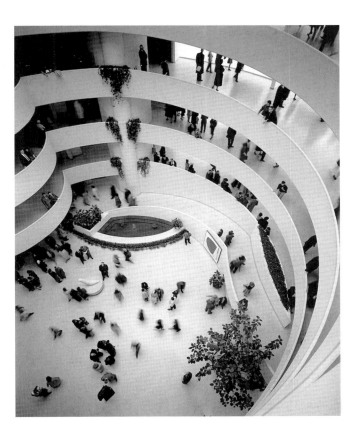

Fig. 1: Frank Lloyd Wright, The Solomon R. Guggenheim Museum, New York, USA, 1943–59

View from the motorway (computer simulation)

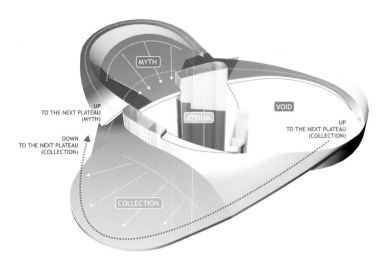

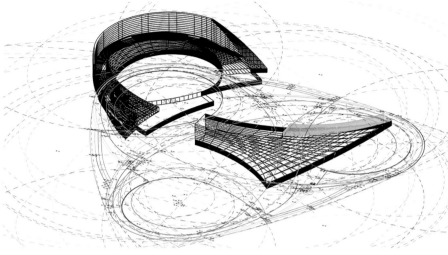

Cloverleaf-shaped diagram

Geometrical diagram: 'Twist'

Diagram: 'Neverending story'

Design models, 2001

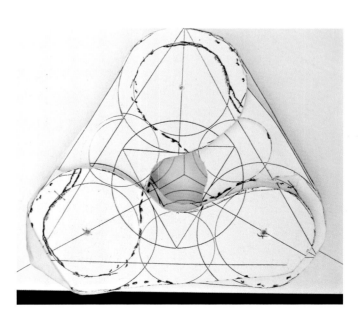

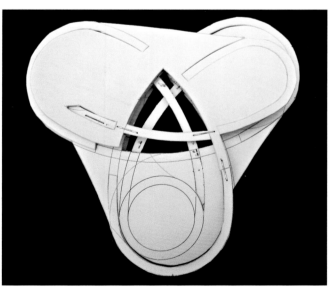

that turned into play with mathematical diagrams. And now the diagrams have turned into what we call 'design models'. One strategy for design can turn into a variant, like a prototype for a car, which can generate five or six cars." Their Möbius House (Naarden, 1998) already experimented with the idea of a continuous loop, applied in Stuttgart on a much larger scale, and to different effect. Ben van Berkel admits that the parametric modelling of the Mercedes Museum reaches a degree of complexity that only computer specialists can fully grasp, but the upshot of this system is that unique parts can be fitted into the whole design without engaging in the kind of cost overruns that were typical in the past of such innovative buildings. "Another advantage", he says, "is that throughout the design process, when changes were required, especially the kind that had repercussions on the building as a whole, the engineering programs we use were capable of changing the entire structure to meet the new requirements."

The firm's description of their own proposal for the museum in Stuttgart explains much of their attitude: "This proposal is about a museum for a legendary car, the product of a complex spirit in which technology, adventure, attractiveness and distinction are merged – it is also a museum for people who can move through it, dream, learn, look and let themselves be oriented by fascinations, light and space…. Lastly, it is a museum for the city, a new landmark to celebrate the enduring passion of Stuttgart's most famous inventor and manufacturer."

Measuring 47 meters in height, the design was intended to stand out from the first against the green, hilly topography of the city that has few landmarks, becoming the "architectural affirmation of the Mercedes brand". Located fairly far from the city centre, the site of the museum is in an industrial zone, but the architects have insisted that in designing an essentially vertical structure, they have created a new, outdoor plaza that can be used for various events. Inside, a 'trefoil'

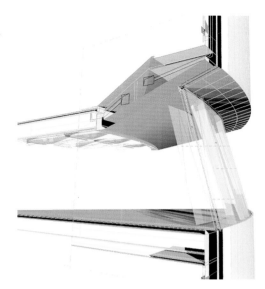

Façade detail

Visitor movement (Guggenheim Museum New York, Neue Nationalgalerie Berlin and Centre Georges Pompidou Paris, Mercedes-Benz Museum)

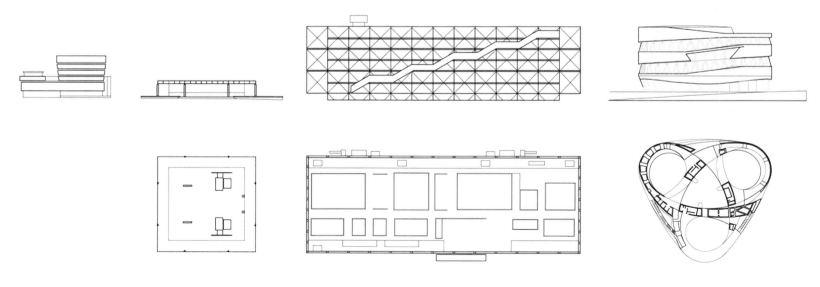

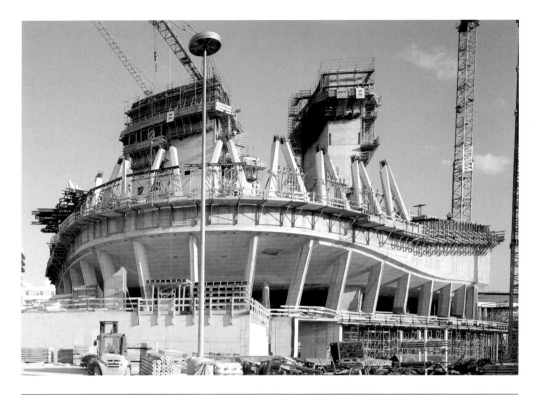

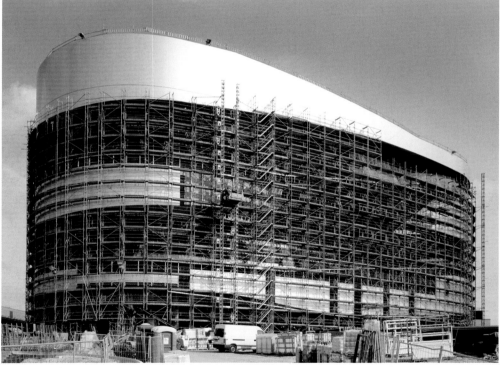

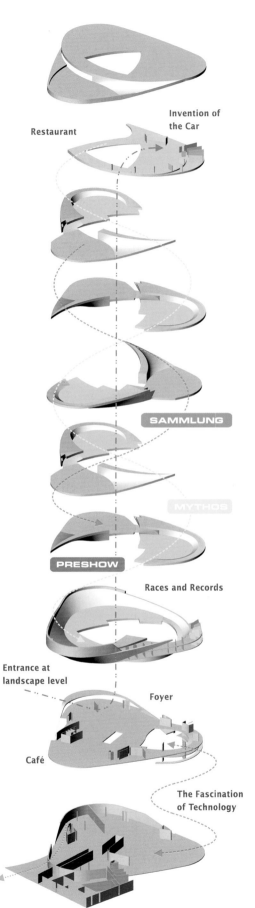

Restaurant

Invention of
the Car

SAMMLUNG

MYTHOS

PRESHOW

Races and Records

Entrance at
landscape level

Foyer

Café

The Fascination
of Technology

Construction site, 2004 and 2005

'Helix programme' spatial designs

3D section (computer simulation)

design permits the architects to weave the story of the trucks, cars and 'myths' that make up the brand's history into an uninterrupted flow. The myths are Mercedes vehicles ranging from the first production car, the Benz Velo (one of the 381 cars built between 1894 and 1899), to the most recent and technologically spectacular experimental models. Sensitive to the car manufacturer's desires as they were expressed in the competition programme, the Dutch architects state that "This museum proposal strives to respond to questions relating to the Mercedes identity, to the contemporary experience with driving and with cars in general, and to the contemporary museological experience. The scheme derives its struc-ture from the surprising combination of these elements." Although there is a chronological order to the presentation of the vehicles, the visitor is always free to wander from one zone to another and to discover some of the unexpected links that appear between periods and types of car. Physically imposing, as it was intended, the Mercedes-Benz Museum sums up the longest continuous tradition in the car industry, but above all it places the company firmly in the 21st century and allows visitors to discover cars much as they would works of art – as significant objects in the history of our times.

Philip Jodidio

Bernard Tschumi Architects

The New Acropolis Museum
Athens, Greece

Client: Hellenic Ministry of Culture, Organization for the Construction of the New Acropolis Museum
Design: 2002
Construction: 2003–2007
Budget: 50 million euros

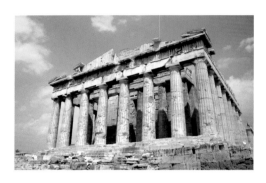

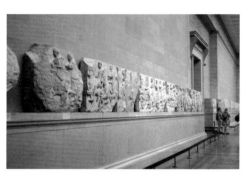

Fig. 1: Parthenon (447–38 BC), Athens, Greece

Fig. 2: Parts of the Parthenon frieze
at the British Museum, London

Site plan and demonstration of visual relationships

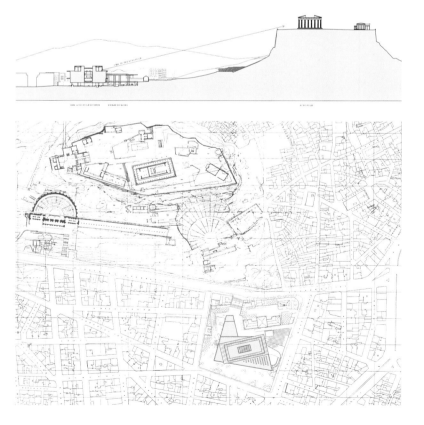

Impressive time-space architecture: Bernard Tschumi's New Acropolis Museum in Athens

The archaeological excavation site over which the new museum in Athens seems to float is south of the Acropolis, with a direct view of the Parthenon (fig. 1) high above, and only a stone's throw away from the Theatre of Dionysus at the foot of the hill. For the international competition, Daniel Libeskind devised a building complex for this terrain consisting of two triangles, which won second prize, while Arata Isozaki proposed an ovoid volume for the new museum. Building an imposing archaeological museum on this higgledy-piggledy site meant more than a challenge for first-prize-winning architect Bernard Tschumi and his project partners. The excavation site that was already there was to be affected as little as possible and it was necessary to follow strict earthquake protection guidelines and rigid local regulations for new buildings in this historical context. A design was needed that would bring together, within the arrangement of a central new building, the parts of the Parthenon frieze that are still in Greece and many other exhibits that are at present still distributed among the little museum by the Acropolis, the National Museum and various storage facilities.[1] Also, mindful of the unique quality of the exhibits to be presented here, the clients were demanding a uniquely striking piece of architecture. This was to be transparent above all else, so that it would not disturb the sightlines relating to the Parthenon. But how was it possible to combine transparency and conservatorial requirements in such a hot climate, with such an

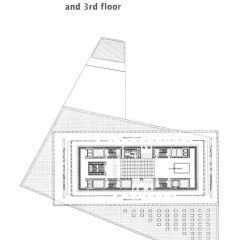

Ground plans: 1st basement storey
(excavation site level), ground floor
and 3rd floor

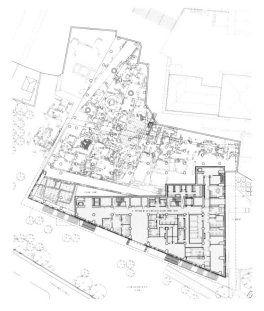

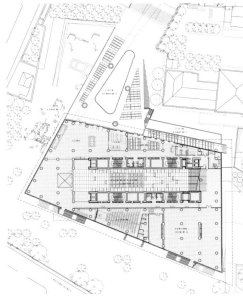

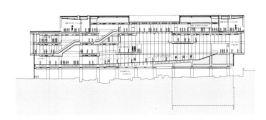

Cross-section
and longitudinal section

abundance of light? And how was it supposed to be possible to shepherd about 10,000 visitors through the museum each day without any loss of contemplative spatial quality?

The only way to do justice to the location and the collection was with minimalistic simplicity and a complete lack of constructive-structural ambiguity. So what is currently being built is an archaeological museum in three sections, devoted to absolute lucidity. The building's spine is formed by a pathway through the exhibition, manifesting itself spatially, by analogy with the dramaturgy of the exhibits on show, in three building materials: concrete, marble and glass. The cubature of the new building is also tripartite. Here, the excavation site as the 'cellar floor' has been left largely untouched. All that has happened is that columns have been inserted intermittently, and these support the actual main floor of the new museum. And the entrance

lobby, the temporary exhibition area and ancillary rooms have also been accommodated in an archaeologically unexceptional corner. The excavation zone is enclosed only by honeycomb-like wall grilles and sun-protection walls on the periphery. The main volume above, also accessible from the outside by open-air steps, has two storeys, and a mezzanine floor has been added. It contains all the major exhibition galleries from the Archaic Period to the Hellenistic-Roman epoch, and additionally accommodates lecture theatres, light wells, access systems, infrastructure facilities and a café terrace. All this is topped by a largely glazed pavilion, strictly rectangular in conception. It is linked directly with the Parthenon in terms of sightlines, and presents its world-famous frieze fragments (fig. 2).

Dividing the building into three like this means that the new building attempts to match the mathematical precision and conceptual

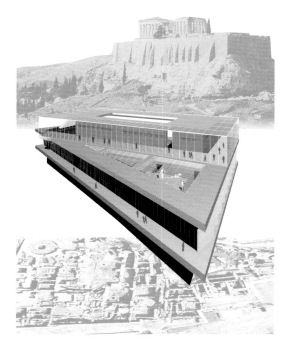

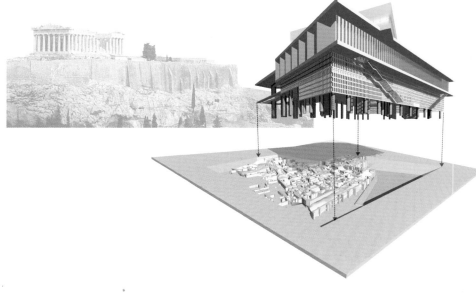

Perspective views with reference
to the Parthenon and excavations
(computer simulation)

Entrance sequence with excavations
below (computer simulation)

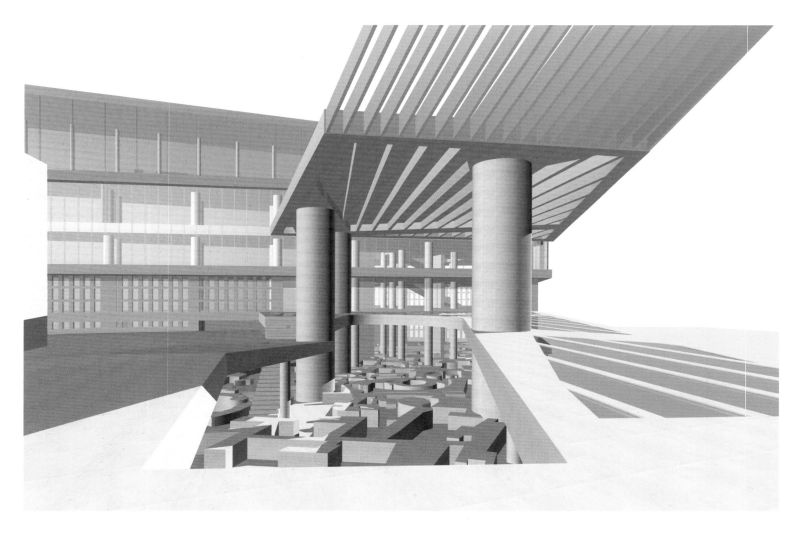

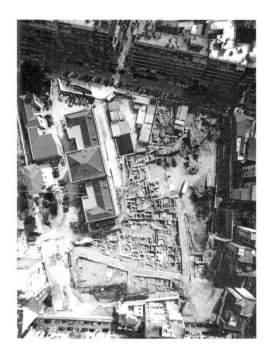

Aerial view of the construction site

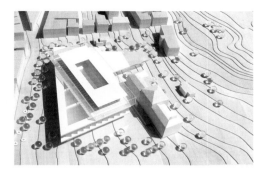

Exhibition model, 2003

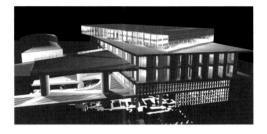

Night view with illuminated galleries and excavations (computer simulation)

lucidity of ancient Greek architecture. This is accompanied or underpinned by three impressively implemented conceptual strategies.

The first is concerned with the subject of "light and the handling of light". Because of the unique Mediterranean light that ancient statues and building fragments always had to stand up to, a completely pragmatic decision was taken to make this a daylight museum. This means that daylight, whether from above, below or from the side, is allowed to penetrate as deeply as possible into the cellular structure of the new building. The high degree of precision that architects and specialist engineers are showing here is admittedly articulated only where subdued, muted light is needed for conservational reasons. For such situations they have created systems, as complex as they are aesthetic, of light-filtering wall areas, multiply staggered behind or above each other. This results in an impressive, sieve-like spatial structure whose porous system of light chambers of a whole variety of kinds is able to react minutely to conservational needs, without preventing visitors from feeling that they are moving completely freely in transitory border areas between inside and outside, yesterday and today.

The second strategy is based on an intensive analysis of the problems and opportunities of possible routes round the museum. This has produced the built image of a visitors' route articulated extremely strikingly as a three-dimensional

spiral. Starting with the exhibits of the Archaic Period, the route rises past items from the Hellenistic-Roman period until it reaches its apex at the climax of the tour, the Parthenon frieze fragments, and then drops back down to its starting-point. This routing is not least aimed at handling the enormous visitor volumes.

The third strategic aim was programmatic implementation of that model based on different historical strata that Bernard Tschumi had used once before, though under quite different conditions, for his National Studio for Contemporary Arts in Le Fresnoy (1993–98). But in Athens he was principally interested in achieving a conceptually unambiguous model with three strata: at the bottom the hollow excavation chamber, above this the 'sandwich' with the main exhibition areas and the mezzanine floor, and finally the Parthenon gallery right at the top. This is the architects' and engineers' pride and joy; here they have succeeded, with the aid of the most up-to-date glass technologies, in protecting the valuable sections of the frieze from extreme heat and glaring light, and at the same time maintaining an unbroken visual link with the Parthenon as their

View from the south (computer simulation)

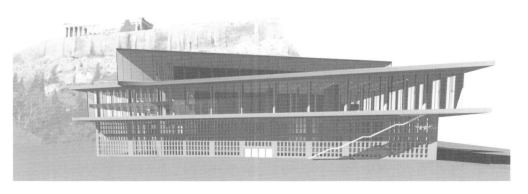

place of origin. This Parthenon gallery, arranged around a *cella*-like inner courtyard, is thus a contemporary paraphrase of the classical Greek peripteros temple type. In just the same way, all the rest of the architectural and spatial organism gives an impression of stimulating time-place architecture, attempting to locate relations between objects and bodies in space that are far apart in a contemporary fashion. The New Acropolis Museum in Athens must thus be understood as a metaphor of convincingly anchoring "floating objects in space", as intelligent as it is readily comprehensible, though never superficial.

Frank R. Werner

1 Approximately half of the preserved metopes and relief sculptures of the Parthenon are to be found in the British Museum, in London, the remainder in the Acropolis Museum, in Athens. The return of the works sold to the British Museum by Lord Elgin in 1816 has just recently been the subject of heated debate.

Façade details: Parthenon Gallery

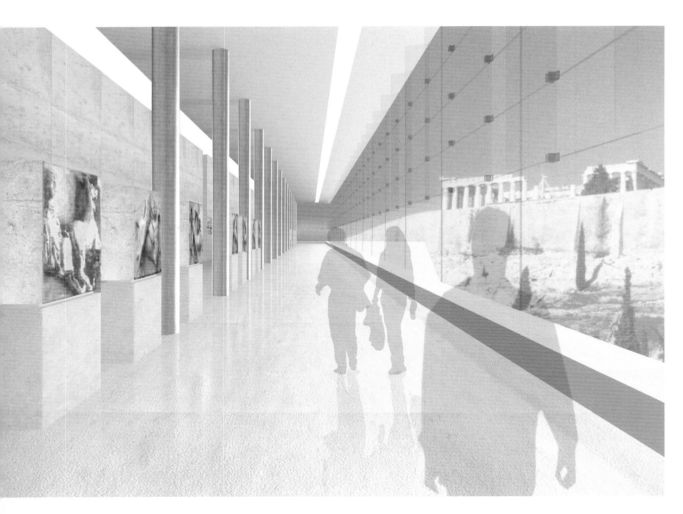

Parthenon Gallery showing views of the frieze and metopes, and of the temple (computer simulation)

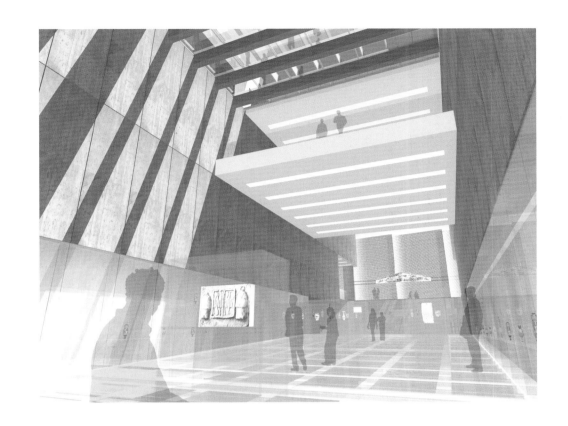

Atrium gallery
(computer simulation)

Archaic Gallery
(computer simulation)

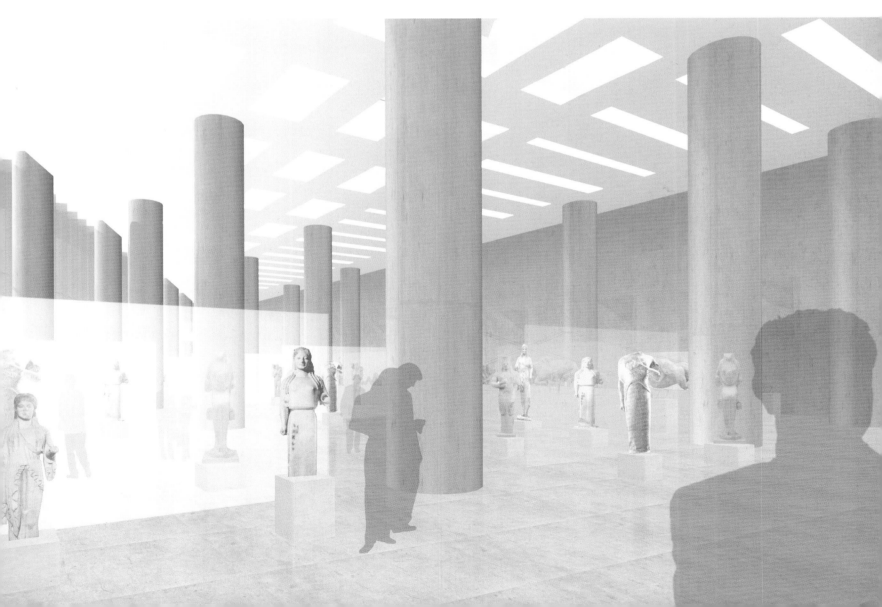

atelier brückner | ART+COM

Redesign of the BMW Museum
Munich, Germany

Client:	BMW AG
Design:	2002–2004
Construction:	2004–2008
Budget:	no data

Draft plans for the exhibition area in the circular building

Gathering momentum
The redesigned BMW Museum and
the future of exhibiting

A ramp runs dynamically through the room, past flickering media walls that appear to dissolve a spatial demarcation of the exhibition area. Glass walls backlit by LEDs dominate the central area of the BMW Museum, the low building originally erected as the west wing of Group HQ. Mass has seldom looked so thoroughly dematerialised. A generation on from the BMW 'Four-Cylinder' and the adjacent circular museum building by Karl Schwanzer (known as the *Schüssel*, or bowl), BMW has entered the 21st-century exhibition landscape with its expanded museum.

BMW was a pioneer in moving from a simple sales business to a brand museum. The circular building by Karl Schwanzer, which opened its doors on 18 May 1973, has long become an architectural classic, a symbol of Munich now protected by listing and therefore not available for changing or extending at will. Besides it stands a building that has hitherto attracted little public interest – the low building between the museum and the office tower block. It was once the canteen and training centre, but is now the shell of an externally extremely restrained but, in fact, mould-breaking expansion of the museum. It increases the exhibition floor space fivefold to around 5,000 square metres.

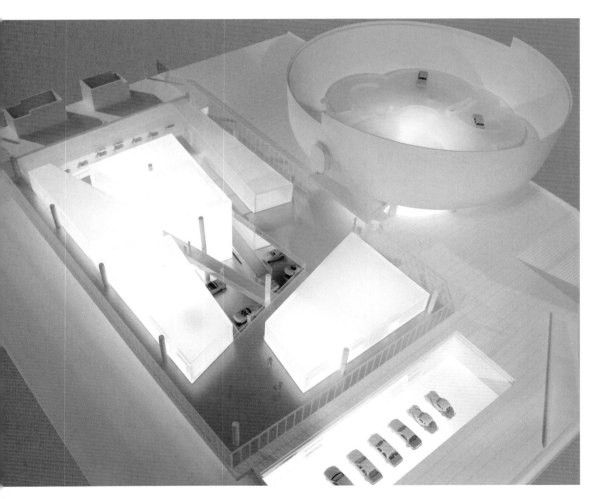

Model; circular building and adjacent low building

One of the first roughs

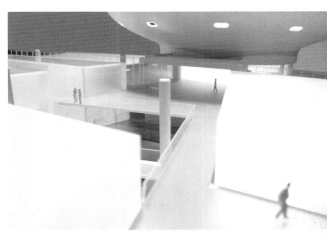

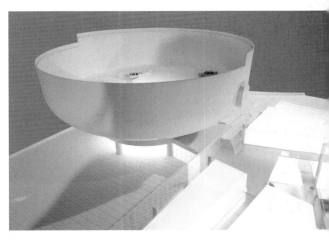

Conversions are among the most demanding tasks an architect can face. What makes them so much more onerous, as opposed to designing from scratch, is that the architect has to take the location and its history into consideration along with the concept and legacy of its predecessors – and, of course, the statics and materials of the past as well. In the case of the BMW museum, it was not high-profile architects who were brought in – bought for their style – but experienced specialists in exhibition design. The architects and scenographers of Stuttgart-based atelier brückner and the media design people at ART+COM from Berlin have been collaborating with the BMW project team on the redesign of the museum since April 2002, backed by the graphic design skills of Ruedi Baur from Zurich.

The revamped museum will open in the spring of 2008, a generation after the original building, which has been subsumed into a completely new exhibition complex – the familiar overhanging circular *Schüssel* building alongside the externally likewise familiar but internally redesigned low building, which is now a fundamental part of the BMW museum. Completely gutted and expanded, the latter building is in-

ternally unrecognisable. Three new stairwells hold the featherweight structure, while 300 tons of steel now support media walls, showcases and ramps in the room. The fussy support frame of the previous function rooms was removed. In its place comes a 13-metre-high shell containing an urbane ensemble of houses, streets, squares and bridges. When animations and picture sequences are being shown on the LED walls, the road seems to be the destination, lending the architecture vitality and dynamism.

This is where Schwanzer's central idea at last comes fully into its own: the road in the converted space. The original building treated it as a simple spindle; Schwanzer's successors from Stuttgart and Berlin have created a winding track cutting across the rooms, connecting houses and squares, and offering a succession of new perspectives on the exhibits.

Rectangular leading to circular

Whereas Schwanzer's museum building provided a smooth upwards movement via its ramps and access roads – though it echoes not only Frank Lloyd Wright but also traditional, multi-storey

Model, detailed views

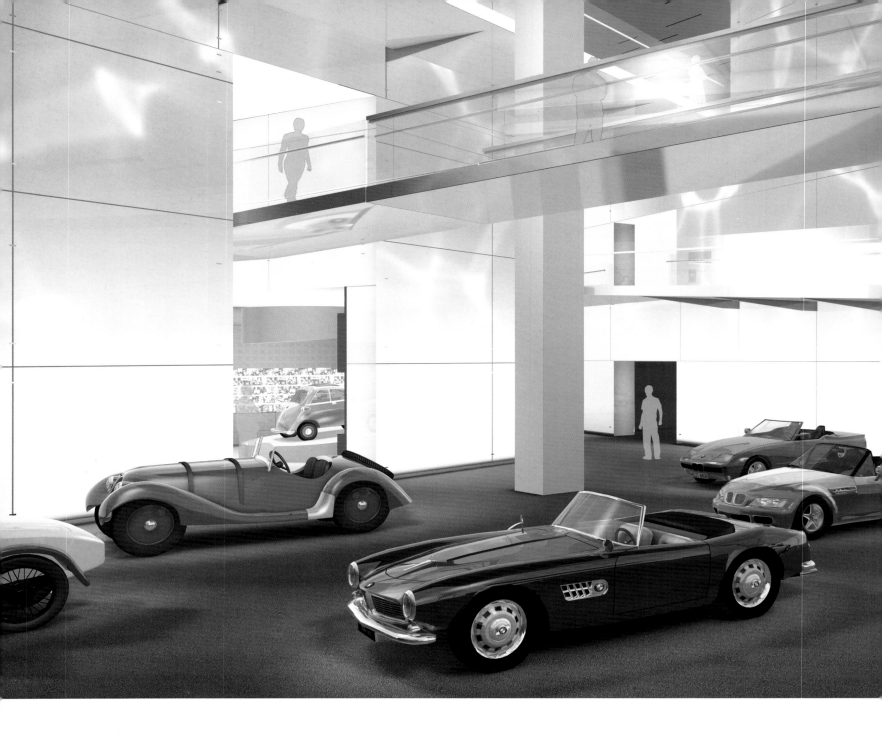

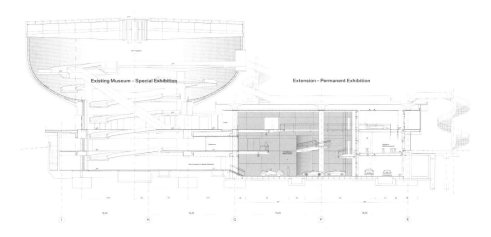

Draft plans for the exhibition area in the circular building

Section; the rooms for the temporary exhibitions in the circular building and the zones for the permanent display in the adjacent low building

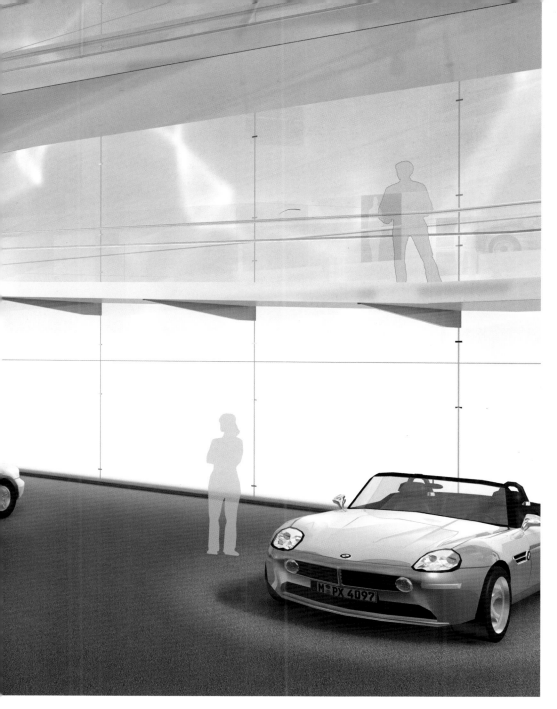

there is a lightweight steel building with frosted-glass surfaces and backlit panes, followed by a fully up-to-date media tour with tall, dynamic LED façades, which have a total area of 660 square metres, the steady upward movement culminating in the brilliant finale of Schwanzer's concrete sculpture of 1973.

The Austrian architect's structure for the museum 'bowl' was, in its day, cunningly concealed. While the lightweight concrete shell is reminiscent of a car body and is, indeed, comparatively lightweight, inside there are six massive piers carrying the load of the various platforms. Arranged like waterlily leaves, the latter form a circuit through the exhibit areas, which are neither black box nor white cube. They constitute a wholly distinct spatial experience – Schwanzer was here interpreting the psychedelic 1970s in architecture. Visitors spiral upwards from platform to platform in the half-darkness, in an open, apparently unlimited exhibition landscape. Then, suddenly, something happens that the building promised outside: a single, large space, a panorama in the original sense of the term, opens up, updating its cinematographic forebears of the 19th century. A six-meter-high, unsupported circular space rests on 120 metres of unfurled wall. Space becomes an experience, and architecture dissolves into multiple projections.

In the centre of mobility

Munich's focal point is shifting northwards. Herzog & de Meuron's new football stadium gleams beside the motorway. The buildings along the Mittlerer Ring form an immense new skyline beside the classic 99-metre-high, 'four-cylinder' BMW head office. Opposite the roofs of the Olympia Park, a constructed landscape of Alpine slopes now has an inverse counterpart in the

car park architecture – the low building comes across as a world of corners and edges. What initially looks like a deliberate break with the past because of the structural parameters of the job also contains a psychological change of step. An interesting museum circuit requires a span of excitement – attention has to be choreog: aphed. Two arrangement systems are contrasted precisely at the interface of classic modernism and the digital future – soft and hard, fluid and angular. If visitors spend two or three hours in the exhibition buildings, this interface of new and old acquires particular importance. At the beginning

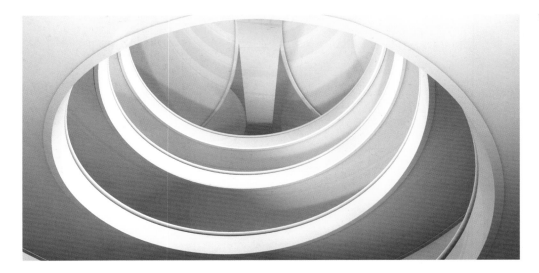

Frosted glass and LED structures

Detail of the fastening systems of the heavy glass panes

dynamic roof of the new BMW delivery centre – BMW Welt (completed by Coop Himmelb(l)au in October 2007 and not explored here). Architectural history has rarely been as tangible as here – classic modernism and digital modernism intermeshed and reflecting each other in the centre of mobility, directly by the city motorway.

Schwanzer designed the distinctive BMW high-rise building and the bowl-shaped museum building as complementary to each other, more effective as a combination than singly. The slender elements of the 'four-cylinder' emphasising the verticals – they are, in fact, suspended from the roof and need the counterpart of the terra firma-based volumes of the museum, which grows upwards from a slender base. How much the two structures are interdependent will be clear only after BMW Welt is added as a third element. 180 metres long, 130 wide and just under 28 metres high, BMW Welt forms a counterweight to the existing architecture, so that a new ensemble is created. This is not just because a bridge connects the delivery centre with the museum as a kind of archway – the conical upper part of the undulating steel structure also corresponds to the museum bowl.

The bridge curves from BMW Welt over to the museum as an invitation to explore the history of the car manufacturer. What is being built here is no ordinary exhibition building. This is a brand museum that tells stories and expounds history. The BMW museum is intended to break through the limitations of built architecture and liberate the converted space. The LED walls are not simply presentation media in the exhibition space – they also contribute to dematerialising it. The walls are in motion; it is the visitors who stand still. It is paradoxically enough a fulfilment of the Futurist dream, annulling the existing order and paying homage to the beauty of speed. Architecture becomes a dynamic communicative surface that, in turn, suggests change and acceleration. This is how the future of exhibiting might look. It is being realised in the context of what visitors might expect from a motor museum appended to a motor manufacturer that cultivates its image. The tour takes visitors through 25 exhibition areas with around 120 original exhibits, including aircraft engines and motorcycles. At the heart of the display, however, are cult vehicles, such as the BMW 2002 or the Roadster BMW 328, and 507 models, which as exhibition objects represent mobility and BMW innovation in the BMW museum.

Thierry Greub

The interplay of architecture, exhibits, media and light in the centre of the redesigned museum

Section; the circular building with a projection of the 360° panorama in the upper zone

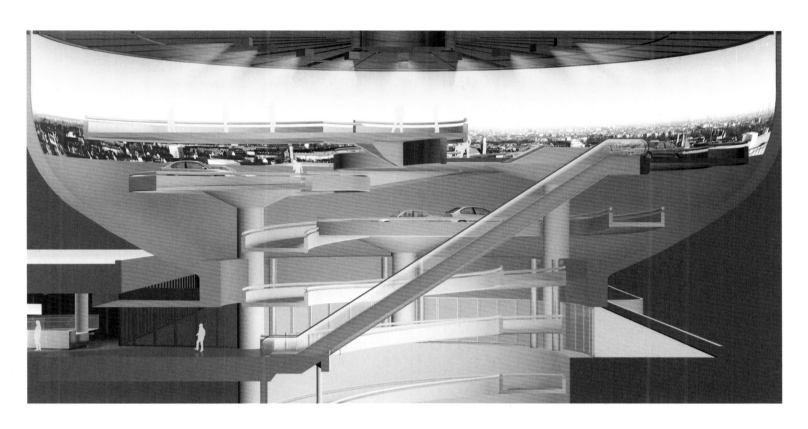

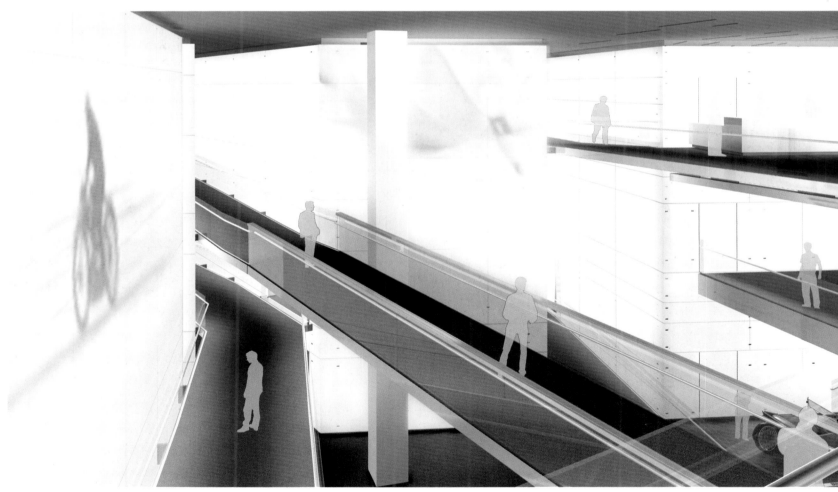

Zaha Hadid Architects

MAXXI, Museo nazionale delle arti del XXI secolo
Rome, Italy

Client:	Italian Ministry of Culture, Rome
Design:	1997
Construction:	2003–2009
Budget:	ca. 70 million euros

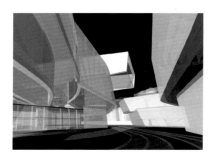 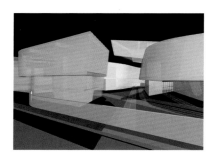

Exterior views (computer simulation)

Main entrance (computer simulation)

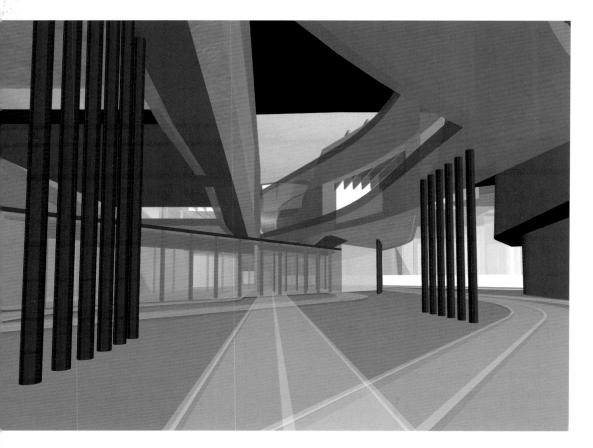

Suspended art

Zaha Hadid's project for the Contemporary Art Centre in Rome is an important and unexpected crossover between the architectural history of the city and the career of an architecture superstar. In mid-1990s Italy, state and city governments were trying to shake a disturbing condition of architectural understatement by developing a new policy for "the promotion of contemporary architecture" – a policy with different domains: legislation, cultural activity and competitions. The path that led to the foundation of the CAC (now MAXXI, Museum for the Arts of the XXI Century) and to the international design competition united all these aspects: the creation of a new specific agency for contemporary arts and architecture in the Ministry of Culture; a strong desire for novelty and international glamour; and general acknowledgement that a larger number of international competitions would be an appropriate way to achieve innovation. Further evidence of this approach is found in the site chosen for the new centre: midway along the astonishing architectural promenade that goes from the site of the Auditorium designed by Renzo Piano (still under construction when the competition began) to the modernist Olympic Village by Libera and Moretti, and then, passing by the beautiful Palazzetto dello Sport by Nervi and Vitellozzi, to the magnificent 1930s urban perspectives of the Foro Italico across the river. CAC had therefore to be thought of as an architectural set piece inserted in a larger open-air museum of architecture.

Stage one of the competition consisted of an open international call for architects. Of the 273

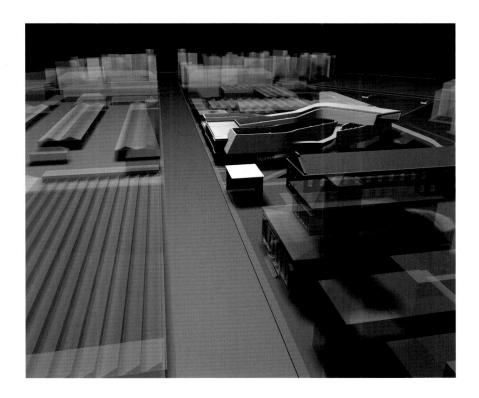

Aerial view from the east (computer simulation)

Aerial view from the west (computer simulation)

entries, 15 were selected for stage two, to be completed by February 1999. The jury, which included Jacques Herzog, Richard Gluckman, Gino Valle, Alessandro Anselmi, chose six Italian and nine foreign firms. Among those chosen were Steven Holl, Rem Koolhaas, Souto de Moura, Toyo Ito, Kazujo Sejima, Jean Nouvel, Vittorio Gregotti and Zaha Hadid. The number and quality of the entries and the list of finalists were clear signs of the expectations the competition raised in Rome and in the architectural community.

The competition brief was based on two main issues: the museum programme and the urban condition. The museum programme was rather loose. The new institution had not yet appointed a curator and Sandra Pinto, Curator of the Galleria Nazionale di Arte Moderna and competition coordinator, explained that the new museum would initially host only a few art works currently located in the GNAM collection. By contrast, the 'urban' programme of the building was tight and ambitious, based on a desire to establish multi-scale relations and pathways through the site and to challenge differing urban contexts on the two main orientations.

Hadid's proposal showed ways to satisfy the duality of a building based on a certain lack of programme but with a clear urban role. This may explain why Hadid won the commission. On the one hand, her project is a spectacular urban machine, transforming the future traces of the flows of visitors and citizens through the building into an impressive contemporary urban sculpture. On the other hand, she turns the footprints of this movement into dynamic and indefinite exhibit space, apparently ready to be shaped only by incoming art, suspended in the large,

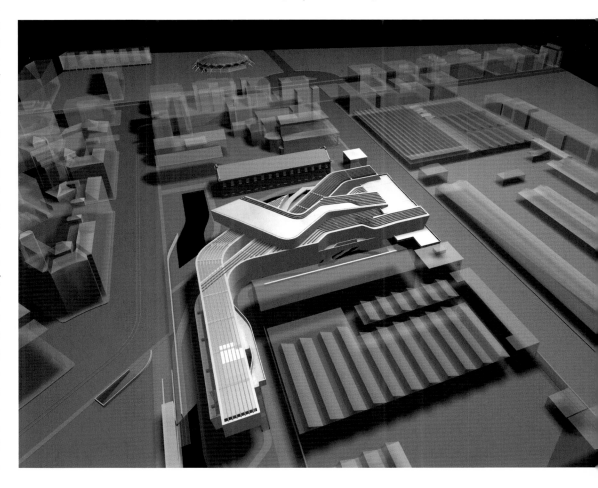

**Views of the roof area
(computer simulation)**

**Ground plans:
roof and ground floor**

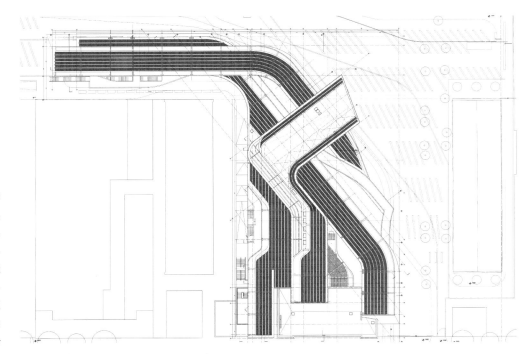

open halls. The first impression given by the competition drawings is of a series of layers, overlapping public space, pathways and galleries. A closer look at the final presentation and construction drawings makes clear that the different layers merge and shape a continuous and animated space, less conceptual, more sensuous and most effective in terms of urban continuity: "…the museum expands in the city, the city enters the museum". In the same interview, Zaha says: "…You might almost say the Rome project is a sort of Peak project melted down. This idea of a series of levels is connected to my initial interest in geological formations and geology. I think that if these analogies are considered today, after all our experience in dealing with the overlapping, interpenetration and juxtaposition of space, then we need to recognise that we've found a decidedly more fluid way of expressing these concepts."[1]

In the search for a progressive CAC, the city of Rome sought an artefact appropriate for the monumental context of the site and worthy of placing Rome in the itinerary of current masterpieces of architecture. Hadid's proposal appeared to the jury as the only one that gave a strong and believable answer to this quest. Rem Koolhaas, Steven Holl and Eduardo Souto de Moura were her close competitors in the final run, but OMA's

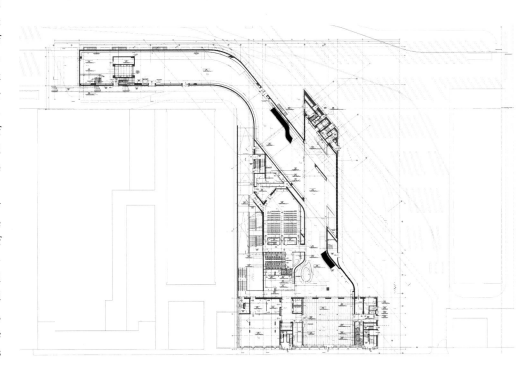

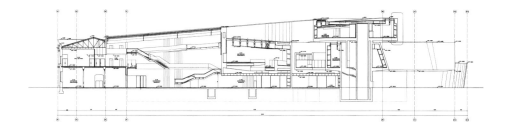

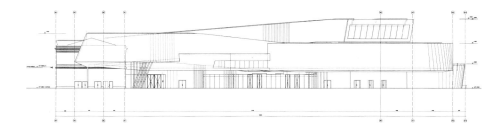

entry was too conceptual, lacking in memorable imagery; Holl and Nordensen, on the other hand, by enclosing the different identities in a single building, however attractive, did not challenge the complexity and flexibility of programme, while Souto de Moura's project was too cleverly timid, changing very little of the old site, perhaps in keeping with the typical Italian attitude favouring architecture conservativism. The jury's criteria included architectural quality, relation to the context, creativity and feasibility, and Zaha seemed to have all the right solutions: her design was based on the idea of a space widely open to the public and the city, carrying a strong architectural image, and sensitive to the cultural programme of the institution. At some point, the jury and the media questioned the feasibility of the long, curved boxes floating in the air but such concerns seem to be a minor obstacle now that the project is finally under construction.

While working on the Rome design, Zaha Hadid completed another Contemporary Art Centre – in Cincinnati. For that small, downtown building, the emphasis is all in the articulation of the masses in the façade and on the long path through the galleries, which are rather small, completely dark and tight. In Rome, the building is horizontal rather than vertical, each gallery achieving its own spatial status, with an imme-

Sectional view and view from the east

Interior views:
entrance atrium and internal partition system (computer simulation)

Sectional view and view from the south

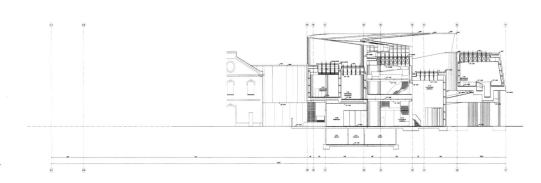

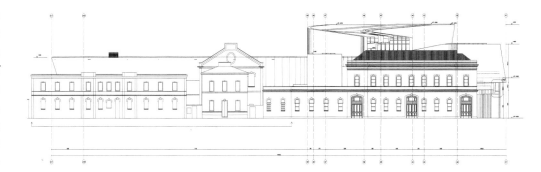

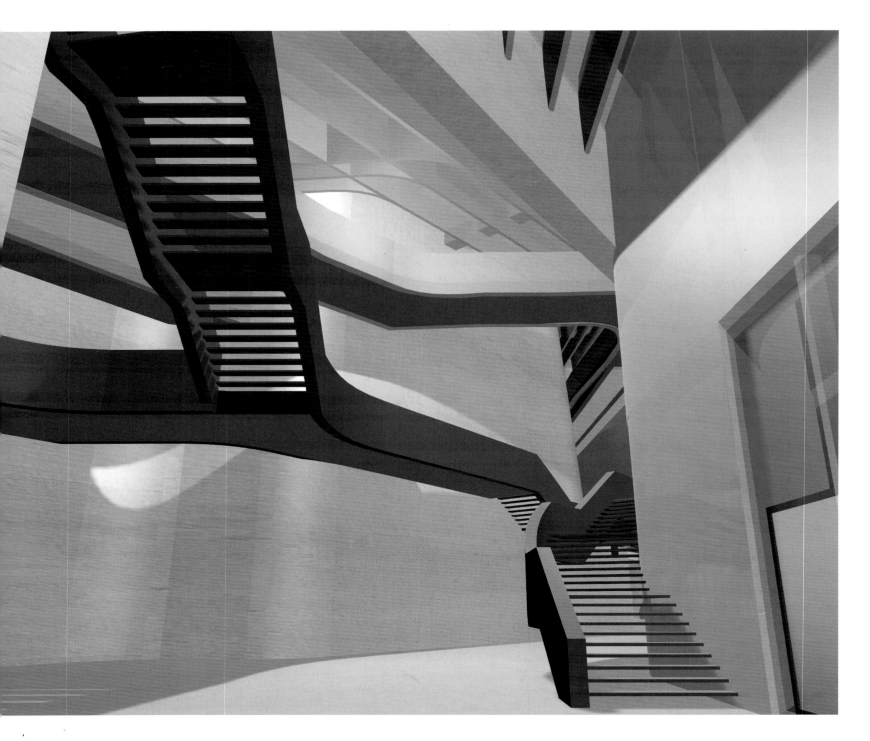

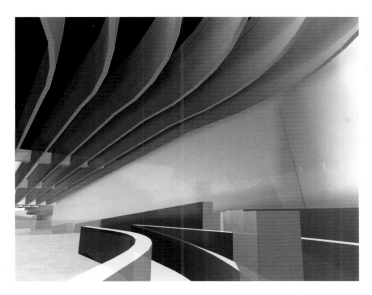

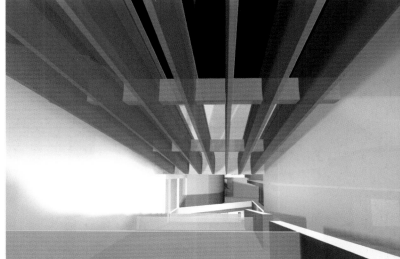

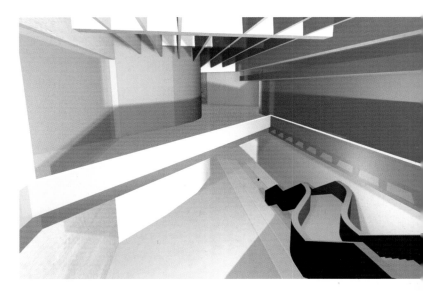

diate and sophisticated access to natural light for a wide and flexible range of exhibit spaces and installations.

The building is expected to be completed by the end of 2008, with a final budget of about 70 million euros. Interestingly, the building is still under construction yet MAXXI is already developing its exhibitions practically within the construction site, in one of two existing barracks that Zaha Hadid preserved and included in her design. This will probably help the institution to move into the new building in early 2009 with a clearer curatorial profile and stronger cultural identity.

Pippo Ciorra

1 Mohsen Mostafavi, "Landscape as Plan. A Conversation with Zaha Hadid", in: *El Croquis*, no. 103 (Madrid 2004), pp. 40 f.

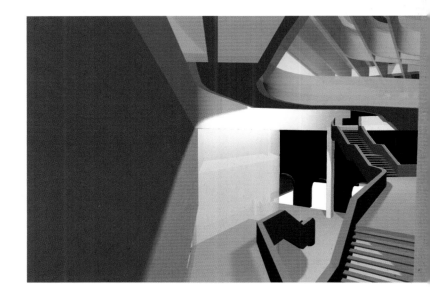

Coop Himmelb(l)au

Musée des Confluences
Lyons, France

Client: Département du Rhône
Design: 2001–2002
Construction: 2002–2009
Budget: 152 million euros

Conceptual sketches

Model, 2003, entrance

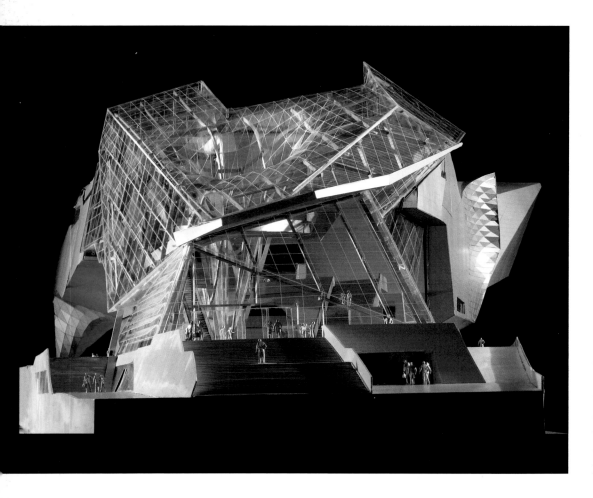

A museum as a three-dimensional 'access provider'

Presumably, the Département du Rhône had the 'Bilbao effect' in mind when it awarded the building of a new museum of science and ethics to Viennese architects Team Coop Himmelb(l)au, and chose as a site the auspicious but very neglected spit of land where the Rhône and Saône meet in the centre of Lyons. As in Bilbao earlier, the aim was to reclaim an industrial brownfield site completely cut off from the city centre by rivers, motorways, railways and bridge structures. The competition winners from Team Coop Himmelb(l)au, Wolf Prix and Helmut Swizcinski, seemed just the people for the job, having spectacularly demonstrated with the East Pavilion of the municipal museum in the inland port of Groningen, in Holland, in 1995 how to react to heterogeneous situations with strikingly appropriate architecture. The new Musée des Confluences in Lyons likewise occupies a 'non-place' in the city centre programmatically, and its symbolic qualities radiate far beyond the immediate precinct, over the spit and surrounding district and even features in the silhouette of the city as a whole.

The new ensemble consists of basically four components: the plinth, the Crystal, the Cloud and the Landscape. The structures are divergently oriented on the one/two-storey plinth, which anchors them solidly to terra firma and also contains all the infrastructural facilities that a museum of this size requires. The plinth is linked with the Cloud via three vertical concrete nuclei. On its 'roof', which is also the entrance level, a large pool reflects the structures that loom over

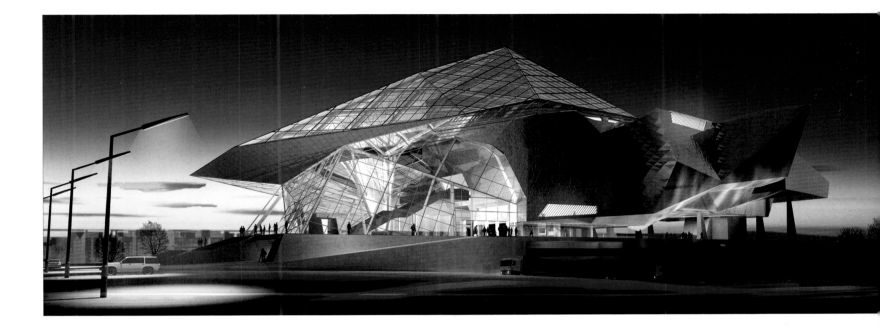

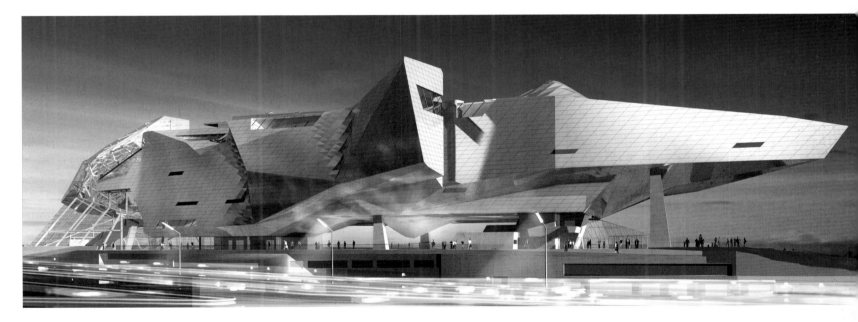

it, binding the concrete plinth into the newly-designed Museum Park.

The north-facing Crystal, oriented towards the city centre, rises to a height of 40 metres and has two functions. It is in the first place a public space, freely accessible where people can meet, linger and do a variety of things without visiting the museum. At the same time, it naturally acts as an 'anteroom' to the museum. It is a dynamically open, multifunctional feature, transitory in the best sense of the word. It is neither heated nor air-conditioned, but has passive energy and ventilating systems. The Crystal will presumably become the most important new social facility in the city of Lyons, open to all and for any purpose. To emphasise this, it is dominated by an expressive, dynamic interplay of forces reflected in the light – light that differs dramatically according to the time of day and season. The glass facets of this part of the building are mounted in a very complicated, inwardly-upturned, pointed, funnel-shaped, filigree support structures clad in

Crystal and Cloud
(computer simulation)

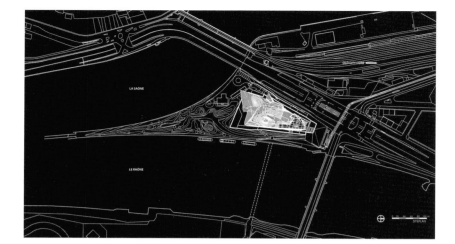

Site plan

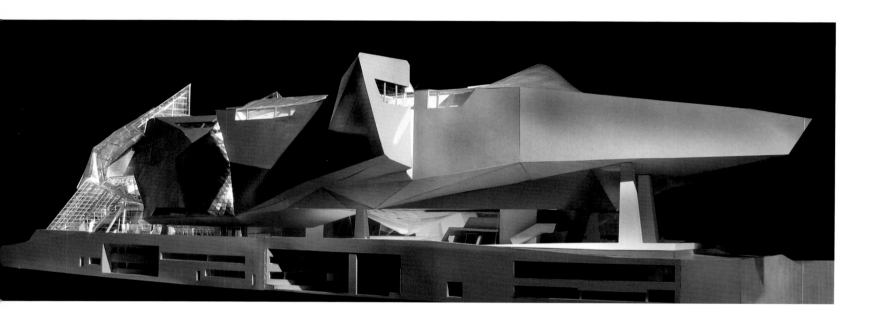

Model, 2003, view from the west

Unfolded Crystal

Surface-structure studies

grey-coated steel. The crystalline structure in Lyons is thus a logical development of the crystal that Coop Himmelb(l)au designed for the UFA cinema complex in Dresden in 1998.

In contrast, the Cloud in Lyons is an innovation, though conceptually linked with the works of Coop Himmelb(l)au during the 1960s and 1970s. The three-storey Cloud with its opaque cladding contains the administrative offices and, most importantly, the ten exhibition rooms. Three of these are for the permanent exhibition, while the rest are reserved for temporary installations. A kind of open, organic passage (espace liant) runs through all the exhibition areas, connecting them as a kind of network or weave. With a maximum height of just under 28 metres, the elongated Cloud is noticeably lower-set than the lofty vertex of the neighbouring Crystal.

The Museum Park as a totality is a wholly new artificial landscape. In the end, it is a place where all lines of movement and thrust, topographical traces and vectors of the city and the new buildings meet in balance. The new land-scape does not attempt to gloss over fault lines or warpings but constitutes a vivid reaction to the newly-opened-up force field between the museum building, the history of the site and the surrounding areas of the city. The result is an artistically self-sufficient but nonetheless involving and, above all, socially stimulating new urban landscape of high quality.

However, even more important than the buildings themselves and the parks seems to be the desire of the architects that users should see their new Museum of Science and Ethics not as a finished building but as completely the opposite – a programmatic ensemble of three-dimensional, dismantled borderlines, transitions and tendencies toward hybridisation. The focus is not on an architectural shape set in concrete once and for all but one that is analogous to the constantly changing subject content of the exhibitions within – mutations of form, deformation, inter-penetration, dissolution and variability. The museum architecture thereby tends to become more a vehicle for social processes than a mirror of col-

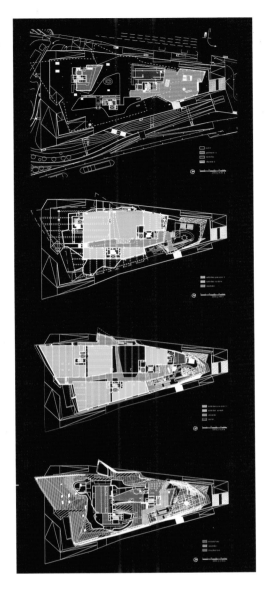

Ground plans: level +0,00, +8,84, +15,64, +27,03

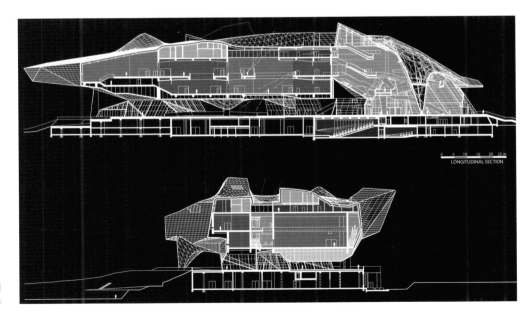

Longitudinal and transversal sections

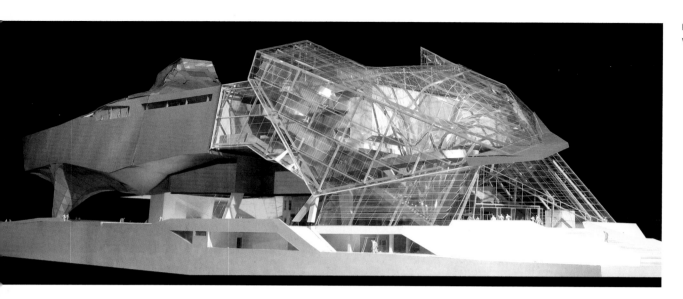

Model, 2003,
view from the east

lected knowledge and accumulated facts as we know them. The architecture that results from this consistently eludes any articulation as a sacrosanct work of total art, but is conceived as a momentary snapshot in concrete and steel of the overlapping, merging and amalgamation of a wide range of processes. Thanks to its architecture, the museum becomes a visual place of reflection and healthy uncertainty. Instead of finding themselves facing an exclusive museum temple of the educated middle classes, visitors are confronted with the logical image of a three-dimensional server, a built 'access provider' to the knowledge of our time that seems to stimulate us into making active, direct use of it. Moreover, the architecture of the Musée des Confluences adds a new category to the known typology of museums – the public leisure facility that is social in the best sense. Coop Himmelb(l)au are thus opting for a strategy similar to Rem Koolhaas's, whose recently completed Public Library in Seattle is conceived less as a hi-tech book depository than as a 'social condenser' on a hitherto undreamt-of scale.

It was the hybridisation of museums first taking architectural shape here in Lyons and not formal, aesthetic considerations that led to what we shall shortly see as a completed entity: the Crystal facing the city will become the urban forum. Meantime, the Cloud will contain 'future knowledge', as Coop Himmelb(l)au put it. They have thus made a soft texture from "hidden cur-

rents and countless transitions" – a web of alternating locked black boxes and free exhibition areas. To achieve this, the architects exploit the double height of the two exhibition areas in a variety of ways, nearly all of them spectacular. Over and beyond its didactic purpose, the museum is deliberately conceived as a three-dimensional experimental arrangement for "stimulating public curiosity". From the point of view of the urban landscape, the borderline between inside and outside is dissolved into a sequence of three-dimensional events by a landscape of ramps and planes.

In short, the 'Bilbao effect' seems to be imminent in Lyons as well. In both places, the successful reinvention of the site becomes an ensemble of urban social events. The added-value feature in Lyons is the architecturally fascinating reinterpretation of a museum as a server or access-provider. This gives the city of Lyons a head start in both a regional and global context.

Frank R. Werner

Cross-section: gravitational funnel

Interior view of lobby
(computer simulation)

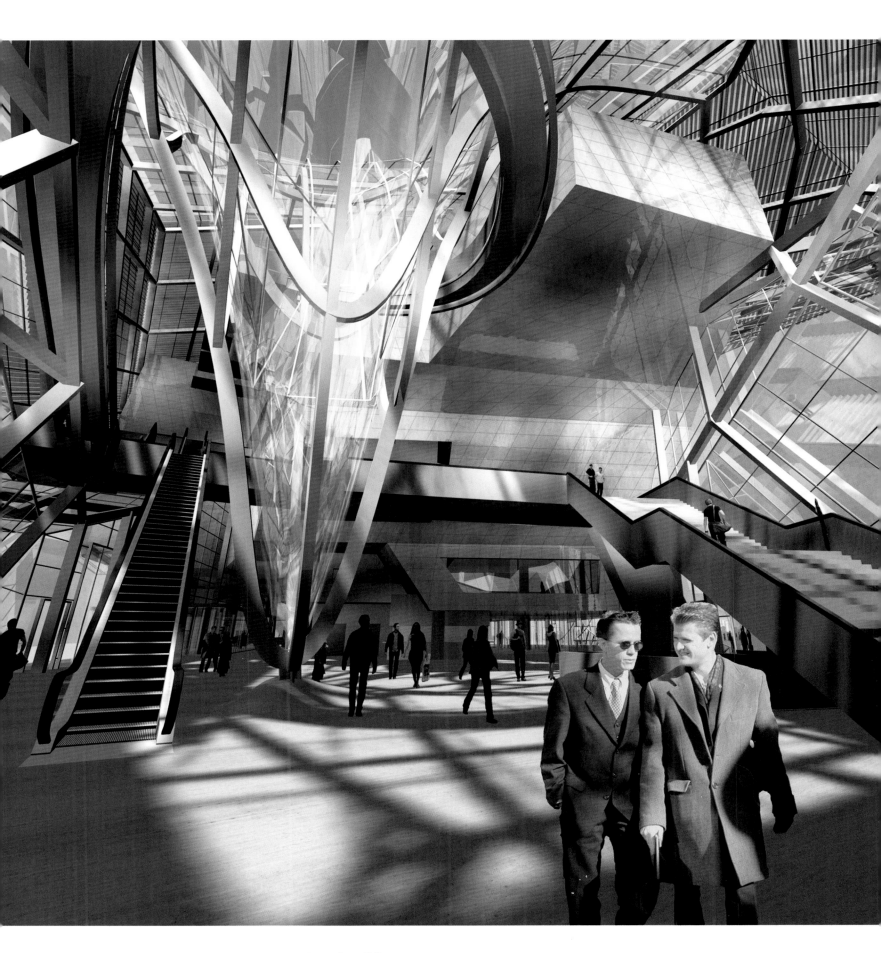

Anamorphosis Architects

Museum of the Hellenic World
Athens, Greece

Client:	Foundation of the Hellenic World (FHW)
Design:	2002–2006
Construction:	2009–2011
Budget:	35 million euros

Draft: Greek theatre (Classical Antiquity), dome (Byzantium), sheltering cell (Modern Era)

Master plan model, 2002–05, The Thematic Park of the Hellenistic Cosmos

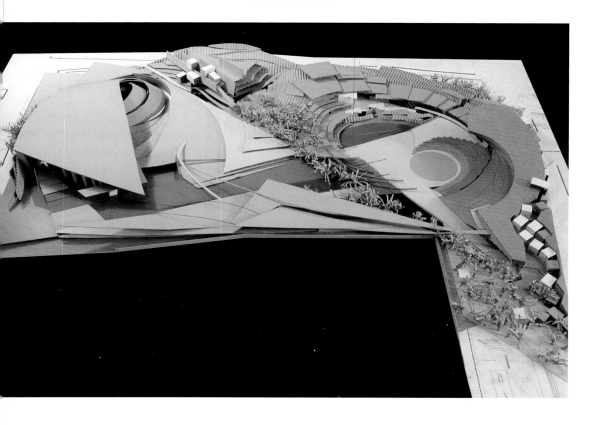

Historic museums are a special case in that the exhibits in them are documents, fragments and sections of an imaginary, not directly tangible world. History is reconstructed from chance remnants, so that the picture of the past that emerges is not infrequently distorted.

In view of these limitations, Greek architects Anamorphosis[1] came up with the idea of a museum without original exhibits – a first in museum history: a museum that would be based solely on conveying history by contemporary means of communication. Since 1992, the founders of the architectural firm – Nikos Georgiadis, Panagiota Mamalaki, Kostas Kakoyiannis and Vaios Zitonoulus – have been exploring urban and virtual experience spaces, largely on a theoretical basis in the wake of Georgiadis's psychoanalytical spatial research work. The project is now funded by about 35 million euros from FHW. Originally, the client had envisaged a conventional museum in an industrial building, but Anamorphosis reacted by putting forward its novel approach. Actual work on the structure is due to begin in 2009 and be completed in 2011.

Using their psychoanalytical spatial concept of emptiness,[2] the architects translate the content to be depicted – the history of Hellenic Asia Minor, from its beginnings up to today – into spatial experiences, or, as they themselves call it, a three-dimensional monument. This anti-object concept of exhibitions and museums is, in the first place, a criticism of the collecting and purchasing activities of museums and the removal of Greek cultural assets – the empty space literally symbolises the lack of historic objects. Secondly, it is a criticism of architecture that mutates into an advertising medium. The formal design of the

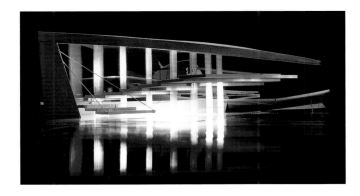

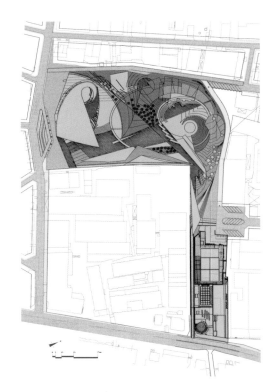

Night view with water installation

museum and the museological concept are therefore in accord – the architecture is not just a container for the exhibition nor is it its architectural representative. The architects blend shapes, thereby demonstrating the coexistence and simultaneity of the past, involving the viewer's physical movement and psyche in the design of the spatial structures.

A continuous contorted strip forms the path visitors follow through the three 3-dimensional gestures, which develop homeomorphously from a common basic form. The differing spatial qualities of the theatre, the dome and the cell are created by varying the use of lighting, material, depiction and function:

Classical Antiquity (Greek theatre)
- Bright daylight, hard shadows
- Tectonic materials – marble, stone
- An encounter with materials and objects plus a hybrid introduction of the landscape
- Assembly, meeting point

Byzantium (dome)
- Indirect, diffuse ambient light without shadows
- Material for casting
- Graphic and mosaic-style treatment of surfaces
- Dense, congregation-style arrangement

Modern (concealing cells)
- Cinematic light from the side, long shadows
- Wood, glass, metal structures
- Solidarity, relationships
- 'Dramatic' image

In short, Anamorphosis are deliberately making a break from familiar museum typologies and rejecting the series of rooms such as the classic *enfilade* or even the museum without walls. With the overlapping levels, the intention is to bring out the connection between Greece and Asia Minor in prehistorical and early historical, Hellenistic, Byzantine and Modern times. Typo-

Master site plan,
the Thematic Park of the
Hellenistic Cosmos

Model, 2003, view from the
north

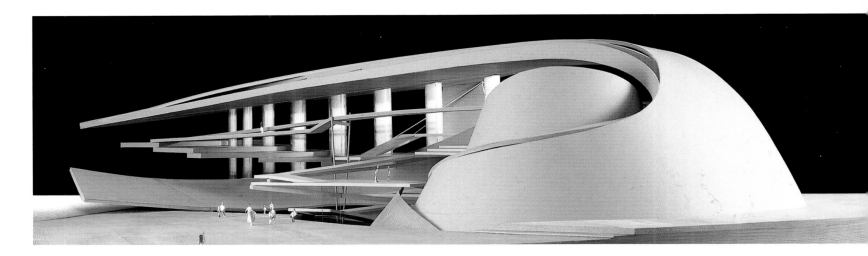

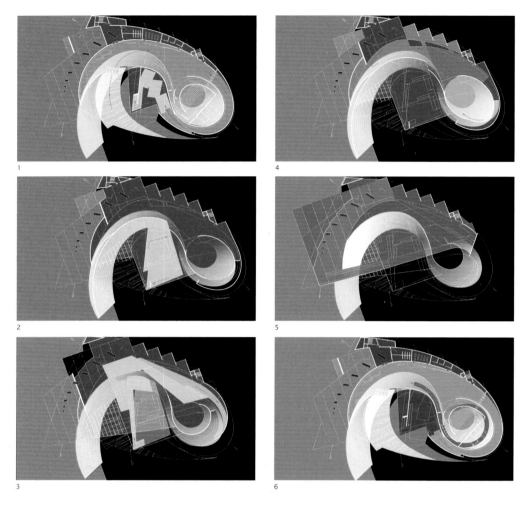

1 Ground plan: entrance and Prehistory
2 Ground plan: Classical Antiquity
3 Ground plan: Alexander the Great and
the Hellenistic Period

4 Ground plan: Byzantium
5 Ground plan: Modern Era
6 Ground plan: exit route

Draft model, 2002, The Physicality
of Historical Forms

Fig. 1: Frederick Kiesler, Endless House, model, 1959

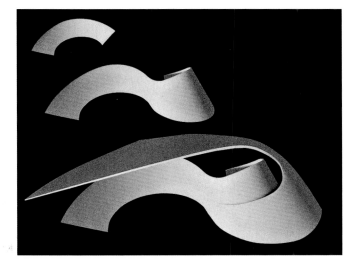

Self-anamorphosed surface

Structural model, 2002

Model without the roof, 2003

logically, the museum is comparable to a cave or a shell you put to your ear in order to hear alien or familiar sounds from afar. According to Gaston Bachelard,[3] shells are a psychological place where the dialectic of large and small is inherent – the motion out of the shell into the world. "Thus the spiral being, which externally looks so nicely arranged round its centre, never reaches its centre. The existence of mankind cannot be fixed."[4] The anthropological constants of a cave, a roofed cell and an open space are seen by Anamorphosis as a back translation of historical spaces into psychic and physical qualities of space, with the designers abstracting archaic models and transferring them conceptually to their spatial programme. Since the viewer's own movements are involved, the three installations can be experienced differently: when the viewer enters the space or goes past it. Thereby the rooms merge to become a complex organism and create new situations, rather like the way Frederick Kiesler proposed in his Endless House in the 1950s, when he took everyday habits of the user as the starting point for his formal design (fig. 1).[5] UN Studio produced an exemplary implementation of Kiesler's approach in the Mercedes-Benz Museum (see pp. 114–19). Whereas Ben van Berkel and Caroline Bos adopt the spiral

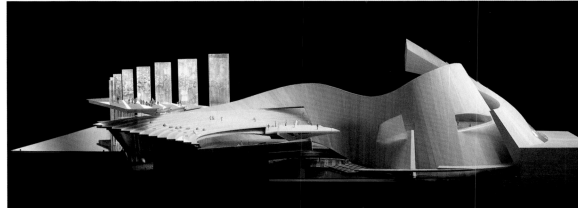

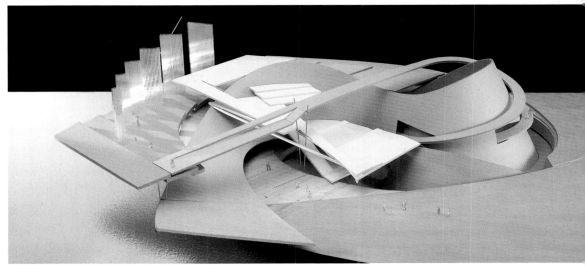

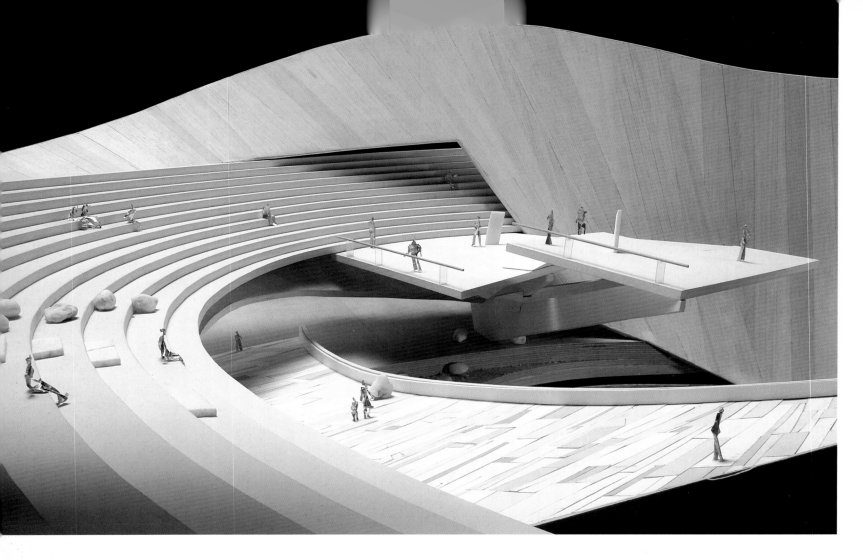

Classical Antiquity (Greek theatre)

ramp of a modernist car park for the content of the car museum, interweaving the loops of two ramps running in opposite directions and twisting inside and outside, in Anamorphosis's performative architecture the history and culture of man are the focus. The individual rooms are likewise accessed via a ramp, but like a thread of DNA it winds slowly upwards, leading to changing views and links of the "spatial installations, whereby the rooms are constantly redefined and functions shifted. The actual shift is less important than the awareness of a permanent potential capability of spaces and functions to be shifted, or even the pictorial shift".[6]

Although the Museum of the Hellenic World in Asia Minor deviates from the rules of a normal museum with exhibits, a symbiosis of event and work is constructed through the performative and psychostructural layout that draws the visitor in and establishes a common basis, namely the experience of a *cultural identity*. Thus, real historical space and not history recalled is to the fore, which the architects also link with the difference between the words 'historical' and 'historic'[7] – just as history can be depicted through symbolic shapes and we ourselves are embedded in history through our own past, deposited as memory in the various rooms of a house.

Lilian Pfaff

1 Anamorphosis: an image or drawing that appears distorted unless viewed from a particular angle (Greek *anamorphosis* 'transformation')
2 Nikos Georgiadis, 'Lacking the Lack', in: "Extreme Sites: the 'Greening' of Brownfield", *Architectural Design*, vol. 74, no. 2, March/April 2004, pp. 122–25
3 Gaston Bachelard, *Poetik des Raumes*, 6th impression (Frankfurt 2001), p. 119
4 Ibid., p. 213
5 Though Endless House was never built, plaster and wire-netting models of various sizes were made. Cf. Frederick J. Kiesler: Endless House, model, 1959, in: Peter Noever and Dieter Bogner (eds.), *Frederick J. Kiesler, Endless Space* (Ostfildern-Ruit 2001), p. 31
6 Barbara Steiner, 'Performative Architektur', in: Angela Nollert (ed.), *Performative Installation* (Cologne 2003), p. 185
7 Nikos Georgiadis interviewed at the 8th Biennale, Venice 2002

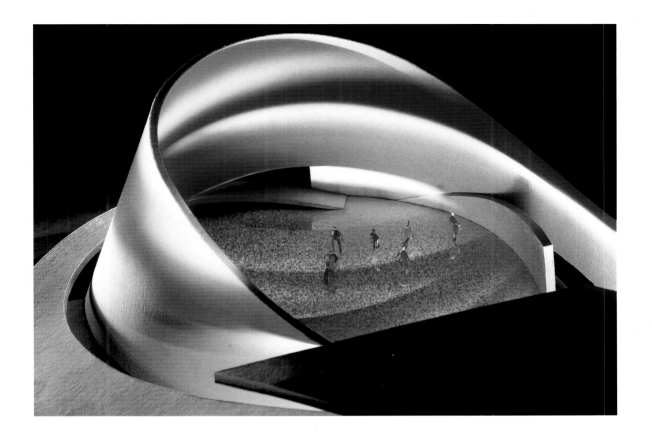

Byzantium (dome)

Modern (sheltering cell)

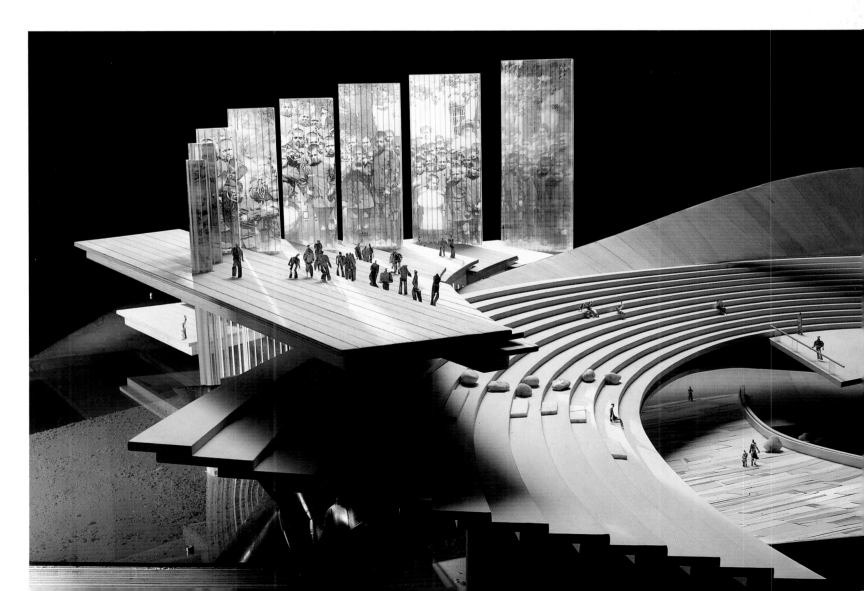

The Museum Island Planning Group, Berlin

The Museum Island
Berlin, Germany

Client: Stiftung Preussischer Kultur-
besitz, represented by the
Federal Office for Construc-
tion and Town & Country
Planning
Design: 1999
Construction: since 1999
Budget: no data

No other museum project in the 21st century is so deeply rooted in history as the Museum Island in Berlin. All the plans for its restoration, re-organisation and further development should therefore always be considered only in the context of its 175-year history.

In 1830, Karl Friedrich Schinkel's Altes Museum was opened as the first public museum in Prussia. Located on an elevated site on the northern edge of the Lustgarten opposite the royal palace and between the cathedral and the arsenal, it was a visible demonstration of the socio-political importance attributed to it as a new institution for the future. Free access to art would raise the educational standards of the citizens, transforming the capital of Prussia into a new Athens on the Spree.

Hardly had the Altes Museum opened when a first extension was deemed necessary. This was followed in 1841 by a momentous decision by King Frederick William IV to designate the whole area north of the Altes Museum to the tip of the Spree Island as a future "sanctuary for the arts and sciences". It was in effect the first 'master plan' for the area that is still called Museumsinsel (Museum Island). Specifying the ideal plan drawn up by Friedrich Stüler in 1841 in emulation of Schinkel, the Museum Island set the standard from the first for an approach based on antiquity. The idea of a developing museum city was unparalleled in a European context.

Surprisingly, this initial grand scheme survived the following generations intact. After the opening of the Neues Museum in 1859 and the Alte Nationalgalerie in 1876, plus the Kaiser Friedrich Museum (now the Bode Museum) in 1904, the final piece in the jigsaw of Frederick

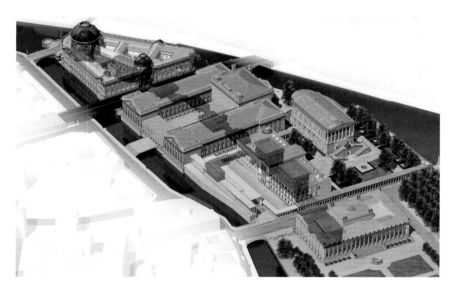

View of the Museum Island and the archaeological promenade
(computer simulation)

Site plan: (1) Bode Museum, (2) Pergamon Museum, (3) New entrance building,
(4) Neues Museum, (5) Alte Nationalgalerie, (6) Altes Museum

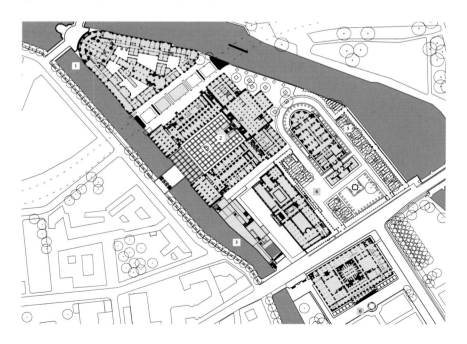

Historical photos of the museums
on the Museum Island, Berlin:
Bode Museum, Alte Nationalgalerie,
Pergamon Museum, Neues Museum,
Altes Museum

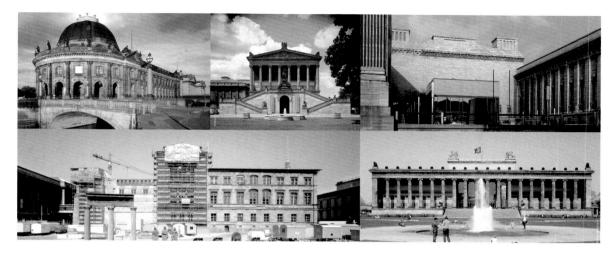

Historical photos of the museums on the Museum Island, Berlin: Bode Museum, Alte Nationalgalerie, Pergamon Museum, Neues Museum, Altes Museum

Master plan for the Museum Island, Berlin

Architects:	Museum Island Planning Group (David Chipperfield Architects/Hilmer & Sattler/ Heinz Tesar/O.M. Ungers/ Levin Monsigny/Polyform)
Design:	1999
Construction:	since 1999
Budget:	no data

Restoration of the Alte Nationalgalerie

Architect:	HG Merz
Design:	1993–1994
Construction:	02/1998–06/2001
Budget:	66 million euros

Overall refurbishment and design of the permanent exhibition of the Bode Museum

Architect:	Heinz Tesar
Design:	1997–2004
Construction:	1997–2006
Budget:	159 million euros

Rebuilding of the Neues Museum

Architect:	David Chipperfield Architects
Design:	1997
Construction:	2003–2009
Budget:	233 million euros

New entrance building

Architect:	David Chipperfield Architects
Design:	2007
Construction:	no data
Budget:	73 million euros

Refurbishment and completion of the Pergamon Museum

Architect:	Büro Prof. O.M. Ungers
Design:	1999
Construction:	no data
Budget:	no data

Refurbishment of the Altes Museum

Architect:	Hilmer & Sattler and Albrecht
Design:	1998–2003
Construction:	2010–2014 (earliest)
Budget:	approx. 85 million euros

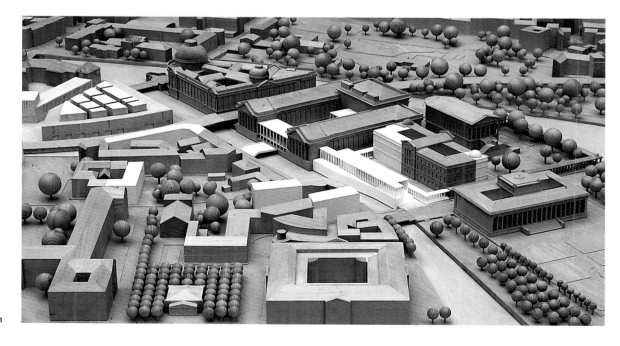

Site model: Museum Island, Berlin

Alte Nationalgalerie: view of the
main façade (after restoration)

Longitudinal section and view of
the main façade

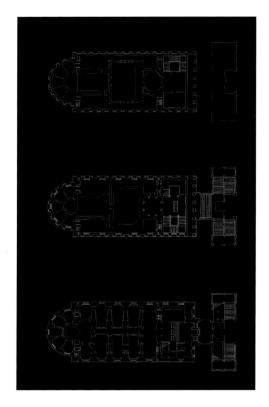

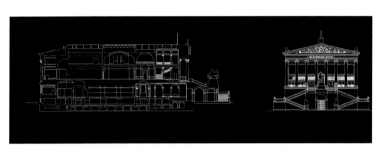

Ground plans of 3rd, 2nd and
1st exhibition floors

Wilhelm IV's original vision for the Museum Island was put into place for the centenary in 1930 with the completion of the Pergamon Museum.

Right from the start, Schinkel's design for the Altes Museum set a benchmark for the quality of museum architecture. The subsequent buildings on the Museum Island were also laid out to be expanding and effective statements of their cultural mission as publicly accessible treasure houses and places of scholarly research. This meant that the architecture was from the first faced with the conflicting requirements of accommodating constantly growing collections and providing appropriate and long-term facilities for the changing role and concept of museums. Generally, no sooner had the buildings been completed than they were found to be too small for the role envisaged for them. In complete contrast to the popular notion of the timeless permanence of museums as institutions, large parts of the collections have always been constantly on the move. In this historical development, the Museum Island and its collections grew into an ensemble that took on the character of a palimpsest in its architectural and conceptual variety.

Shortly after the completion of the Museum Island, a period of setbacks and destruction set in. During the Nazi period, the forced disposal of 'degenerate' art resulted in irreversible losses, while the consequence of World War II was the catastrophic destruction of the fabric. In sum, the art collections, buildings and the structure of the museums that had developed were so permanently damaged by the War and its political consequences that the original condition was lost forever. Whereas the buildings – apart from the New Museum – were rebuilt soon after the war, the works of art removed from them for safe storage generally did not return to their previous locations. A lot was destroyed. The whereabouts of a large number of works were found by American and British troops and the works were removed to West Germany, whence they were sent back to West Berlin. In 1958, a large number of the works shipped to Russia were returned to East Germany. But a lot still remains in Russia even today. Moreover, the partition of Berlin long ruled out any hope of the remaining collections being combined.

The reunification of Germany brought a turn in the fortunes of the Museum Island. Barely two

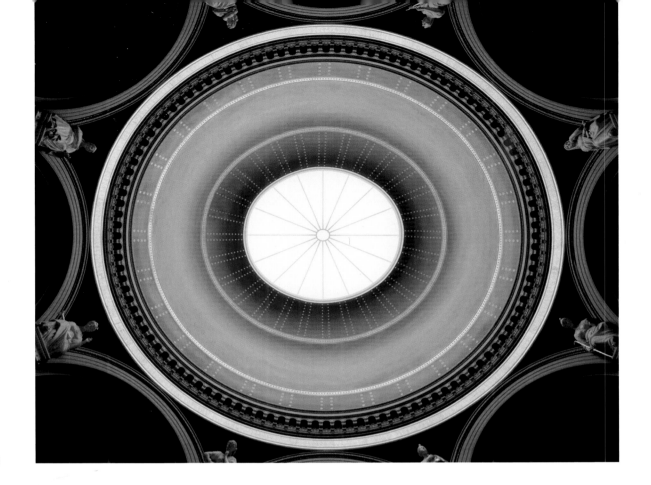

Domed hall (after restoration)

Exhibition room: Caspar David
Friedrich Hall (after restoration)

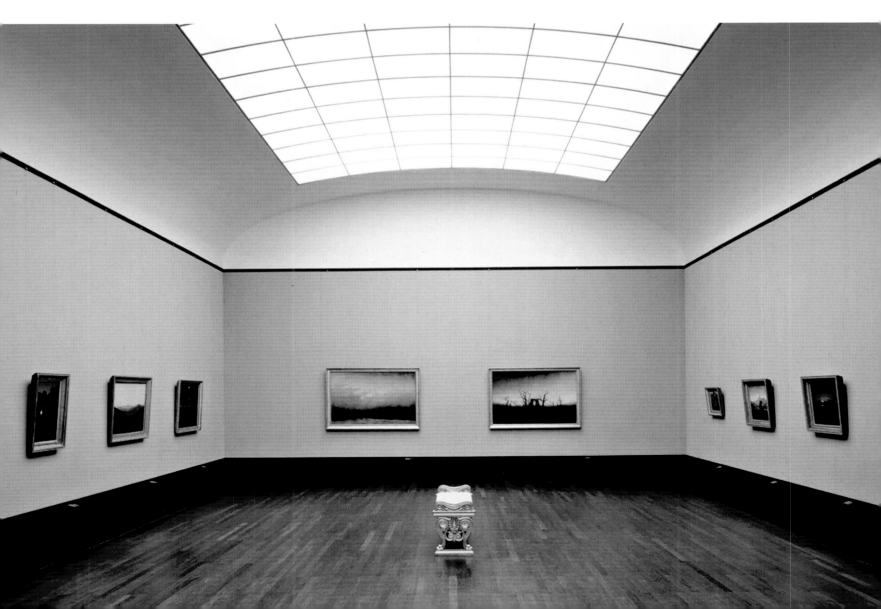

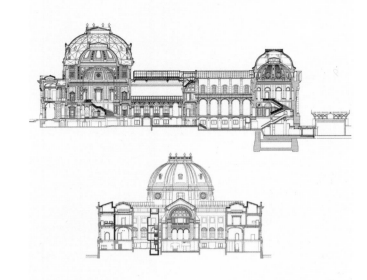

**Bode Museum: exterior view
(after the general reconstruction)**

Longitudinal and cross-section

Ground plans: levels 2 and 1

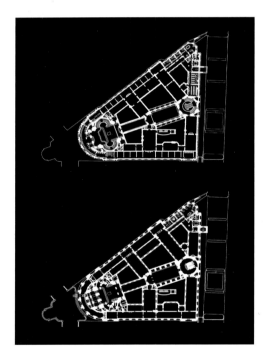

years after the fall of the Wall, the state museums east and west had already been reunited into a single organisation, and shortly after they set about refurbishing and renovating the Museum Island as one of the most pressing joint tasks facing them. Because of the poor state of the fabric, the Alte Nationalgalerie had top priority. Following its renovation under the guidance of architect H. G. Merz, it had a glittering reopening in 2001 as the first restored building on the Museum Island.

The restoration of the other buildings on the Museum Island subsequently developed into an extremely tricky business. The central problem was to retain the original character of the individual buildings while at the same time doing justice to contemporary visitor requirements and scholarly presentation, in tandem with an overall scheme for the ensemble that took the future into account.

A first competition for the completion and reconstruction of the Neues Museum was announced in 1993. Up to then, the Neues Museum had remained a ruin virtually untouched since the War, in the heart of Berlin. The competition

also demanded an overall plan for the re-establishment of all the collections and new infrastructure. Along with the bringing together of all the archaeological collections on the Museum Island (Egypt, ancient Greece and Rome, Asia Minor, prehistory and early history, Islamic art), the construction of a new entrance building and new access routes for the Pergamon Museum and Altes and Neues museums were already taken into account at this planning stage.

But the competition for the Neues Museum, won by Giorgio Grassi, came to nothing. In 1994, the first five prizewinners were invited to take part in new appraisal proceedings in which initially only the rebuilding of the Neues Museum plus a new scheme for its utilisation was to be planned. As a result, David Chipperfield, who had come second in the first (1993) competition, moved up into first place. However, during the planning process he discovered that the fragility of the fabric of the Neues Museum made it impossible for it to fulfil the future function of a central entrance building for the whole of the Museum Island as planned.

In 1997, the partnership of Heinz Tesar and Christoph Fischer was awarded the commission to carry out a general refurbishment of the Bode Museum, which had been earmarked to house the sculpture collection and the Museum of

**Watercolour sketch:
'Double-domed light cylinder', 1998**

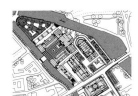

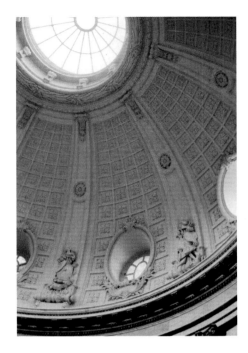

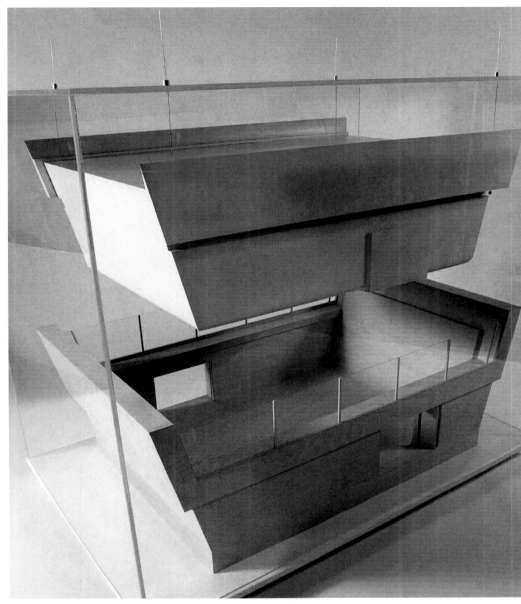

Interior view, small dome

Model: tubs in the sound room
under the rails

Model: sound room

Model: sound room under the rails

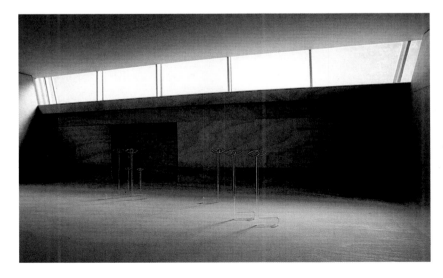

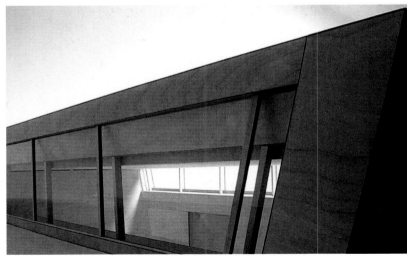

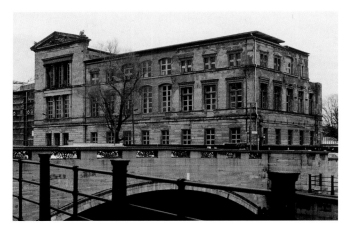

Neues Museum: exterior view
(before restoration)

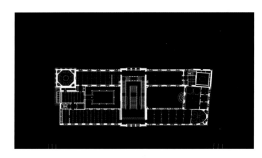

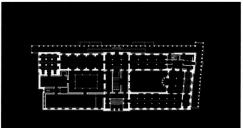

Floor plans: levels 3, 2, 1 and 0

West, south, east and north
elevations

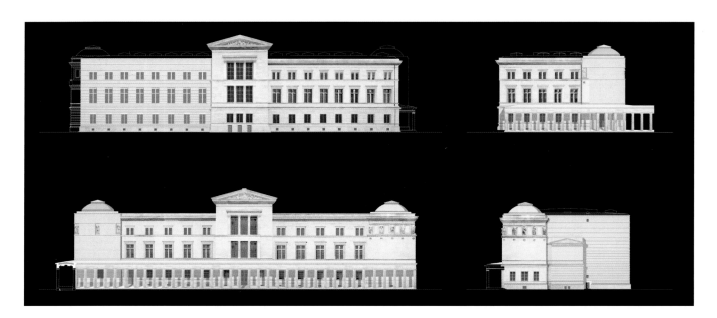

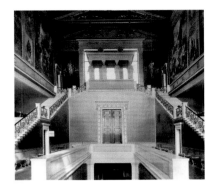

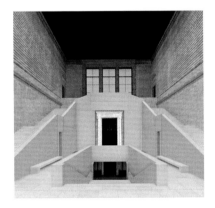

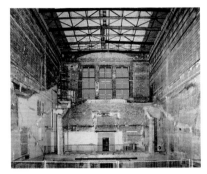

Stair hall:
historical photo, condition in
2005 (before restoration) and
new design (photomontage)

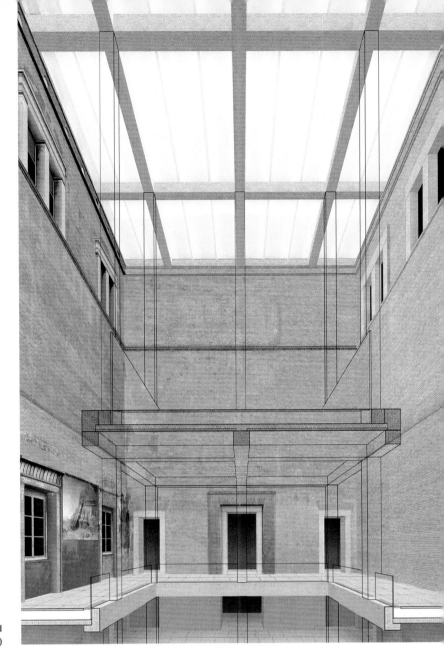

Egyptian Courtyard
(computer simulation)

Byzantine Art. Included in this scheme was the refurbishing and renovation of the Numismatics Cabinet – the only collection on the Museum Island to remain in the same premises right from the earliest years. In 1998, the firm of Hilmer & Sattler and Albrecht won the competition for the refurbishing of the Altes Museum. The same year, the Stiftung Preussischer Kulturbesitz was awarded the political task of taking charge of the overall architectural and design planning for the Museum Island.

The architects commissioned to carry out the renovation of individual buildings were now brought together into a working group, which drew up a comprehensive master plan for the joint infrastructure, access and general presenta-

tion of the Altes Museum, Bode Museum, Neues Museum and Pergamon Museum, plus the construction of a new entrance building.

One of the key elements of the new master plan is the 'archaeological promenade', a continuous route system making all the buildings conveniently accessible from the tip of the Museum Island to the Altes Museum. This was the missing link – a central path joining all the buildings together. The new entrance building in front of the Neues Museum can then take over the functions that are presently inadequately catered for or absent from individual museums (restaurants, shops, cloakrooms, lecture rooms, etc.) and open up central access to the archaeological promenade. However, since each of the museums con-

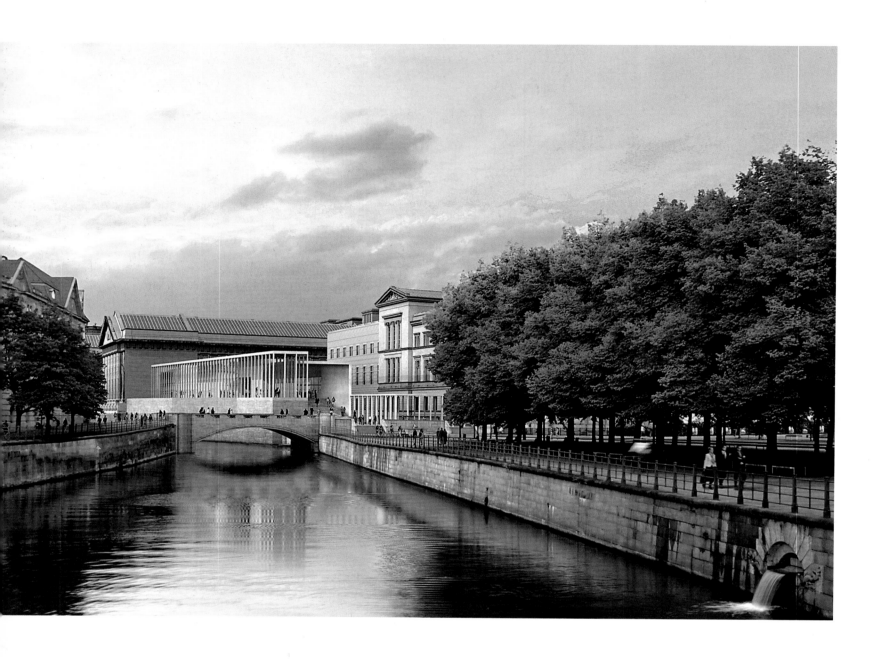

New entrance building, planning stage:
June 2007; view from the Schlossbrücke (photomontage)

tinues to have its own separate entrance, the historical structure of the Museum Island as a collection of detached buildings in the urban environment remains completely intact externally. At the same time, the archaeological promenade re-establishes the inner unity in the presentation of all the arts and genres that was the guiding principle and purpose of the Museum Island from the first.

In 2000, a competition was announced for the refurbishment and completion of the Pergamon Museum, the central building on the Museum Island. The fourth wing towards Kupfergraben, planned but never built by the first architect, Alfred Messel, is due to be constructed as part of the renovation work. This will make it possible to do a complete circuit within the Pergamon Museum. The competition was won by Oswald Mathias Ungers, whose task includes making a conceptual link between the large-scale architectural styles of Egypt, Asia Minor, Greece and Islam. Ungers was henceforth involved in the working group drawing up the Museum Island master plan.

Once the individual architects had been selected and brought together in a joint working group to evolve a master plan, everything was on course for a reconstruction of the Museum Island that preserved the historic fabric, was visitor-friendly and took account of requirements for the foreseeable future. The nomination of the island as a World Heritage Site by UNESCO in 1999 further underlined the unique international importance of the ensemble. But though the speedy implementation of the accepted master plan was recognised as economically sensible and necessary from a design point of view by all the bodies involved, it was subsequently slowed down by financial reservations and political misgivings over the concept of an overall approach. And although committed to it contractually, in 2002 the state government of Berlin washed its hands of any part in financing the construction work on the Museum Island, leaving it to the federal government to pick up the bill.

Thus the comprehensive and complete implementation of the 1999 master plan for the Museum Island with the central 'archaeological promenade' – a key feature for the future – is still

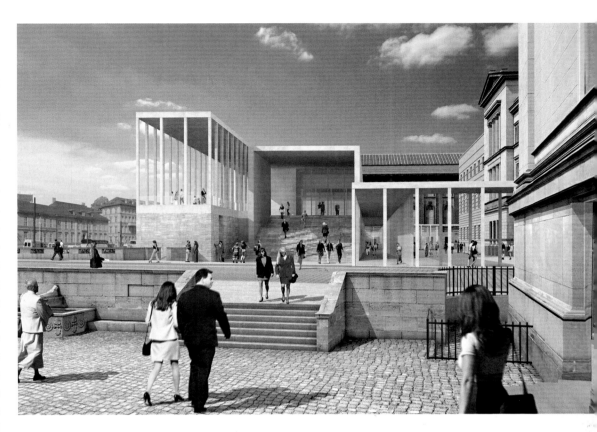

**View from the Lustgarten
(photomontage)**

**View from the Kupfergraben
(photomontage)**

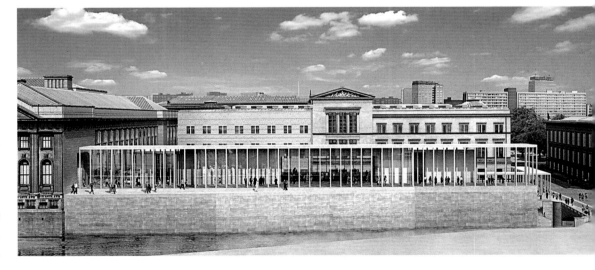

Pergamon Museum: perspective view of the
Tempietto and the new fourth wing

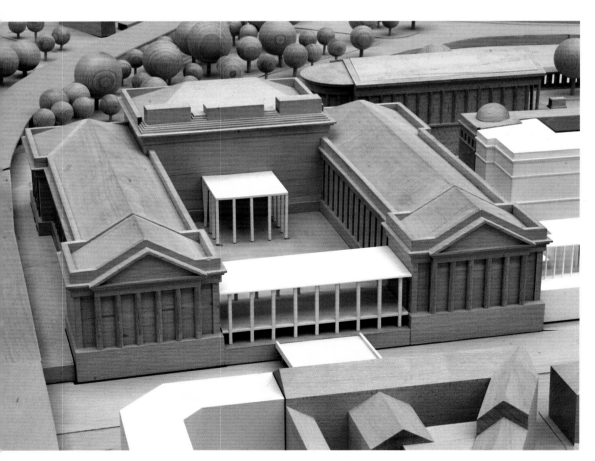

Model, with new fourth wing
and Tempietto

pending. However, it remains the basic guiding principle for the approved part plans. In the renovation and refurbishment of the Bode Museum an entry was created beneath the small domed room on the south side for the planned passage to the Pergamon Museum. In a competition in 2001, won by landscape architects Levin Monsigny, a scheme for the open areas between the buildings was devised that allows visitors to circulate easily outside and therefore reinforces the perception of the Museum Island as a unity.

The Bode Museum was reopened in 2006, housing the sculpture collection and the Museum of Byzantine Art, and works of the paintings gallery and Museum of Applied Arts were integrated into it. Work on rebuilding the Neues Museum began in 2003. It will reopen in 2009 and will accommodate the Egyptian Museum and the Museum of Prehistory and Early History. In November 2006, the German Government also approved funding to build the Museum Island's new entrance building – the James Simon Gallery – on the last remaining building site in the south-west corner of the island. A design by architect David Chipperfield was approved in June 2007, and construction is due to begin in 2009 and be completed in 2012.

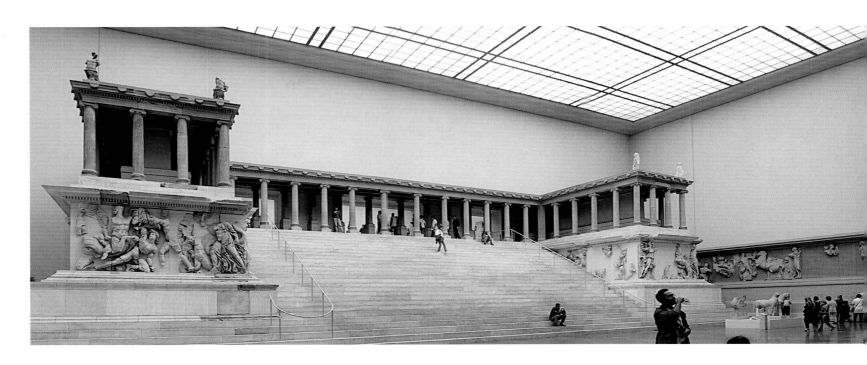

Exhibition rooms: Pergamon Hall with Pergamon Altar
(180–159 BC, above) and Market Gate of Miletus (circa 120–130 AD, below),
both before basic restoration

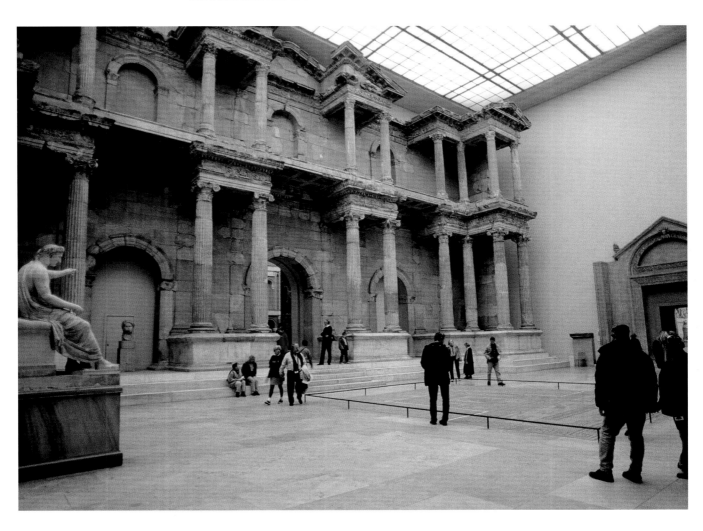

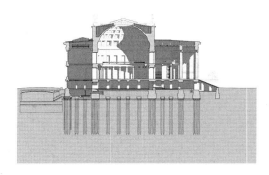

Altes Museum: view of the main façade, longitudinal and cross-section

Draft planning for the Altes Museum has been concluded, but construction work is unlikely to start prior to 2012. On completion, this is where sculptures of classical antiquity will be exhibited.

After planning three variants of the basic restoration programme and completion of the Pergamon Museum, the decision was taken in 2006 to establish a full circuit on the main floor by constructing a fourth wing linking the two side wings and initially building the archaeological promenade as a shell. Since then, the firm of O. M. Ungers has submitted an agreed draft plan for this core feature of the Museum Island. It also includes the design of the exhibitions and the main tour of 3,240 years of architectural history. (Construction starts in 2011/2012.)

Since 1842, the Museum Island has been developed on the basic concept of a constantly growing temple city along with the necessary development areas to accommodate the growth potential. It is therefore imperative and logical that the directly adjoining extension area on the other side of Kupfergraben, that is, the former barracks site, also be taken into account in forward planning in the 21st century. A city plan-

ning competition inviting ideas for the 'museum courtyards' planned there was won in 2005 by the architects Auer and Weber. Though the implementation of the 'archaeological promenade' would create further space for exhibitions and presentations on the Island itself, space has to be found somewhere to which the auxiliary functions of the museums can be relocated (depositories, workshops, restoration facilities, offices, etc.). Museum Island-related structures on the site on the western side of Kupfergraben mean these functions and an extension of the Bode Museum for the Old Masters Picture Gallery can be kept in the immediate vicinity and linked in. At the same time, the museums will also forge stronger links, geographically and practically, with the neighbouring Humboldt University on the western side. Joint use of the 'museum courtyards' has already been agreed with the German Historical Museum, so that the temple city of the Museum Island can continue to grow dynamically in the future as well.

Andres Lepik

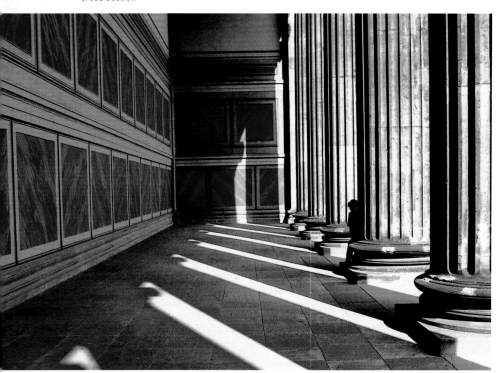

Columned porch

Rotunda, photomontage (before restoration)

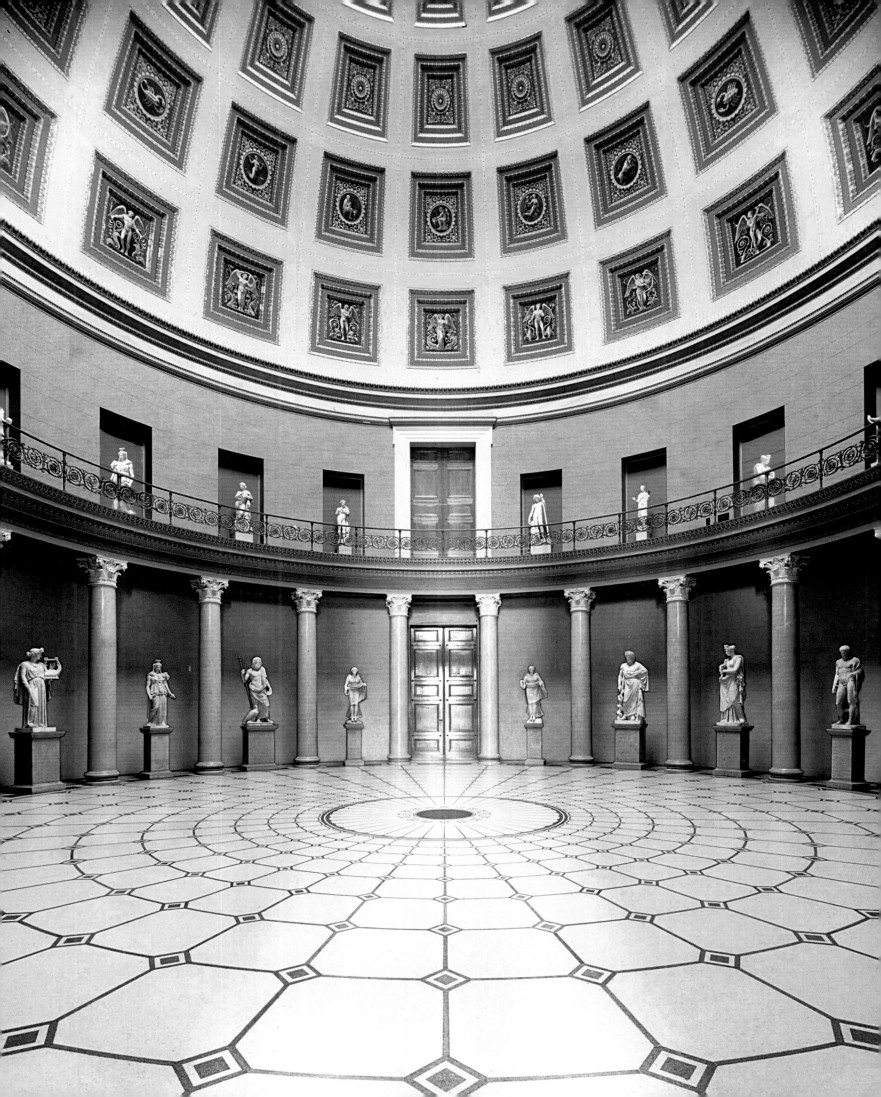

The Humboldt Forum
Idea, drama, dimensions – and palace

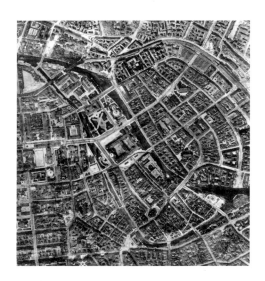

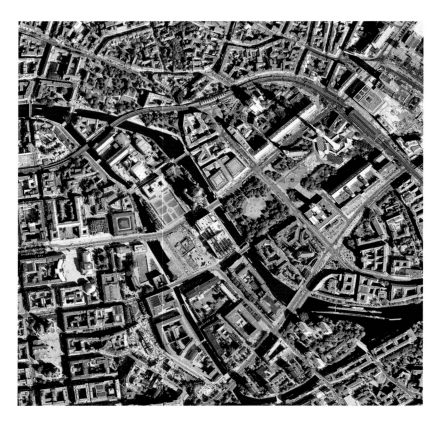

Aerial view of the site of the royal palace (*Stadtschloss*) in Berlin, 1928 and 2007

The Humboldt Forum on the site of the former royal palace in the historical heart of Berlin occupies a special place among the *Museums of the 21st Century*. It is not a museum in a conventional sense. In the overwhelming variety of its anticipated cultural uses and great institutional breadth, the Humboldt Forum constitutes something quite new. Moreover, apart from the specification that the historical façades of the royal palace on the north, west and south fronts and in the Schlüterhof (Schlüter's courtyard) inside must be reconstructed, how the architecture of the Humboldt Forum will turn out is at the present stage of planning still completely open. In contrast with many other impressive construction projects described in this publication, there are as yet no models, CGIs or computer animations that can tangibly convey to us the miracle of the new.

Yet the process of turning the Humboldt Forum into architecture has long been under way. The vital preliminary work at a conceptual level has now been completed, along with preparations for the public competition for the design and construction. This involved firming up the idea behind the Humboldt Forum, transforming it into a dramatic sequence as intellectual architecture and finally translating it into a programme for practical use – at all stages taking the historical and infrastructural specifics of the place into account.

The idea

The intellectual core of the Humboldt Forum is the idea of an accessible cosmos of non-European arts and cultures that embraces all con-

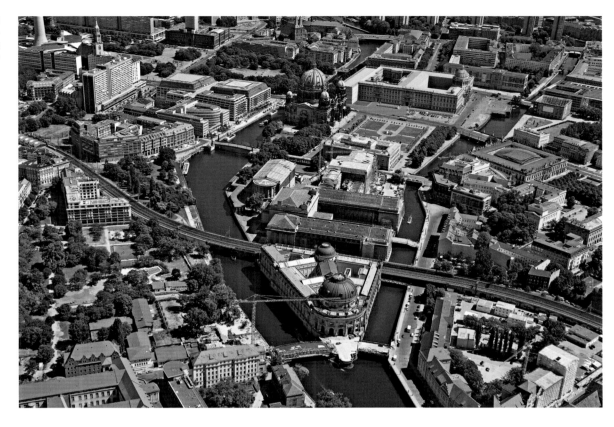

tinents and eras. It is intended to complement the Museum Island and its rich collections of the cultural and artistic history of Europe, so as to make them overall a world panorama of human civilisation. The inspiration and name for the Forum come from the brothers Alexander and Wilhelm von Humboldt, as representatives of a universal erudition and humanity that no longer makes any distinction of rank.

The core exhibits of the Humboldt Forum are the non-European collections of the Staatliche Museen zu Berlin presently kept at the Dahlem museum site. Additional to these are the scholarly collections of the Humboldt University of Berlin and the major book and media stocks of the Zentral- und Landesbibliothek Berlin (Berlin Central & State Library) relating to the non-European world. These institutions in the Humboldt Forum make up an interdisciplinary network facility for research and for understanding the art and culture of non-European civilisations through collections, libraries, exhibitions, lectures, festivals and a diverse offering of music, films and dance events.

The idea of a cosmopolitan forum for all arts and cultures in the historic heart of Berlin has immense symbolic importance in the broad polity of the Federal Republic of Germany. Here, the symbolism of the location is of key importance. This was where Andreas Schlüter's royal palace (*Stadtschloss*) stood, severely damaged in World War II and blown up at Walter Ulbricht's behest in 1950. It was replaced in 1976 by the East German Palast der Republik, now almost completely dismantled. After a century of national catastrophes and urban devastations, this location in Berlin will now acquire the function of a central interface in the interchange of cultures and scholarship. The museums, university and libraries are back where it all started, namely, the place where Brandenburg/Prussia had its first *kunstkammer*, once housed on the 3rd floor of the palace overlooking the Schinkel Museum in the Lustgarten. It contained all the collections and libraries on art and nature, a kind of interdisciplinary foreshadowing of the Humboldt Forum.

Staging it as drama

The envisaged dramatic sequencing will turn this concept of the encyclopaedic *kunstkammer* reborn in the Humboldt Forum into an altogether novel kind of museum experience for visitors. It involves five intellectual levels:

1. Agora
2. Workshops of knowledge
3. Continents of Africa and America (ethnological collections, gallery of world art, glass archives)
4. Continents of Australia, Asia and Oceania (ethnological collections, gallery of world art, glass archives)
5. Themes of humanity in the exhibition theatre

The agora sets the scene. It acts as a gateway to the world. Crossing it, visitors experience the civilisation of the 21st century on a metropolitan level in its wide variety of cultures and media. Visitors become cosmopolitan *flâneurs*. There

cause in it the collections and cultural/geographical areas overlap in particularly memorable fashion.

At the end of the journey and on the top level you get a panoramic view of an ample exhibition floor, looking out over the supra-cultural themes of mankind. Exhibitions organised on interdisciplinary lines offer visitors answers to both the great specific issues of our time (for example, "What is the future of cities?" or "What is regional identity in a globalised world?") and the timeless, constantly recurring questions of human culture (such as "What is art?" or "What is beauty?"). On this exhibition and panorama floor with catering facilities there are areas for visitors to take stock and meet up with other visitors.

There, the drama reaches its climax – sitting there high up in the *schloss*, visitors look out over central Berlin, its unique landscape of educational institutions and the Museum Island as a place of European Art opposite the *schloss* as a place of non-European art.

Dimensions

The terms of the Federal Parliament vote on 13 November 2003 set the architect two challenges with regard to the idea and the sequencing of the Humboldt Forum as drama, and these are clearly identified in the current design-and-construct competition. The first stipulation is a convincing overall architectural scheme for accommodating the planned concept for cultural use in a new building. The second is to come up with a design in which history can be experienced.

A declaration of deference to the past history of the topography of the site as a palace is to orient the dimensions of the Humboldt Forum to the ground plan and elevations of the palace immediately prior to its destruction. As mentioned earlier, there are plans to re-erect the Baroque façades on the north, west and south sides and the elevations within the Schlüterhof (Schlüter's courtyard). With the exception of the eastern front, the stereometry of the former *schloss* has to be retained. Apart from that, the cultural functions have priority. Only within the direct area of the Baroque façades is it obligatory to retain the

will be something to appeal to all the senses in a rich programme of music, theatre, films and lectures, exhibitions (particularly of international contemporary art), and a wide selection of restaurants, cafés, bookshops and other outlets. As a wholly urban environment in the entrance area to the palace, the agora is intended to stir people's fascination for art and scholarship and make them curious about the roots of cultural variety and the overarching historical connections.

On the next level and complementarily to the agora, the workshops of knowledge illustrate an understanding of the world in its cultural diversity, conveyed through the senses. Visitors enter the world of scholarship, historical scholarly collections, reading rooms and media archives. Research becomes a multimedia experience. Here, in the rooms where academics work, hold seminars and study, is also where new knowledge about the world arises. Visitors discover that the *schloss* of old was, in fact, always a place of art and scholarship. Thanks to reconstructions of the *kunstkammer* and *wunderkammer* (cabinets of art and curios respectively), they travel back in time to the age of Leibniz and the Humboldt brothers. The former art cabinet of the royal palace, which Leibniz had in mind for his *Theatrum Naturæ et Artis*, is experienced as the

place where the Staatliche Museen, Humboldt University and the libraries all started out.

After the agora and workshops of knowledge, the journey round the world begins on the third level. The first stop is Africa as the cradle of humankind and a neighbour to Europe, with the Ife, Benin, Cameroon savannah and Congo art centres. From here, visitors follow the trail of Alexander von Humboldt to the New World, experiencing the great lost civilisations of the North American continent – the Mayas and the Aztecs. On the fourth level, the journey continues to Oceania and Australia, and from there to the millennia-old high cultures of China and India. This is where the collections of the Ethnological Museum and the masterpieces of the Museum of Asian Art interface. Thus the journey from the *kunstkammer* of yore shapes up as a trip through the museum and university collections as a voyage of discovery round the world.

At all stages on this journey across the continents, non-European cultures will be illustrated in all their diversity of life and artistic variety by means of original products of their visual, material and sound cultures, supported by all present-day media. Public collections pass seamlessly into scholarly collections in glass display cases, and visitors can rediscover hidden treasures. A key role is played by the Gallery of World Art, be-

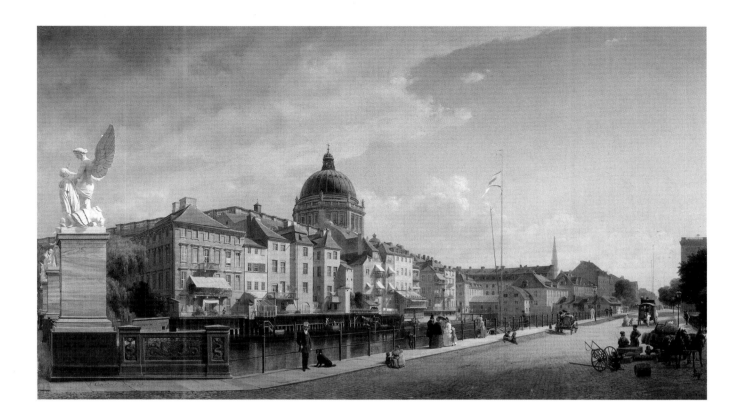

View of the rear façades of the
houses along the Schlossfreiheit,
1855, painting by Eduard Gaertner

overall height of the historic fabric. For the façades facing east there are no design stipulations. On the east side of the Humboldt Forum facing the Spree, the opportunity could be explored of taking on board the concept of the (East German) Palast der Republik as both an open cultural institution and a parliamentary building.

In the interiors, museum considerations dominate, in terms of architectural design, the technical aspects of maintenance and the curatorial requirements. The dimensions are governed by the usable floor areas specified: 9,500 m² for the agora, 24,000 m² for the non-European collections of the Staatliche Museen zu Berlin, 1,000 m² for the Humboldt University collections, 4,000 m² for the Zentral- und Landesbibliothek (Central & State Library) and 1,500 m² for the ancillary, design-dependent functions. In many of the collection areas, a ceiling height of up to 8 m is envisaged for the exhibition rooms. In some areas, it is proposed to integrate reconstructed historic room structures. A conceivable arrangement, for example, would be the conceptional or even three-dimensional restoration of the Royal Art Cabinets as a nucleus of the mu-

seums or the inclusion of a room the size of the East German parliamentary chamber, which could be integrated into the agora's functional system.

Of vital importance is the architectural implementation of the agora with its multiple functions. It acts in the first place as a central distribution platform for up to 16,000 visitors a day, providing central information, ticket offices, collection points, rest areas and cloakrooms. The agora allows all levels of the building to be opened up vertically, and channels the stream of visitors quickly to their destinations. Conceivably, there will be not only flights of steps but also lift installations, escalators and exterior lifts in the courtyards – all specially tailored to the floors and their functions. In addition to this, the agora functions as an area of experience, events and education with special exhibition facilities, a lapidarium with fragments of the original palace and Schlüter's sculptures, a multifunctional room accommodating 500 people, four seminar rooms and an auditorium with 300 seats. In addition, the agora will have a special attractiveness as a place to stroll, regardless of the closing times of the collections, with museum shops, bookstores,

boutiques and music shops, classy eateries and bistros.

Palace

In his introductory essay, Werner Oechslin argues with great persuasiveness that museums of the 21st century could turn out to be the cathedrals of the present day. However, the Humboldt Forum starts out wholly from the metaphor of the palace. It represents the right, authentic location for the transformation of a monarchic/imperial power architecture into the democratic vision of a palace of the arts, science and cultures for the understanding and discovery of the world characterised by openness and tolerance.

This new palace reborn out of the spirit of the Enlightenment and its former *kunstkammer* and curio cabinet has a message that matches in every way its overwhelming architectural dimensions. The very significance of the place is unique: the centre of Berlin and the cultural and scholarly topography of its Museum Island, Deutsches Historisches Museum (German Historical Museum), Humboldt University, Staatsbibliothek und Zentral- und Landesbibliothek (National Library and Central & State Library) provide a real, symbolic, future-oriented location of prime importance for the reunited Germany. Major scholarly and artistic treasures of Western cultural tradition have been collected here ever since the 19th century, and from here the Humboldt brothers subsequently turned their eyes on the alien and the other. This urban centre can now be rediscovered as the intellectual heart of the European metropolis of Berlin. Once it was decided to go ahead with the Humboldt Forum on the site of the old palace, it conferred a fascinating sense of the future on this outstanding location in the capital – with the world having a stake in the classiest place in Germany and Berlin as an interpreter between the cultures of the world.

Peter-Klaus Schuster and Moritz Wullen

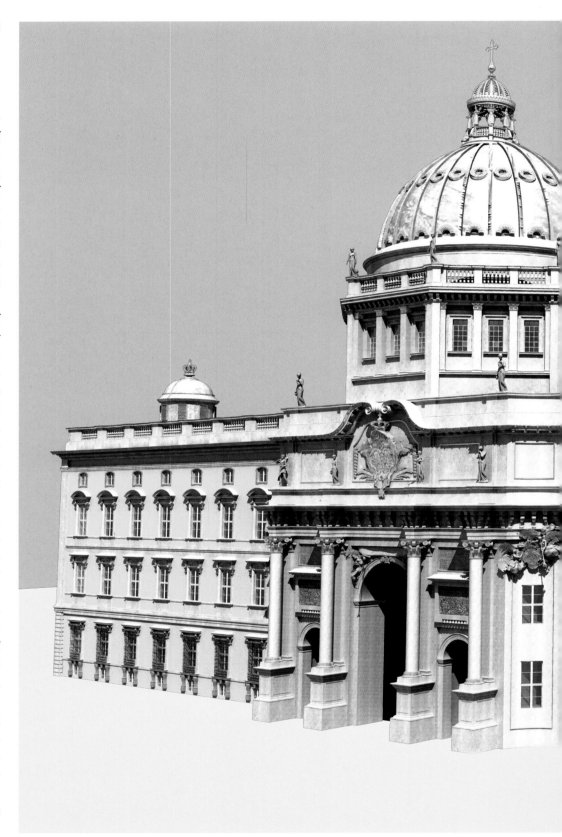

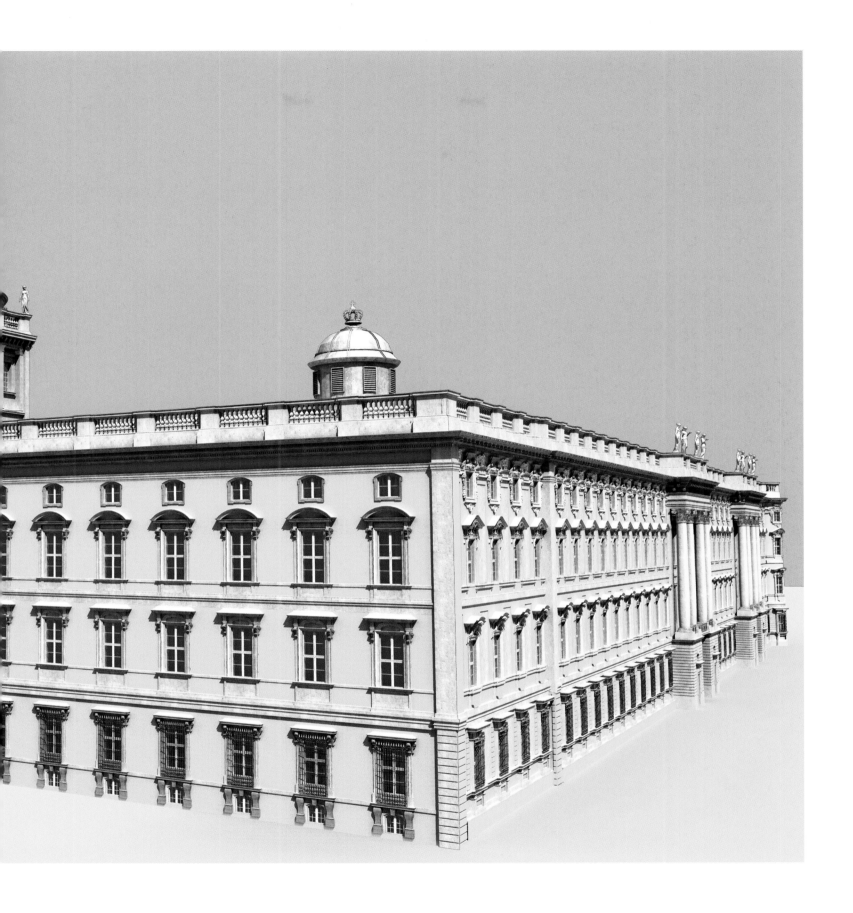

Digital reproduction of the exterior of the
royal palace (*Stadtschloss*) in Berlin, 2007

Made in America:
Museums in a Privatised Culture

James S. Russell

Jacques Herzog once told a group of journalists about his first meeting with Dede Wilsey, president of the board of trustees of the de Young Museum in San Francisco. He confesses to shuddering. Would Wilsey – wearing a conservative Chanel suit, blonde pageboy hairdo shellacked into place, and bejewelled – support the restlessly exploratory architecture of Herzog & de Meuron? Could a woman who looked like the European caricature of the heedless, unsophisticated American understand his work?

Wilsey, it turned out, not only supported, she encouraged. What's more, she scoured San Francisco to raise more than $190 million from almost 7,000 private donors to help make the extraordinary design of the museum possible. This is the kind of commitment it takes to build publicly-owned museums in America.

Herzog's encounter with Wilsey says much about contemporary museum culture in the US. Like the rest of the world, America has experienced a museum-building boom: attendance and collections are growing and institutions are expanding. There is a new appreciation of the role architecture can play, and the architects engaged for prominent projects are increasingly of the highest international stature.

What makes contemporary American museums different is money, since they are built and operated largely with private funds. Americans regard as quaintly European the idea that the state should acquire collections and both build and operate museums.

The marriage of private capital and public institution is expressed literally at the Seattle Art Museum[1] (fig. 1), where a 16-storey addition is being laminated to a 42-storey office tower.

Architect Brad Cloepfil, of the Portland-based Allied Works Architecture (see also pp. 206–11), laboured to give the museum a distinct identity, but the configuration of the tower imposes major limitations on the size and shape of the galleries. Some galleries, at 11 feet high, are lower than museum norms, while others, at 28 feet, are far higher, for example. The museum says the financial partnership with the bank that is building the tower was too good to pass up, but if the galleries prove to be compromised it will pay a heavy price.

Fig. 1: Allied Works Architecture, Seattle Art Museum, Seattle, WA, USA, extension, 2004–2007: model photographs, north and west façades

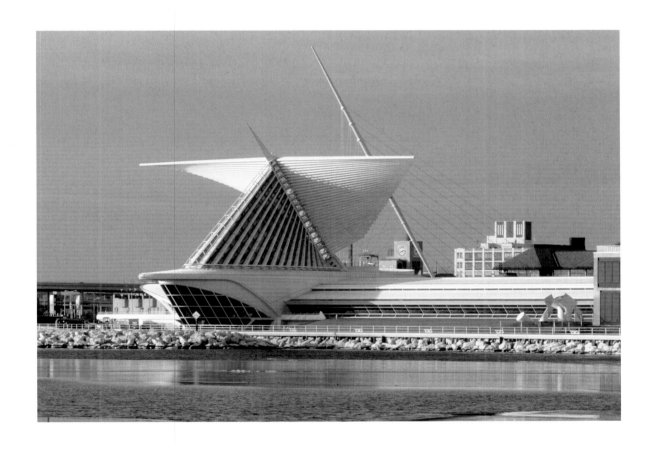

Museums everywhere must come to terms with shrinking government support and the pressures of commerce. Americans tend to believe that privatised culture does a better job than publicly directed culture can and that government bureaucrats cannot possibly know what is important because they have little personal stake in the outcome. Just as works of art assume value thanks to the Darwinian workings of the international art market, American museums rise and fall according to their skill at developing public support and raising private money. Museum

directors in the US must devote considerable time to doting on donors. Curators must not only be brilliant scholars but must also communicate skilfully and diplomatically with collectors, local politicians and local interest groups.

As a source of civic pride, museums can draw wide public support and often reflect a wide range of values. Fort Worth, Texas, built a modern-art museum by Tadao Ando.[2] Richmond, Virginia, hired Rick Mather to dramatically overhaul its facility. Baton Rouge, Louisiana, recently opened an elegant building by the Boston firm of

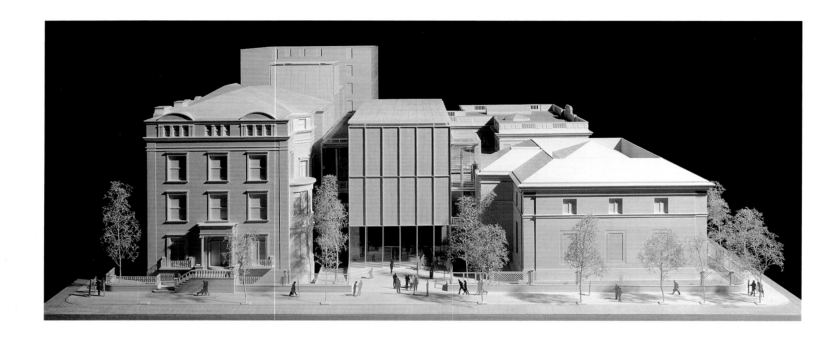

Schwartz/Silver. Frank O. Gehry's affinities may lie with the top tier of contemporary artists, but a museum he designed in honour of the self-styled 'mad potter of Biloxi', George Ohr, will open in 2006 in Mississippi. (That opening will be delayed because of recent hurricane damage.)

With fund-raising so central to an American museum's success, the idea that an art museum could, almost singlehandedly, put a city on the international cultural map is enormously appealing. In the US, museum boards and local officials have sought to emulate the so-called Bilbao effect. After Gehry's extraordinary Guggenheim Museum opened in the Basque Country, spectacular and expressive museum buildings or additions were among others commissioned in Washington (see pp. 176–81), New York (see pp. 20–25 and 182–87), Los Angeles, Boston,

Denver (see pp. 194–99), San Francisco, and Fort Worth.[3]

One of the most poetic recent museum projects was Santiago Calatrava's lakeside addition for the Milwaukee Art Museum, in Wisconsin (fig. 2).[4] Everyone was so enamoured with the design's iconic image – its movable, bird-wing sunshades – that few noticed that relatively little space was devoted to exhibitions. It proved far more expensive to build than anticipated and the museum's ability to mount exhibitions and manage its collection has been hobbled since it opened in 2001 by the need to keep raising money to pay for the building.[5]

Steven Holl's Bellevue Art Museum in Washington[6] suffered a worse fate. With poor attendance and insufficiently endowed, the handsome structure closed its doors in Septem-

Fig. 3: Renzo Piano Building Workshop, Pierpont Morgan Library, New York, USA, extension, 2003-06: model photograph, view from Madison Avenue with new entrance

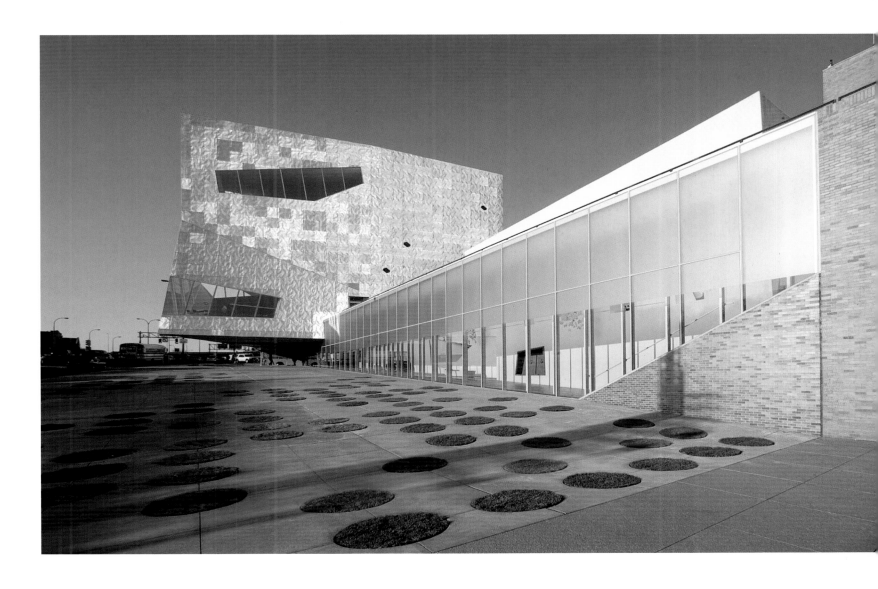

Fig. 4: Herzog & de Meuron, Walker Art Center, Minneapolis, MN, USA, extension,1999–2005: exterior view

ber 2003, less than three years after completion. Board members apparently assumed that museum admissions would cover operating costs, which is almost never the case[7] (for Holl, see pp. 200–05).

The most admired museums in the US tend to be those built to the vision of individuals, even if the institutions ultimately become public ones. The Menil Collection in Houston (1986), by Renzo Piano, is that rare museum admired by curators, architecture critics and the public alike. It reflects the personality of Dominique de Menil, who assembled the collection.[8] Raymond Nasher, a Texas collector with major holdings in 20th-century Modernism (cf. pp. 188–93), was inspired by de Menil. He hired Piano to create a home for his sculpture collection, the Nasher Sculpture Garden, Dallas (2003).

The Dia Art Foundation, which possesses one of the most idiosyncratic of contemporary art collections, followed the intentions of its great eminence, artist Donald Judd, in the creation of Dia:Beacon, a display space that attempted to banish what Judd regarded as the inevitably self-conscious presence of the architect.[9] Dia realised Judd's vision in a gloriously light-filled, luxuriantly spacious, rural setting – in an abandoned factory the size of an airport terminal an hour's drive north of New York City.

These projects add to a distinguished history of museums built to suit great American collectors: The Frick Collection in New York, the Isabella Stewart Gardner Museum in Boston, and the Barnes Foundation in Merion, outside Philadelphia. The very singularity of the privatised museum, however, has pitfalls. Albert C.

Barnes's great collection of African, Post-Impressionist, and early modern works will move out of his handsome mansion into a new building in Philadelphia because Barnes left restrictive and inadequate resources to assure its maintenance.[10]

Private fund-raising has become more difficult in the US in recent years. This environment has claimed the dramatic Eyebeam project in New York, by Diller Scofidio & Renfro (see pp. 182–87) and has led a number of institutions to choose architects of certified quality yet whose designs are not too controversial. A beneficiary of this approach has been Renzo Piano, now the dominant figure in American museum architecture. The Nasher was followed by the High Museum in Atlanta (2005), a Piano-designed addition to Richard Meier's iconic 1983 building, and Piano's overhaul of the Morgan Library was set for mid-2006 (fig. 3). In San Francisco's Golden Gate Park, construction has begun on the California Academy of Sciences, a sod-roofed marvel of 'green' technology combining a planetarium, a rainforest exhibit and an aquarium. The Art Institute of Chicago has broken ground on a 230,000-square-foot addition. The Whitney Museum unveiled Piano's design for its nine-storey wing in 2004, the same month he was tapped to design an addition to the Isabella Stewart Gardner Museum in Boston. The Los Angeles County Museum of Art announced plans in 2005 for a three-phase overhaul of its 20-acre campus. The first phase, a $130-million wing and entry pavilion, will open in 2007.

No architect in recent memory has had so many substantial projects underway in America at the same time. Piano claims not to have a signature style, but designs for the Art Institute, the Morgan and the LACMA are clearly descended from the metal, glass and stone temples he created for Menil's Twombly Pavilion (1995) and Basel's much-admired Fondation Beyeler (1997).[11] The fluttering roof crowning Piano's Paul Klee Museum (2005) in Berne shows a much more individual expressiveness (see pp. 102–07).

The conservatism of Piano's American designs is no coincidence. The US sees itself as individualist and entrepreneurial, but these qualities are too often belied by unadventurous museum architecture. Americans are impressed by a collegiality of public officials and museum administrations in Europe and Asia that is only rarely to be found at home, where the quality of the architecture often suffers whenever museums have to reconcile the conflicting desires of trustees, curators, elected public officials and citizen activists.

Despite such difficulties faced by museums, the place of architecture seems more firmly established. This is especially evident in a resurgent desire among Americans to use museum design to memorialise key events. Among the most successful of such projects is the Holocaust Memorial Museum in Washington, D.C. (1993), built to convey the enormity of the extermination of Jews and other 'undesirables' by the Nazis in World War II – and thus prevent such horrors from ever happening again. In his design, James Ingo Freed, of I. M. Pei & Partners, embedded imagery drawn from buildings at the death camps. Exhibition designer Ralph Appelbaum also took a narrative approach, using hundreds of images of peoples' faces to lend individual human identity to industrialised murder.

The museum was built with enormous skill and sensitivity and is enormously popular. Such an overtly emotional approach is rarely attempted outside the US, however, because many curators regard it as too manipulative. Even in America the museum's role as a chronicler of tragedy has proven less successful when history has not offered some emotional distance.

All of America, and arguably much of the world, has an interest in the design and meaning of a memorial museum for the site of the World Trade Center terrorist attacks of 2001. And yet, during the design process, the larger meaning of the tragedy has been subsumed in deference to survivors' families. Instead of helping visitors to come to terms with the nature of the disaster and its consequences, the memorial museum, at this writing, is turning into a grandiose display of victimhood.

The design sensibility of many US architects may well have been honed by the difficult and contentious climate in which museums are built. Strangely, it can take the form of an evocative, almost romantic lyricism, perhaps as an antidote to the difficult process.

America's unique atmosphere also appears to have invigorated foreigners. Zaha Hadid's first urban-scale built work is the Contemporary Arts Center in Cincinnati, Ohio (2003).[12] Hadid has turned to advantage the constraint which the small, downtown site imposes on her characteristically sprawling sculptural sensibility. Its overlapping cubic forms look coiled with energy, ready to explode. In New York's Museum of Modern Art, the concisely introverted Yoshio Taniguchi became an extrovert (see pp. 20–25). The enormous numbers of people who visit the

building become part of an unfolding public spectacle that unexpectedly opens to carefully framed views of the surrounding city pressing in – the noisy chaotic streets that inspired much of the art on view.

Herzog & de Meuron responded to the diverse situations of two museums they designed at almost the same time, creating in the process some of their richest architectural statements. The de Young museum's low, hunkering forms are in the carved, abstract mode of the firm's cool, modernist work. The Walker Art Center, in Minneapolis (2005), is a radical departure from the composed, sanitary modernism found in most museums today (fig. 4). Its expression is intentionally ambiguous and indeterminate, reflecting the exploratory nature of the Walker.

The feisty, almost cut-throat competitive environment that cultural institutions find themselves in has honed these institutions' distinct personalities. America's privatised museum culture remains vibrant in part, ironically, because it is so difficult to sustain.

1 James S. Russell, 'The Merger of Art, Commerce and Public Land', in: *The Wall Street Journal* (20 April 2004), p. D8
2 *Museums for a New Millennium: Concepts, Projects, Buildings* (Munich, London, New York 1999), pp. 194–99
3 Washington: The Corcoran Museum of Art (Gehry Partners), cancelled in 2005; New York: Guggenheim Museum (Gehry, also cancelled), Whitney Museum (OMA, later cancelled and restarted with Renzo Piano Building Workshop); Los Angeles: Los Angeles County Museum of Art (OMA, later cancelled. Renzo Piano was hired to design additions later); Boston: Fine Arts Museum addition (Foster & Partners); Institute of Contemporary Art (Diller Scofidio + Renfro); Denver: Denver Art Museum (Daniel Libeskind); San Francisco: de Young Museum (Herzog & de Meuron), California Academy of Sciences (Piano); Fort Worth: Museum of Modern Art (Tadao Ando)
4 *Museums for a New Millennium* (1999), pp. 162–67
5 *Architectural Record* (26 July 2002)
6 *Museums for a New Millennium* (1999), pp. 200–07
7 Author interviews. The museum recently reopened with a different programme.
8 Author interviews pursuant to a story on Piano
9 James S. Russell, 'Do Museums Need Architecture?', *Architectural Record* (October 2003), pp. 108–15
10 *The New York Times* and *The Philadelphia Inquirer* extensively reported on the Barnes' financial woes and its move.
11 *Museums for a New Millennium* (1999), pp. 154–61
12 *Museums for a New Millennium* (1999), pp. 208–13

Gehry Partners, LLP

The Corcoran Gallery of Art
Washington, D.C., USA

Client: The Corcoran Gallery of Art
Design: 1999–2003
Construction: on hold
Budget: US $170 million

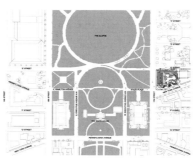

Schemes, 2000

Site plan

Final design model, 2005, view from the north-east

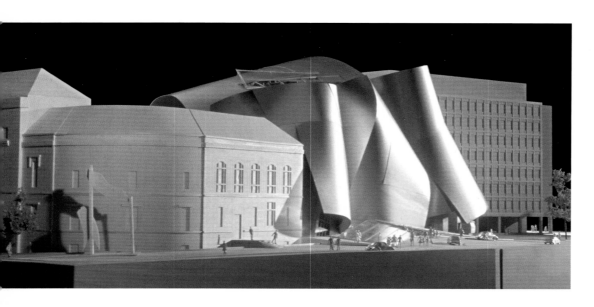

Founded in 1869 as the largest non-state museum institution in Washington and its only college of art and design (Corcoran College for Art and Design), the Corcoran would have finally got the extension it had long wanted if David C. Levy, the long-standing director and president of the art gallery, had had his way, but lack of funds and internal conflict led to his resignation on 23 May 2005. The gallery therewith lost the most important, far-sighted and tireless advocate of the $170-million Gehry plan to renovate and extend the gallery. Construction work on the controversial, emblematic design in the centre of the conservative, largely neo-Classical American city was therewith not just postponed once more – the whole project has been shelved for the time being. Although the public reacted with enthusiasm, only a small proportion of the necessary finance has been raised so far.

Frank O. Gehry rode to victory against high-quality international competition in June 1999 on the back of the 'Bilbao effect'. The success of the Guggenheim Museum there, completed in 1997 (see fig. 1, p. 9), made him the ideal candidate, ahead of Daniel Libeskind and Santiago Calatrava. When the Corcoran commissioned the extension building and the design phase began in October 1999, construction was due to start in 2003 and be completed by winter 2005.

The gallery occupies a prominent position near the White House in the north-west quarter of Washington, D.C. The strong point of the collection is American art. The existing Beaux Arts-style museum, completed in 1897, was designed by Ernest Flagg (1857–1947), with an extension wing added in 1928 by Charles Platt (1861–1933).

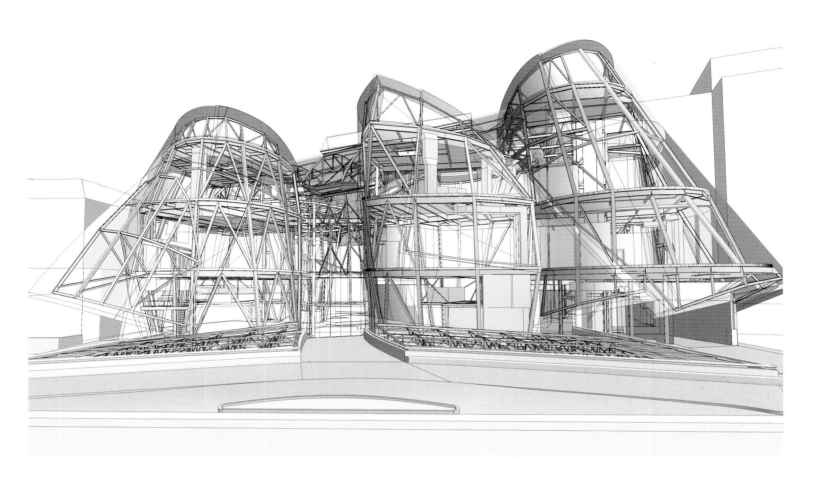

Digital project model with
transparent surfaces (above) and
rounded-surface guidelines (below)

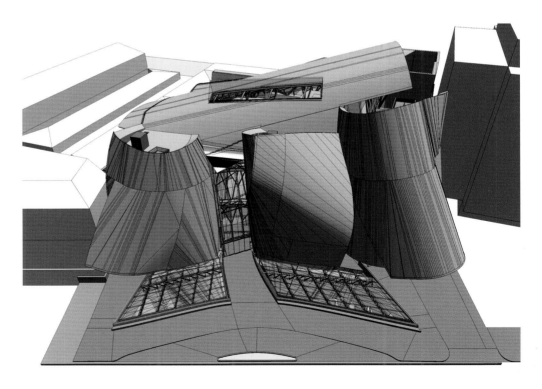

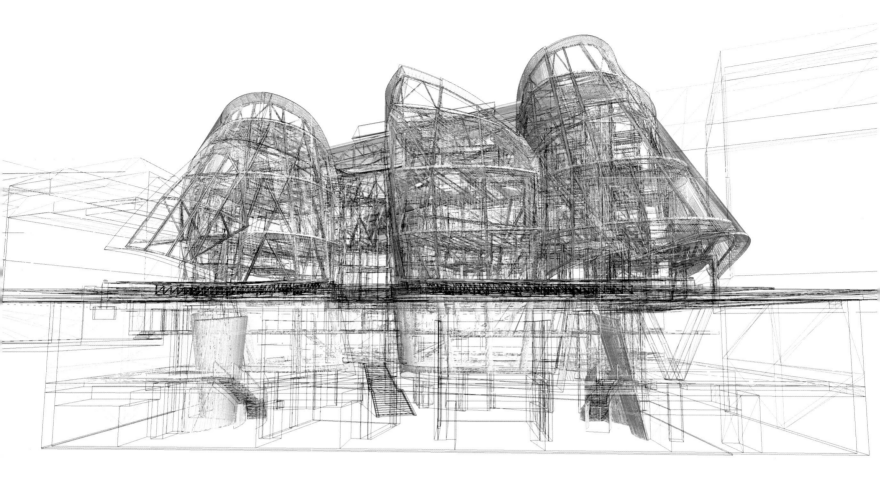

Digital project model with triangulated surfaces

Longitudinal section through the
digital project model

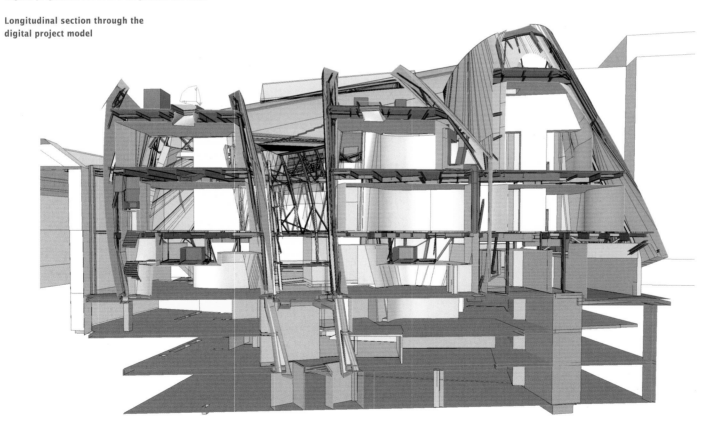

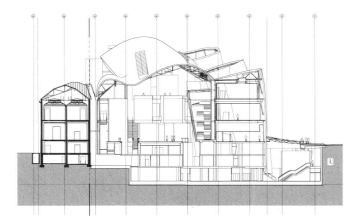

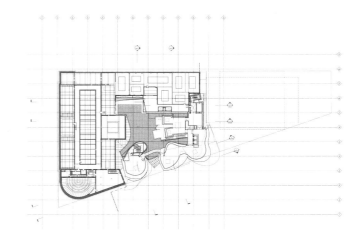

Cross-section

The new proposal envisaged an extension building with usable floor space of 13,000 square metres, with accommodation for museum offices, exhibitions, archives, research, educational facilities, a library and a cafeteria. The extension was also intended to give new purpose and an identity to an institution that was floundering.

The key feature linking old and new is a monumental atrium. The roof ends like an open, abstract design in space carrying a shell structure. Beneath the curved, metal roof shapes rigid, elongated rectangular skylight windows are inserted. They are arranged as interfaces of varying types so as to create contrasts between hard and soft, rigid and fluid, straight lines and curved surfaces.

The atrium is also a linking centrepiece around which the new, rather traditionally designed gallery rooms stack up like boxes. These geometrical, vertically aligned structures correspond to the partially cubically fragmented walls enclosing the hall that span several floors and extend down into the lower levels, where the new studios and premises for the school are. The architectural mantle mutates into sculpture as the wall is activated, blurring and challenging the borderline between architecture and sculpture and formulating new relationships between space and object, inside and outside. In Gehry's design practice, the deconstruction of space and the design of new, three-dimensional links go hand in hand, and are important design

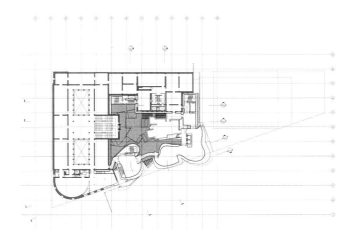

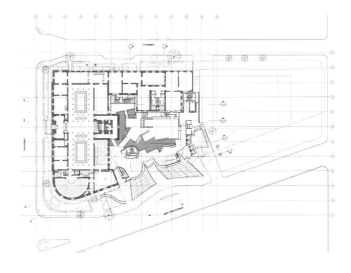

Ground plans (top to bottom):
2nd floor, 1st floor, ground floor

resources in the search for new rhythms and dynamics in architectural expression.

The box-shaped galleries lie formally somewhere between the rigorously flighted enfilades of the existing buildings and the implementation of new spatial ideas given shape in the three spectacular volumes on the New York Avenue side. These new embodiments of space have fluid ground plans and rhythmically designed wall lines. Unevenly alternating soft curves and hard edges, concave and convex inclined surfaces create an exciting enhancement of the spatial impression. The eye is not able to take in the spatial arrangement at a glance or with constant intensity – the space opens to our gaze in ever-changing ways, vaulting or by stealth.

The routes from the existing buildings to the rather conventional gallery rooms on the one hand and the richly curved, chiselled rooms on the other are effected by traditional staircases and stairwells. But in the new main entrance, where a full-height, glazed wall lets light into the atrium, the transitions are formed as footbridges.

They connect the various rooms, bridging the ravine-like cleft between the steeply pitched structures flanking the doorway.

This monumental intervention emphasises the façade on New York Avenue – transparent, full of light, and vertical. Like a broad slit, the aperture marks an axis that, together with the jetty-style transition leading to the street and the reflecting surfaces of the monumental windows at the sides at street level, follows a symmetrical arrangement. The compositional balancing act of vertical and horizontal is offset by the gigantic, uneven, gleaming metal shell features. The balance of forces is established in the three-dimensional architectural composition of the exterior.

The architectural high point of Gehry's extension project is undoubtedly the dramatic façade, which constitutes a powerfully sculptural and material presence between the simple, austerely geometrical blocks of the existing buildings. The sandblasted, titanium zinc carapaces, which look like wind-blown sails – a metaphor that Gehry himself is supposed to have sought

**Final design model, 2005,
views from the north-west and west
(right)**

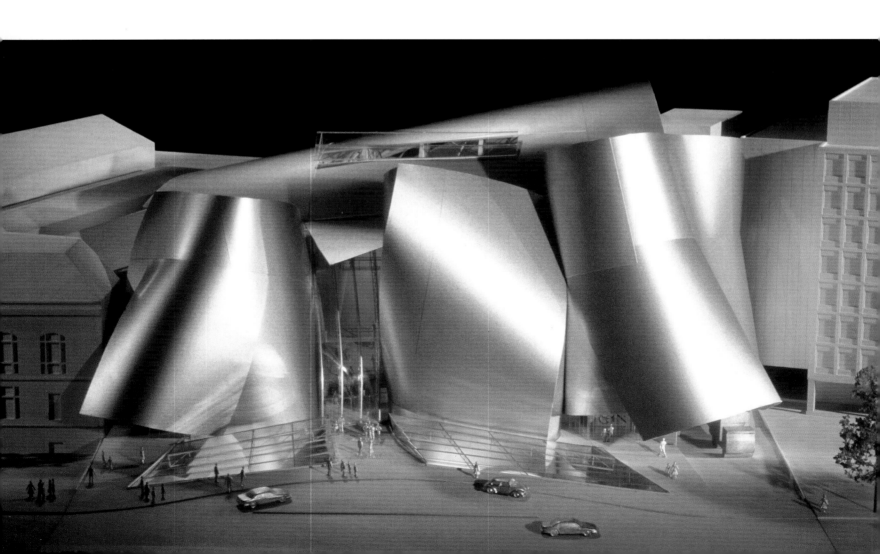

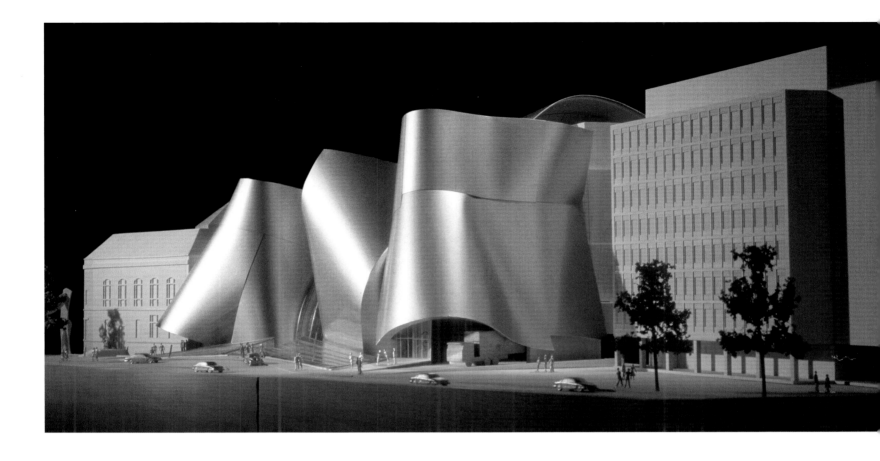

out – are in striking contrast to the light marble or whitewashed sandstone of the neo-Classical setting. Like an urbane intervention that prefers a curve to a sudden break, the three rhythmically grouped façade elements change the architectural aggregate condition from solid into fluid, and hard into soft. The quality of the vibrating membranes lies in the capacity of their material appearance to transform. The new main façade bears the signature of Gehry's Bilbao period, but also of his collaboration with artists such as Richard Serra, Claes Oldenburg and Coosje van Bruggen, and his keen interest in contemporary art generally.

The original competition model was designed as a highly complicated, chaotic-looking cascade of tumbling, irregular structures, similar to Gehry's design for the Chiat Lodge in Telluride, Colorado (1996–98) or his never-built design for the Samsung Museum of Modern Art in Seoul (1995). As if Gehry now wanted to let himself go completely, the Corcoran project manifests a rebellion, an exuberant eruption bursting the frontiers of architectural feasibility.

Gehry's experimental design method meant the project underwent a long series of modifications before it was finally signed off by the Fine Arts Commission in 2003. The smooth, supple surfaces and the sensual, slightly curved structures almost add up to an abstract sculpture of three torsos evocative of the three Graces of Botticelli, the quintessence of harmony and balancing contrasts. Once again, Gehry not only showed himself possessed of an urbane, virtuoso sense of scale but also created an aesthetically unmistakable identity for the location and the institution.

Verena M. Schindler

Diller Scofidio + Renfro

Eyebeam Museum of Art and Technology
New York, USA

Client: Eyebeam Museum of Art and Technology
Design: 2001
Construction: on hold
Budget: US $60 million

Concept: pliable ribbon

View from an acute angle
(computer simulation)

The critical eye

In his book *Secret Knowledge*, David Hockney describes how Western artists have for centuries used optical devices to generate new ways of seeing. The work of Diller Scofidio + Renfro, with its complex constellations of mirrors, lenses and projections, clearly extends and enriches this tradition. The production of their interdisciplinary studio, which they call "aberrant architectures", includes buildings, multimedia installations and performances, electronic media and print – diverse explorations united by a desire to question distinctions between image and reality. This body of work was honoured in a 2003 retrospective at the Whitney Museum of American Art in New York. Characteristically, rather than merely assembling a passive summary, Diller Scofidio + Renfro used the exhibition to aggressively critique the very notion of the museum as institution. During the three months of the show, digitally-guided, robotic power drills mounted on rails randomly bored $1/2$-inch-diameter holes in the gallery walls, attacking the pure, abstract, white surfaces and deliberately creating "… a visual and aural nuisance that actively resist[ed] the mediating authority of the museum."[1]

Given their international reputation as both artists and architects, their provocative use of audiovisual media and their unorthodox view of museums, it could be said that Diller Scofidio + Renfro were poised to design the Eyebeam Museum of Art and Technology. Founded by film-maker John S. Johnson in 1996 to expand aware-

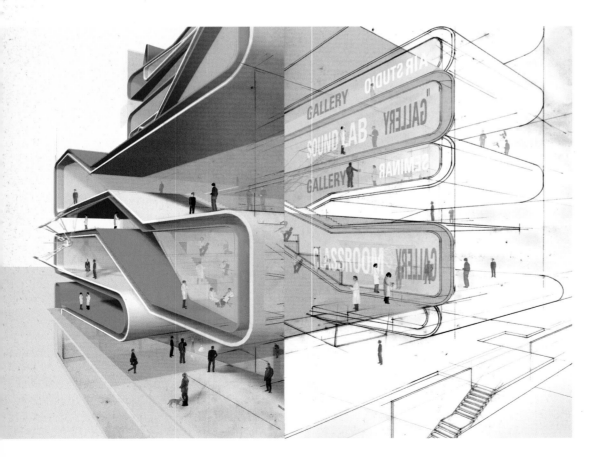

View from the north-east (computer simulation)

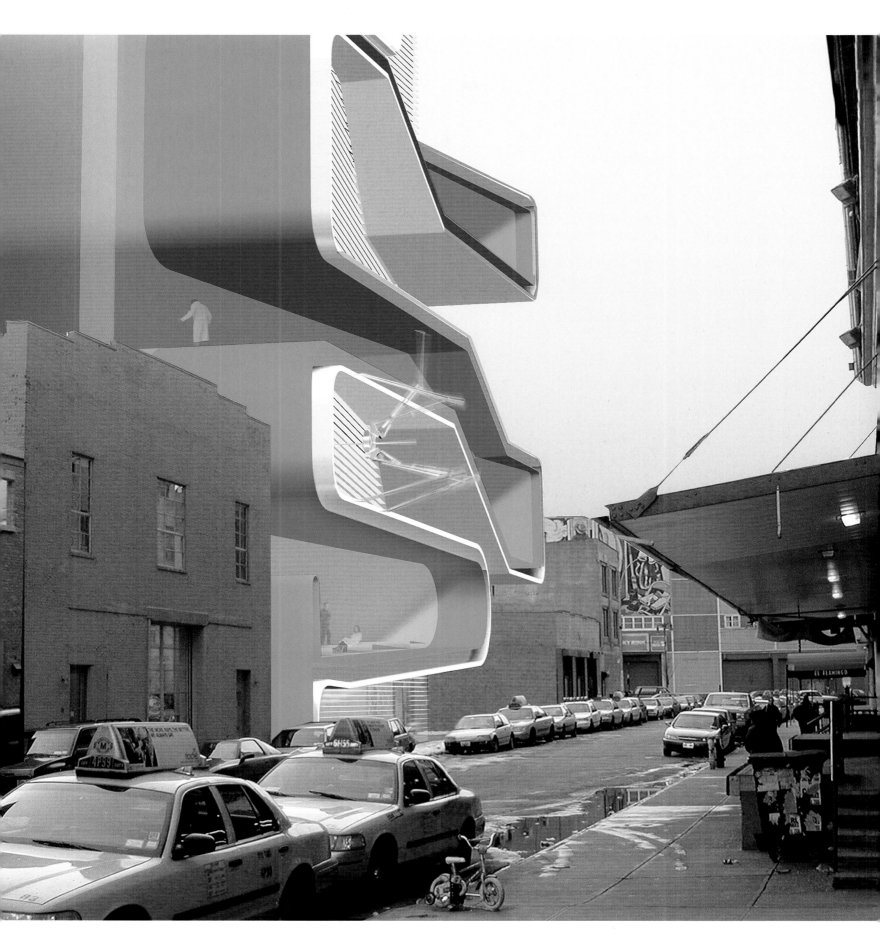

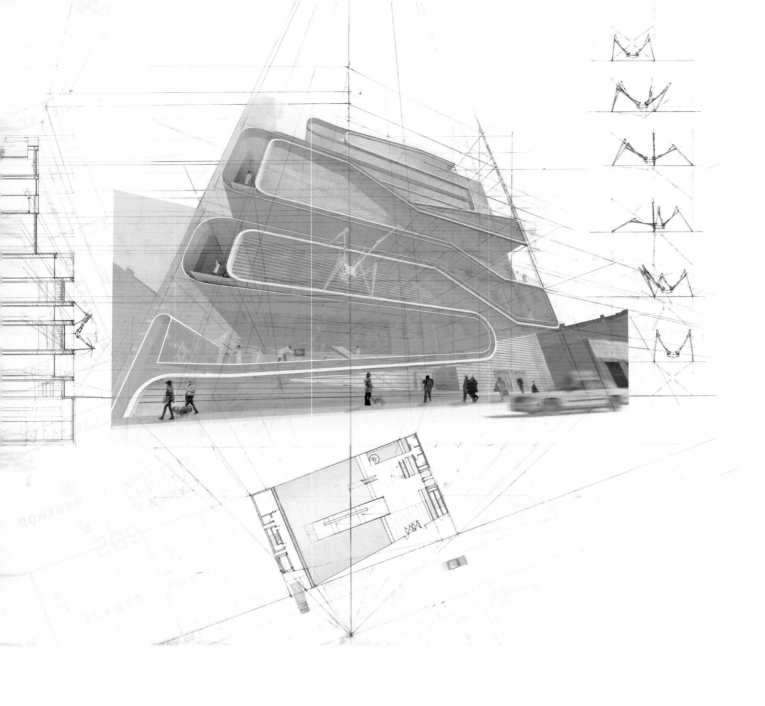

View from 21st Street
(computer simulation)

View onto the open-air cinema and
restaurant (computer simulation)

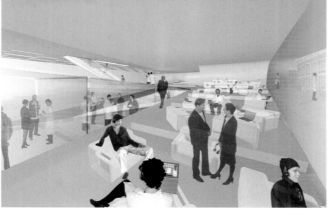

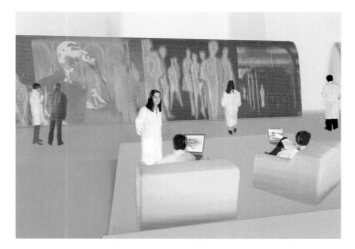
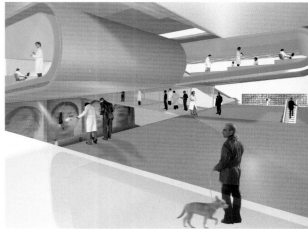

Interior views: bar, mediatheque,
digital mural, lobby, classroom,
theatre (computer simulation)

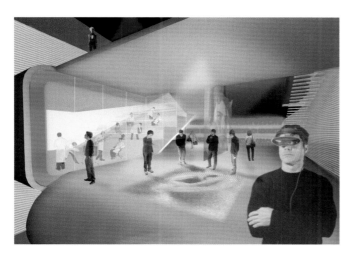

ness of new media, Eyebeam was conceived as an institution that would combine education, exhibition and production on a site in Chelsea, an area of Manhattan in the midst of transformation from industrial to arts uses. In 2000, Eyebeam launched a three-stage international design competition, inviting proposals from 30 architects. Fifteen were selected to present conceptual designs and, in the final stage, three offices – MVRDV, Thomas Leeser, and Diller Scofidio + Renfro – were asked to develop their concepts. The competition stressed the importance of

adaptation to technical change and future technologies, as well as the interrelationship of diverse functions, particularly the intersection of public and museum space.

Like drills attacking gallery walls, Diller Scofidio + Renfro's winning scheme challenges a number of common perceptions of museums. It is conceptually organised around two materially coded surfaces: one for presentation, the other for production. Rather than being developed as distinct public and private domains, these surfaces are folded, spliced, shuffled and inter-

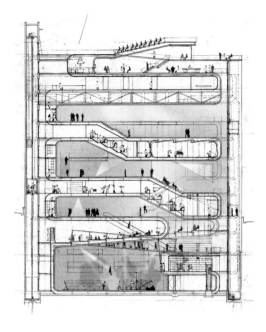

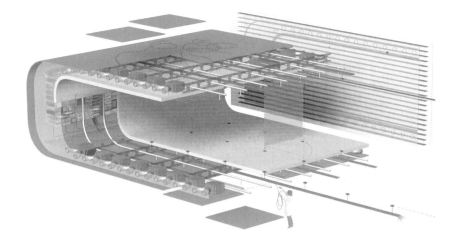

Longitudinal section

Mechanical details of the
'nervous system'

woven, making the hybrid character of the pro- gramme legible and providing calculated con- nections, which the architects call 'controlled contamination', to create the potential for ran- dom cross-fertilisation.

Instead of perpetuating the museum as a treasure house, the Eyebeam proposal – like their spectacularly successful Blur Building for Swiss EXPO 2002 (fig. 1), designed during the same period – is an unpredictable organism, a three- dimensional field of technology that invites ex- ploration and exploitation. At the Eyebeam, the matrix of water nozzles devised for the Blur transforms into a grid of 'pores' embedded in the concrete floors and ceilings of the presentation ribbon's galleries. These pores provide data and electronic feeds; connections for space, light and sound systems; and structural mounts for equip- ment, screens, curtains and artefacts. This infra- structure allows the building to adapt continu- ously to changing desires and technologies. Unlike the traditional hermetic museum, the Eyebeam's fully glazed façade exposes human, artistic and technological activity within the building to public scrutiny. Devices like pho- totropic louvres and electrochromic glass, which change from transparent to opaque on demand,

seek to endow this architecture with the same mutable qualities as the cloud of mist on Lake Neuchâtel instead of the fixed institutional vis- age,

This proposal also intentionally undermines the role of the museum as an arbiter of artistic taste, promoting instead what Elizabeth Diller calls "the democratic ethos of information tech- nologies".[2] Emphasising the pervasive character of digital media, art installations are not restrict- ed to galleries but can occur anywhere, even in toilet rooms or on the street. Instead of the museum only dispensing carefully scripted and edited information, Diller Scofidio + Renfro

Fig. 1: Diller + Scofidio, *Blur*, designed for EXPO 2002, Switzerland

envisage an open communications network that permeates building surfaces, furniture and people. Wearable devices with electronic ID tags – tools for tracking as well as educating and entertaining – enable visitors to be in contact with artists, students and staff and to receive and transmit data. A roving robotic spider, a sur- veillance device the architects describe benignly as a 'pet', traverses the face of the building, attracted to concentrations of human and tech- nological activity by thermal sensors. The video eye of the spider transmits images to an electron- ic mural in the mediatheque. Occupants and visitors, together with multimedia installations and the building itself, become active partici- pants in this dynamic spectacle, a comment perhaps on the increasingly narcissistic character of media-saturated culture.

David Hockney's study spans the early 1400s to the present and maps the changing relation- ship between lens-based objective images and subjective images manipulated by the hand and eye of the artist. Hockney observes that some artists "… cross the line, transcending mere nat- uralism to produce paintings that not only depict exterior reality but also reveal inner truths".[3] Diller Scofidio + Renfro consistently cross this

line, deftly blending technical virtuosity with the probing insight of a critical eye. In the Eyebeam project, they propose a lens through which to explore the increasingly ambiguous boundaries and overlaps of real and mediated experience, of image and imagination. In this regard, Eyebeam both reaffirms the traditional role of art and the museums in which it is housed and provokes new ways of seeing.

Annette LeCuyer

1 *Scanning: The Aberrant Architectures of Diller + Scofidio* (Whitney Museum of American Art, New York 2003), p. 4
2 Keith Mitnick (ed.), *Diller + Scofidio* (Michigan Architecture Papers, Ann Arbor 2004), p. 36
3 David Hockney, *Secret Knowledge* (Thames & Hudson Ltd, London 2001), p. 184

Exterior view from the north-west (computer simulation)

Rafael Viñoly Architects, PC

The Nasher Museum of Art at Duke University
Durham, NC, USA

Client: The Nasher Museum of Art
Design: 2000–2001
Construction: 2003–2005
Budget: US $23 million

Site section sketch, 2001

Night view from the south-west

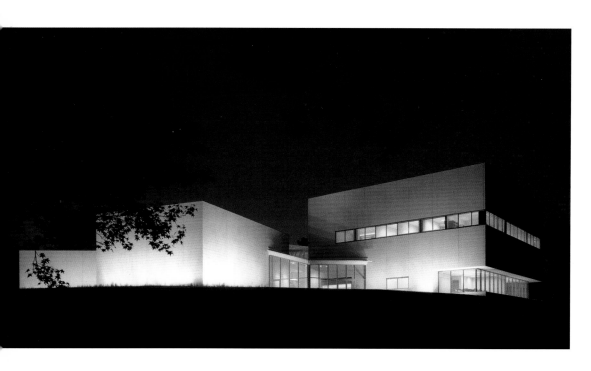

The Nasher commissioned the first free-standing art museum built at Duke University in the school's 80-year history from Rafael Viñoly in 2000. The $23-million complex, containing 65,000 square feet, broke ground in 2003 and opened in the autumn of 2005. A prestigious home for the collection of Raymond and Patsy Nasher, which has distinguished holdings in 20th-century sculpture and American art, it also serves as a venue for emerging artists and topical exhibitions and as a state-of-the-art teaching facility for the university's visual arts programmes. The complex houses three gallery spaces, one for the museum's permanent collection, the other two for changing exhibitions; a 173-seat auditorium; and a variety of support services, including classrooms, administrative offices, a museum shop, and a café. Set into a sloping nine-acre site planted with trees and meadows, it is centrally located between the east and west campuses and adjacent to the university's extensive public gardens.

The parti comprises five boxlike volumes that pirouette around a glazed central atrium space. The atrium's lightweight glass-and-steel canopy is a signature Viñoly feature. It rises to 45 feet, forming an irregular pentagon evocative of a cat's cradle. It is spanned by five steel box beams, which are supported on structural columns concealed inside the precast concrete walls of the perimeter volumes. The atrium nearly doubles the 14,000 square feet of display area in the three volumes containing gallery space, and accommodates large sculptures and temporary installations. In between the solid volumes, views of the surrounding greenery are framed by full-height glass openings, interspersing fragments of nature

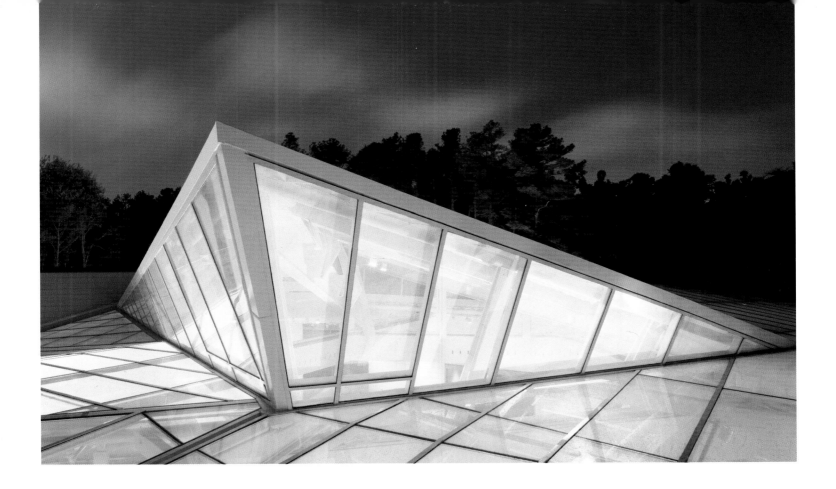

Exterior and interior views
of the roof skylight

Box beam details

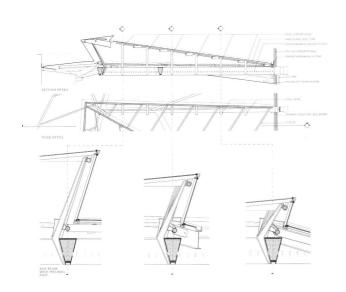

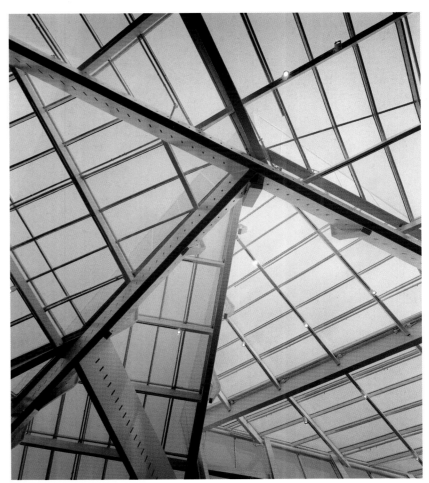

189 Rafael Viñoly

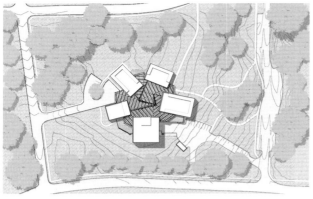

Site plan

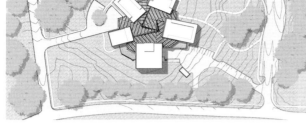

Axonometric site-plan sketch, 2001

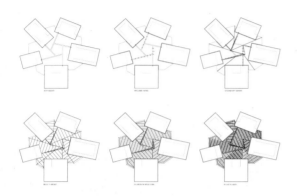

Structural diagram: lobby roof

Section and east elevation

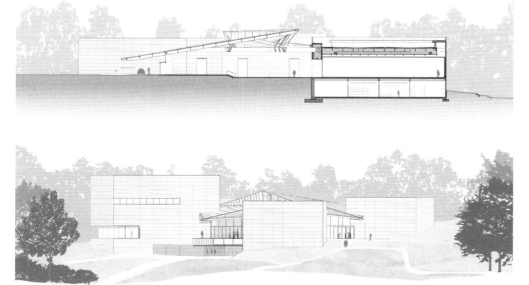

with architecture and blurring perceptions of interior and exterior. The blurring of boundaries is amplified by the extension of the atrium's green, slate paving and portions of the canopy beyond the building's perimeter to define entry terraces and outdoor café seating, as well as by the presence inside the atrium of large planters with vegetation. As on a carousel, movement from one volume to the next is a cinematic, in-the-round experience inflected by changing views of the natural landscape and the play of light and shadow from the glass roof.

In counterpoint to the 'event space' of the atrium are the five megaron-like volumes. They belong to the genre of the iconic 20th-century art space, which, as elaborated by Brian O'Doherty in his classic essay 'Inside the White Cube' (1976), serves to consecrate the art object and rarefy its aura. The art gallery volumes are entered off the atrium through deep vestibules. Within, pristinely defined, rectilinear galleries are illuminated by controlled natural light that filters through a strip of recessed clerestory windows. At the floor level, another reveal further separates the vertical surfaces from the horizontal, making the walls appear to float. This detailing reinforces their quality as idealised planes for contemplation and intensifies the impression of curatorially controlled space. "Context becomes content", as O'Doherty noted; "the ideal gallery subtracts from the artwork all cues that interfere with the fact that it is art."

At the same time, the somewhat surreal gesture of multiplying the solid volumes fivefold in a pinwheeling plan and appending them to the

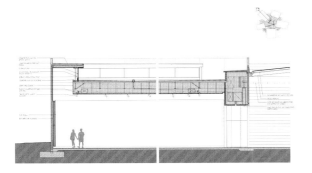

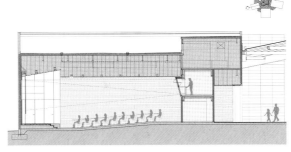

Gallery and lecture hall section

Sketch of lobby interior, 2001

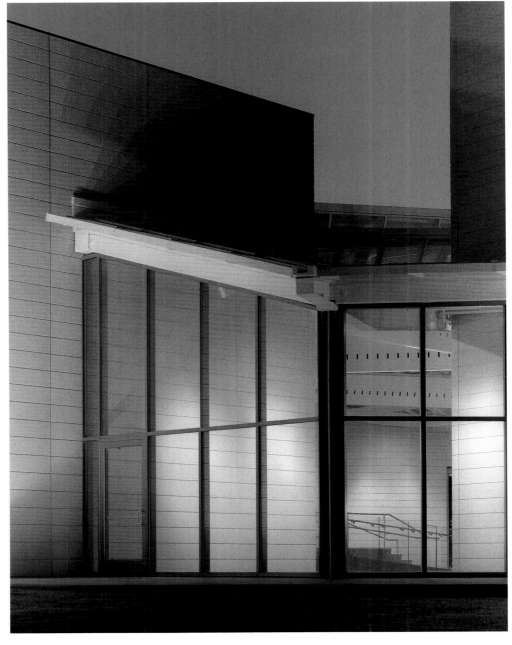

Exterior night view: café terrace

191 Rafael Viñoly

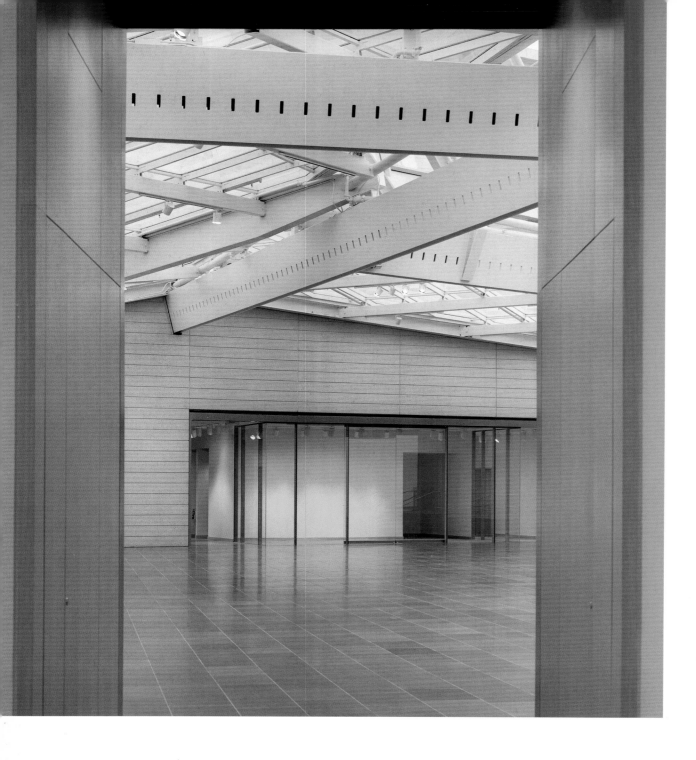

'big top' of the central atrium-pavilion serves, at least in a tongue-in-cheek way, to recontextualise the high-seriousness of the modernist art space. The juxtaposition dramatises the contrast between two archetypal kinds of public viewing experience: introverted and extroverted, hermetic and hyperactive, abstract and picturesque. A place for both attentive and distracted spectator-

ship, the Nasher Museum of Art finds its form within a contemporary art culture poised between connoisseurship and spectacle.

Joan Ockman

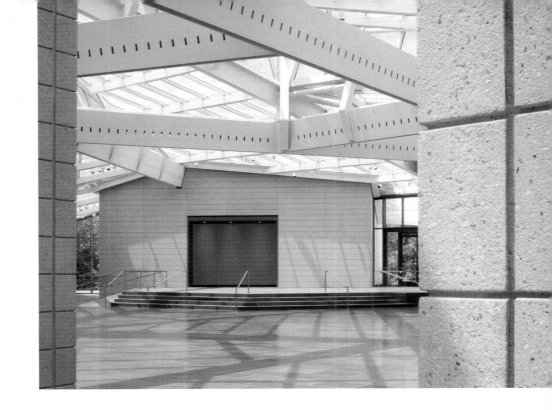

Interior views of the lobby
by day and night

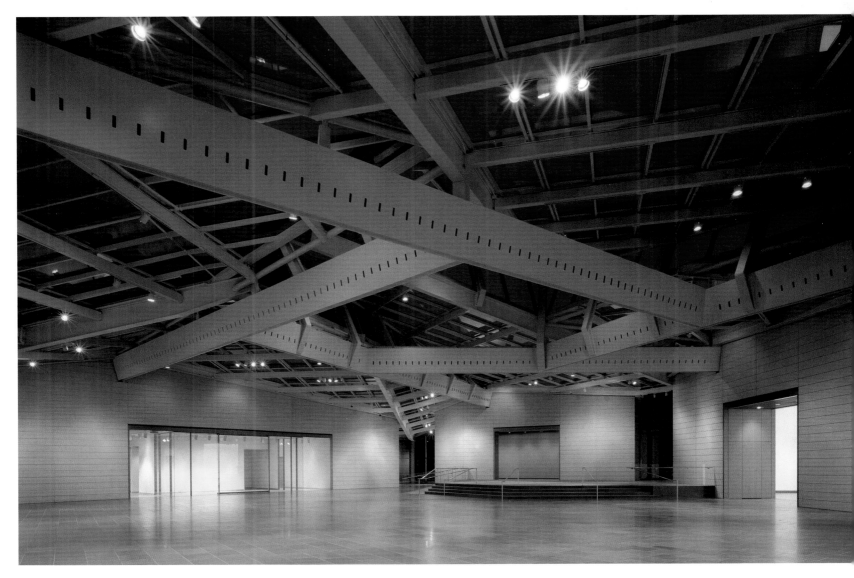

193 **Rafael Viñoly**

Studio Daniel Libeskind with Davis Partnership, PC

Expansion of the Denver Art Museum
Denver, CO, USA

Client:	City and County of Denver
Design:	2000 – 2003
Construction:	2003 – 2006
Budget:	$90.5 million

Conceptual study 'Composite Image', 2000

Construction site, 2003/2005

Since 1971, the Denver Art Museum has been permanently housed in a 28-sided, seven-storey, glass-tile-clad structure designed by Italian architect Gio Ponti and Denver-based architect James Sudler. The 210,000-square-foot building was the first major art museum building in Denver and remains one of the most dominant architectural features in the region. It has been a wonderfully flexible, efficient and beautiful place for the museum to evolve over the last three decades, but in the autumn of 2006 the Denver Art Museum began a new era by opening a dramatic expansion designed by Daniel Libeskind.

Founded in 1893, the Denver Art Museum has in recent decades defined itself as a museum that does things differently. From the way its collections are displayed, to the interpretation that accompanies the work and, most obviously, in the structures built to house its collections, the museum has continually challenged traditional notions of the American art museum. Its outstanding holdings in art representing the Americas include some of the finest collections of American Indian, pre-Columbian and Spanish colonial art in the country. At the same time, the museum has continued to build collections of world art to provide a global sense of art to the surrounding community, while celebrating the culture and history of Colorado and the American West.

Explosive growth in its collections, membership and attendance in the last two decades of the 20th century made obvious the need for expansion. The physical demands on the space for staging major travelling exhibitions and the display of its own collections had exceeded the capability of the current building.

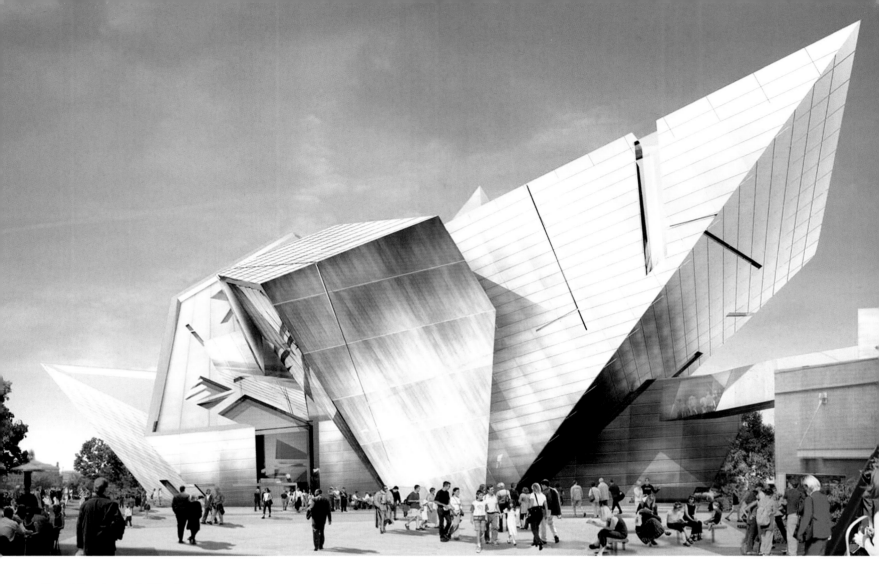

View of the extension building from
the north-east (computer simulation)

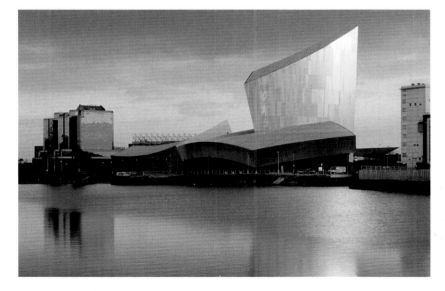

Fig. 1: Studio Daniel Libeskind, Imperial War Museum,
Manchester, UK, 1997–2002

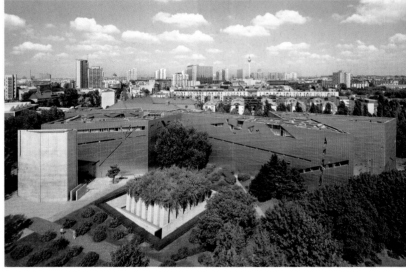

Fig. 2: Studio Daniel Libeskind, Jewish Museum Berlin,
Berlin, Germany, 1989–99

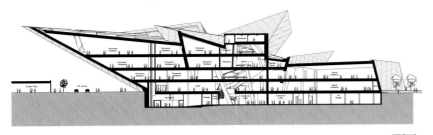

Longitudinal section

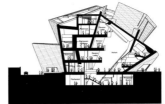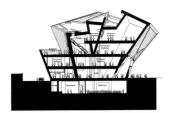

**Cross-sections through the atrium
and the restaurant**

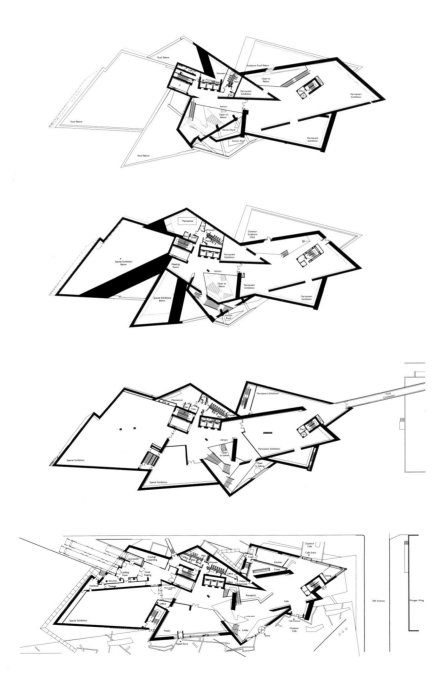

Ground plans: 3rd, 2nd, 1st floors and ground floor (from top to bottom)

Denver supports culture in a unique way, with a metropolitan-wide sales tax that distributes more than $35 million to more than 300 arts and culture organisations in the Denver area. This has transformed the city into a major cultural center for the region and has enabled the largest arts and culture organisations to complete major expansions or renovations in recent years.

The expansion process moved forward through a partnership with the city of Denver that allowed the museum to seek approval of bond funds from Denver voters. Continual population growth in the metropolitan area had increased the community's appetite for art. That demand – coupled with the museum's desperate need for space to show more of its holdings, as well as the need for improved space for travelling exhibitions to attract top shows – motivated voters. In 1999, voters approved $62.5 million in bonds to support an expansion and the museum immediately began looking for an architect to design a 146,000-square-foot structure directly south of the existing museum along a major thoroughfare for downtown commuters.

The list of 41 international architects approached by the museum was quickly reduced to ten. A selection committee of city officials, cultural leaders, community members and museum trustees was then formed to make the final selection. The three finalists – Thom Mayne of Morphosis, Arata Isozaki and Daniel Libeskind – each participated in a public lecture about his work that drew more than 800 members of the community. The level of public interest exceeded expectations and has become a model for architectural projects in the city. In June 2000, after travelling the world to see buildings by the

finalists, the committee unanimously chose Libeskind as the lead architect for the expansion (fig. 1).

Libeskind's ability to communicate and listen to the committee and his keen understanding of the museum's programme and the goals of this expansion were key to his selection. Those goals included the need for open, versatile gallery spaces, flexible space for travelling exhibitions, efficient space for art movement, and landmark architecture. His ability to articulate a vision, comprehend the complicated nature of large civic projects and create spaces that become artworks in their own right were qualities that spoke loudly to the selection committee.

Libeskind had been in Berlin for more than a decade designing and overseeing construction of his first commissioned project, the Jewish Museum Berlin (fig. 2), when he was hired for the Denver expansion, and the commission that would launch him into the international spotlight – his master plan for rebuilding the World Trade Center site in New York City – was still almost three years away.

Studio Daniel Libeskind, along with its Denver-based joint-venture partner, Davis Partnership Architects, exceeded the Denver Art Museum's expectations with an angular, titanium and glass-clad design unlike any building in the world. The architecture was bold and daring, but appropriate in scale and complementary to the surrounding buildings. It served the museum's needs with major spaces for travelling exhibitions, large volumes of space for permanent collections, adequate areas for operational functions and a grand atrium rising 120 feet from the first floor that serves as visitor orientation, while providing an aesthetic experience unlike any other space in Denver. The gallery spaces within the building provide a unique platform for the museum to showcase its collections and spur creativity in ways that will produce some of the most compelling art museum experiences existing today.

Construction site of the atrium lobby, 2003/2005

Night view, from the south-east, of the museum extension and Acoma Plaza for the Arts (computer simulation)

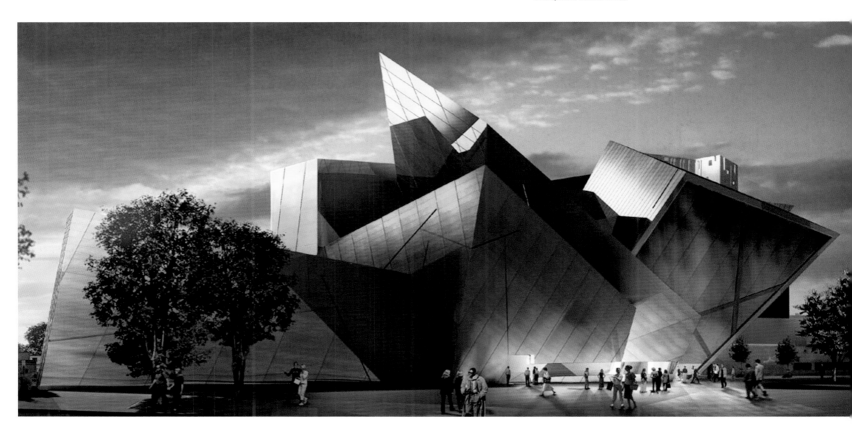

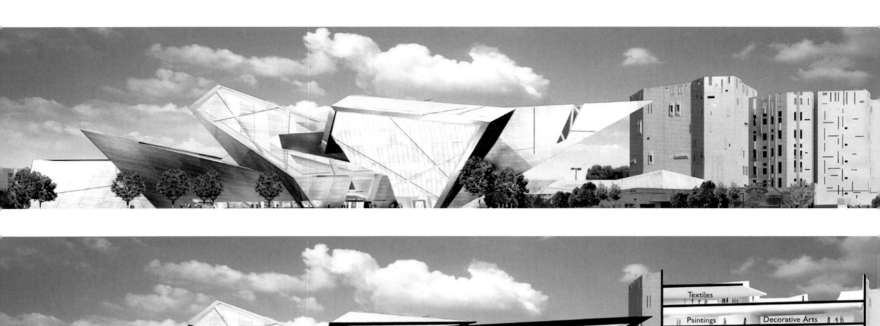

View from the east and section

Additionally, Libeskind was engaged to develop a master plan for the entire block-and-a-half site just south of the city's major civic area, making him the master planner and architect for the entire development, consisting of the museum expansion, parking facility, residential units, retail spaces, a pedestrian plaza and landscape elements.

In addition to the $62.5 million provided by Denver voters for the expansion and the $28 million in capital funds raised from individuals, foundations and corporations to realise the intended vision of the complex, the museum's board of trustees also came forward with $61 million to enhance the museum's endowment and ensure the viability of the museum for future generations. In recognition of the role played by the board's chairman, the museum named Libeskind's expansion the Frederic C. Hamilton Building.

The Hamilton Building celebrates Denver's energy and entrepreneurial spirit and its distinct architecture will likely become an icon for the Rocky Mountain region, as well as a defining project within Daniel Libeskind's body of work. It is one of Libeskind's most dramatic structures and captures the essence of his brilliance and optimism. As an achievement of design and engineering, the Hamilton Building has shown that architectural excellence can be achieved within the typical constraints of civic projects and that it is possible to be bold and interesting while serving a highly defined function and a broad community.

Lewis Sharp / Andrea K. Fulton

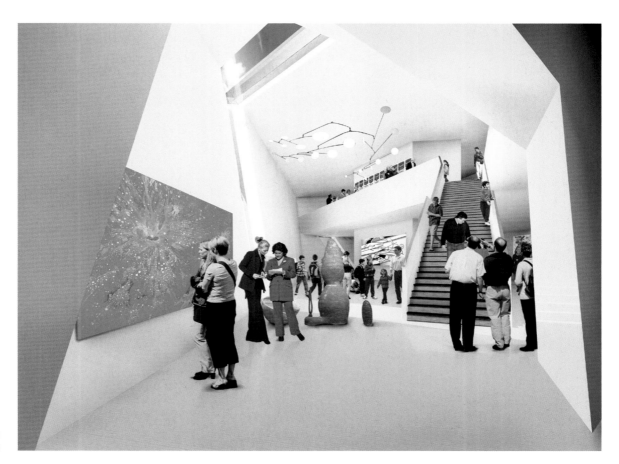

Interior view: exhibition room
(computer simulation)

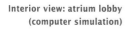

Interior view: atrium lobby
(computer simulation)

Steven Holl Architects

Nelson-Atkins Museum of Art expansion
Kansas City, MO, USA

Client:	Nelson-Atkins Museum of Art
Design:	1999–2004
Construction:	phase 1: 2001–2002;
	phase 2: 2002–2007
Budget:	no data

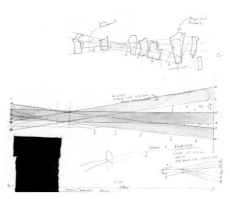

**Study: The Stone & The Feather,
and conceptual study, 1999/2000**

**Aerial view of the museum during
construction, 2003**

Steven Holl's concept for expanding the renowned Nelson-Atkins Museum of Art in Kansas City is based on the idea of linking art, landscape and architecture. The Bloch Building, attached to the east side of the 1933 Beaux Arts building, is not an extension in the usual sense: the lightness and transparency of the five sculpted sections of the building contrast excitingly with the heavy stone and self-contained quality of the neo-Classical structure. Holl calls this contrapuntal concept "The Stone and the Feather", and cites major works of art in the museum's Chinese art collection, like Zhou Chen's 16th-century *The North Sea*, to justify his approach of interpenetrating landscape and architecture. Here, his aim is to create a "timeless, exciting and inspiring" effect for the new building.[1]

Steven Holl won the competition in 1999 against five other finalists (Tadao Ando, Christian de Portzamparc, Gigon/Guyer, Carlos Jiminiez, Rodolfo Machado & Jorge Silvetti) with a particularly unconventional concept that deviated from the brief. The competition programme had placed the planned extension on the imposing north façade of the Nelson-Atkins building. But Holl was the only entrant to leave the existing museum untouched and placed his extension concept, originally consisting of seven glass 'lenses', on its east side. The additional 15,330 square metres give the museum an additional 45 per cent of usable space, providing more space for temporary exhibitions and educational museum activities. After the new underground car park had been constructed beneath a pool and the plaza in front of the entrance façade, work began in 2002 on the new Bloch Building, planned to open in 2007; the old building will be

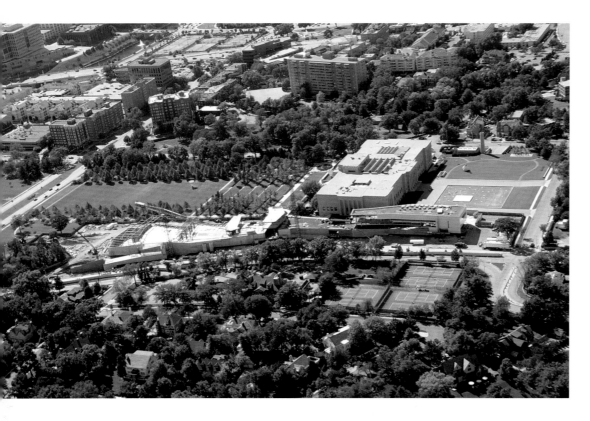

comprehensively refurbished at the same time.

Most of the long section of the new Bloch Building is buried under a terraced landscape garden. It is visible above the surface over its 256 metres only in the form of five sculptural sections rising from below the ground – the glass 'lenses' or 'lanterns'. Thus the new building also becomes part of the sculpture garden, whose paths wind around the lenses. The quality of the lenses' presence changes as the paths meander: by day their translucent or transparent glass takes in light; by night they stand out from their surroundings like glowing bodies of light.

This concept has also been used for the new, light and transparent glass lobby. When it is dark outside, the entrance looks like an inviting shop-window on the activities and events within the building. The northern, narrow side of this largest of the lenses is in line with the edge of the pool and thrusts itself against the old building. It will accommodate the lobby, café, offices, library and multi-purpose rooms. The two floors beneath it offer more visitor facilities, like the museum shop and the lower lobby.

The adjacent exhibition galleries will accommodate permanent collections of contemporary art, photography and African art, and will be completed by a sculpture courtyard containing the museum's comprehensive collection featuring sculptures by Isamu Noguchi. There is also lavish space available for temporary exhibitions. The path through the galleries is laid down in the traditional way in the old building; in the new building it is replaced by undirected traffic on various levels, constantly opening up new sight-lines and views of the landscape and the sculpture garden for visitors.

The lens façade is constructed of channel glass in various thicknesses and with differently treated surfaces. For the outer wall, pairs of glass planks were used in pairs in a sandwich system; the second, inner wall consists of single glass planks, with space for the artificial lighting between them. This structure is interrupted by transparent glazing affording occasional glimpses of the surrounding area and the sculpture park. A third type of glass is used in the four lenses above the exhibition galleries. This is laminated, acid-etched sheet glass in translucent white, which re-

Conceptual study, 1999

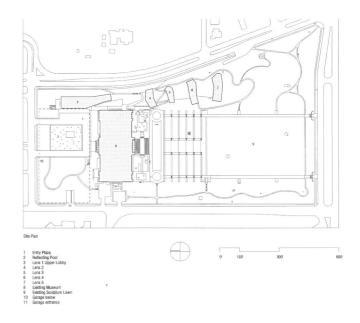

Site plan

Model, 2000

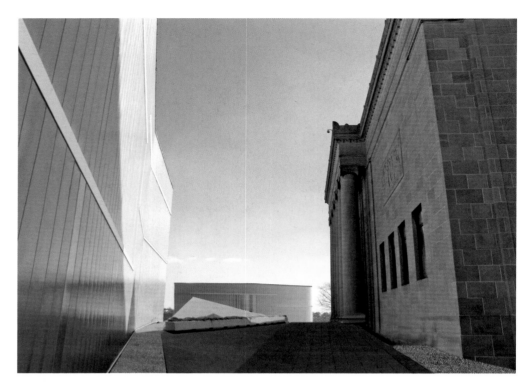

duces surface reflection, absorbs ultraviolet light and gives the surface a shimmering appearance that changes visually with the weather and the light and thus forms an interesting contrast to the old building in its material quality.

This interplay of changing surfaces, transparency, translucency and different light situations was also used for the spacious reception area of the J.C. Nichols Plaza outside the Nelson-Atkins Museum. Holl, working with artist Walter de Maria, created a shallow, rectangular pool of water, shifted slightly off the main axis of the old building. The pool has 34 round windows let into its bottom, and during the day these admit light affected by the movement of the water into the car park. At night, built-in lamps illuminate the square, paved with black granite. Additionally, a rectangular, slightly curved sculpture is placed in the pool, and this and the oculi comprise the work *One Sun/34 Moons*.

Steven Holl acquired his major reputation as a museum architect through the 'Kiasma' Museum of Modern Art in Helsinki (1992–98). There, too, his expressively contoured museum enters into a dialogue not just with the context of the town, culture and nature of Töölö Bay in the Finnish capital, but also forms an exciting contrast with the architecture of the massive neo-

View from the north: between old and new building (computer simulation)

Night view from the north, with *One Sun/34 Moons* (2002) by Walter de Maria in reflecting pool of water (computer simulation)

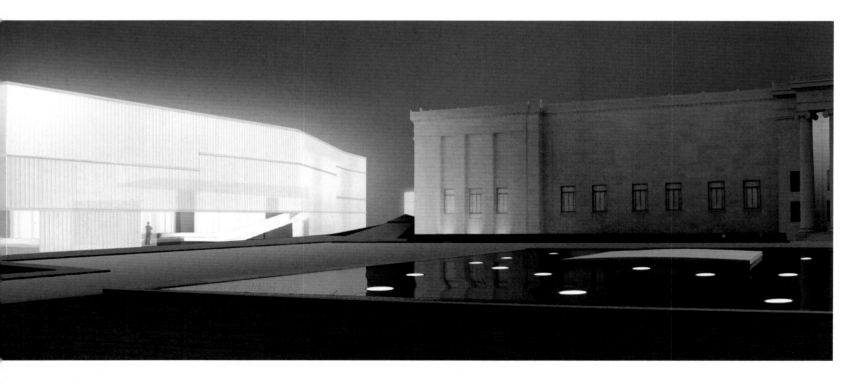

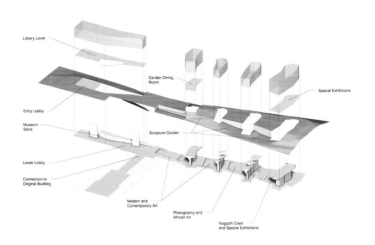

Library Level

Garden Dining Room

Special Exhibitions

Entry Lobby

Museum Store

Sculpture Garden

Lower Lobby

Connection to Original Building

Modern and Contemporary Art

Photography and African Art

Noguchi Court and Special Exhibitions

Division schema, lenses, garden level, basement storey

Ground plans: library, 1st floor and ground floor

Longitudinal section and view from the west

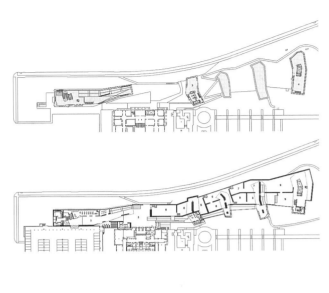

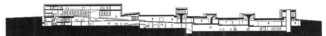

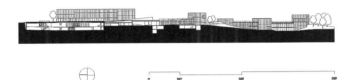

View from the west (computer simulation)

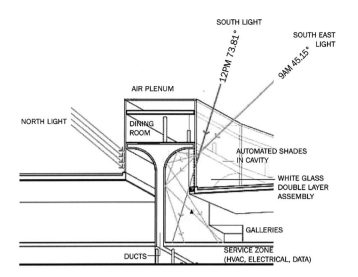

SOUTH LIGHT

SOUTH EAST
LIGHT

12PM 73.81°

9AM 45.15°

AIR PLENUM

NORTH LIGHT

DINING
ROOM

AUTOMATED SHADES
IN CAVITY

WHITE GLASS
DOUBLE LAYER
ASSEMBLY

GALLERIES

DUCTS

SERVICE ZONE
(HVAC, ELECTRICAL, DATA)

**Sectional view through lens,
with incidence-of-light study**

Classical 1931 parliament building. According to Joan Ockman, Holl created "a phenomenological field for discovery and interaction … a kind of cultural power station",[2] in his Bellevue Art Museum in Bellevue in the US state of Washington (1997–2001), a building based on the idea of 'trinity'. In his poetic and unusual design for the extension of the Nelson-Atkins Museum, Holl not only synthesises these approaches, but also creates a new high point for his architecture and contemporary museum architecture in general – in the reticent and thus particularly impressive

Study: exhibition room, 1999/2000

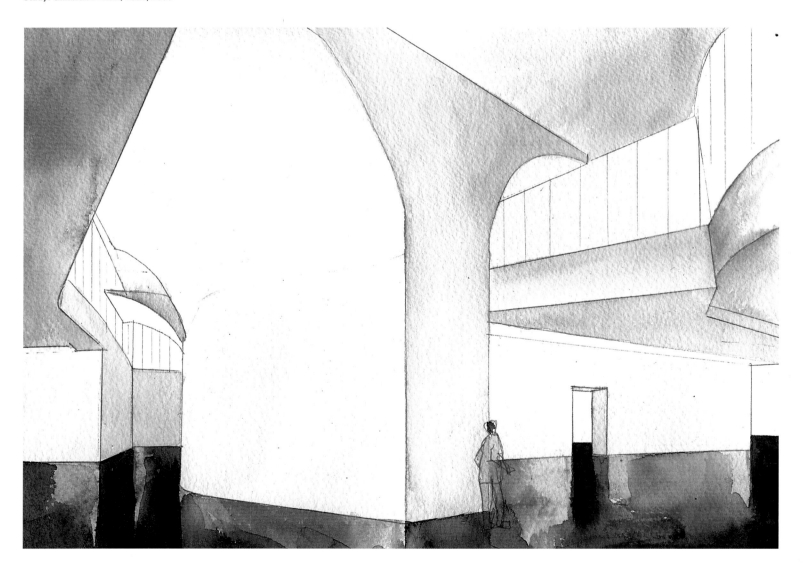

appearance of the new Bloch Building's sculptural body and in the many experiences in terms of views and movement that visitors can experience in the field of tension between the old and the new building, in the landscape of the culture park and inside the new galleries.

Angeli Sachs

1 http://www.stevenholl.com
2 Joan Ockman, 'Steven Holl: Bellevue Art Museum', in: Vittorio Magnago Lampugnani, Angeli Sachs (eds.), *Museen für ein neues Jahrtausend. Ideen, Projekte, Bauten* (Munich, London, New York 1999), p. 206

Study: Noguchi room, 1999/2000

Noguchi room with works by Isamu Noguchi (computer simulation)

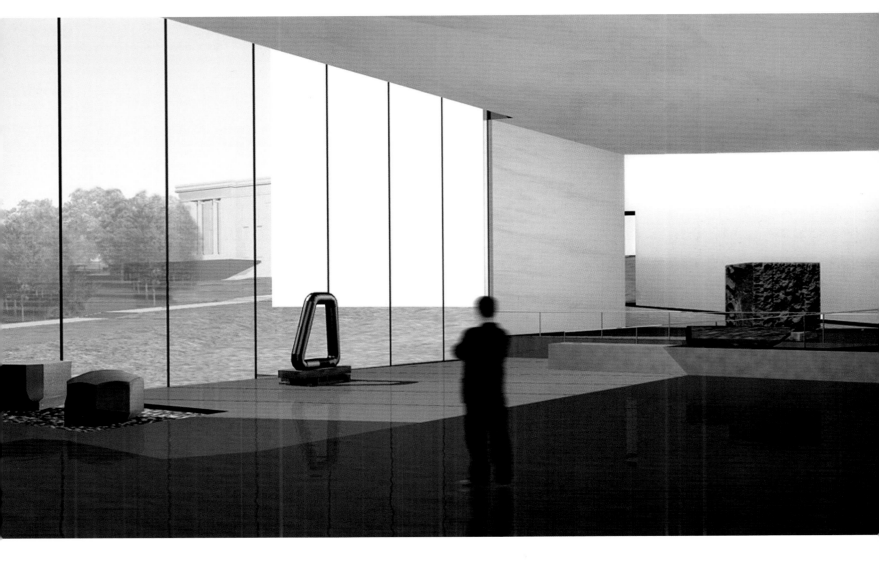

Allied Works Architecture

University of Michigan Museum of Art expansion
Ann Arbor, MI, USA

Client: University of Michigan
 Museum of Art,
 James C. Steward, Director
Design: 2003 – 2005
Construction: 2006 – 2008
Budget: US $26 million

Conceptual sketch, 2005

Site-plan drawing, 2005

The 98,000-square-foot expansion and renovation of the University of Michigan Museum of Art by Allied Works Architecture presents a unique series of solutions to problems related to urban planning, architectural innovation and museum culture. Allied Works' design calls for a 55,000-square-foot addition to the Beaux Arts-style Alumni Memorial Hall, which was completed in 1910 and originally served as a tribute to students of the university who had died in the American Civil War and other conflicts.

The existing museum faces State Street, a principal thoroughfare and border to the centre of the historic campus. The proposed addition takes up the setbacks along the street, reinforcing the campus's historical edge.

The site for the expansion has – since a pre-existing building was demolished some time ago – become criss-crossed with pedestrian pathways leading to the centre of the university's main quadrangle and its graduate library.

The design of the addition weaves the existing circulation alongside and through the building. In keeping with the informality of university life, students can pass through the building as well as along its western edge, traversing a terrace that extends from the 50-seat commons area and passing by a ground-level gallery with floor-to-ceiling glass walls. The glazed façades facing the terrace and pathway open the building up to passersby, suggesting a more accessible environment than the introspective and formal character of the existing building. A secondary entrance facing the terrace leads to the commons and the 225-seat auditorium on the lower level.

The proposed addition has several important features that give it its own sense of identity while

respecting the qualities of Alumni Memorial Hall. The existing structure is biaxially symmetrical, with a monumental entry portico leading to a double-height, colonnaded apsidal hall. The proposed new entrances do not attempt to rival or replace the formality of the existing structure's principal compositional element, which would have needlessly rendered it architecturally incoherent. The new addition consists of three interlocking volumes and connects with, and reinforces, the cross axis of the older building. A new triple-height gallery connects the three volumes of the addition and echoes the grander apsidal hall of the original structure. The upper galleries of the new wing will, like those of Alumni Memorial Hall, allow light to filter in from above.

The new wing is composed of a series of clear constructive elements. Three L-shaped concrete walls extend outwards from the central triple-height gallery and define the principal volumes of space. A glazed façade completes the perimeter of each volume, its vertical mullions rising up

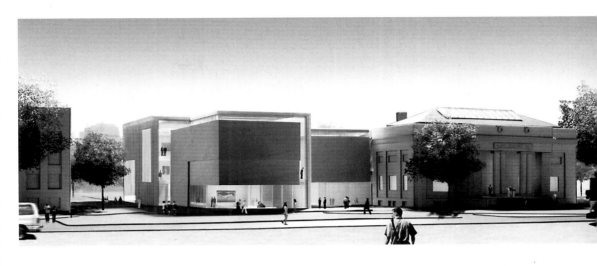

View from South State Street
(computer simulation)

Event Court at night
(computer simulation)

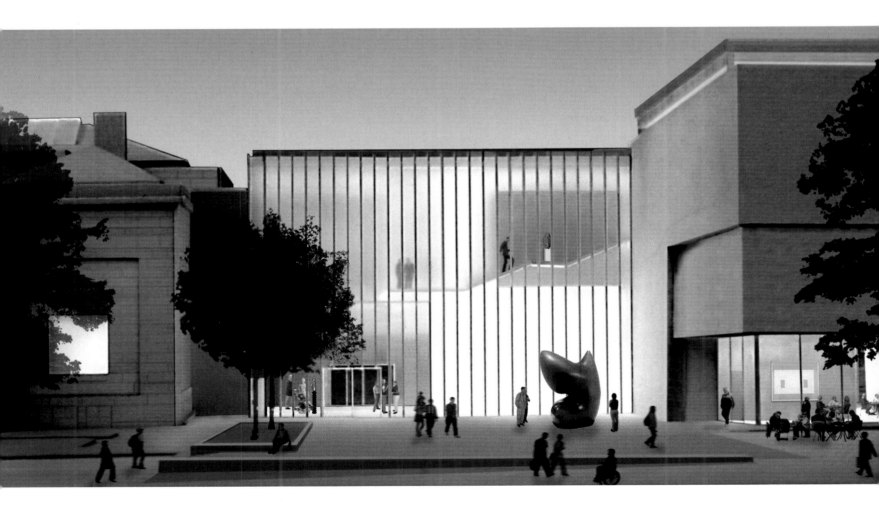

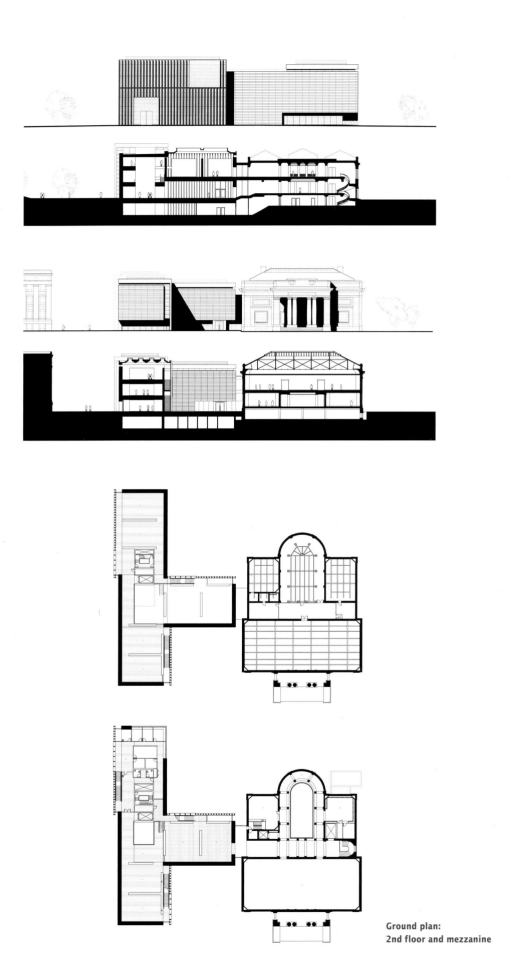

Ground plan:
2nd floor and mezzanine

and the over the volume as the roof structure. The concrete and glazed surfaces interlock in their respective horizontal and vertical dimensions with a narrow light-filled gap running beneath and alongside them. Along the glazed façades, interconnecting stairways fill the gap in each of the volumes, animating the structure from within and without.

Further manipulations of the three principal volumes of space allow for greater spatial and formal variety. At ground level, the shorter legs of the concrete walls cantilever, recalling the hovering volumes of I. M. Pei's 1968 Everson Museum in Syracuse, New York. The open ends of the three pin-wheeling volumes thus become as transparent as possible, allowing for maximum visibility into and from the commons area, the ground-level gallery and between the original building and the new addition.

The new and renovated spaces address various programmatic needs identified by the museum staff. The new space will not only allow for the doubling of the museum's exhibition space but will also expand the collections storage areas, including an 'open' storage area for greater public accessibility. Other elements include a print study room, classrooms and art studios, an auditorium and conservation labs.

While the proposed design, in keeping with many contemporary museum practices, includes an expanded shop, rentable space for non-art-related functions as well as other amenities that have become associated with museums today, the overall environment is well suited to university life. On a campus that offers many points of interest to a community of students, Allied Works' design is neither populist nor academic but has a self-confident sense of its own intellectual attrac-

Conceptual diagrams

Working model, 2005,
façade detail

Entry Court at night
(computer simulation)

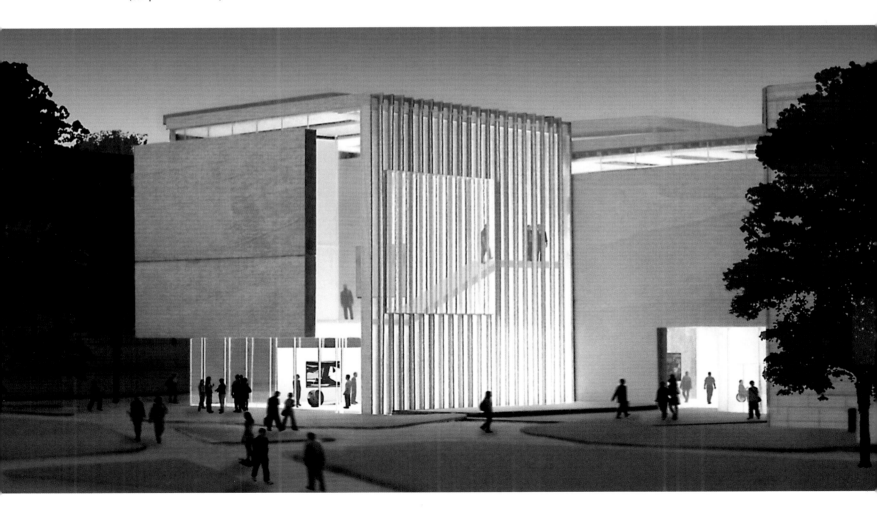

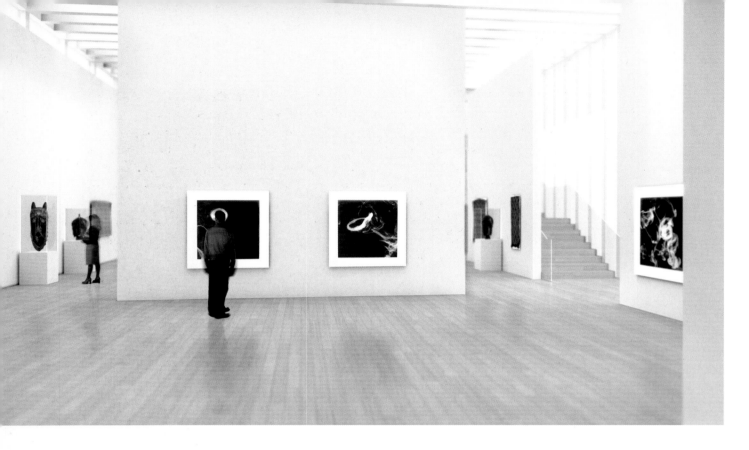

Exhibition rooms: bridge gallery and
atrium gallery (computer simulation)

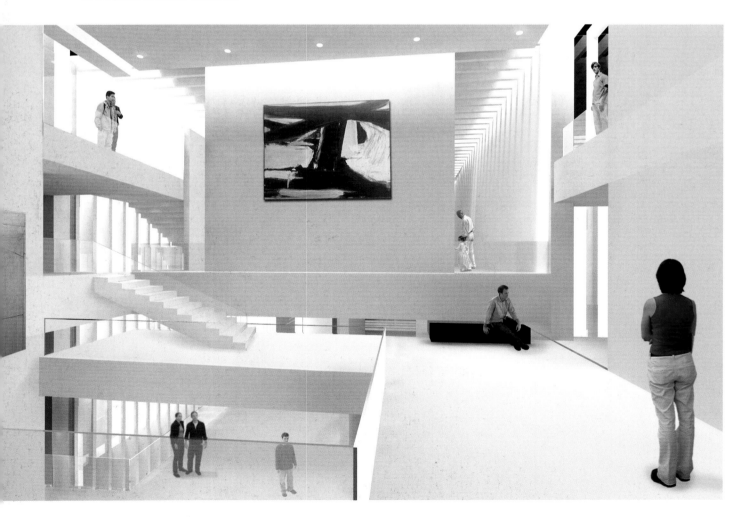

tion. The multiple points of entry and the various interconnecting stairways will ensure an environment that favours self-direction over an overly didactic experience. This sense of intellectual autonomy is essential to any arts enterprise that depends on critical thinking. In this respect, the model for the new museum can be seen, appropriately, as a library, where numerous individuals pursue various activities under a common roof, rather than simultaneously share the same experience.

The galleries themselves are regular enough to accommodate a varied collection of art that must be reinstalled regularly to show the depth of the museum's holdings. Yet they have enough spatial variety – into adjacent galleries and above

and below through the interconnecting stairways – to create a sense of self-awareness on the part of the visitor that is an essential part of appreciating and understanding a work of art. The views out to the campus and the world beyond also serve to connect the art to daily life, further ensuring that the experience of visiting the museum remains vitally connected to the university's mission.

Terence Riley

**Exhibition room
(computer simulation)**

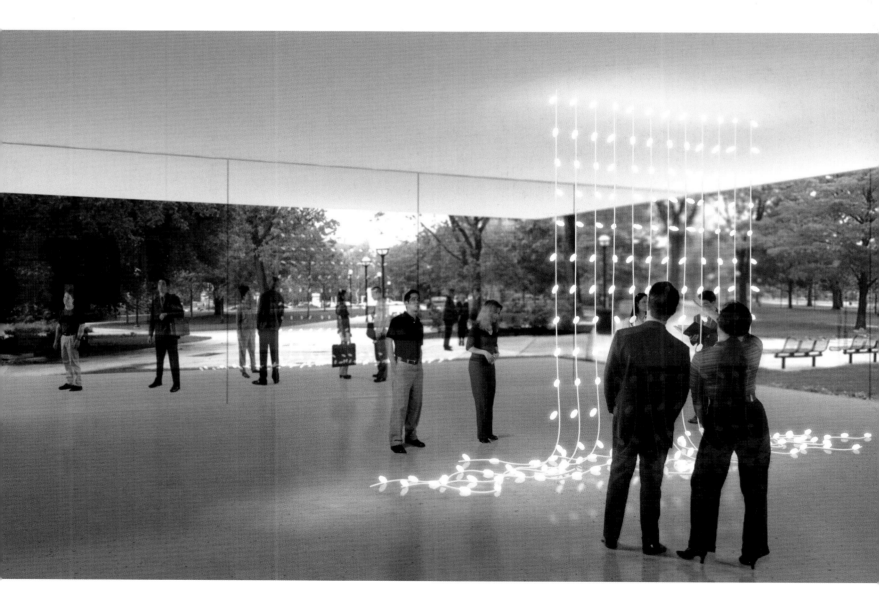

Biographies

Allied Works Architecture

Brad Cloepfil, b. 1956 in Portland, Oregon; founded Allied Works Architecture in 1994 in Portland; office in New York since 2003
Project team:
Brad Cloepfil, Thomas Robinson, Chelsea Grassinger, Dan Koch
Partner: Integrated Design Solutions

l. to r.: Vaios Zitonoulis, Nikos Georgiadis, Panagiota Mamalaki, Kostas Kakoyiannis

Anamorphosis

Anamorphosis Architects consists of Nikos Georgiadis (b. 1955), Panagiota Mamalaki (b. 1958), Kostas Kakoyiannis (b. 1961), Vaios Zitonoulis (b. 1963); office founded in 1992 in Athens

Tadao Ando

b. 1941 in Osaka; Tadao Ando Architect & Associates founded in 1969 in Osaka

Jun Aoki

b. 1956 in Yokohama, Kanagawa, Prefecture; Jun Aoki & Associates founded in 1991 in Tokyo

ART+COM

The design office for new media, interactive installations and stagings in Berlin was founded in 1988 by, amongst others, Joachim Sauter (b. 1959).

atelier brückner

Uwe R. Brückner (b. 1957 in Hersbruck) and the Atelier Brückner have been providing architectural, exhibition and scenographic solutions since 1997 on the principle that "form follows content".

Shigeru Ban

b. 1957 in Tokyo; head of Shigeru Ban Architects in Tokyo since 1985; temporary office on the roof of the Centre Georges Pompidou in Paris since 2004

Mario Botta

b. 1943 in Mendrisio, Switzerland; office in Lugano since 1970

Stephan Braunfels
b. 1950 in Überlingen, Germany; office founded
in 1978 in Munich

l. to r.: Helmut Swiczinsky, Wolf D. Prix

Coop Himmelb(l)au
founded in 1968 in Vienna by Wolf D. Prix (b.
1942) and Helmut Swiczinsky (b. 1944); opened
studio in Los Angeles, California, in 1988 and in
Guadalajara, Mexico (COOP HIMMELB(L)AU
Mex S.A. de C.V.), in 2000

l. to r.: Charles Renfro, Ricardo Scofidio, Elizabeth Diller

Diller Scofidio + Renfro
Elizabeth Diller (b. 1954 in Lodz, Poland) and
Ricardo Scofidio (b. 1935 in New York) founded
their joint architecture office in 1979 in New
York; Charles Renfro joined Diller Scofidio in
1997 and is now a partner
Project team: Diller, Scofidio, Renfro
Project leaders: Deane Simpson, Dirk Hebel
Structural + MEP Engineering: Ove Arup, NY
(Markus Schulte, Mahadev Ramen, Nigel Tonks)

David Chipperfield
b. 1953 in London; David Chipperfield Archi-
tects founded in 1984 in London; second office
in Berlin since 1997 and representative office
in Shanghai since 2005

Denton Corker Marshall
Founded in 1972 in Melbourne by John Denton,
Bill Corker and Barrie Marshall; offices in Mel-
bourne, Sidney, Brisbane, London and Djakarta

Frank O. Gehry
b. 1929 in Toronto, Canada; Gehry Partners,
LLP founded in 1962 in Los Angeles, California

l. to r.: Christoph Sattler, Thomas Albrecht, Heinz Hilmer

Gigon/Guyer

Annette Gigon (b. 1959 in Herisau, Switzerland) and Mike Guyer (b. 1958 in Columbus, Ohio); joint office in Zurich since 1989

Hilmer & Sattler und Albrecht

office of Hilmer & Sattler founded in Munich in 1974 by Heinz Hilmer (b. 1936 in Münster) and Christoph Sattler (b. 1938 in Munich); Berlin branch founded in 1988; entered into partnership with Thomas Albrecht (b. 1960 in Munich) in 1993; business conducted under the name of Hilmer & Sattler und Albrecht GmbH since 1997

Kisho Kurokawa

b. 1934 in Nagoya, Japan; office in Tokyo since 1962. † 2007 in Tokyo

Zaha Hadid

b. 1950 in Baghdad; office in London since 1982

Steven Holl

b. 1947 in Bremerton, Washington; office in New York since 1976

Daniel Libeskind

b. 1946 in Lodz, Poland; office in Berlin since 1990 and in New York since 2003; European head office in Zurich

Fumihiko Maki
b. 1928 in Tokyo; Fumihiko Maki + Maki and Associates founded in 1965 in Tokyo

Jean Nouvel
b. 1945 in Fumel, France; first office founded in 1970; current head office in Paris

Spacelab
Peter Cook (b. 1936 in London) and Colin Fournier (b. 1944 in London); co-founders of Spacelab Cook–Fournier GmbH Graz, which was fitted out to realise the Kunsthaus Graz

HG Merz
b. 1947 in Tailfingen, Germany; architecture and exhibition design office established in 1981 in Stuttgart; second office opened in 1993 in Berlin

Renzo Piano
b. 1937 in Genoa, Italy; Piano & Rogers founded in 1971 with Richard Rogers; l'Atelier Piano & Rice founded in 1977 with Peter Rice; Renzo Piano Building Workshop founded in 1993, with offices in Paris and Genoa

Yoshio Taniguchi
b. 1937 in Tokyo; office founded in 1979 in Tokyo

Heinz Tesar

b. 1939 in Innsbruck, Austria; studio in Vienna since 1973 and in Berlin since 2000

O.M. Ungers

b. 1929 in Kaisersesch/Eifel, Germany; architecural offices opened in 1950 in Cologne and Berlin. † 2007 in Cologne

Rafael Viñoly

b. 1944 in Uruguay, moved to the USA in 1978; founded Rafael Viñoly Architects, P.C. in 1982, with offices in New York and London

l. to r.: Randal Marsh, Roger Wood

Bernard Tschumi

b. 1944 in Lausanne, Switzerland; office in Paris since 1982, head office in New York since 1988
Project team:
Bernard Tschumi, Joel Rutten with Kim Starr, Adam Dayem, Jane Kim, Aristotelis Dimitra-kopoulos, Eva Sopeoglou

UN Studio

Ben van Berkel (b. 1957 in Utrecht) and Caro-line Bos (b. 1959 in Rotterdam); joint office, Van Berkel & Bos Architectuurbureau, founded in 1988 in Amsterdam
Project team:
Ben van Berkel, Tobias Wallisser, Caroline Bos with Marco Hemmerling, Hannes Pfau and Wouter de Jonge

Wood/Marsh

Roger Wood and Randal Marsh; joint office in Melbourne since 1983

Bibliography

The publications listed below deal primarily with the projects presented in this catalogue.

Allied Works Architecture

'Letting There Be Light', in *ARTnews* (November 2004), pp. 126–27

'Modern Meets Tradition: University of Michigan Museum of Art Expansion/Restoration by Allied Works Architecture', ArchNewsNow.com (11 August/3 September 2004)

'Campus Planning Is Breaking New Ground', in *Architectural Record* (August 2004), pp. 87–94

'Allied Works Unveils Addition Design for University of Michigan Museum of Art', archrecord.construction.com (12 July 2004)

'Big Changes Ahead for U-M Museum of Art', in *Ann Arbor News* (19 June 2004), p. 1B

'U-M Art Museum Given $10 Million', in *Detroit Free Press* (5 May 2004), p. 1C

Anamorphosis

Kahn. S. / Steele, J., *Museum Revolution* (London 2005, in press)

Emmer, M., 'Mathland – From Topology to Virtual Architecture', in *Mathematics and Culture II* (Berlin 2005), pp. 65f., 77

Emmer, M., *Mathland, From Flatland to Hypersurfaces* (Basel 2004), p. 87

Anamorphosis Architects, 'The Spatial Monument: The Museum of the History of the Hellenic World', in *Design + Art in Greece – Annual Review* (Themata Horou + Tehnon), no. 35 (2004), pp. 60–63

Georgiadis, N., Lacking the Lack: The Museum of the History of the Hellenic World, Athens', in *Extreme Sites, AD/Architectural Design*, vol. 74, no. 2 (March-April 2004), pp. 122–25

Georgiadis, N., 'The Museum as Spatial Ritual In The Completion of Mourning', in *A+T Architectural Magazine*, no. 2 (2004), pp. 88–94

Dragonas, P., 'Anamorphosis in Venice', in *Architecture in Greece – Annual Review* (Architektonika Themata), no. 37 (2003), p. 17

Kopylova, L., 'Descendants of The Russian Avant-Garde', in *Uhmepbep*, no. 2 (May 2003), pp. 134–37

Quinn, M., 'Don't Blame the Tools', in *Blueprint*, no. 204 (February 2003), pp. 42–44

Antoniadis, A., 'The Museum of Hellenism in Asia Minor', in *A+T Architectural Magazine*, no. 1 (2003), p.18f

'Anamorphosis-Architects: Hellenic World Museum, Athens', in *NEXT- 8th International Architecture Exhibition. La Biennale di Venezia*, exhib. cat., (Venice 2002), p. 78f

Peressut, L. B., 'Il Museo Di Domani, Museo de la Cultura Ellenica', in *Area*, no. 65 (November–December 2002), p. 90f

Georgiadis, N., 'Museum of the History of Hellenism', in *Architects-SADAS*, no. 36 (November–December 2002), pp. 66–68

Tessa, R., 'Un luogo per conoscere, non solo per informarsi', in *La Repubblica* (21 October 2002), p. 33

Connah, R., 'Anamorphosis Architects Athens', in Constantinopoulos, V. (ed.), *10 × 10* (London 2000), pp. 40–43

Anamorphosis Architects, 'The Museum of History of Hellenism', in Aesopos, G. / Simeoforidis, G. (eds.), *Landscapes of Modernisation – Greek Architecture in 1960s and 1990s* (Athens 1999), p. 195

Tadao Ando

The Japan Architect (winter 2005, T. Ando)

Architectural Record (October 2005, N. R. Pollock)

Departures (August 2005, F. A. Bernstein)

The Architectural Review (August 2005, Ph. Chow)

Interni (May 2005, M. Vercelloni)

art 4d (April 2005)

md – moebel interior design (February 2005, S. Tamborini)

Wallpaper (January–February 2005, J. Reid)

Jodidio, P., *Architecture : Art* (Munich/New York, 2005)

Chichu Handbook (Chichu Art Museum, 2005)

Chichu Art Museum (Chichu Art Museum, 2005)

Akimoto, Y./Golan, R./ de Maria, W. et al., *Chichu Art Museum – Tadao Ando Builds for Walter de Maria, James Turrell, and Claude Monet* (Ostfildern-Ruit 2005)

The Daily Yomiuiri (30 October 2004, Sh. Hagiwara)

Esquire (Japan, October 2004, Sh. Ohno/T. Ando)

Casa Brutus (October 2004, N. Aono)

Shinkenchiku (September 2004, T. Ando/ Y. Akimoto)

Bijutsu Techo (September 2004, K. Mogi/ H. Sugimoto/T. Ando et al.)

GA Japan, no. 70 (2004, T. Ando)

GA Document, no. 81 (2004, T. Ando)

waraku (August 2004, T. Ando/J. Turrell/ Y. Akimoto)

Newsweek (19 July 2004, K. Itoi))

Suzuki, H./Iijima, Y./Ando, T., *Tadao Ando: Regeneration – Surroudings and Architecture* (Tokyo 2003)

GA Document, no. 73 (2003, T. Ando)

Jun Aoki

'The Labyrinth inside the Volume: The Exterior Finish as Architecture and the Depth of Ornament' (interview with Jun Aoki), in *a+u architecture and urbanism*, no. 416 (May 2005)

Jun Aoki, 'Aomori Museum of Art', in *Toward Japan to the World – Museums by Japanese Architects*, exhib. cat., (2004)

Jun Aoki, 'Jun Aoki, 3 projects', in *AA Files*, no. 47 (2002)

Jun Aoki & Associates 'Aomori Museum of Art', in *JA*, no. 45 (March 2002)

'How to connect the Jomon period and present' (interview with Jun Aoki), in *GA Japan*, no. 53 (2001)

'Aoki joins the super league', in *World Architecture* (April 2000)

'Result of the architectural design competition for the Aomori Museum of Art', in *Shin Kenchiku 0003* (March 2000)

atelier brückner | ART+COM

Grunert, M. / Triebel, F., *Das Unternehmen BMW seit 1916* (Munich 2006), BMW Dimensionen 5

Sauter, J. / Jaschko, S., 'Medial Surfaces/Mediale Oberflächen', in Gruentuch, A. / Ernst, A. (eds.), *Convertible City. Modes of Densification and Dissolving Boundaries /Formen der Verdichtung und Entgrenzung. German Pavilion/Deutscher Pavillon Venice Biennale 2006 10th International Architecture Exhibition, archplus,* no. 180 (September 2006), pp. 42–45

'BMW Museum', in Fischer, J. (ed.) *1000 x European architecture* (Berlin 2007), p. 479

Schlag, E., 'Automobilmuseen in München, Shanghai und Dingolfing', in *Museum aktuell* (January 2007)

Shigeru Ban

Andreotti, G., *Per una architettura del paesaggio,* (Trento 2005)

Paper Temporary Studio, Shigeru Ban Architects Europe avec Jean de Gastines Architect (Librairie Flammarion du Centre Pompidou, Paris 2005)

McQuaid, M., *Shigeru Ban* (London 2004)

Centre Pompidou-Metz (Editions du Centre Pompidou, Paris 2004)

Mario Botta

'Mart – Museum of Modern and Contemporary Art', in *The Phaidon Atlas of Contemporary World Architecture* (London 2004), p. 568

Cuito, A. (ed.), *Mario Botta* (Düsseldorf, New York 2003), pp. 72–77

Mario Botta Mart Museo di Arte Moderna e Contemporanea di Trento e Rovereto, Opera Progetto, no.1 (Bologna 2003)

'Mart/Museo di Arte Moderna e Contemporanea di Trento e Rovereto', in Corgnati, M. (ed.), *Architetture e Culture passato, presente e futuro,* exhib. cat., (Bologna 2003), pp. 54–59

Mario Botta. Il Museo di Arte Moderna e Contemporanea di Trento e Rovereto (Milan 2003)

'Mart – Museo di Arte Moderna e Contemporanea', in Cappellato, G. (ed.), *Mario Botta Luce e Gravità Architetture 1993–2003,* exhib. cat., (Bologna 2003), pp.154–65

'Mario Botta e Giulio Andreolli, Polo culturale e museale (Mart)', in Pavan, V. (ed.), *Nuova architettura di pietra in Italia/New Stone Architecture in Italy,* exhib. cat., (Verona 2002), pp. 60–67

'Mart Museo di Arte Moderna e Contemporanea di Trento e Rovereto', in Sega, I. / Calzà, P. (eds.), *Musei e collezioni della Vallagarina* (Rovereto 2002), pp. 50–53

Sakellaridou, I., *Mario Botta Poetica dell'architettura* (Milan 2000)

Jodidio, P., *Mario Botta* (Cologne 1999), p. 160

Stephan Braunfels

Braunfels, S. 'Pinakotéka moderního umení, Mnichov', in *Fórum* (Czech architectural journal), (June 2003)

Mönninger, M. / Braunfels, S., *Stephan Braunfels – Pinakothek der Moderne. Kunst, Architektur, Design* (Basel, Berlin, Boston 2002)

Herwig, O., *Pinakothek der Moderne,* München (Berlin 2002)

Knapp, G., *Stephan Braunfels. Pinakothek der Moderne* (Munich 2002)

Massarente, A., 'Pinakothek der Moderne', in *Area 65* (December 2002), pp. 50–61

Büttner, 'Sammelstelle', in *md International magazine of design,* (December 2002), pp. 41–47

'Architektur als Dienstleistung', in *Weltkunst Moderne* (October 2002), pp. 45–52

Stock, W. J., 'Stephan Braunfels. Pinakothek der Moderne in München, Deutschland', in *Architektur.aktuell* (September 2002), pp. 80–93

Baus, U., 'Kult', in *Deutsche Bauzeitung* (September 2002), pp. 60–69

Borodziej, W., 'Das Staatsviertel', in *StadtBauwelt,* no. 24 (2002), pp. 88–93

Düttmann, M., 'Die Pinakothek der Moderne in München', in *Bauwelt,* no. 22 (2002), pp. 26–33

'Pinakothek der Moderne in München', in *Wettbewerbe aktuell* (July 2002), pp. 87–92

Pehnt, W., 'Pinakothek der Moderne. Stephan Braunfels Architekten', in *Baumeister,* B7 (2002), pp. 37–47

'Pinakothek der Moderne. Ein überdisziplinäres Haus', in *Vernissage Bayern,* no. 3 (2002), 16–19

Hufnagl, F. (ed.), *Einblicke Ausblicke. Für ein Museum von Morgen* (Stuttgart 1996)

Burg, D. v. d., *Die Pinakothek der Moderne* (Munich 1995)

'Die neuen Museen neben Alter und Neuer Pinakothek', in *Kunst im Bau,* vol. 1 of *Forum* text series (Kunst- und Ausstellungshalle der Bundesrepublik Deutschland, Göttingen 1994)

Stephan Braunfels. Entwürfe für München (Deutsches Architekturmuseum Frankfurt a. M. (Frankfurt a. M. 1987)

David Chipperfield/ Planungsgruppe Museumsinsel

Lehmann, K-D., *Jahrbuch Preussischer Kulturbesitz 2003,* vol. XL (Berlin, 2004)

Schuster, P-K. / Steingräber, C. I. (eds.), *Museumsinsel Berlin,* (Berlin, Cologne 2004)

David Chipperfield 1998–2004, El Croquis, (Madrid 2004)

Casabella, no. 721 (Milan, April 2004)

'David Chipperfield – Continuity', in *Architecture & Urbanism,* no. 402 (Tokyo, March 2004)

David Chipperfield Architects (eds.), *Neues Museum. Museumsinsel Berlin – Dokumentation und Planung* (June 2003)

Weaver, T., David Chipperfield, *Architectural Works 1990–2002* (Barcelona 2003)

Jester K. / Schneider E. (eds.), *Weiterbauen. Erhaltung, Umnutzung, Erweiterung, Neubau* (Berlin 2002)

Wedel, C. (ed.), *Die neue Museumsinsel. Der Mythos, Der Plan, Die Vision* (Berlin 2002)

David Chipperfield 1991–2001, El Croquis (Madrid 2001)

Hesse, F. P., 'Neues vom Neuen Museum', in *Die Denkmalpflege,* no. 1 (Berlin 2000)

Planungsgruppe Museumsinsel, *Wege zum Masterplan. Museumsinsel Berlin 1998–2000* (Berlin 2000)

Lepik, A., *Masterplan Museumsinsel Berlin. Ein europäisches Projekt* (Berlin 2000)

Bauwelt, no. 41 (3 November 2000)

2G: David Chipperfield Recent Work (Barcelona 1997)

Museumsinsel Berlin. Wettbewerb zum Neuen Museum (Stuttgart, Berlin, Paris 1994)

Badstübner E. / Dorgerloh H. / Gebeßler A. et al., 'Das Neue Museum in Berlin. Ein denkmalpflegerisches Plädoyer zur ergänzenden Wiederherstellung', in *Beiträge zur Denkmalpflege in Berlin,* no. 1 (Senatsverwaltung für Stadtentwicklung und Umweltschutz Berlin, Berlin 1994)

Coop Himmelb(l)au

'COOP HIMMELB(L)AU Musée des Confluences, Lyon, France', in *The Architectural Review* (April 2005)

'Musée des Confluences Lyon, France Coop Himmelb(l)au', in *CA – Architecture & Concept* (December 2004)

'Coop Himmelb(l)au Musée des Confluences, Lyon, France, 2001–2007', in *a+u – Architecture and Urbanism* (October 2004)

Flagge, I. / Schneider, R., *DAM: Die Revision der Postmoderne/Post-Modernism Revisited* (Berlin 2004)

Flouquet, S., *L'architecture contemporaine* (Paris 2004)

La Biennale di Venezia: Metamorph – 9th International Architecture Exhibition Trajectories (Venice 2004)

Lapierre, E., *Métropoles en Europe – Lille* (Paris 2004)

Latham, P. / Beaver, R, *1000 Architects* (Victoria 2004)

Schmal, P. C., *workflow: Struktur – Architektur/ Architecture – Engineering. Klaus Bollinger + Manfred Grohmann* (Basel, Boston, Berlin 2004)

'Coop Himmelb(l)au Musée des Confluences, Lyon, France', *GA Document*, no. 73 (2003)

'Wolf D. Prix, Coop Himmelb(l)au', in *Oris Magazine for Architecture and Culture*, vol. V (2003)

'Musée des Confluences, Lyon, Frankreich. Überarbeitung', in *Wettbewerbe – Architekturjournal*, no. 223/224 (March 2003)

Noever, P. / MAK, *Architectural Resistance. Contemporary Architects face Schindler today* (Ostfildern-Ruit 2003)

Esporre Area 65 (November–December 2002)

Hadid, Z. / Schumacher, P., *Latent Utopias – Experiments within Contemporary Architecture* (Vienna 2002)

Jodidio, P., *Architecture NOW! Architektur heute* (Cologne 2002)

Noever, P. / Zugmann, G., *Blue Universe. Modelle zu Bildern machen / Transforming Models into Pictures. Architectural projects by Coop Himmelb(l)au* (Ostfildern-Ruit 2002)

'Architect Coop Himmelb(l)au', in *Space* (June 2002)

'Coop Himmelb(l)au's "Crystal Cloud of Knowledge" wins competition for science museum in Lyon, France', in *Architectural Record* (May 2001)

'Coop Himmelb(l)au: Musée des Confluences in Lyon', in *Architektur Aktuell*, no. 254 (May 2001)

'Musée des Confluences Projet lauréat Coop Himmelb(l)au', in *l'architecture d'aujourd'hui* (July–August 2001)

Denton Corker Marshall

Susskind, A., 'Home and Away', in *The Bulletin* (5 April 2005)

Merrick, J., 'A law unto themselves', in *The Independent* (9 March 2005)

Styant-Browne, T., 'Stonehenge Visitor Centre', in *Architecture Australia*, vol. 92, no. 5 (September/October 2003), pp. 60–63

Benjamin, A., 'What next? Notes on the Venice Biennale', in *Architecture Australia*, vol. 92, no. 1 (January/February 2003), pp. 19–20

Farrelly, E., 'Romancing the stone', in *Sydney Morning Herald* (2/3 September 2002)

'The wizard from Oz', in *Building* (29 June 2001), pp. 30–31

Diller Scofidio + Renfro

Mancia, P. G. (ed.), 'Eyebeam Institute of Architecture', in *Architecture & PC. La rivoluzione digitale in architettura* (Milan 2004), pp. 116–12

Giorgadze, T., 'Eyebeam – Museum of Art and Technology', in *Architecture + Design* (Georgia, July 2004), pp. 118–19

Papadakis, A., 'Eyebeam School', in *New Architecture*, no. 7 (December 2003), pp. 98–101

'Eyebeam Atelier/Museum of Art & Technology', in *Dialogue* (Taiwan 2002), pp. 68–73

'Eyebeam Atelier', in Lupton, E., Skin: *Surface, Substance and Design* (Princeton 2002), pp. 210–11

Rappaport, N., 'Eyebeam Atelier', in *Wall Street Journal* (10 October 2001)

Frank O. Gehry

Futagawa, Y., *Frank O. Gehry. 13 Projects After Bilbao*, GA Document, no. 68 (Tokyo 2002)

Lindsay, B., *Digital Gehry* (Basel 2001)

Ragheb, J. F. (ed.), *Frank Gehry Architect*, (The Solomon R. Guggenheim Foundation, New York 2001)

Friedman, M. (ed.), *Gehry Talks* (New York 1999)

Bechtler, C. (ed.), *Art and Architecture in Discussion – Frank O. Gehry / Kurt W. Forster* (Ostfildern-Ruit 1999)

Dal Co, F. / Forster, K. W., *Frank O. Gehry: The Complete Works* (New York 1998)

Menges, A. (ed.), *Frank O. Gehry – Guggenheim Bilbao Museo* (Stuttgart 1998)

Van Bruggen, C., *Frank O. Gehry - Guggenheim Museum Bilbao* (The Solomon R. Guggenheim Foundation, New York 1997)

Marquez Cecilia, F. (ed.), *Frank O. Gehry: 1991–1995, El Croquis* (Madrid 1995)

Vegesack, A. von / Futagawa, Y., *Vitra Design Museum* (GA Design Center, Tokyo 1993)

Steele, J., *Schnabel House* (London 1993)

Futagawa, Y., *Frank O. Gehry, GA Architect*, no. 10 (Tokyo 1993)

Marquez Cecilia, F. (ed.), *Frank O. Gehry, El Croquis*, no. 45 (Madrid, Oct/Nov 1990)

Bletter, R. H., *The Architecture of Frank Gehry* (New York 1986)

Arnell, P. / Bickford, T. (eds.), *Frank Gehry: Buildings and Projects* (New York 1985)

Gigon/Guyer

Projekte – Gigon/Guyer (Lucerne 2004)

Gigon/Guyer. Seen by Kield Vindum (Louisiana Museum of Modern Art 2002)

Bürkle, C. (ed.), *Gigon Guyer Architekten – Arbeiten 1989–2000* (Sulgen 2000)

Annette Gigon/Mike Guyer 1989–2000, El Croquis, no. 102 (2000)

Köb, E. (ed.), *Museum Liner Appenzell, Gigon/Guyer* (Kunsthaus Bregenz, Werkdokumente 18), (Ostfildern-Ruit 2000)

Carter, B. / LeCuyer, A. (eds.), *Gigon/Guyer, Michigan Architecture Papers*, 8 (Michigan 2000)

Rüegg, A. / Rehsteiner, J. / Wirth, T., *Fenster-Fassade. Annette Gigon/Mike Guyer* (ETH Professur Arthur Rüegg, Zurich 1998)

Werkstoff. Annette Gigon/Mike Guyer (Architekturgalerie Luzern, Lucerne 1993)

Zaha Hadid

Zaha Hadid Complete Works (London 2004)

Car Park and Terminus Strasbourg (Baden/ Switzerland 2004)

Digital Hadid (Basel 2004)

Zaha Hadid 1983–2004, El Croquis (Madrid 2004)

Zaha Hadid Space for Art (Baden/Switzerland 2004)

Newsweek (May 2003)

Zaha Hadid Architektur, (MAK) (Vienna 2003)

Time Magazine (October 2002, June 2003)

The Independent (June 2002, March 2004)

The Financial Times (June 2002, June 2003)

The New York Times (June 2002, June 2003, March 2004)

Guccione, M. (ed.), *Zaha Hadid, Opere e Progetti* (Turin 2002)

Zaha Hadid, GA Document, no. 65/66 (Tokyo 2001)

Zaha Hadid 1996–2001, El Croquis, no. 103 (Madrid 2001)

Architecture of Zaha Hadid in Photographs by Helene Binet (Baden/Switzerland 2000)

Zaha Hadid: LF One – landscape formation one in Weil am Rhein (Basel 1999)

Zaha Hadid: The Complete Buildings and Projects (London 1998)

Zaha Hadid 1992–1995, El Croquis, no. 73 (Madrid 1995)

Zaha Hadid 1983–1991, El Croquis, no. 52 (Madrid 1991)
'Zaha Hadid', in *AA files*, no. 5 (1986)

Hilmer & Sattler und Albrecht

Hilmer & Sattler und Albrecht – Bauten und Projekte/Buildings and Projects (Stuttgart/London 2004)
Hilmer & Sattler – Bauten und Projekte/Buildings and Projects (Stuttgart/London 2000)
Baulig, J. W., *Geschichte und Rezeption. Theorien und Projekte: Heinz Hilmer & Christoph Sattler, Oswald Mathias Ungers, Johannes Uhl* (dissertation, Bonn 1986)

Steven Holl

Holl, S., 'Steven Holl', in *CA: Contemporary Architecture Press*, no. 26 (August 2005)
Holl, S., 'Alvar Aalto: Villa Mairea, Noormarkku and Porosity to Fusion', in *Lotus Eventi* (May 2005), pp. 186–91
Gannon, T. (ed.), *Steven Holl. Simmons Hall* (Princeton 2004)
Holl, S., 'Voice of the Suburbs?', in *Domus*, no. 876 (Milan, December 2004), pp. 16–17
Steven Holl: Competitions, GA Document, no. 82 (December 2004)
Garofalo, F., *Steven Holl* (New York 2003)
Steven Holl 1986–2003, El Croquis (Madrid 2003)
Frampton, K., *Steven Holl Architetto* (Milan 2002)
Architekturzentrum Wien (ed.), *Steven Holl, Idea and Phenomena* (Baden/Switzerland 2002)
Müller, L. (ed.), *Steven Holl. Written in Water* (Baden/Switzerland 2002)
Steven Holl 1998–2002, El Croquis, no. 108 (Madrid 2001)
Holl, S., *Parallax* (New York 2000)
Holl, S., *The Chapel of St. Ignatius* (New York 1999)
Steven Holl 1996–1999, El Croquis (Madrid 1999)
'Intertwining With the City: Museum of Contemporary Art in Helsinki', in *Harvard Architecture Review*, no. 10 (1998)

Kisho Kurokawa

'Big Wave in Roppongi', in *Asahi Shinbun* (1 July 2005, evening edition), p. 7
Kunz, M. N., *Tokyo architecture & design* (Kempen 2005), p. 64f
'Roppongi Renaissance', in *Tokyo Shinbun* (30 December 2004, morning edition), p. 26
'A museum which boast largest class area for exhibition', in *Nikkei Architecture 2004*, no. 780 (October 2004)
'Economy on Art – New National Museum', in *Asahi Shinbun*, (20 May 2004, evening edition), p. 7
Kisho Kurokawa: Metabolism and Symbiosis, exhib. cat. (Berlin 2005)
Das Kurokawa-Manifest (German translation of *Philosophy of Symbiosis*) (Berlin 2005)
Kisho Kurokawa: The London Texts, exhib. cat. (London 2005)
Kisho Kurokawa – Museums (Milan 2002)
Kisho Kurokawa Architect and Associates (New York 2001)
Kisho Kurokawa Architect and Aassociates. Selected and Current Works (Mulgrave/Australia 2000)
Retrospective Kurokawa Kisho: Penser la symbiose, exhib. cat. (Maison de la culture du Japon á Paris, Paris 1998)
Hanasuki (literary texts), (Tokyo 1997)
Kisho Kurokawa: Le Metabolisme 1960–1975, exhib. cat. (Centre Georges Pompidou, Paris 1997)
Each One A Hero – Philosophy of Symbiosis (Tokyo 1997)
Kisho Kurokawa: Abstract Symbolism (Milan 1996)
Kisho Kurokawa Note (biographical texts), (Tokyo 1994)
Kentiku-no-uta (literary texts), (Tokyo 1993)
Kyosei-no-shiso (Philosopy of Symbiosis), (Tokyo 1987)
City Planning (Toshi-design), (literary texts), (Tokyo 1970)

Daniel Libeskind

Tilden, S. J. (ed.), *Architecture for Art. American Art Museums 1938–2008* (New York 2004)

Fumihiko Maki

GA Document International 2003, no.73 (Tokyo 2003)
Taylor, J., *The Architecture of Fumihiko Maki: Space, City, Order and Making* (Basel 2003)
Fumihiko Maki 4: 1993–1999, (Contemporary Architects Series, Tokyo 2001)
Fumihiko Maki: Buildings and Projects (New York 1997)
Fumihiko Maki 3: 1986–1992, (Contemporary Architects Series, Tokyo 1993)
Kioku no Keisho (essays), (Tokyo 1992)
Fragmentary Figures: The Collected Architectural Drawings of Fumihiko Maki (Tokyo 1989)
Salat, S., *Fumihiko Maki: Une Poetique de la Fragmentation* (Paris 1987)
Maki, F. et al., *Design Methodology in Technology and Science* (Tokyo 1987)
Fumihiko Maki 2: 1979–1986, (Contemporary Architects Series, Tokyo 1986)
Miegakuresuru Toshi: A Morphological Analysis of the City of Edo-Tokyo (Tokyo 1979)
Fumihiko Maki 1: 1965–1978, (Contemporary Architects Series, Tokyo 1978)
Japanese translation of *Communitas* (P. and P. Goodman) by Fumihiko Maki, (Tokyo 1965)
'Some Thoughts on Collective Form', in Kepes, G. / Brazilier, G. (eds.), *Structure in Art and Science* (New York 1965)
Movement System in the City (Cambridge, Mass. 1965)
Investigations in Collective Form (St. Louis 1964)
Metabolism 1960 (Tokyo 1960)

HG Merz

Aus der Tradition in die Zukunft. Der 3. Bundesdeutsche Architekturpreis Putz, (AIT-edition, vol 4), (Stuttgart 2004)

Schuster, P.-K. (ed.), *Die Alte Nationalgalerie* (Berlin 2003)

Stüler/Strack/Merz: *Alte Nationalgalerie, Berlin* (Stuttgart/London 2003)

Staatliche Museen zu Berlin (eds.) *Die neue Alte Nationalgalerie* (Berlin 2002)

Maaz, B., *Die Alte Nationalgalerie. Geschichte, Bau und Umbau,* (with essays by Gisela Holan, HG Merz und Hartmut Dorgerloh, Bernhard Maaz), (Berlin 2001)

Dogerloh, H., *Die Nationalgalerie in Berlin. Zur Geschichte des Gebäudes auf der Museumsinsel 1841–1970* (Berlin 1999)

Maaz, B., *Alte Nationalgalerie,* (Berliner Ansichten, vol. 7), (Berlin 1999)

Petras, R., 'Die Nationalgalerie von August Stüler und Heinrich Strack', in *Die Bauten der Berliner Museumsinsel*, pp. 77–92 (Berlin 1987)

Rave, P. O., *Die Geschichte der Nationalgalerie* (Berlin 1968)

Justi, L., *Der Umbau in der Nationalgalerie* (Berlin 1914)

Jean Nouvel

Moore, R., in *Specifier* (April 2005)

Margot, Ol, in *Palace* (March 2005)

Le Parisien (30 December 2004)

Prat, V., in *Figaro Magazine* (18 December 2004)

Legrand, C., in *Journal du Dimanche* (7 November 2004)

Riding, A., in *International Herald Tribune* (7 September 2004)

Riding, A., in *The New York Times* (6 September 2004)

Dugrand, A., in *GEO* (France), (October 2003)

Delannoy, P., in *Paris Match* (7 March 2002)

AJN: Architectures Jean Nouvel 1994–2002, El Croquis, no. 112/113 (2002)

AJN: Architectures Jean Nouvel, GA Document, no. 04 (2000)

Dumas, S., in *L'architecture d'aujourd'hui*, no. 326 (February 2000)

De Roux, E., in *Le Monde* (7 December 1999)

Renzo Piano

Blaser, W., *Zentrum Paul Klee. Renzo Piano Archimorphosis* (Basel 2005)

Zentrum Paul Klee (brief guide), (Zentrum Paul Klee, Berne 2005)

Zentrum Paul Klee (Zentrum Paul Klee, Berne 2005)

Jodidio, P., *PIANO Renzo Piano Building Workshop 1966–2005* (Cologne 2005)

Piano, R., *On Tour with Renzo Piano* (London 2004)

Buchanan, P., *Renzo Piano Building Workshop. Complete works, vol. 4* (London 2000)

Piano, R., *Giornale di bordo* (Florence 1997)

Piano, R., *Renzo Piano buildings and projects 1971–1989* (New York 1989)

Piano, R., *Renzo Piano projects and buildings 1987–1994* (Stuttgart 1994)

Spacelab

Klik (Slovenia, March 2005)

Interior (Russia, February 2005)

'Anatomy of a Monster', in *Time and Architecture* (January 2005)

'Kunsthaus, Graz (Austria) Spacelab (Cook & Fournier)', in *Diseño Interior* (June 2004)

'Dokumentation Kunsthaus Graz', in *Detail Auswahl 2004* (2004)

'Techné ed Inventio, la Kunsthaus di Graz', in Biondo, G. et al. (eds.), *Abitare il Futuro. innovazione e nuove centralita urbane* (Bologna 2004)

Jontes, G., 'Friendly Alien', in *100 steirische Meisterwerke* (Graz 2004)

Mathewson, Casey C. M., 'Return of the Blob', in: *Architecture Today* (Berlin 2004)

'The British Scene', in *AV* (May–June 2004)

'Priatelsky votrelec', in *Architektura Stavebnictvo Byvanie* (April 2004)

'Close encounter: P. Cook and C. Fournier in Graz', in *Architecture Today* (April 2004)

'Museo d'arte contemporanea – Graz, Austria', in *The Plan* (March 2004)

'Una Bolla Blu a Graz', in *L'Eco Della Stampa* (February 2004)

'Focus su Graz Capitale dell'Architettura', in *Costruire* (February 2004)

'Kunsthaus Graz – przyazny obcy', in *Architektura Biznes* (January 2004)

'Spacelab Cook-Fournier', in *Architecture and Urbanism* (January 2004)

'Whatever happened to their Rock 'n' Roll', in *Bauwelt* (December 2003)

'Spacelab Peter Cook, Colin Fournier Kunsthaus in Graz', in *Baumeister* (December 2003)

'Der große Blob', in *art* (December 2003)

'Atteraggio a Graz', in *Domus* (December 2003)

'Memoria del futuro', in *Arquitectura Viva* (November–December 2003)

'Ein bläulich schimmerndes Sprachorgan', in *Hochparterre* (November 2003)

'Blauwal am Murufer gestrandet', in *architektur* (October–November 2003)

'Skin and Pin', in *Architektur und Bauforum* (December 2002)

Yoshio Taniguchi

Lowry, G. D., *The New Museum of Modern Art* (The Museum of Modern Art, New York 2005)

Riley, T., *Museums by Yoshio Taniguchi* (Nagoya/Japan 2005)

GA Japan, no. 76 (September–October 2005)

Shinkenchiku (September 2005)

Nikkei Architecture (5 September 2005)

Architectural Record (January 2005)

Casa BRUTUS (January 2005)

Deutsche Bauzeitschrift (January 2005)

CASABELLA, no. 728/729 (December 2004–January 2005)

The Architects' Journal (2 December 2004)

Riley, T., *Yoshio Taniguchi: Nine Museums* (The Museum of Modern Art, New York 2004)

Taniguchi, Y., *The Architecture of Yoshio Taniguchi* (New York 1999)

Elderfield, J. (ed.), *Imaging the Future of The Museum of Modern Art* (The Museum of Modern Art, New York 1998)

Heinz Tesar

Nerdinger, W. (ed.), *Heinz Tesar, Architettura,* (*documenti di architettura* no. 169), (Milan 2005)

Kristan, M., *export. Austrian Architecture in Europe – Österreichische Architekten bauen für Europa* (Vienna/New York 2003)

Heinz Tesar. Zeichnungen/Drawings (Stuttgart/London 2003)

Alessi, A., *Heinz Tesar* (Rome 2002)

'Raum, Licht und Bewegung. Zur Architektur des Ausstellungshauses. Rudi Fuchs und Heinz Tesar im Gespräch', in *Sammlung Essl – The First View* (Cologne 1999)

Zukowsky, J., 'Contemporary Architecture in Austria – At Last, Another Revolution in the Empire', in Zukowsky, J. / Wardropper, I. (eds.), *Austrian Architecture and Design. Beyond Tradition in the 1990s* (The Art Institute of Chicago), (Berlin 1991)

Bernard Tschumi

'A Swiss constructs the Acropolis Museum', in *Tribune des Arts*, no. 328 (Geneva, February 2005), p. 25

'New Acropolis Museum', in *Architecture Technology & Design*, no.125 (Hong Kong, January 2005), pp. 86–87

Atina, Y., 'New Acropolis Museum', in *Yapi* (October 2004), pp. 71–75

Bernstein, F., 'Greece's Colossal New Guilt Trip', in *The New York Times* (18 January 2004), Arts & Leisure section, p. 1. Reprinted in French in *La Presse* (Montreal, 28 January 2004)

'Greece Builds a Museum for Missing Statues', in *The Week* (New York), p. 4

Zitzmann, M, 'Parkanlagen und Museen: Kulturelle Wegweiser im Stadtraum von Athen', in *Neue Zürcher Zeitung*, no. 187 (13 August 2004), pp. 43–44

Lobell, J., 'Acropolis Museum back on track and wants the Parthenon marbles to come home', in *Archaeology* (New York, July/August 2004), pp. 10–12

'The New Acropolis Museum', in *GA Document International*, no. 79 (Tokyo, April 2004), p. 64

'Un cofre de crystal para las joyas de la Acrópolis', in *GEO*, no. 201 (Madrid, October 2003), p. 14

Galpin, R, 'Acropolis building site stirs up storm', broadcast on *BBC News On-Line World Edition*, (18 August 2003), www.bbc.co.uk

Ungoed-Thomas, J., 'Museum in secret talks to return Elgin Marbles', in *The Sunday Times* (London, 2 August 2003), section 1, p. 1

Bong, J., 'Bernard Tschumi', in *Space*, no. 428 (Seoul, July 2003), pp. 109–57

Van Gelder, L., 'Greece: Approval for a Museum', in *The New York Times* (New York, 29 July 2003)

Rosenbaum, L., 'Meeting of the Marbles?', in *Art in America*, no. 5 (New York, May 2003), p. 41

Dablis, A., 'Athens museum awaits disputed marbles', in *USA Today* (22 March 2002), p. 10

Glover, M., 'Olympic Effort', in *ArtNews* (New York, March 2002), p. 60

Dufour, N., 'Athènes devoile son future Musee del' Acropole', in *Le Temps*, no.171 (Paris, 21 February 2002)

'Athens', in *Architecture Today*, no. 125 (London, 2 February 2002), p. 15

'Neues Akropolismuseum', in *StadtBauwelt*, no. 152 (December 2001), p. 9

Bastea, N., 'You Respect Tradition, You Don't Imitate It', in *Grand Larousse* (Greece, 3–4 November 2001), pp. 10–14

Alberge, D., 'Greece to build £29m home for Elgin Marbles', in *The Times* (London, 26 October 2001), p. 17

Booth, R., 'Tschumi Plans Home for Elgin Marbles', in *Building Design*, no. 1506 (London, 19 October 2001), p. 5

Illia, T., 'Commission for Acropolis Museum, intended as home for Elgin Marbles, goes to Tschumi', in *Architectural Record* (New York, October 2001), p. 28

O.M. Ungers

10 Kapitel über Architektur – Ein visueller Traktat (1999)

Zwischenräume, exhib. cat. (Düsseldorf 1999)

O.M. Ungers Architektur 1991–1998 (1998)

O.M. Ungers Architekt, exhib. cat. (Kunsthalle Hamburg 1994)

O.M. Ungers Architektur 1951–1990 (1991), *1951–1984 Bauten und Projekte* (1985)

UN Studio

'Insight – Foresight – Stuttgart', in *Ark* (July 2005) p. 68

Silva, J. M. F., 'Plano Inclidnado', in *arquitectura construcão* (June 2005), p. 101

Slessor, C., 'Stuttgart spiral', in *Architectural Review* (June 2005), p. 74

Klein, D., 'Das neue Mercedes-Benz Museum in Stuttgart', in *Beton- und Stahlbetonbau* (May 2005), p. 325

Baus, U., 'Speeding up', in *A10* (April 2005), p. 10

Johannes, R., 'De hele bedrijfsvoering in een dubbele schroef', in *Cobouw* (March 2005), p. 7

Najak, A., 'The Multidimensional Contemporary', in *Indian Architect* (February 2005), p. 72

'In den Tempeln der Mobilität', in *Form Art* (December 2004), p. 5

Van Berkel, B. / Boos, C., 'The new, new concept of the architect revised', in *Indian Architect* (November 2004), p. 84

'>Next', in *Pol Oxygen*, (November 2004), p. 104

Paoletti, I., 'Una costruzione a puzzle', in *il Giornale dell'Architettura* (October 2004)

Liu, Yu-Tung (ed.), *Diversifying Digital Architecture* (Basel, September 2004), p. 34

'Crossover im Trend', in *Die Welt* (May 2004)

'Love it Live it', in *digital tectonics* (April 2004)

'Het wilde bouwen, 'vrijde vormgeving vereist nauwe samenwerking…', in *De Ingenieur* (April 2004)

Rafael Viñoly

Bliwise, R. J., 'Designing for Duke', in *Duke Magazine* (May–June 2003), pp. 28–29

Yee, C., 'Nasher Construction Underway', in *The Chronicle Online* (22 May 2003)

Kakissis, J., 'Shades of Progress', in *The News & Observer* (Raleigh), (16 March 2003)

Sweet, K., 'Duke Art Museum Architect, Benefactor Survey Progress', in *The Herald-Sun* (7 March 2003)

'Works in Progress', in *The News & Observer* (Raleigh), (8 September 2002)

Wooldridge, J., 'Love Triangle; Raleigh – Durham – Chapel Hill; Growth Doesn't Mar Charms of NC Trio', in *Richmond-Times Dispatch* (8 September 2002)

Cheng, V., 'Duke Gets Showcase Architect for Showcase Museum', in *The News & Observer* (Raleigh), (10 March 2000)

Levy, J., 'Duke Picks Art Museum Architect', in *Duke Chronicle* (9 March 2000)

Vogel, C., 'Duke Gets Gift for Art Museum', in *The New York Times* (13 November 1998)

Wood/Marsh

Van Schaik, L., *Mastering Architecture. Becoming a creative innovator in practice* (Chichester/Australia 2005)

'The Shape We're In', in *City Weekly*, no.12 (2005)

'The Piety of Rust', in *Architecture Australia* (May/June 2005)

'Australian Centre for Contemporary Art', in *C3 Topic* (Cultural Facilities II), (2004)

The Phaidon Atlas Of Contemporary World Architecture (London 2004)

Peterson, C., 'Art outcrop: centre for contemporary art', in *Architectural Review*, vol. 214, no. 1277 (July 2003), pp. 58–61

'Australian Centre for Contemporary Art, Melbourne, Australia', in *The Architectural Review* (July 2003), pp. 58–61

'Lo Specchio dell' Australia', in *Domus*, no. 857 (March 2003)

Burns, K., 'Surface: architecture's expanded field', in *Architectural Design*, vol. 73, no. 2 (March 2003), pp. 86–92

Kaji-O'Grady, S., 'Arts and the Iconic', in *Architecture Australia*, vol. 92, no.1 (January 2003), pp. 36–43

'Raw Drama in Steel', in *Poster* (January 2003)

'Arts and the Iconic', in *Architecture Australia* (January 2003)

Goad, Gollings, Pigeon (eds.), *Judging Architecture: Issues Divisions Triumphs Victorian Architecture Awards 1929–2003* (Melbourne 2003)

'Australian Centre for Contemporary Art', in *Architecture Review U.K.* (Summer 2002/2003)

'Building Art-Forging South', in *Monument*, no. 51 (2002)

Day, N., 'Daring, whimsical and rusty', in *The Age* (16 September 2002)

Carnevale, V., 'For art's sake', in *Architectural Review Australia* (2002)

Bringham-Hall, P. / Goad, P., New Directions in *Australian Architecture* (Sydney 2001)

Perera, N., 'Art Attach', in *Herald Sun* (18–24 December 1999)

Holgate, B., 'Malthouse designers focus on function', in *The Australian* (13 August 1999)

Photo credits